THE HOBBIT

THE BATTLE OF THE FIVE ARMIES

✦

CHRONICLES

THE ART OF WAR

OTHER PUBLICATIONS FROM WETA INCLUDE:

The Hobbit: An Unexpected Journey:
Chronicles: Art & Design

The Hobbit: The Desolation of Smaug:
Chronicle Companion: Smaug, Unleashing the Dragon

The Hobbit: An Unexpected Journey:
Chronicles: Creatures & Characters

The Hobbit: The Desolation of Smaug:
Chronicles: Cloaks & Daggers

The Hobbit: The Desolation of Smaug:
Chronicles: Art & Design

The Hobbit: The Battle of the Five Armies:
Chronicles: Art & Design

HarperCollins books may be purchased for educational, sales, or promotional
use. For information please e-mail the Special Markets Department at
SPsales@harpercollins.com.

Published in 2015 by
Harper Design
An Imprint of HarperCollins*Publishers*
195 Broadway
New York, New York 10007
Tel: (212) 207-7000
Fax: (855) 746-6023
harperdesign@harpercollins.com
www.hc.com

'Tolkien'® is a registered trademark of The J.R.R. Tolkien Estate Limited.

The Hobbit: The Battle of the Five Armies Chronicles: The Art of War is a companion
to the film *The Hobbit: The Battle of the Five Armies* and is published with the
permission, but not the approval, of the Estate of the late J.R.R. Tolkien.

The Hobbit is published by HarperCollins*Publishers* under license from The J.R.R.
Tolkien Estate Limited.

Library of Congress Number: 2015943467

ISBN 978-0-06-226572-2

Printed and bound in China, 2015

Cover design by Monique Hamon
Artwork on pages 1 and 7 by Concept Art Director John Howe
Artwork on page 6 by Concept Art Director Alan Lee

The Art of the Adventures of Tintin
The Art of District 9: Weta Workshop
Weta: The Collector's Guide
The Crafting of Narnia: The Art, Creatures, and Weapons
* from Weta Workshop*
The World of Kong: A Natural History of Skull Island

**Visit the Weta Workshop website for news, an online shop, and much
more at www.wetanz.com.**

THE HOBBIT™

THE BATTLE OF THE FIVE ARMIES

CHRONICLES

THE ART OF WAR

FOREWORD BY LEE PACE ✦ AFTERWORD BY RICHARD ARMITAGE

INTRODUCTION BY TERRY NOTARY WRITTEN BY DANIEL FALCONER

HARPER DESIGN

An Imprint of HarperCollins Publishers

www.wetaNZ.com

CONTENTS

Acknowledgements

I began *The Hobbit: Chronicles* in 2012 because of my love of Middle-earth and excitement at having been part of the mission to bring Tolkien's world to the screen through Peter Jackson's lens. These books have afforded me the opportunity to share my enthusiasm and the experiences I have had living and breathing this world for so long, and remain part of it long after my duties as a designer for Weta Workshop were done. Now I can add the role of Chronicler, a person entrusted by his peers and colleagues to tell their stories, the stories behind the scenes, to quote a common but apt cliché. It has given me the chance to indulge my passion beyond the walls of the design studio, visiting and engaging with other artists and specialists of diverse disciplines and learn about their challenges and experiences on these films: digital effects artists, actors, stunt-people, dialect coaches, specialist craftspeople and so many others. It has truly been a privilege and I am deeply grateful for the trust and goodwill with which my inquiries have been met in all quarters. Everyone has been supportive and enthusiastic, which has made my task all the more enjoyable.

That said, there are a number of special people who merit specific mention for their contributions and assistance, and without these books would have either been impossible or much less than they have become.

Firstly, warmest and deepest appreciations go to my closest collaborators at Weta Workshop in this grand endeavour: Monique Hamon, Karen Flett and Kate Jorgensen. Their good humour and professionalism have made working with them an honour and a pleasure. Thanks also to the diligent and ever-reliable Fiona Ogilvie for her tireless contribution, and to Richard Taylor, Mike Gonzales, Tasha Guillot and Rik Athorne for their confidence and support.

Sincerest thanks to our partners at UK HarperCollins*Publishers* for their guidance and assistance at every turn: Chris Smith, David Brawn, Terence Caven, Kathy Turtle and Stuart Bache, as well as Marta Schooler in the USA.

Many kind thanks to our friends, the patient facilitators of our constant requests at 3Foot7, Weta Digital, Wingnut Films and Warner Bros. We relied heavily upon them throughout this series and especially on this concluding volume. Thank you to Matt Dravitzki, Amanda Walker, Judy Alley, Melissa Booth, Anna Houghton, Susannah Scott, Jill Benscoter, Elaine Piechowski, Victoria Selover, Melanie Swartz, Joe Letteri, David Gouge, and Amy Minty.

I had the great pleasure of interviewing a huge number of crew and cast with diverse and astonishing talents as I researched and prepared the content for this book and am deeply appreciative to all of them for their generosity, openness and trust. Everyone was obliging and delightful, but I wish to thank Richard Armitage, Lee Pace and Terry Notary in particular for the time they took to craft their contributions in the form of Afterword, Foreword and Introduction, respectively.

There would be no *Chronicles* if it weren't for *The Hobbit*. Sincerest thanks to Peter Jackson, Fran Walsh and Philippa Boyens for creating three films so rich in wonder and depth that, in more than six books, we have still only scratched the surface!

Finally, thank you to the readers of the *Chronicles*, fellow devotees of Tolkien and filmmaking. To you I express my deep gratitude for exploring Peter Jackson's adaptation of Middle-earth with me and enabling the expression of my affection for this world, its collaborative creators and the stories behind their work. It has been a great adventure. I'm so pleased that Wizard came calling.

- DANIEL FALCONER

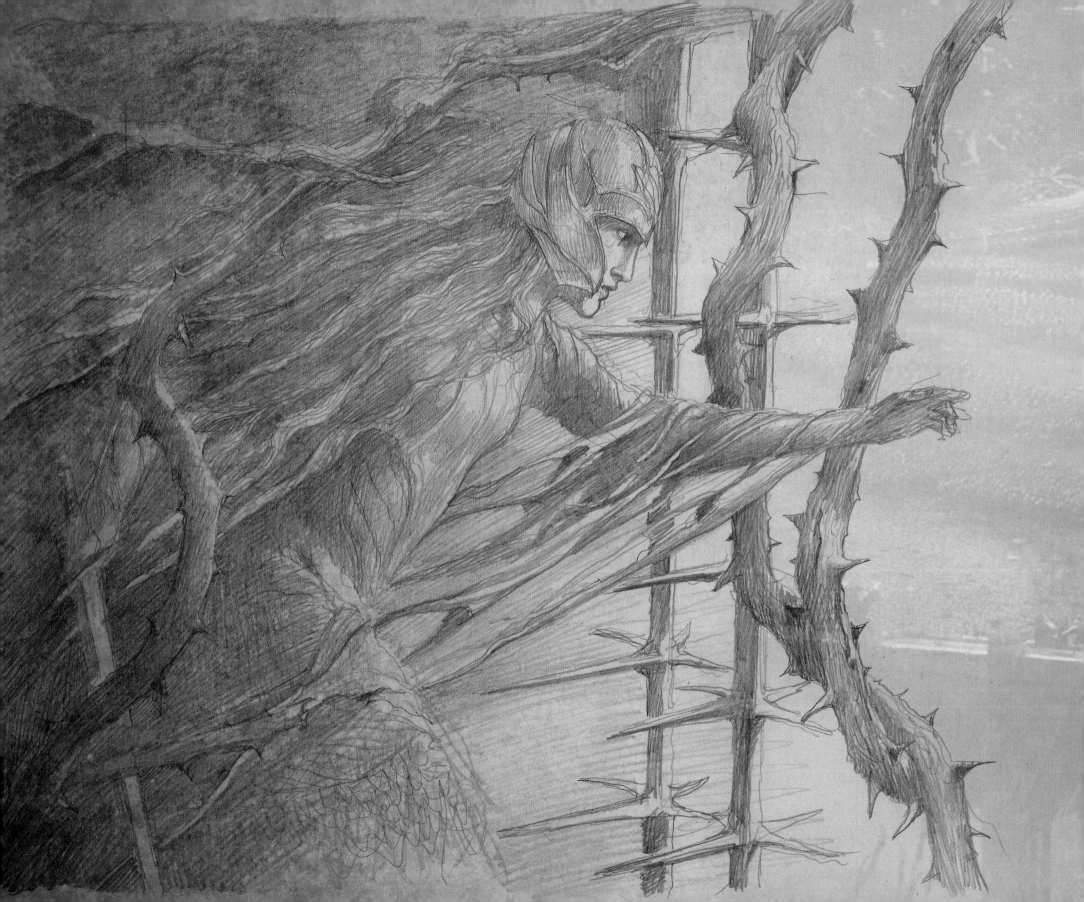

FOREWORD

It is early morning...

We are in a no man's land of fluorescent green. I wear the Elven-king's armour, beautifully created by the teams of Bob Buck's Costume Department and Weta Workshop. I ride a horse named Moose, who will be digitally transformed into giant, angry elk. On the white stallion beside me, Luke Evans, dressed as Bard the Bowman. Bard pulls the Arkenstone from his pocket. The gesture hangs in the air. The alliance of Elves and Men is making one last attempt at peace. War could erupt at any moment. I am Thranduil, the King of the Woodland Realm, an ancient Sindarin Elf. My precious white gems are in the Mountain; my greatest desire. I am utterly committed. I stare up at Thorin Oakenshield; how will he respond? Will he have peace or war? I despise Thorin and the Dwarves. Secretly, I hope that Bard's peace mission will fail, so that I can rain arrows on the walls of Erebor... but, something is missing...

'Um, where is my Elven army?' I ask, quietly. No need to shout when you are wearing a microphone on your body.

Peter Jackson's voice booms through the stage like the voice of God; he has a microphone and speakers. 'Yeah, Lee, you've got Elven archers everywhere.'

Our fearless director is inside a black tent, watching us approach the walls of Erebor on 3D television screens.

I glance around the vast soundstage sheathed in blinding green; empty, save the cameras. The Wizard, the magnetic Ian McKellen, is preparing to make his entrance. Richard Armitage waits behind the camera, elevated in front of us by a cherry picker, so that Luke and I can look up at him standing upon the battlements of Erebor. There is no army of Elves.

'This army of mine... my Elven army... it's a very large Elven army, right?'

'Of course,' Peter chuckles. 'There's lots of them.'

Sitting at the premiere of the film in London, two years later, I finally saw my army, and it was astonishing; both in scale and style. This is the magic of Middle-earth.

The Hobbit: The Battle of the Five Armies is a work of collaborative alchemy. It blends the imagination and skill of hundreds; stunt people and make-up artists, carpenters and coders, wigmakers and swordsmiths, the brilliant artists Alan Lee and John Howe, the creature designers of Weta Workshop and Weta Digital, and Howard Shore's music played by the London Philharmonic, to mention just a few. This fantastic team created the thrilling scope of this emotional battle. They imagined and then burned Lake-town; they haunted Dol Guldur, they brought Dwarves, Men, Elves, Orcs and Eagles to an epic, rousing clash on the rock-strewn plains of the Lonely Mountain.

We were there. We witnessed the Battle of the Five Armies. Collected in this book are a few of our stories.

- LEE PACE
ACTOR, THRANDUIL

INTRODUCTION

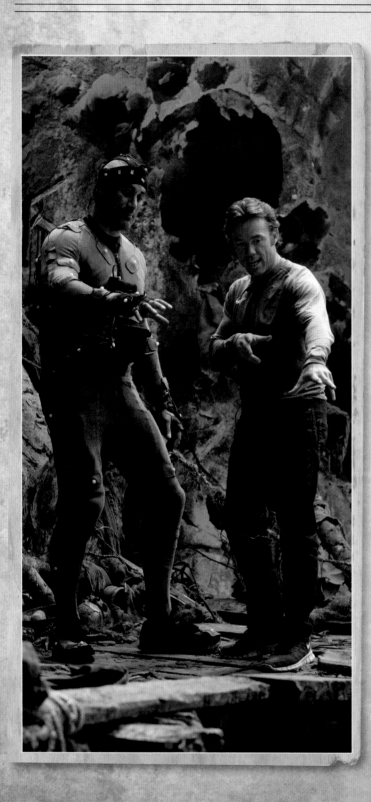

The story of *The Hobbit* is about Bilbo Baggins, who finds the courage to venture into uncharted lands, challenge ideas, conquer fears and return home with a better knowledge of himself. Ironically, the journey of our hero Bilbo was a looking glass into the ambitious three-year journey that the cast and crew embarked on during the making of these three films.

The years seemed to pass as swift as an army of Elves. Marriages were announced, children were born and a few more grey hairs proudly pronounced themselves upon our heads. In the beginning, our journey together felt like the preparation for a strategic military operation as Peter's handpicked army of international specialists arrived, one by one, in the small city of Wellington. Our Commander in Chief, Peter, was no stranger to these sorts of missions. Meetings began with the HODs and each was assigned our own essential role to help build the ship that would steer us across the vast sea of production. Even amongst the seasoned veterans, there was a palpable buzz of anticipation for the venture we were all about to embark on.

Movement and voice rehearsals began, make-ups were tested, costumes made, cutting-edge new 3D camera systems explored, stunts designed and sets constructed; some of the most talented filmmakers in the world had assembled at Peter Jackson's Stone Street Studios to collaborate on one of the most ambitious film projects to date. After three months, the ship was ready to set sail.

On our first day of shooting, the entire cast and crew gathered for an unforgettable Maori blessing. The clouds miraculously parted and magic light illuminated the ceremony that would ensure the safety of our journey. We all stood in silence knowing that there was no turning back.

As Bilbo ventured into uncharted lands, so too did we. Unimaginable obstacles emerged, but seemingly impossible challenges were met with an unwavering determination. Day after day, Peter pushed on, breaking new ground in the art of filmmaking and setting lofty new standards for us to achieve, exceeding our own expectations.

When the Dragon was slain and our hero's journey had come to its end, our exhausted crew of filmmakers felt as though we had done battle with a Dragon of our own. As we said our goodbyes and parted ways, it dawned on me how an army of gathered strangers had grown into a tight-knit family of artistic collaborators. The magic had worked; we had ventured into uncharted lands on our own, challenged our ideas, conquered our fears, and returned safely home with a better understanding of who we were.

Thank you to Peter, the producers, and to the incredible cast and crew that became family along our own unforgettable hero's journey.

– TERRY NOTARY
MOVEMENT COACH

THE RAZING OF LAKE-TOWN

Fulfilling the prophetic words of Bard, who spoke against Thorin's quest to enter Erebor for fear of provoking the Dragon to wrath, Smaug descends in a storm of fury to vent his rage upon Lake-town. Belching torrents of flame, the great worm strafes the frail buildings in pass after fiery pass. Smaug is an artist, painting an apocalyptic masterpiece in flame, soaring high to view his work, delighting in the carnage wrought with each stroke.

Imprisoned by the jealous Master of Lake-town, who now seeks to make his escape in a barge over-laden with stolen treasure, Bard must free himself to reunite with his children. Taking advantage of the Master's passing vessel, he ensnares the barge and its unctuous captain in a hastily contrived rope of rags, tearing free the bars of his gaol cell.

While the people flee and Tauriel ferries his children to safety between the burning streets, Bard does not run, but with bow and quiver in his arms, makes for the beleaguered town's belfry, there to make his stand against the rampaging fire drake. Arrow after arrow he lets fly, but the Dragon's hide proves impervious to such meagre missiles, serving only to entertain the brute and tempt him to land amid the cataclysm, the better vantage from which to savour his victory and taunt his impotent would-be slayer.

Appearing suddenly at his father's side is Bain, bearing the Black Arrow of Girion in his fist, and though his bow is broken, Bard improvises even as the Dragon charges, sending the twisted steel arrowhead spinning between the one gap in Smaug's scaly armour where it punctures his blackened heart.

The Dragon claws at the sky, desperately gasping for breath before his life's furnace sputters, sending his immense body plummeting down upon the town. Smaug's corpse plunges into the inky lake, taking with it the Master and his own hoard, leaving Lake-town a gutted ruin and its people bereft and strewn like flotsam upon the shores of Esgaroth.

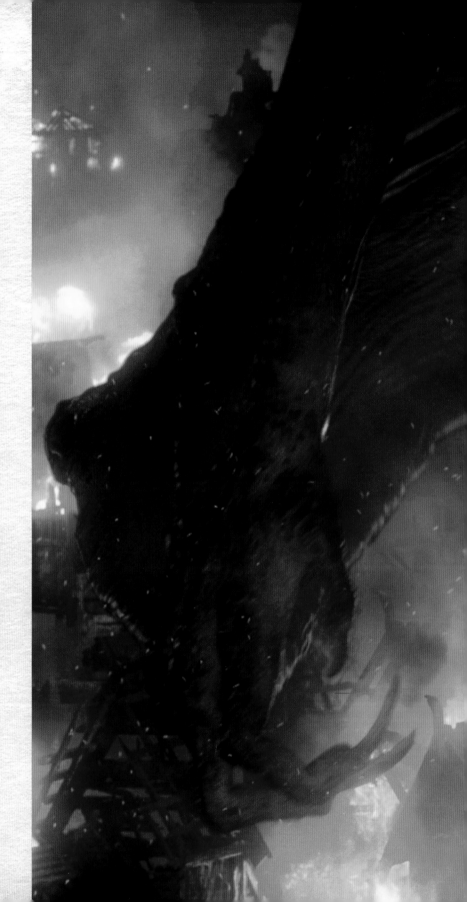

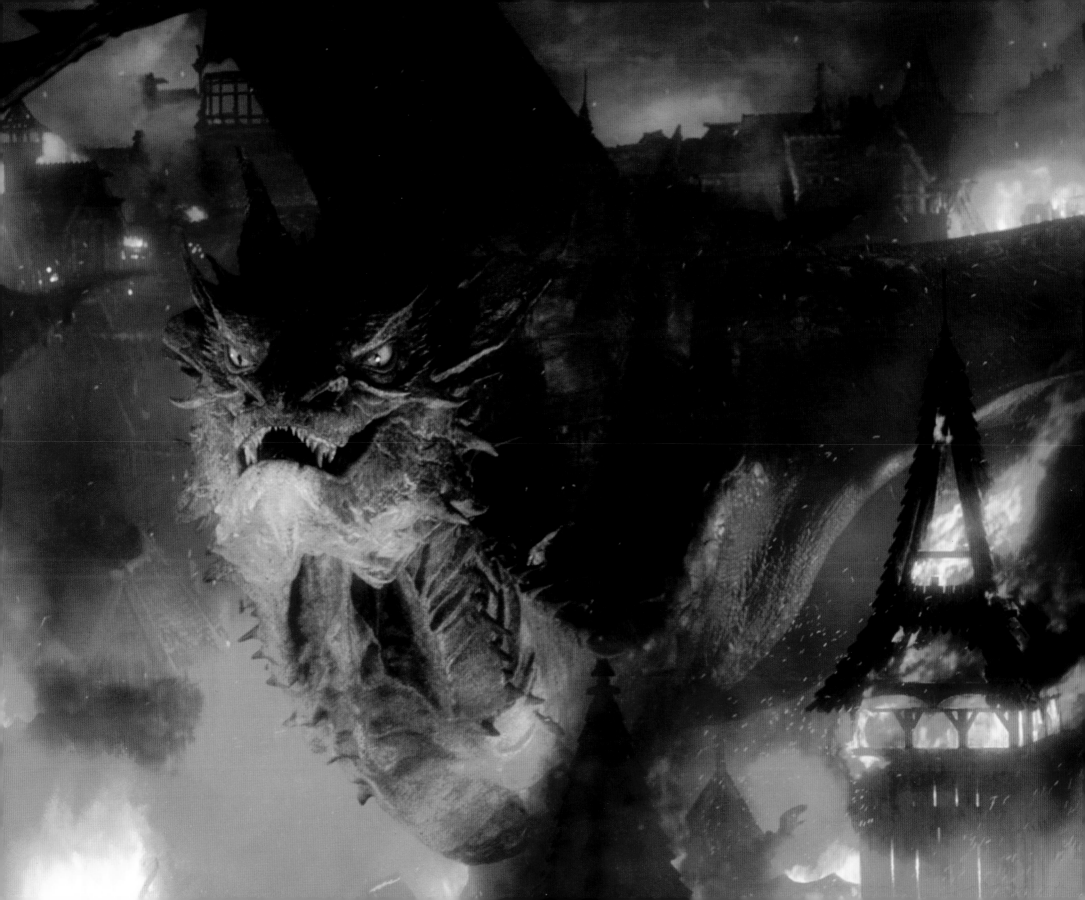

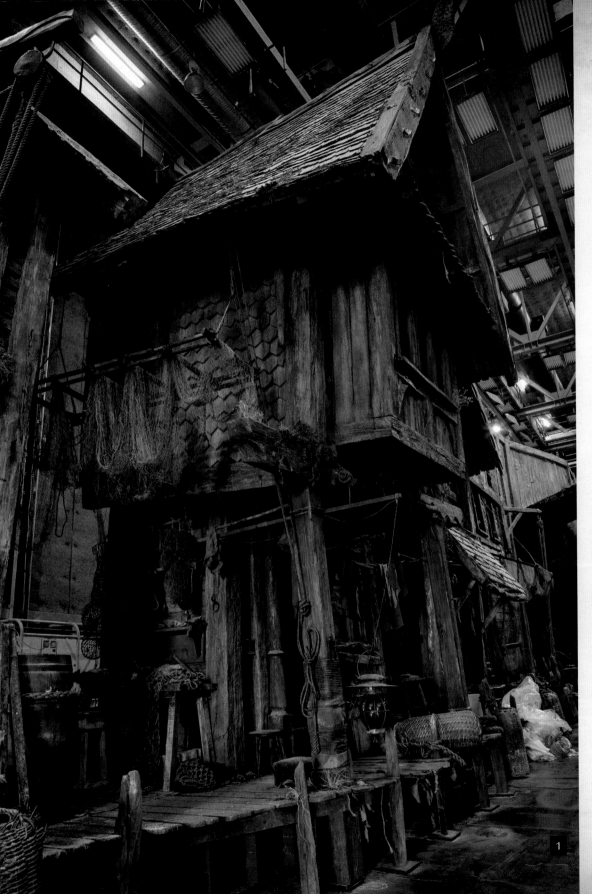

BUILDING LAKE-TOWN

Lake-town existed both inside the studio and as a massive backlot set, both built over water in giant, shallow pools that we made before putting the buildings in. We made the sets reconfigurable by having the buildings on wheels and repainted and dressed them so that they could represent different parts of the town. We began with two-storeyed buildings but rebuilt them to include third floors and roofs in our K Stage set. That gave Peter more freedom to shoot and capture as much in camera as possible without needing to digitally extend the set all the time.

With the destruction of the town in mind, we also designed certain buildings so that they could be burned without destroying the set, because usually film sets are made of materials like wood and polystyrene, that don't react well to fire. The finish wasn't exactly the same, but being blackened by fire and the way in which it was shot, it was close enough.

Simon Bright, Supervising Art Director

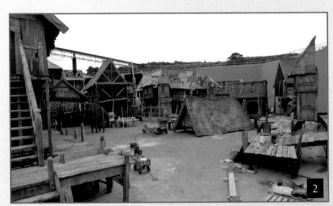

Lake-town was an extraordinary set. It was huge and the detail was unbelievable. I think one of the most remarkable things about it was that it was assembled and then taken down, reconfigured and reconstructed something like five times, so it was always changing and growing, moving inside a studio and out into the backlot. I was in awe of the Lake-town sets, and the people who made them. I got to be all over them, as well, from the underbelly to the rooftops, inside the houses and outside, on the water.

I recall when the outdoor set was being burned I was returning from dinner in town and saw the red glow over the studios as I was driving home. I had to go and see it and can remember being there at 2am watching it. It was an incredible experience.

Luke Evans, Actor, Bard

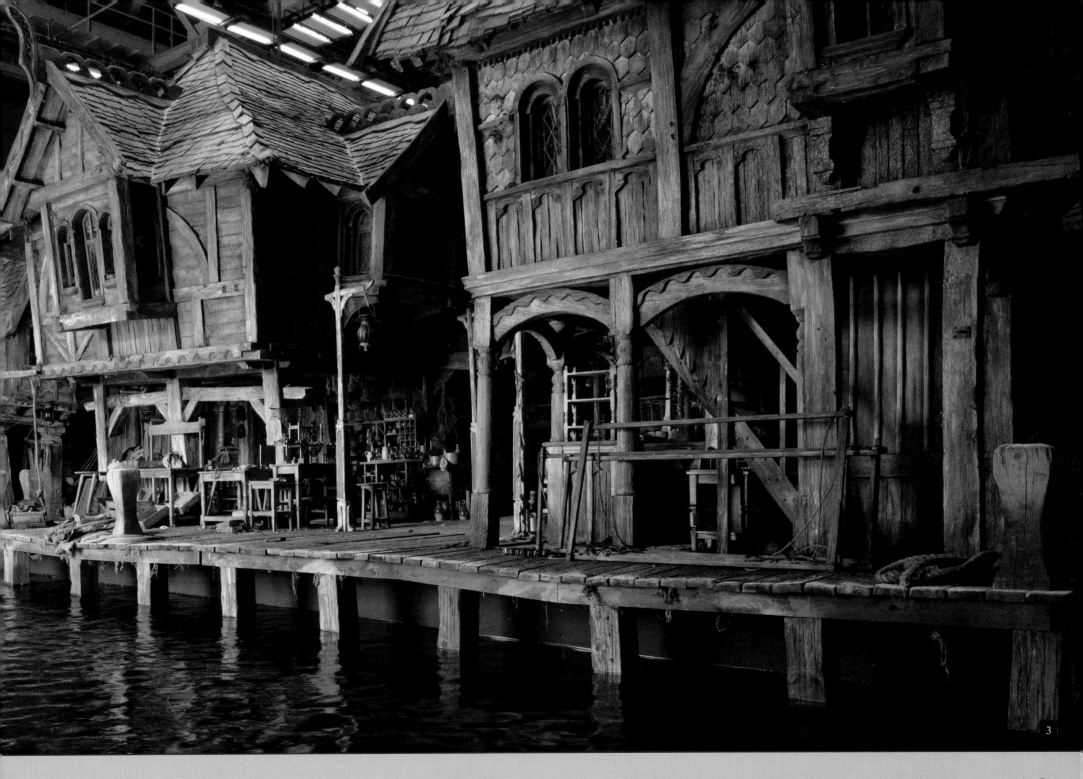

1. The indoor Lake-town set in K Stage prior to flooding.
2. The back lot Lake-town set under construction.
3. The indoor K Stage set in the process of being flooded.

"Those snivelling cowards with their longbows and black arrows! Perhaps it is time I paid them a visit?"

- SMAUG: *THE DESOLATION OF SMAUG*

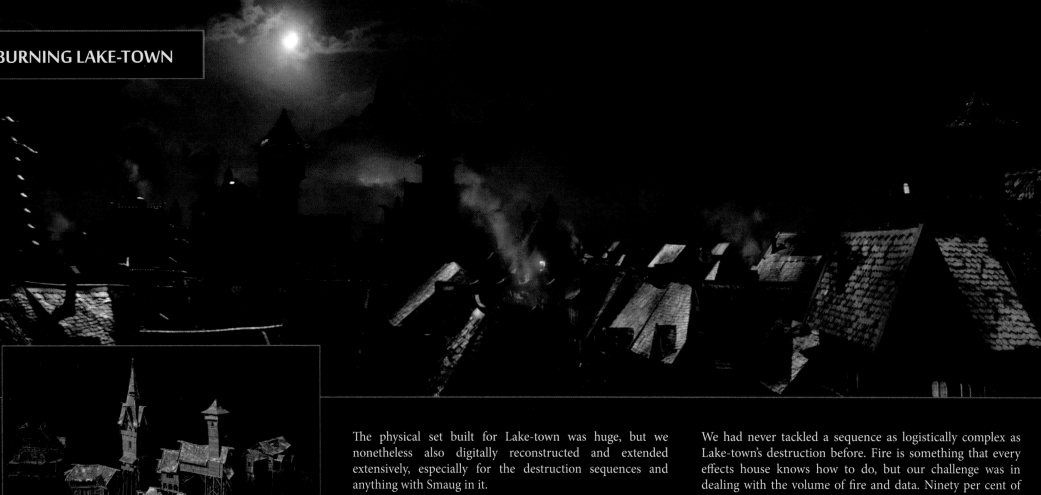

1. Lake-town building digital model in undamaged and partially damaged states. Weta Digital's library of Lake-town buildings included multiple stages of destruction for every one of its thirty-eight buildings and many other structures.

The physical set built for Lake-town was huge, but we nonetheless also digitally reconstructed and extended extensively, especially for the destruction sequences and anything with Smaug in it.

Joe Letteri, Weta Digital Senior Digital Effects Supervisor

There were three primary challenges that faced us as we began working on the destruction of Lake-town. The first was the razing of the city, building by building. We needed to create and destroy hundreds of buildings in a physically correct manner.

Secondly, Smaug's fire instigated the burning of the city. Because he was travelling at such a high rate of speed, with such precision, we needed to develop new simulation techniques, based on flamethrowers, to have him ignite the buildings.

Finally, creating all the fires, smoke, and embers was the biggest challenge of all. Art Directing hundreds of fires for each shot, including their placement and dynamics, was important to the story and the overall look of the sequence.

R Christopher White, Weta Digital Visual Effects Supervisor

We had never tackled a sequence as logistically complex as Lake-town's destruction before. Fire is something that every effects house knows how to do, but our challenge was in dealing with the volume of fire and data. Ninety per cent of our time was spent developing the pipeline and getting it to work. We can burn things, we can make things fall, we can make things that are burning fall, or go through other things and make them fall or burn. Burning things falling and going through other things isn't a problem, but there were over a thousand buildings in Lake-town. The scale of it was crazy!

Every shot was a different angle, with the whole city aflame, but each of those fires had to look good. That meant someone artfully applying fuel where it needed to be to create the right burning effect for each building, and it could take a couple of days to get a single building right just for one shot.

Apart from perhaps nudging a building here or there for the composition of a shot, we adhered to the established layout of Lake-town for the sake of consistency. The fire and destruction progressed through the sequence, with the city starting out lightly on fire and over the course of the scene becoming more and more saturated in flames.

We spent time creating a library of effects and this proved to be very useful. We could create lots of elements like smoke plumes that were fast, slow, narrow, wide or whatever they

needed. We had fires that could burn on the edge of something, fires that could sit on a roof, fires to sit on a window, or come out of one, fires of all shapes. Crew members could look through our library and see animated pictures of everything in categories, selecting what they needed. Instantly a 2D representation could be dropped into their scene wherever they needed it and they could use the settings to rotate it, change speed, etc. It took a lot of work to set up, but it was such a useful thing to have once it was established.

To keep things manageable, we built Lake-town out of thirty-eight basic building structures that were repeated, plus we had walkways, bridges and other smaller elements. Each also had several states of ruin representing how that building looked in different stages of destruction. A building might have an 'as new' state, one with a few beams missing, one with its roof collapsed, etc. and each state also had its own burn map. It required us to have a number of artists at the beginning of the project working on establishing those artistic fuel maps, which would dictate how the fire looked as it consumed the building. They examined them on turntables and tweaked them for things like the amount of smoke, wind direction consistency, and so many other tiny details that meant the difference between something that looked real and beautiful, or not.

Once our library was filled with hundreds of burning buildings we populated the city with them. We had to do that upfront because every shot had the burning city as a background element. Normally one Effects person would be responsible for looking after any destruction action in a single shot, but the background in these shots was so vast and full that there was no way we could put all of that on one guy. The data to produce a burning effect is also quite heavy, which means it takes a lot of processing power. A single fire could account for 20 gigabytes, so manipulating individual fires or structures in a shot that might have a thousand buildings loaded and on fire would be completely impractical. With fire being the driving artistic factor in a shot, we needed to find a solution.

That solution came in the ability to turn our fires into low resolution, sliced, two-dimensional cards. The camera could move around and, for the most part, the fire looked good and matched what we had laid out in the beginning. All an artist had to do was work with an art director to select which buildings were on fire in their shot and which weren't, depending on when it fell in the progression of the scene. Any buildings they selected would be tagged and would go through to Shots for the 2D representations. When they were finally ready to be rendered, we would swap them for the heavy volumetric data, loaded at the very last minute to keep the shot workable as long as possible.

Sebastian Schmidt was our pipeline guy for Lake-town, and he did a fantastic job writing all the crazy back end code to make our systems work. Pipelining involves taking existing digital tools (and/or creating new ones) and streamlining or configuring their use so that things are automated as much as possible. Often on a new project the tools already exist, but the pipeline is usually entirely new and particular to the demands of those scenes. If we ever need to do another show with a burning wooden city on a lake, we'll be all set.

For the first three months Lead Technical Director Brian Goodwin, Seb Schmidt and I were the only members of our team assigned to Lake-town, conducting research and development, working around the clock to set up our pipelines so that once we were assigned crew we could immediately put them to work efficiently. We prototyped the processes and Seb then wrote all the tools for layout, lighting and compositing to get the fires in our shots, including how we got the 2D representations through the pipeline to Shots. Every night, at around 1am in the morning (and then later in the film on an hourly basis), Seb's system would automatically look for any updates to models and run the constraint rig to pull everything in, doing all kinds of things that in the past a Technical Director would have been responsible for. Pipelining Lake-town to such a level was the only way we could tackle something so huge and guarantee we would finish in time.

Peter was very descriptive about how he imagined the buildings to crumble. In our very first tests they shattered into lots of shards and a lot of wood poured out of each building when Smaug smashed them, but Peter was quite right when he said that isn't what he would expect to happen. What we found was that things looked more real when they had more cohesion, so we had large, solid oak beams that were more resilient than smaller timbers. Panelling would burn and shatter away from a building to leave a skeleton of harder wood, so we started with the skeletal support framework of each building and constrained it to be very solid. The walls we constrained to that structure but made them weaker, as well as less strongly constrained to each other. The roof tiles had their own settings, again. We essentially constructed our digital buildings the same way real ones would be built, with different techniques so that they broke in complex ways, with sides of buildings burning away and sheering off, roofs collapsing, floors sagging, and wood ripping. Though it required new technology, the result was a much more realistic destruction.

Ronnie Menahem, Weta Digital Effects Supervisor

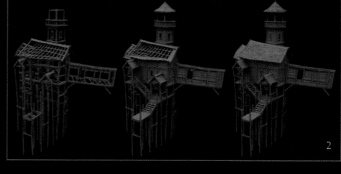

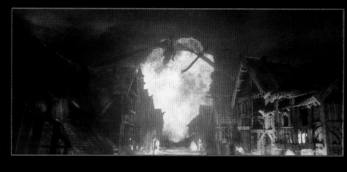

2. Lake-town building digital model showing the different layers of construction, from structural timber through to light cladding, distinguishing details that were essential to depicting realistic destruction.

3. A single frame from a destruction simulation using Smaug's baked geometry to accurately destroy large sections of Lake-town. Baked geometry refers to animation being applied to a high resolution model. Initial animation was done using a segmented, 'lightweight' model because animating the higher resolution version would be unwieldy and slow. Once that motion was final, it would be applied to the 'heavier' model and a simulation run to deform the creature's hero geometry accordingly.

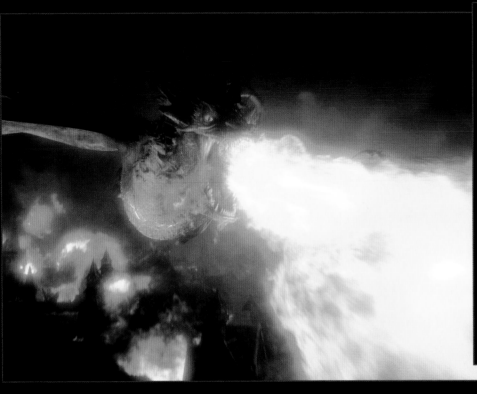

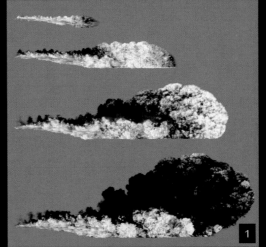

1. Multiple frames of fully volumetric, fluid simulation for Smaug's fire, showing progression over time.
2. Concept art of the Lake-town inferno by Concept Art Director John Howe.

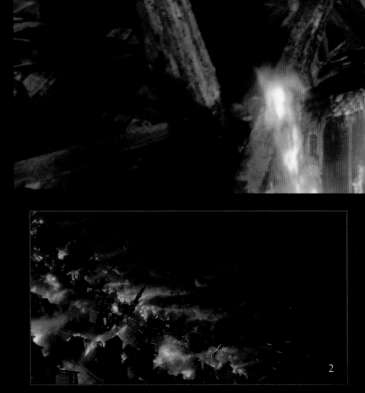

Another layer of complexity came from the fact that wood floats, and Lake-town was, as its name suggested, a town built on water. How much would large, heavy pieces of wood displace the water and how much would the water push back against it? Things like that were 'two-way solves', meaning it wasn't simply one element affecting another – there was feedback both ways. We tried to avoid doing as much as possible because fully coupled solves added significant complexity and time to a destruction simulation. This would break our workflow when multiple iterations were required.

So, we burned lots of digital buildings and simulated lots of incendiary destruction, but there was also the Dragon to consider. He was smashing buildings too, and his wingspan was so vast that he would displace a huge amount of air as he flew by.

If we had the Dragon flying through a shot we ran a process that gave us an estimated volume of air that he would affect. It gave us an area within which every fire would be re-simulated, taking into account the force of his passage. As he flew by there should be a long-lasting effect, because his huge body had generated massive turbulence in the air. We wanted to see that violently disturbed air affecting the fire in the shot, but it couldn't be a simple turbulence simulation that generated an even amount of noise. We wanted wind shadow effects that took into account the buildings as well, with calm areas

and violently displaced areas, and it had to be a lasting effect. There was one shot, from the side, in which we saw Smaug rise up and even long after he had passed though, his wake was shredding smoke plumes in the distance.

Rigid body simulations also had to be taken into account: if Smaug knocked over any buildings in his pass, those would in turn affect air currents and other nearby fires as they disintegrated and fell over. Depending on the shot and what we could get away with, certain things all had to be done together, because these elements were all so interactive.

Peter was very specific about the violence and the turbulence of the flames that he wanted to see. At first our digital fire was quite slow and didn't whip around as interestingly as he had in mind. There was some reference photography from the set which had a fire that was presumably being fed by a pressurized gas nozzle. It looked great, so we used that as reference for the kind of violence that we were trying to create.

At first we just put CG fuel on our CG wood, but how would we motivate it to move like that? Picking the right level of patchiness, turbulence, and wind strength took some time. We also spent some time getting the colour and temperature just right, so that the reds lasted long enough, that the hot spot was large enough and what kind of quality of smoke it turned into.

Ronnie Menahem, Weta Digital Effects Supervisor

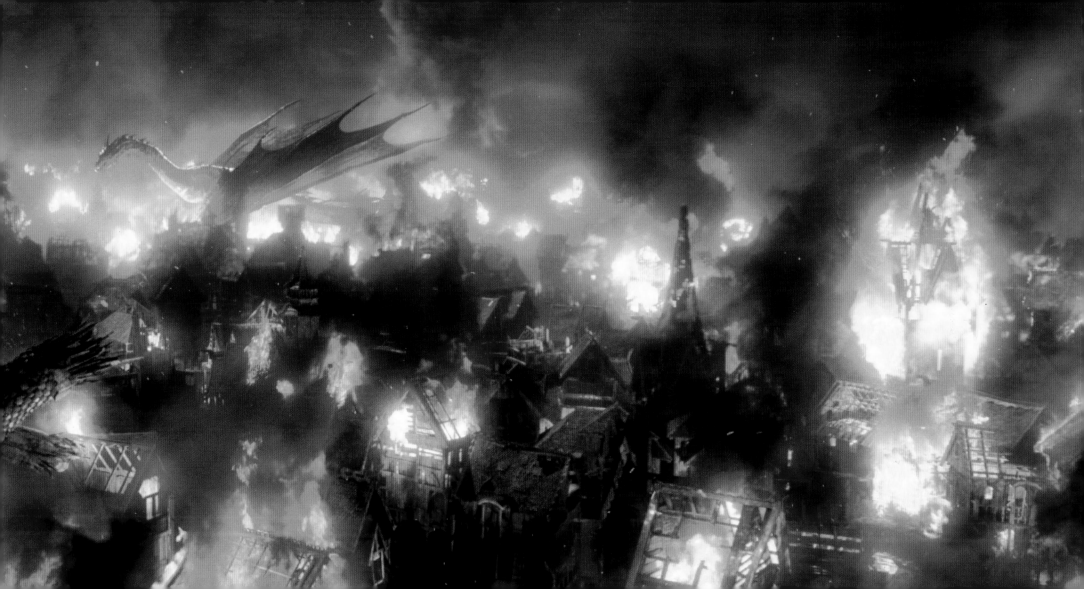

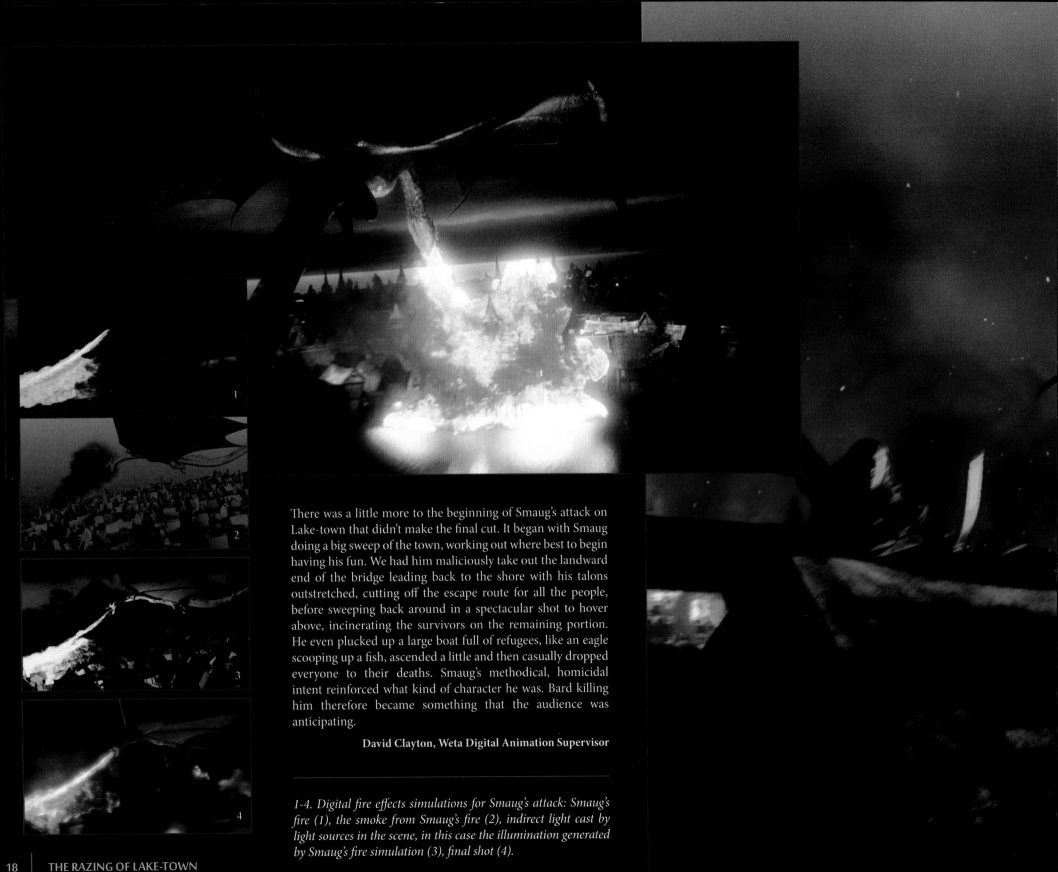

There was a little more to the beginning of Smaug's attack on Lake-town that didn't make the final cut. It began with Smaug doing a big sweep of the town, working out where best to begin having his fun. We had him maliciously take out the landward end of the bridge leading back to the shore with his talons outstretched, cutting off the escape route for all the people, before sweeping back around in a spectacular shot to hover above, incinerating the survivors on the remaining portion. He even plucked up a large boat full of refugees, like an eagle scooping up a fish, ascended a little and then casually dropped everyone to their deaths. Smaug's methodical, homicidal intent reinforced what kind of character he was. Bard killing him therefore became something that the audience was anticipating.

David Clayton, Weta Digital Animation Supervisor

1-4. Digital fire effects simulations for Smaug's attack: Smaug's fire (1), the smoke from Smaug's fire (2), indirect light cast by light sources in the scene, in this case the illumination generated by Smaug's fire simulation (3), final shot (4).

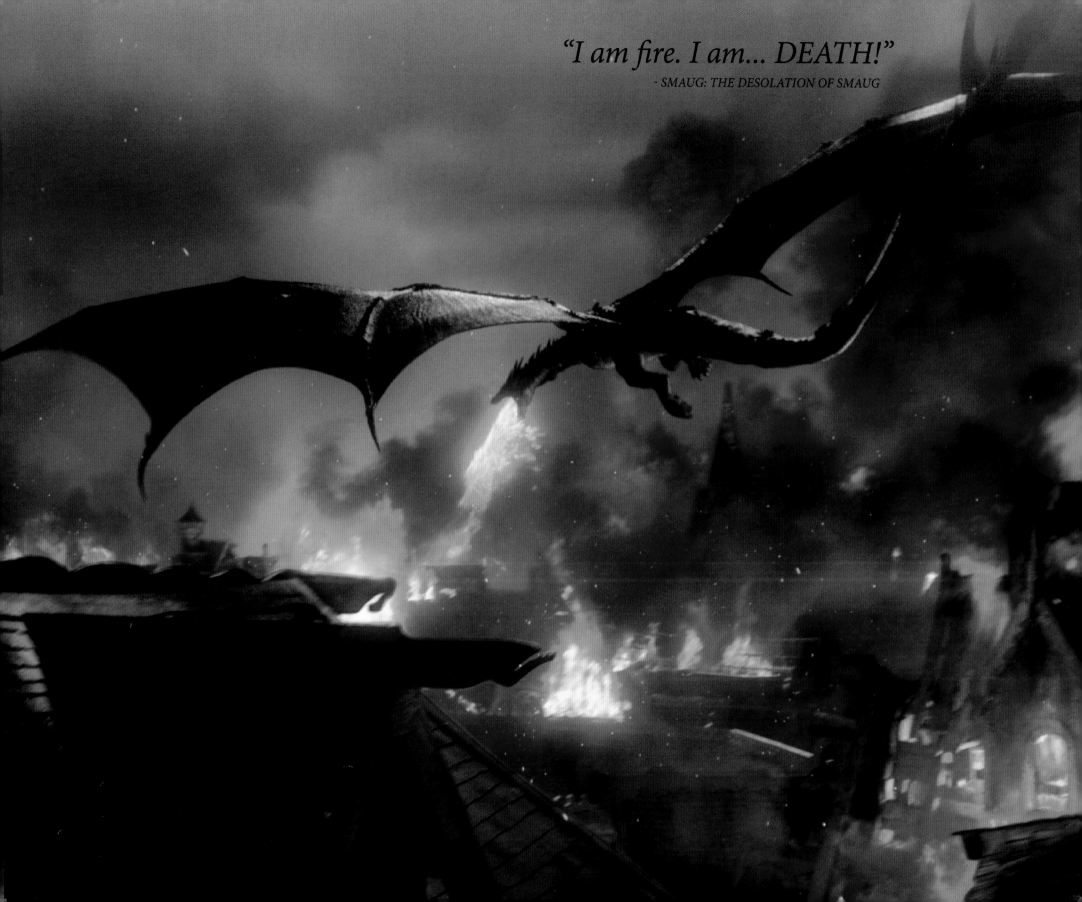

"*I am fire. I am... DEATH!*"
- SMAUG: THE DESOLATION OF SMAUG

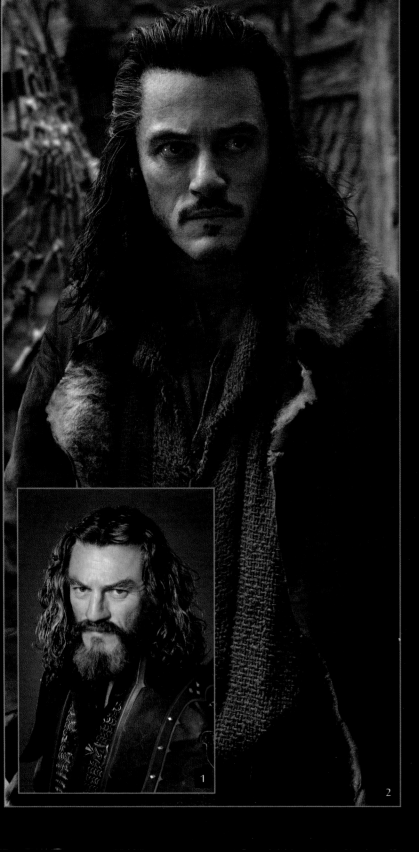

BARD & THE BLACK ARROW LEGACY

Before *The Hobbit*, I had been a Musketeer in another film and done almost all my own stunts, so I had spent a few months preparing and shooting for that movie. There were some huge fight scenes which I can proudly say I did myself. I did wire work and jumped off galleons, air ships and lots of green-screen work. I had worked with whips and chains when I played Zeus in Immortals. With that work in my recent past, I was in a good place when I started my training for Bard, which began the day after I arrived in New Zealand.

Much of the work I did with the stunt team was concerned with establishing a correct posture for shooting a bow and arrow, because there are many different forms of archery and we wanted Bard's style to match the kind of longbow he had.

That bow was huge. When I first saw it I couldn't believe it, I thought it was a joke. It was two metres, ten centimetres in height, which is taller than I am. Looking at such a big weapon, it was incredibly daunting at first, but I came to realize that there is a particular style of drawing a bow so large, which involves turning your palm away from your face to get more extension. It created a very interesting and distinctive look for the character that I liked.

At the same time, Peter, Fran and Philippa decided I should use my own accent in the film. Bard lives in Lake-town, a melting pot of many cultures, but his ancestry is of Dale. I am Welsh, so by having Bard speak with a Welsh accent the filmmakers have forever associated anyone with Dale ancestry with Wales. Within the films, the Welsh accent became an identifying signature of that heritage. Coincidentally, the Welsh longbow was the weapon that won the Battle of Agincourt, so in a way it all links and makes a strange kind of serendipitous sense.

Luke Evans, Actor, Bard

Bard was the Master's nemesis. He was popular, strong, heroic, fearless, and everything the Master was not. There could be only one solution: arrest and imprisonment.

Stephen Fry, Actor, The Master of Lake-town

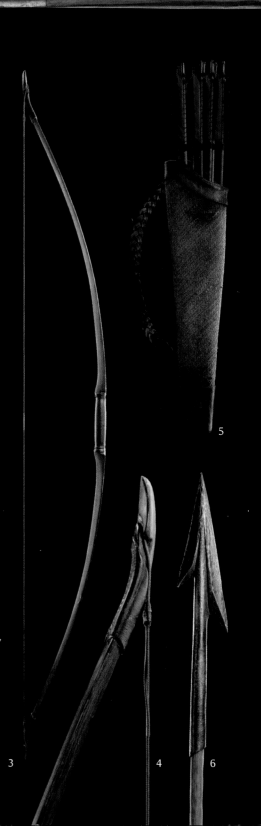

5

2

3

4

6

As much as Bard preferred not to be involved in others' affairs, when Thorin and his Company appeared, he was very aware of what was going on and watched them closely. I imagined Bard spent a lot of his time listening. Providing for his family and navigating the political currents of Lake-town, he had to keep his ear to the ground and on occasion probably had to be a bit underhanded to put food on the table, so I think he would have been an astute reader of people and immediately suspected Thorin's motives, even if he didn't know who the Dwarf was.

Bard and Thorin came from very different places. He didn't trust the Dwarf, and nor did Thorin fully trust Bard, or humans in general. They were two smart men who were wary of each other.

When Thorin tried to rally support from the people of Lake-town with promises of gold and trade, Bard's wariness was confirmed. He knew the stories of what happened last time the Dragon was out and about. Bard's ancestors died in Dale, so he spoke against Thorin, who knew Bard could see right through him and wouldn't be won over by pretty words. All Thorin could hope to do was gain enough support so that Bard's voice was drowned out, which is what occurred, though ultimately it was Bard who was proved right, when Thorin's actions unleashed the Dragon upon Lake-town.

Luke Evans, Actor, Bard and Girion

Though Bard was a humble man who lived an unpretentious life around Lake-town, we discovered in the course of the story that he had a family history dating back to the attack on Dale by Smaug, when his ancestor Girion led the defence of the city and shot the Dragon with one of the famous black arrows. It turned out that Bard still had the last of these arrows in his possession, passed down through the generations, and had kept it hidden in his kitchen. When the Master's guards apprehended him at the end of the second film, he had his son Bain hide the arrow, which would prove to be fortuitous when the Dragon attacked.

Jamie Wilson, Armour & Weapons Production Manager

I could not believe how big the black arrow was when I first saw it. It wasn't until I also played Girion that I understood. While playing Girion I got to experience how these massive arrows were intended to be shot from fantastic, double-bowed crossbows. Suddenly it all made sense and the size of the arrow seemed completely appropriate.

Bard's black arrow was all that he had left from ancestors. It was a relic, masterfully crafted from two twisted pieces of metal forged into a wicked tip by the Dwarves of Erebor and given to the Lords of Dale. These ancient arrows would have been very, very strong, perfect weapons to be shooting against a Dragon. For years Bard kept it hidden in plain sight within his house. He wasn't one to talk about it, but it meant something to him and there was a reason he kept it for all these years.

Bard's son Bain was obsessed with it and with the stories that his grandparents would have told him about ancient Dale. The arrow represented something very special to him – an arrow made to kill a Dragon.

Luke Evans, Actor, Bard and Girion

The black arrow itself was huge and could barely be called an arrow. It was more of a javelin, a missile as tall as a person. Of course, it had to be to believably hurt a creature as enormous as Smaug. Even as big it was, it was a stretch to think it could harm him, but using a regular sized arrow would be like killing a person by flicking a toothpick at them. Just carrying the black arrow prop around was actually difficult. It was heavy, awkward and would get caught in doorways. We had a lightweight version but had to be careful how and when it was used because it wobbled. The hero version was rigid steel and didn't wobble, but consequently it was very heavy!

Jamie Wilson, Armour & Weapons Production Manager

We elected to give Bard dark hair, similar to Luke Evans' natural colour. The slightly dangerous, darker look suited him well. It was consciously borrowed from Aragorn, but we were careful not to get too close to Viggo Mortensen's appearance from the first trilogy. Originally Bard's hair was to be long and flowing, but we cut it short so that it wouldn't resemble Thorin's. Shortly thereafter Fran suggested we tie it back, but I had just cut his wig and now it was too short to tie! Luckily we also had a stunt wig for Bard that hadn't yet been cut, so, while a new hero wig was made, we substituted the stunt version and Luke wore that for the first few weeks of his shoot.

Bard was a father of three and that would put grey in anyone's hair! We added a few grey wisps and oiled the wig to help convey the impression of a man living a little bit down at heel. It kept him very accessible and real.

When Luke turned up with his own beard we decided to go with it rather than glue one on, instead adding just a few little bits here and there to fill it out.

Bard's ancestor, Girion, began in similar territory, but with greyer hair and a full, nicely-shaped beard. Luke played both characters and wore a prosthetic nose for the part of Girion. We greyed and added a little length and upward sweep to his eyebrows, small tweaks that had a big effect. There was no design artwork so we had free rein with his look, which was fun to invent. It came together quickly and everyone loved it because you could see the likeness to Bard in Luke's eyes, but Girion was nonetheless his own character. He looked quite dashing in the beard and Fran even remarked that perhaps we should have had Bard in one like it, though I think we already had enough characters with full beards by that point! Luke enjoyed his look and played the part with wonderful conviction. We only shot Girion for a day, but it was worth all the work. He looked fantastic.

Peter King, Make-up & Hair Designer

1. Luke Evans as Bard's ancestor Girion during a make-up test.
2. Luke Evans as Bard.
3-4. Bard's bow, and detail (4).
5. Bard's quiver and arrows.
6. Detail of Bard's arrowhead.
7. The Black Arrow.

STUNTS ON SET

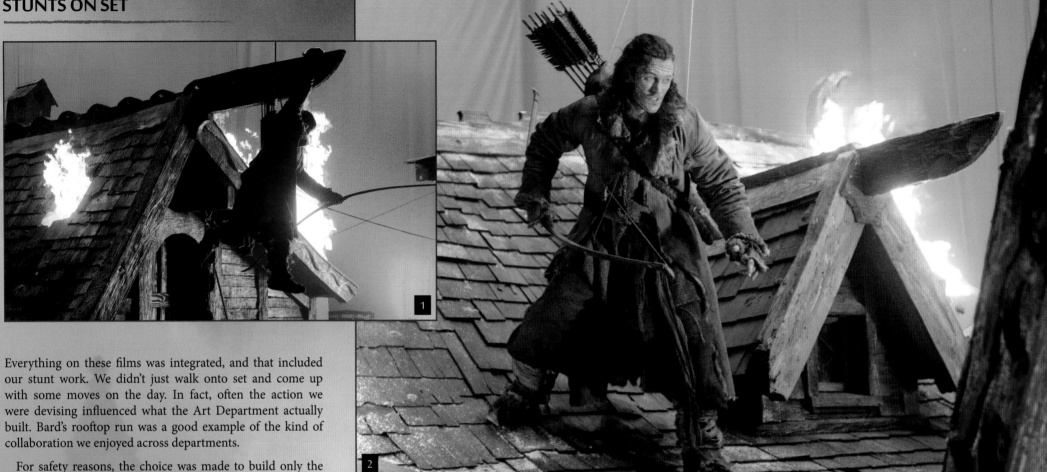

Everything on these films was integrated, and that included our stunt work. We didn't just walk onto set and come up with some moves on the day. In fact, often the action we were devising influenced what the Art Department actually built. Bard's rooftop run was a good example of the kind of collaboration we enjoyed across departments.

For safety reasons, the choice was made to build only the top of the buildings, and keep them as low as possible to the ground. The various rooftops were built on wheels so that we could reconfigure them to suit the action we came up with and reuse them by mixing them up and rotating them. We had the flexibility to shift roofs closer or farther away depending on Luke Evans' comfort with various jumps. That flexibility meant we were able to build a really cool routine. If we wanted a particular jump to be a long one, we could move that roof a little further away, or the reverse. If we wanted to move a roof out of line so that Bard might have to do something a little more interesting than another straight jump, we could do that too. We always worked with the premise of variety, so we moved the roof elements around to keep the combinations new and interesting. We might have a short, straight jump and then have him jump onto a steeper roof and climb, then slide down the other side and maybe do a jump to the side and land differently, for example.

We had our stunt double attached by a harness and wire to a high line that ran above his head, so if he fell it would be cut short, and we had mats between the buildings. He would run through the sequence and we would troubleshoot it for any potential problems. In addition to our own experience, we had Stunt Assistant Bernadette Van Gyen on set with us specifically performing risk analysis and assessment. She was there to raise 'what ifs' to which we would respond by introducing safety measures wherever necessary. We ran it through until we were all satisfied before Luke Evans came in to do it himself.

Wherever possible we tried to use Luke, for coverage purposes, but sometimes we couldn't. When we had live fire close by, we used Bard's stunt double, Steven Davis, who had experience with fire. We had to ensure the roof was both strong enough for him to jump all over as well as fireproof and plumbed with gas. The Art Department's roof tiles were made out of fire retardant materials that didn't burn or transmit heat, but we still put some extra retardant on them, and we used gas flames so that the special effects guys could turn the supply on or off if there was a problem. There had to be a lot of fire for it to read as the kind of inferno that Peter wanted.

When he did his run, Luke was on a wire attached to a safety harness under his costume. Because we were using fire, it meant we couldn't use our usual nylon safety wire. It wouldn't do him much good if it melted!

There was one pretty spectacular stunt we did in which Bard took a flying leap to get across a gap between two buildings. We cabled the stunt double and he leapt from a high roof to a lower one that was on fire and which broke away. Then he slid down through the fire onto some mats where we proceeded to make sure he was safe and wasn't on fire. It turned out very well and we did it twice.

Another fun stunt involved Bard slipping. The only way he could save himself from going over the edge of the roof was to jam an arrow into the tiles. Wherever possible we tried to inject moments of anxiety where it wasn't obvious what was going to happen next.

Glenn Boswell, Stunt Co-ordinator

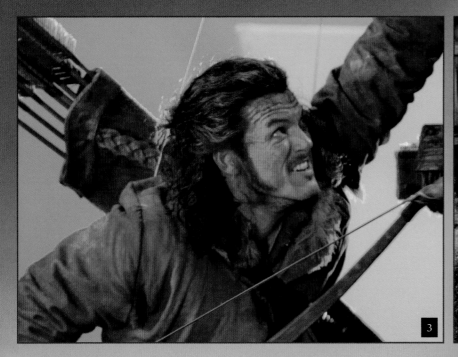

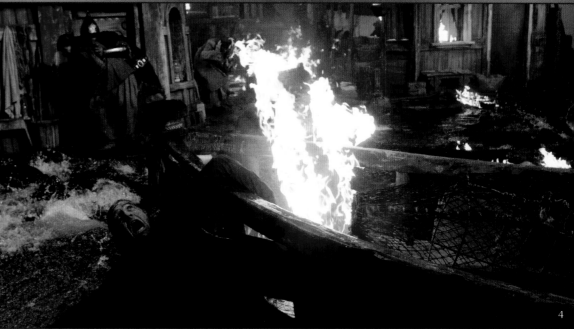

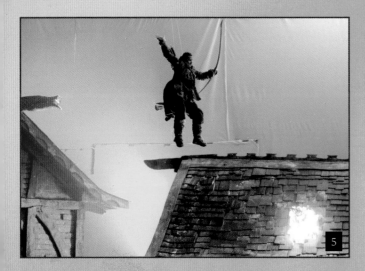

On my very first day on set we were shooting on the Lake-town rooftops. Peter really threw me in the deep end! I was put on cables and ran over rooftops for three and a half days, literally leaping through flames, through ceilings, over roofs, sliding down shingles, jumping down crevices, hanging on chimneys, and all the while carrying a longbow, arrows and a quiver. It was just unbelievable. My knuckles were shredded and I had an eyebrow cut where the black arrow hit me in the head four times, but it was a brilliant way to begin this journey! I still have the scars!

Luke Evans, Actor, Bard and Girion

Amid the mayhem in Lake-town we had the chance to set some people on fire. Fire is always unpredictable so our procedures were very strict. We dictated to the camera team when things were going to happen. We'd signal for them to turnover, do our final touches, fuel up, ignite and by then the cameras would be rolling. Our burning stunties would do their sequence, which was usually timed, and then we'd put them out.

Sometimes the dowsing was part of the sequence – we might have other citizens run in with something to extinguish the flames and carry him off. We also had a specific position that a burning performer could assume which meant they were in trouble. Generally that position wasn't running around waving his arms, which could easily be misconstrued as really good acting!

We had stunts in which we had guys falling into the water to put themselves out. We did tests first to demonstrate that the water was deep enough and would be safe. It was important to Peter that the stunts were always designed with an emotional weight to them, so there might be a lady in a burning house passing a baby to a guy running past; or she might try to get out but can't escape. Perhaps someone falls out of a burning building and is rescued just before they are going to be hit by something. It was all background action in the end, but these little stories helped make it look like something other than just stuntmen running around on fire and gave the audience things to care about.

Glenn Boswell, Stunt Co-ordinator

I'm a trained stuntman, but the producers have been careful about how they have used me on these films because my small size makes me very useful to them as Bilbo's scale double. The risk of injury means I haven't been able to do as much stunt work as I might have wanted, though there were a few notable stunts I did get to perform. I recall one morning being asked, 'Do you want to go and play with the stunties, with fire?'

The next thing I knew, I was being marched to the Wardrobe Department, fitted with a costume and they were all talking about fire retardant clothes. I suddenly realized, 'Oh, they are going to burn me!' Sure enough, I was going to be a character on fire for the scenes in which Smaug burned the city. I started out with flames up to my hips, but by the time Peter was happy with the effect they were over my head! It was great!

Kiran Shah, Scale Double & Stuntman

1-3. Luke Evans on the rooftop Lake-town set, harnessed for safety and shot against green screen.
4. Stunt performers on the burning Lake-town backlot set.
5. Bard Stunt Double Steven Davis leaping between burning rooftops.

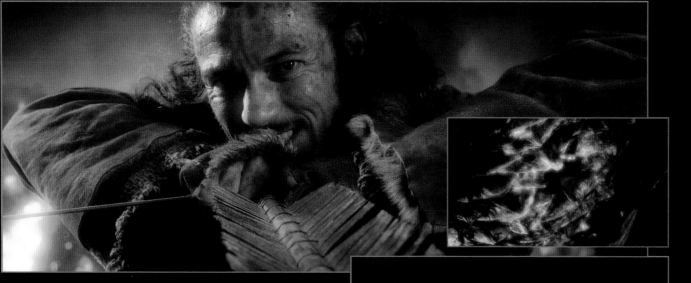

SLAYING THE DRAGON

Though it was dropped from the film's cinematic release, we actually had an extended section of the Lake-town attack in which Smaug clocked Bard running across the rooftops. He took an interest in this mortal who seemed not to be fleeing with the rest and zeroed in on him, blasting down some buildings that Bard had to jump clear of. In a second pass Smaug breathed a jet of flame that Bard had to swing on a rope to avoid. It motivated Smaug to eventually land and try to seek out Bard with a particularly gruesome death in mind. It was a cool few shots with Smaug scanning the rooftops for him and lent a little bit more history to their final exchange, when Bard was in the tower and Smaug recognized him as the same guy he had chased earlier.

Smaug had some great lines in his final scene with Bard. Juicy dialogue is one of the most enjoyable things for animators. A creature like Smaug, cutting back and forth with live action characters and on the move while delivering his lines, was both a challenge and a joy. He was very predatory, prowling in, taunting his prey, savouring the fear and despair.

David Clayton, Weta Digital Animation Supervisor

We used the dramatic, directional fire lighting to give Smaug and Bard a sense of a standoff in their confrontation scene. For the lighting on Smaug we mirrored Bard's of the preceding shot, so cutting back and forth between them they would appear to be staring straight at each other, like a pair of fighters in an arena, face to face.

R Christopher White, Weta Digital Visual Effects Supervisor

Because we had live-action footage shot on set that involved interaction between the characters of Bard and his son and their crumbling environment we had to be careful with what we did with the bell tower. It was a series of shots that demanded great attention to detail. We had a platform that represented the contact surface between our live-action actors and the tower, which was the unchanging component in our shot. We then constrained our CG bell tower to that platform and went about destroying it, pre-fracturing parts that we knew would be close to camera and therefore get lots of scrutiny, so that they splintered beautifully. The way the timber broke up was very controlled and art directed in order to get the exact look we wanted.

There were some completely CG shots in the sequence as well, which we achieved using a full simulation of the tower destruction. We had to tweak parts of our simulation to avoid beams passing through the heads of our characters, because that would have killed them!

Ronnie Menahem, Weta Digital Effects Supervisor

1. Concept art of Bard in the bell tower by Concept Art Director John Howe.

I love that the filmmakers made Bard a father. While Bain exists in Tolkien's lore, he didn't appear in the book of *The Hobbit*. Peter, Fran and Philippa wholly invented Bain's interactions with Bard, but it was a relationship that felt real and worked beautifully in the script. Bain reignited his father's belief, his sense of hope that extraordinary things could happen to regular people.

When Bard found himself on those crumbling rooftops, left behind in this dying town, with just a bow and some arrows, surrounded by people screaming and burning, he was the only one who could fight back against the Dragon. He was the only one brave and capable enough to do it. By the end he had used up all his arrows and was trapped in a teetering tower. He was tired and ready to give up, but suddenly up popped this son of his, grasping the black arrow in his hands.

Despair engulfed Bard. Even at that point, he still said to Bain, 'It's just an arrow boy, it's just an arrow,' and then he realized that he had to use it, that this was the moment that his entire life had been building towards. Bard had never believed it, but Bain's faith, his childish, naïve belief, was what was going to save them. When the bow snapped, all seemed lost, but then it was Bard who rallied, working out how he could still create some kind of mechanism to fire that giant arrow. It was a desperate manoeuvre, but it worked, thanks to a man and the son who believed in him.

Luke Evans, Actor, Bard and Girion

Bard had to improvise to be able to shoot his black arrow after the bow snapped. In reality, when it came for us to fire the black arrow on set, we had to improvise too! It was a cheat in the end, because the actual bowstring simply wasn't long enough to pull that huge arrow back. We extended the string, which hopefully no one would notice in the final film, but was a practical necessity in order for the shot to work.

Jamie Wilson, Armour & Weapons Production Manager

For the shot in which the black arrow went zinging, quivering through the air and hit Smaug under his broken scale we produced a few versions. Some shots were very clean camera moves while some were messy. In the end, Peter shot a version that was a little bit messy. He didn't frame the black arrow the entire time, allowing it to drift in and out of the frame organically before finally finding a nice composition and following it into Smaug's chest. I liked how it ended up, dialled back so that the action still read clearly, but retaining some spontaneity and not looking too computer-generated.

David Clayton, Weta Digital Animation Supervisor

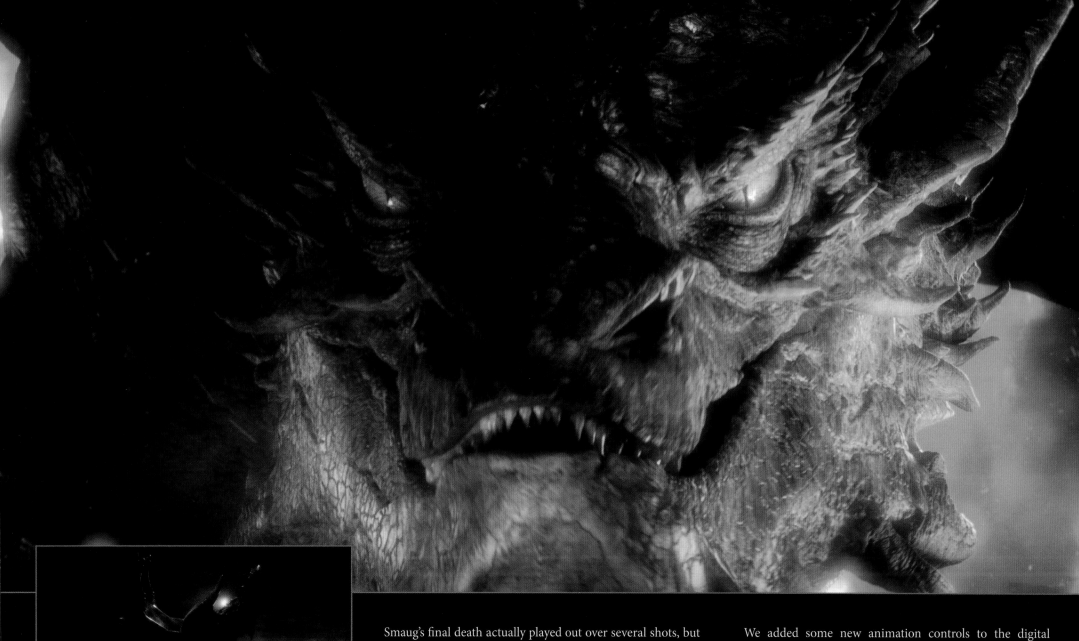

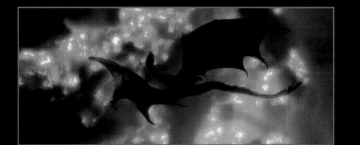

Smaug's final death actually played out over several shots, but it culminated in him clawing his way skyward with the black arrow through his heart. He came right up past the camera and gasped his last breath right in front of the lens, with the Lonely Mountain in the background. It was a shot we began working on quite early so we had time to try some ideas, hone in on the best of them and do our fine-tuning. Peter told us to add more time to the shot if we needed it. He wasn't afraid to draw out the moment. Given what an important moment Smaug's death was to the story, it was nice to be able to spend ample screen time on it and give it the attention and time it deserved.

We added some new animation controls to the digital puppet to achieve Smaug's dying gasp. We had his eyes bulge, something that we had never needed before. Another of the visual tools we had at our disposal to help sell the moment he finally died, was that his pupils dilated and his tongue lolled. We also had his glowing chest and throat go dull in that same moment, fading out and going dead to underscore the point. Peter wanted it to be a visceral, violent, uncomfortable death, and I think it was.

David Clayton, Weta Digital Animation Supervisor

THE MASTER OF THE LAKE

The audience instantly knows when they see the Master of Lake-town that this is a guy they should dislike. We did everything we could to appeal to the natural human preconceptions about certain characteristics, making him greasy, bloated, balding, with a ridiculous comb-over and thin moustache, pasty complexion and bad teeth. Stephen Fry played him magnificently, twisting everything anyone said to his advantage.

When we began exploring looks for the character we started with a mop of grey hair that was significantly thicker than he ended up having. We always knew we wanted a side-parting comb-over, but settling on a colour saw us dye the wigs at least four times before finding his particular tone of washed out ginger. Peter wanted quirkiness so, as with Radagast, we embraced asymmetry. The Master's moustache goes up on one side and down on the other. It seemed like the more we pushed his look to extremes, the happier Stephen was with it. I think with a character like the Master, who is so horrible, making him look so different to Stephen's real life appearance is probably somewhat freeing for the actor, and I would like to think it gave him even more latitude to delve into this detestable creature that is the Master of Lake-town.

Stephen Fry wore an encapsulated silicone prosthetic cowl onto which the wig was laid. It looked much better than a traditional bald-cap and could be pre-painted, which cut down our application time. He had a nose-piece and eyebrows, facial hair and fabulously disgusting teeth which were rodentine and twisted. His hands were dirty and his costume was covered in crumbs, stains and was perpetually damp.

Peter King, Make-up & Hair Designer

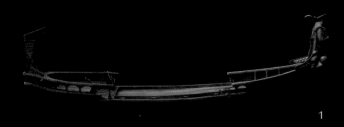

1

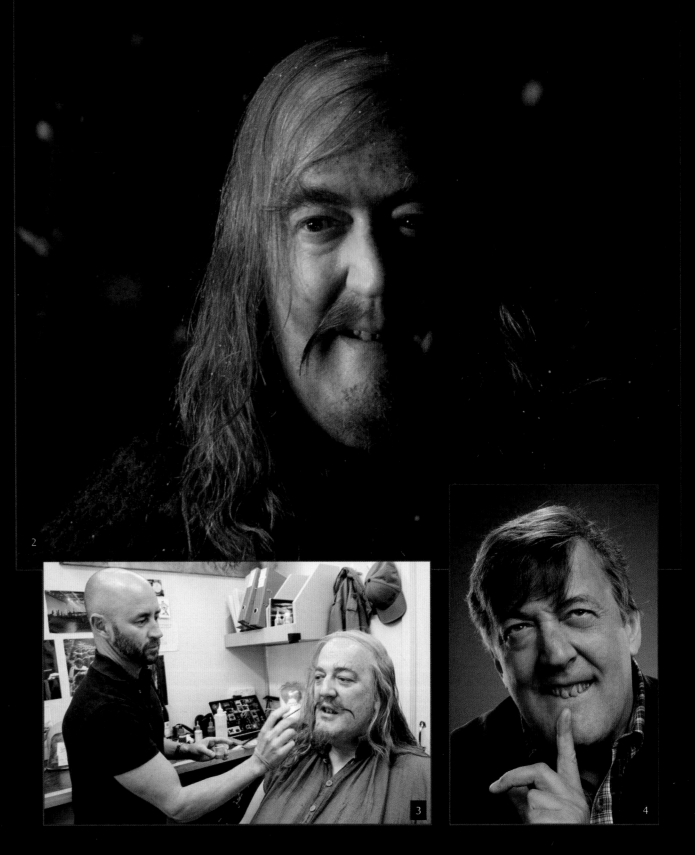

2

1. Digital reference turntable of the Master's barge.
2. Stephen Fry as the Master of Lake-town.
3. Key Make-up & Hair Supervisor Rick Findlater transforms Stephen Fry into the unctous Master of Lake-town.
4. Stephen Fry poses for a photograph wearing a set of rat-like test dentures.
5. Work-in-progress digital fluid simulation for Smaug's splash.

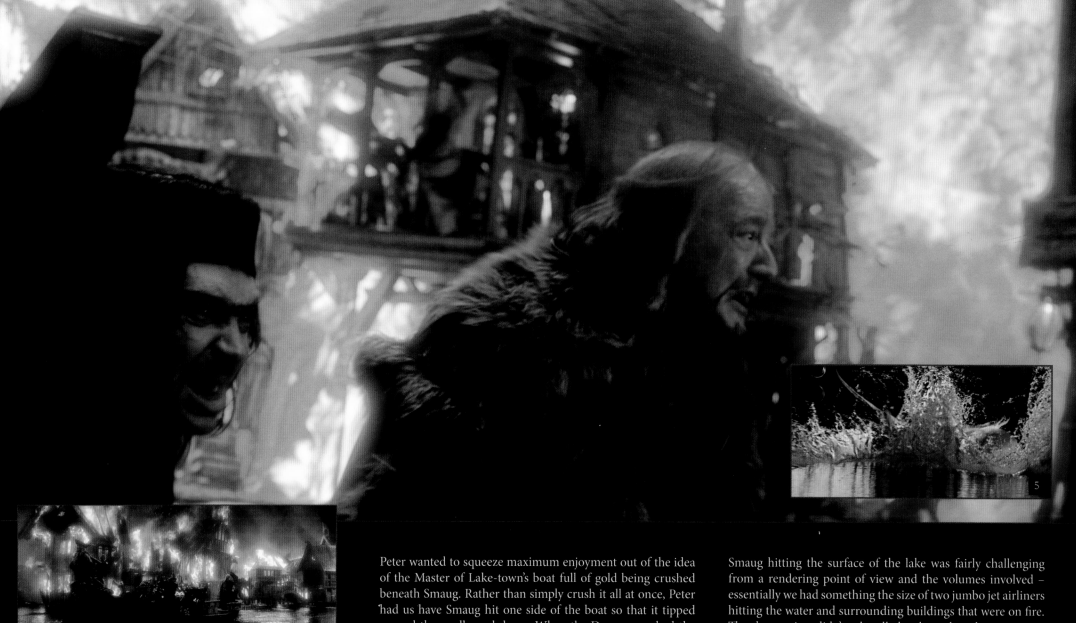

Peter wanted to squeeze maximum enjoyment out of the idea of the Master of Lake-town's boat full of gold being crushed beneath Smaug. Rather than simply crush it all at once, Peter had us have Smaug hit one side of the boat so that it tipped up and then collapsed down. When the Dragon crushed the back end of the boat, where the Master was standing; Braga, the Master's head guardsman at the bow, was sent flying and catapulted out of shot like a little kid on the wrong end of a see-saw after the big kid jumped on. When that shot used to be a little bit longer it was possible to see him eventually fall down again, several rooftops away.

David Clayton, Weta Digital Animation Supervisor

Smaug hitting the surface of the lake was fairly challenging from a rendering point of view and the volumes involved – essentially we had something the size of two jumbo jet airliners hitting the water and surrounding buildings that were on fire. The destruction didn't take all that long, but the water was something we were working on continuously.
The water came straight at the camera so we had to do some specific modelling to get the look just right. We went through a huge number of iterations, balancing all the artistic elements of that shot.

Ronnie Menahem, Weta Digital Effects Supervisor

CAST UPON THE LAKE SHORE

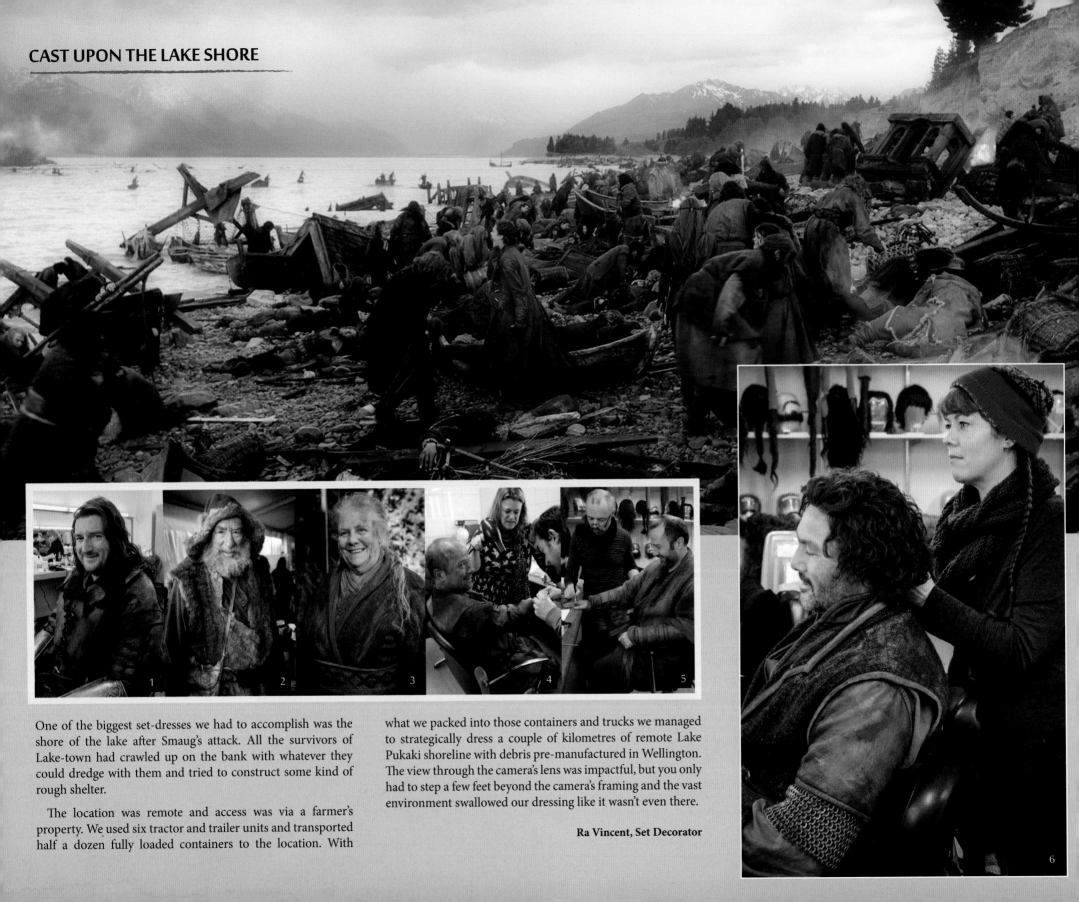

1 2 3 4 5

One of the biggest set-dresses we had to accomplish was the shore of the lake after Smaug's attack. All the survivors of Lake-town had crawled up on the bank with whatever they could dredge with them and tried to construct some kind of rough shelter.

The location was remote and access was via a farmer's property. We used six tractor and trailer units and transported half a dozen fully loaded containers to the location. With what we packed into those containers and trucks we managed to strategically dress a couple of kilometres of remote Lake Pukaki shoreline with debris pre-manufactured in Wellington. The view through the camera's lens was impactful, but you only had to step a few feet beyond the camera's framing and the vast environment swallowed our dressing like it wasn't even there.

Ra Vincent, Set Decorator

6

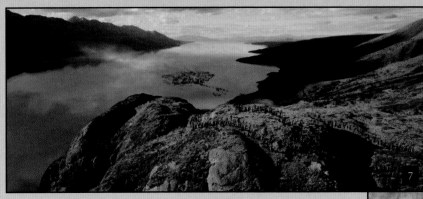

We had the most amazing extras with us at Lake Pukaki! The Tekapo and Twizel extras were lovely, unpretentious people and very committed! Shooting the scenes in which Tauriel was affected by the horrors of the devastation around her, I found those wonderful extras were invaluable to me. They had such an impact on my performance.

Evangeline Lilly, Actress, Tauriel

Lake-town's populace were fun for us to cast because we were looking for lots of gnarly, rough farmer types, which is what we New Zealanders in large part are – very loyal, salt of the earth people, not necessarily always what you would consider traditional beauties, but always interesting. We were looking for extras of all shapes and sizes with as much character-driven diversity as possible.

Liz Mullane, New Zealand Casting Director

Peter imagined Lake-town as a cultural melting pot, which meant we could cast extras with diverse ethnicities and skin colours. I thought the multicultural aspect added visual interest and introduced a layer of complexity and history to the place, making Middle-earth even more interesting.

Miranda Rivers, New Zealand Casting Director

1-3. Lake-town extras.
4. Miniature sculptor Alan Perry, who lost his right arm below the elbow in an accident in 1996, has his stump turned into a fresh wound by Make-up Artist Catherine Maguire and Senior Prosthetic Make-up Artist Shay Lawrence.
5. Miniature sculptor Michael Perry is made-up as a Lake-town extra by Hair & Make-up Stylist Richard Muller.
6. Additional Hair & Make-up Artist Michele J. Perry (no relation to the aforementioned Perry brothers) styles the hair of a Lake-town extra.
7. Concept art of the Long Lake and refugee column by Concept Art Director Alan Lee.

What a lucky gal I am! I had the good fortune of working with Lee Pace, Aidan Turner and Orlando Bloom throughout these films – no shortage of looks, talent or fun there. Tauriel has very complicated relationships with the men in her life. She loves them all: she loves her king, she loves her childhood friend, Legolas, she even finds herself loving a taller-than-average Dwarf, but, each of these loves is tainted by struggle.

After her parents were slain at the hands of Orcs, Tauriel committed her life to fighting and slaying evil. She heads Thranduil's guards and her King and her Prince both hold special places in their hearts for her. She is strong, capable, delightful and beautiful – her King favouring the former two qualities and her Prince favouring the latter two. Where Thranduil loves her with a scrutinizing, fatherly love, Legolas loves her with a protective, romantic love. The trouble is Tauriel loves her King as his faithful subject, but will not sacrifice her own sense of justice to please him, and she loves her Prince as her brother, her dearest friend, but has eyes only for a Dwarf.

Elves and Dwarves hate each other and nurture a long-standing enmity. Their people have been involved in a feud since the day that Smaug took Erebor and all of its treasures from Thror's people while Thranduil sat back and did nothing to help; going back even further, their distrust and hatred has even deeper roots. But, a young, cheeky and handsome Dwarf stumbles into Tauriel's life and surprises her with his spirit.

While her people, the Woodland Elves, are closing their gates and hiding from the world and the darkness that is growing within it, Kili and his party are travelling throughout it, seeing and experiencing new things, engaging instead of retreating, fighting instead of hiding. And he, Kili, embodies that spirit. He is adventurous, brave, and charming. Not to mention, he is utterly smitten with her, despite her being an Elf.

When Kili and Tauriel first meet, she saves his life and he, in turn, beyond reason, falls in love with her upon first sight. Turning his charms on Tauriel, Kili manages to get her attention and, the more she watches him, the more she succumbs to his flirtation, a fact not unnoticed by her Elven suitor, friend, and Prince, Legolas.

Tauriel can't deny how full of life Kili is a longed-for contrast to the stale world under the trees in the Thranduil's closed-off realm. Over the course of the story we tell, Tauriel falls in love with Kili in return, though neither Legolas nor she herself will admit it and it is not until too late that her heart's words are given voice.

So, in summation: Thranduil represents Tauriel's loyalty and her pride. Legolas represents her ability and her heart. And Kili represents her youth and her spark. Being forced to choose between them is Tauriel's dilemma.

Evangeline Lilly, Actress, Tauriel

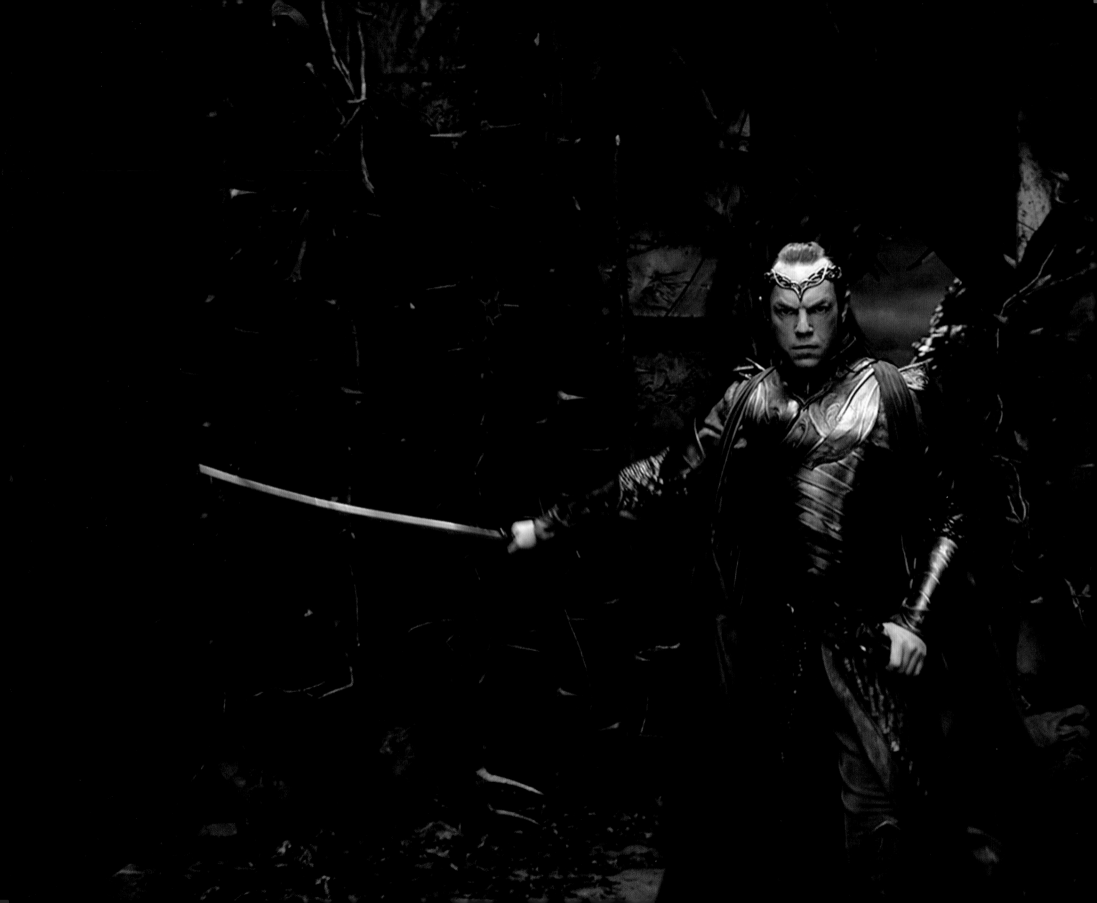

THE CLEANSING
OF DOL GULDUR

Far from the Mountain and the Lake, Gandalf the Grey hangs in a gibbet within the crumbling ruins of Dol Guldur, the secret stronghold of the Necromancer and his minions, the Orcs. Beaten and spent, the Wizard is dragged from his cage by a towering Orc, intent on harvesting the Elven Ring of Power worn by Gandalf for his Master. But before the grim surgeon can do his bloody work, a lone light pierces the gloom of the dungeon – Galadriel has come to Dol Guldur to cast open the pits and tear down its walls. No match for the Elven queen, the foul creature is obliterated in her radiant advance.

The Lady of Lórien takes the failing Wizard in her arms and makes to bear him out of the ruin when the mightiest of the Necromancer's servants, the Nine Ringwraiths, descend to surround her. Revealed as Sauron, their ancient foe returned, the Necromancer taunts Galadriel, thinking her outmatched, but in his arrogance he has not seen her companions. With whirling sword and sweeping staff Lord Elrond Half-elven and Saruman the White stand between the Nazgûl and their quarry while Radagast the Brown ferries Gandalf to safety aboard his sled of sprigs and vines.

Galadriel herself then rises; drawing power and matching it against the Dark Lord, she banishes him, sending him hurtling across a leaden sky toward the east, though at great cost to herself. Weakened by the effort, she is born away by Elrond, while Saruman promises to deal with Sauron himself.

Having fled the haunted fortress, Gandalf and Radagast regroup at the Brown Wizard's ramshackle home, where the unorthodox guardian of the woodland presents Gandalf with his staff. Radagast bids his friend farewell as the Grey Wizard takes to his horse and makes with all speed for the Lonely Mountain to warn his friends of the doom that awaits them.

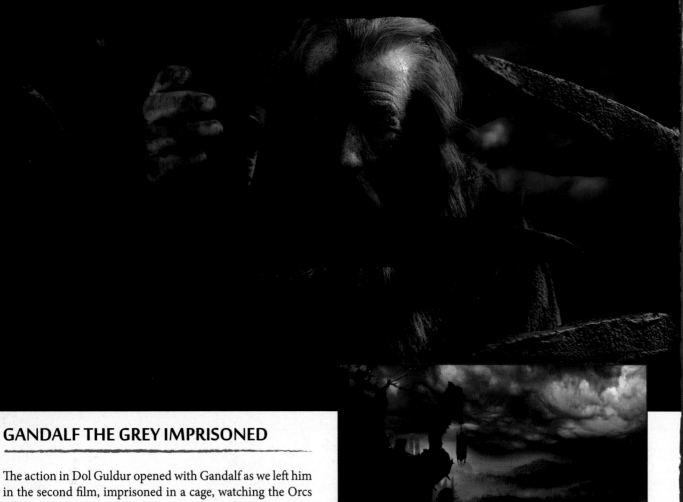

GANDALF THE GREY IMPRISONED

The action in Dol Guldur opened with Gandalf as we left him in the second film, imprisoned in a cage, watching the Orcs file out of the fortress on their way to the Mountain where his friends are. Weta Digital had to create some establishing shots of Gandalf for this segment of the film.

Dol Guldur grew and changed as the films progressed and we saw more of it. We built and altered as we needed to according to the shots and narrative that Peter wanted, so the geography was a bit fluid between the films.

Gandalf's cage hung exposed to the elements. We wanted him to feel isolated and precarious, so there was nothing between him and open sky. It necessitated pushing around some of the architecture that we had established to avoid closing him in too much and losing that sense of isolation, so in those shots we had very little of Dol Guldur itself showing beyond a few jumbled bits of structure. Essentially he was just dangling out the side of the ruin in his little cage, alone and vulnerable.

This was also our introduction to the dungeon keeper of Dol Guldur, a tall Orc who Galadriel would despatch pretty quickly once she arrived to save Gandalf.

Matt Aitken, Weta Digital Visual Effects Supervisor

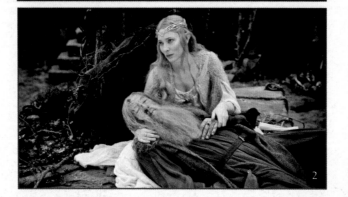

1. Dol Guldur conceptual art depicting Gandalf's cage by Concept Art Director John Howe.
2. Cate Blanchett cradles a prone Sir Ian McKellen on the Dol Guldur set as Galadriel and Gandalf the Grey.

THRAIN, SON OF THRÓR

Thrain provided the link between Gandalf and Thorin. The value of his character grew when we decided to begin the second film in Bree with the story of a son looking for his father. It also allowed us to draw upon the back-story of Thrain and share it in real time, with the audience meeting him alongside Gandalf when the Wizard went to Dol Guldur, rather than being something that had happened much earlier, as it did in the book. Thrain became important to the story. His presence deepened the story and added more pressure to Thorin, who, believing his father was alive, was looking for his father after he went missing in battle decades before.

The mad Dwarf Gandalf encountered in Dol Guldur was revealed to be Thrain, proving Thorin right. He had endured terrible torture in Dol Guldur. Gandalf drew him slowly back to his senses and learned from him that Thorin must not go the Mountain, that it was a trap and that he was expected.

Once we understood what we were doing with that character we knew we needed an actor who could communicate all of this complexity in just a few brief scenes, the perfect definition of what a cameo by a great actor should be. He had to stand alongside Sir Ian McKellen and hold his own, holding a sense of status, and yet also be mad. Sir Antony Sher has been a favourite of Peter and Fran's, and of mine, forever. We reached out to him and were so delighted when he said yes. He is a phenomenal actor and I know Peter found it a joy to work with him.

Philippa Boyens, Screenwriter & Co-producer

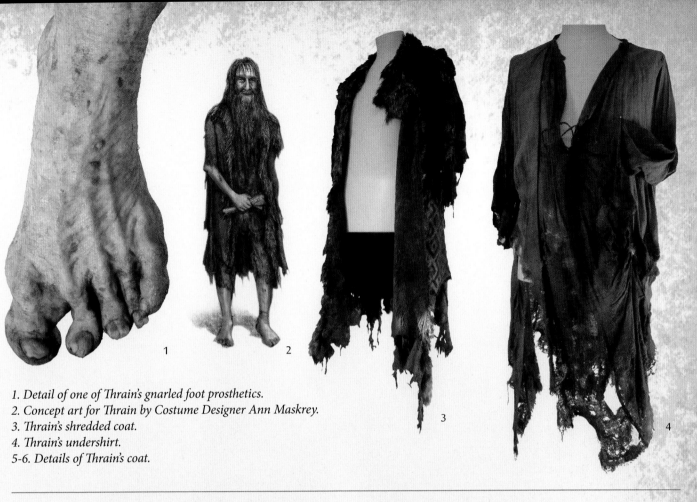

1. *Detail of one of Thrain's gnarled foot prosthetics.*
2. *Concept art for Thrain by Costume Designer Ann Maskrey.*
3. *Thrain's shredded coat.*
4. *Thrain's undershirt.*
5-6. *Details of Thrain's coat.*

We used quite a few techniques on Old Thrain because he had to look very old, and beaten up (having been trapped underground for decades) and also because he was missing an eye. His missing eye and heavy facial tattoo were intended to provide a visual link between his young and old appearances. The tattoo wasn't as crisp or defined, but was still there. We also made his skin look flaky and dry, with pus running from little sores. Not that you really see them, but we had pee stains down his legs and awful looking hands and nails. He was in a sorry state and we did everything we could to make him look like he had really been through it.

Tami Lane, Prosthetics Supervisor

Painting old Thrain's prosthetics were fun because he was so creepy looking and unkempt. We could get really disgusting and sore looking with his skin and the long, dirty nails.

Dordi Moén, Weta Workshop Prosthetics Painting Team Leader

It is never easy when you shoot an older character before you shoot his younger version. We had barely had a discussion about Old Thrain's look before he was brought forward in the schedule. Fortunately I had done one drawing, which Peter liked. The drawing hardly resembled a costume as it was so bedraggled, dirty and ragged, but that was the whole point: Thrain had been incarcerated and neglected for years, so he would hardly be looking his best.

We made a simple Dwarf tunic using Dwarven prints and some devoré and then I attacked it with the scissors. I took it to the Breakdown Department and asked them to make it look like he was covered in excrement and as frayed and dirty as they could manage without destroying it completely. The challenge for our Breakdown team was to make the medium- and small-scale doubles we also had to produce match. It was quite a strange sight on set with three sizes of raggedy Old Thrain.

Ann Maskrey, Costume Designer

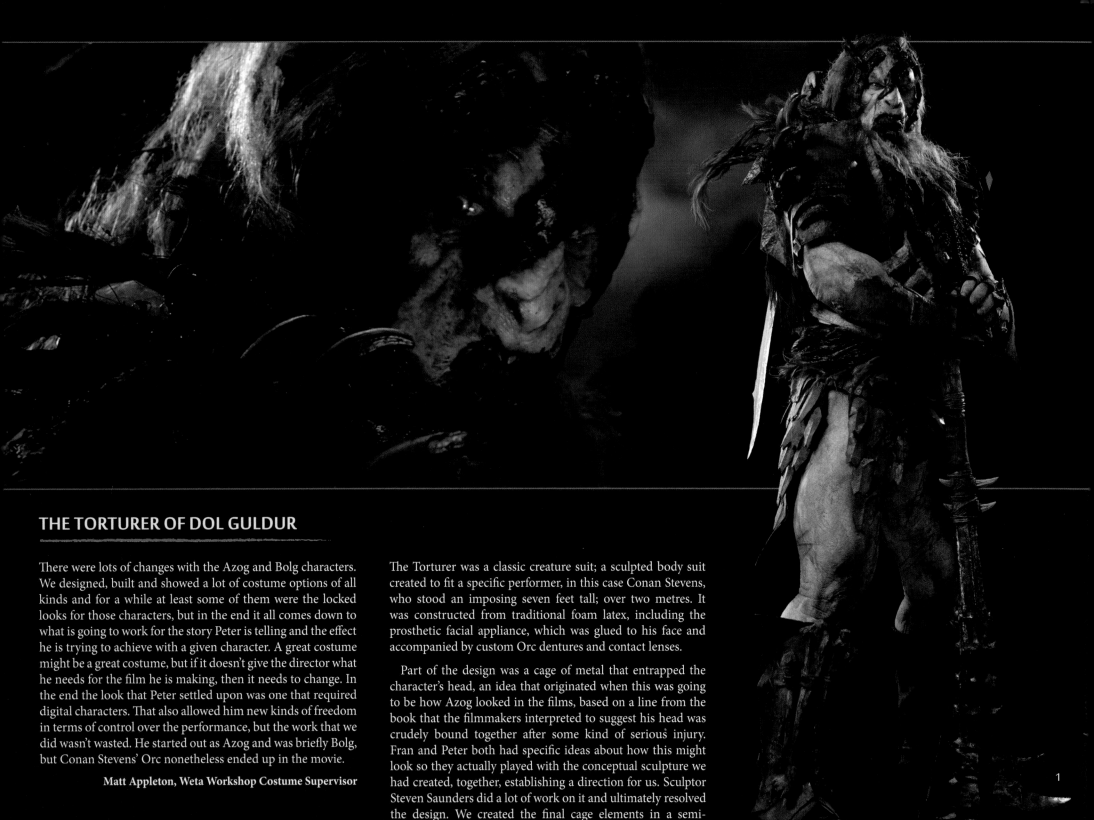

THE TORTURER OF DOL GULDUR

There were lots of changes with the Azog and Bolg characters. We designed, built and showed a lot of costume options of all kinds and for a while at least some of them were the locked looks for those characters, but in the end it all comes down to what is going to work for the story Peter is telling and the effect he is trying to achieve with a given character. A great costume might be a great costume, but if it doesn't give the director what he needs for the film he is making, then it needs to change. In the end the look that Peter settled upon was one that required digital characters. That also allowed him new kinds of freedom in terms of control over the performance, but the work that we did wasn't wasted. He started out as Azog and was briefly Bolg, but Conan Stevens' Orc nonetheless ended up in the movie.

Matt Appleton, Weta Workshop Costume Supervisor

The Torturer was a classic creature suit; a sculpted body suit created to fit a specific performer, in this case Conan Stevens, who stood an imposing seven feet tall; over two metres. It was constructed from traditional foam latex, including the prosthetic facial appliance, which was glued to his face and accompanied by custom Orc dentures and contact lenses.

Part of the design was a cage of metal that entrapped the character's head, an idea that originated when this was going to be how Azog looked in the films, based on a line from the book that the filmmakers interpreted to suggest his head was crudely bound together after some kind of serious injury. Fran and Peter both had specific ideas about how this might look so they actually played with the conceptual sculpture we had created, together, establishing a direction for us. Sculptor Steven Saunders did a lot of work on it and ultimately resolved the design. We created the final cage elements in a semi-flexible material that wouldn't restrict the actor's movements while looking metallic and rigid.

1

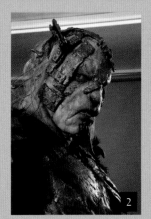
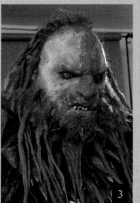

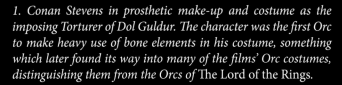

1. Conan Stevens in prosthetic make-up and costume as the imposing Torturer of Dol Guldur. The character was the first Orc to make heavy use of bone elements in his costume, something which later found its way into many of the films' Orc costumes, distinguishing them from the Orcs of The Lord of the Rings.

2-4. Early make-up tests on Conan Stevens, exploring alternate character looks for the Torturer of Dol Guldur, at the time intended to be Azog, the films' chief villain. Efforts were made to find distinctive elements such as his bound head and fiery red war paint.

5. Close-up of Conan Stevens in character during a final costume and make-up test. The pale skin was an important element of the look that was originally devised for the Pale Orc, Azog, but which was retained even when the character changed.

I ultimately had the pleasure of building a lot of the costume myself, making cast components out of elastomeric polymer urethane and then putting it all together with our Weta Workshop Costume Supervisor Matt Appleton and members of his team. It had some cool elements that suggested a personal animosity between him and Beorn, having bears' claws on his shoulders and a bear's rib cage incorporated into the chest. Bolg ended up inheriting some of these elements in addition to the head cage. The Torturer also wore a false beard of chainmaille, presumably a war trophy of some kind, and bore a singular colour signature thanks to all the blood-red fur and pigment-drowned matted hair. He was a very cool looking character and even though he didn't end up being the central villain, it was cool to see he still made it into the movies.

Richard Taylor,
Weta Workshop Design & Special Effects Supervisor

GALADRIEL, LADY OF LÓRIEN

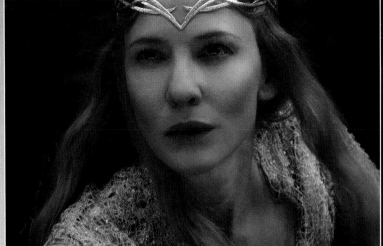

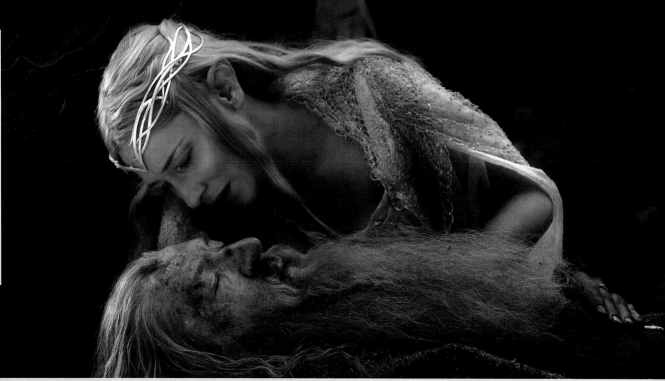

When we met Galadriel in *The Lord of the Rings* she was already diminished. here was the sense that she was withdrawing, which was true of all the Elves. What had to occur in Dol Guldur became clear to us when we made the decision to anchor that scene around her power, and her awesome female energy that Professor Tolkien wrote so brilliantly. Galadriel was the most powerful Elf remaining in Middle-earth, the last of the great Eldar of the First Age.

Tolkien wrote about her going to Dol Guldur and throwing open the doors of the dungeon. We knew that the White Council went there and drove Sauron from his stronghold. We knew that there were Nazgûl there, though admittedly fewer than we depicted in the film, choosing instead to keep them as a unit of nine. Knowing all this, we chose to let the attack on Dol Guldur be a psychic one led by Galadriel, foreshadowed by her promise to Gandalf to come to his aid, should he ever need her.

We already had so many battles in the films that this one had to be different. Peter has such a profound understanding of pace and tone, so he understood what the Dol Guldur scenes needed to be in order to fit into the jigsaw puzzle of scenes that was the trilogy as he was piecing it together.

When Galadriel walked barefoot into that tangle of thorns, broken masonry and jagged steel she did so without any conventional weapons. We could have had her ride in, clad in maille and with an army at her back, but that wasn't where her power came from.

Galadriel steps into the darkness so fiercely and takes Gandalf, telling the Necromancer, Sauron, 'If you try to stop me, I will destroy you.' There was still some fear in her, because of how this match might unfold and what she was risking was very real; but that statement to him was a promise, yet one that came at a price for her as well. As Saruman said: 'She has spent much of her power.' The Galadriel that Frodo would meet years later was changed by that encounter in Dol Guldur and could not have matched her power against Sauron's again. That she resisted the power of Sauron when Frodo offers her the Ring was her final test, after which her fate was clear.

Philippa Boyens, Screenwriter & Co-producer

Cate Blanchett and I were very pleased to share a scene in Rivendell. The physical intimacies were improvised during shooting and rather surprised us, but they led on well to the climactic scene of the final film in which the Queen of the Elves came to the old Wizard's rescue, just in time. The two weeks that she came over from Australia to film was an unforgettable high-spot of all six films.

Sir Ian McKellen, Actor, Gandalf the Grey

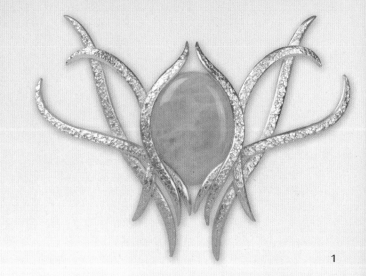

1

1. *Galadriel's Dol Guldur brooch (light version).*
2. *Galadriel's Dol Guldur dress (light version).*
3. *Detail of Galadriel's Dol Guldur dress (light version).*
4. *Galadriel's Dol Guldur coat (light version).*
5. *Detail of Galadriel's Dol Guldur coat (light version).*
6. *Galadriel's circlet.*
7. *Studio photography of Cate Blanchett in the light variant of her Dol Guldur costume.*

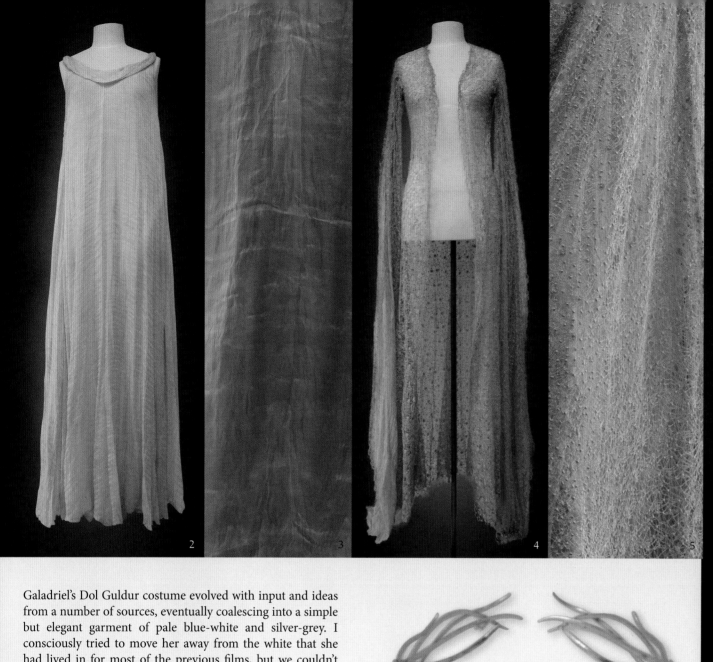

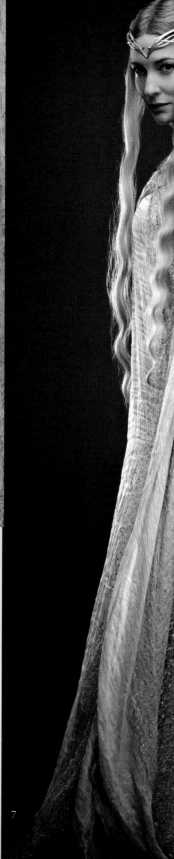

Galadriel's Dol Guldur costume evolved with input and ideas from a number of sources, eventually coalescing into a simple but elegant garment of pale blue-white and silver-grey. I consciously tried to move her away from the white that she had lived in for most of the previous films, but we couldn't stray too far into colour without losing something of her iconic look. Galadriel was an ethereal character and her appearance in the heavy, dank gloom of Dol Guldur had to be one of striking contrast and suggest a sense of fragility that belied her true power. Being light fabrics, the silk chiffons and silk satin that we used moved beautifully when she entered, barefoot.

Ann Maskrey, Costume Designer

2 3 4 5

6 7

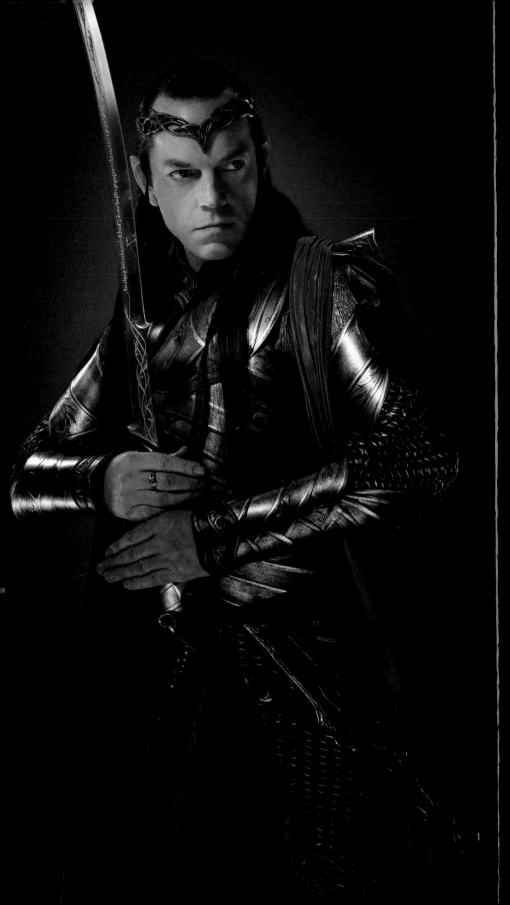

ELROND

Galadriel didn't go to Dol Guldur alone. The White Council turned up to confront the Necromancer and we got to see Elrond wield *Hadhafang* in battle against the Ringwraiths. Originally a sword we made for *The Lord of the Rings*, it was an heirloom of his house. In the lore that was established for those films by Tolkien language expert David Salo, who also named the blade, it was the sword Elrond's grandmother had used. Both Elrond and Arwen used it during *The Lord of the Rings*, so it was made with actress Liv Tyler in mind. I wanted to make a sword that was light and feminine so I tapered the blade to a very thin tip to minimize as much weight there as possible, reducing the strain put on her wrist. Hugo Weaving hadn't been cast as Elrond yet, but it worked well for him too as it was light enough for him to wield one-handed comfortably.

The curvatures that happened on the blade were really nice. Weta Workshop Designer Warren Mahy's design was drawn with side prongs. The angles went into curves that had cut off faces and quite complex shaping. It's actually very difficult to keep everything crisp when there are so many subtle angle changes so that presented quite a practical challenge for me in making it.

There was an interesting accident that occurred during the creation of *Hadhafang*, an example of how sometimes unforeseen things that happen actually result in improvements. Warren's original design had a curve pretty much all the way along the blade, and it straightened out just before the grip. When I heat-treated the blade, it actually warped into a reverse curve through that section in the front of the grip, so actually what you had was a blade that curved and then went into a re-curve before the carved and shaped cocobolo wood grip. It happened by accident, but looked fantastic, so it became part of the design of the sword.

Peter Lyon, Weta Workshop Master Swordsmith

Elrond's Dol Guldur costume had to be replicated for our Swordmaster to wear during filming of some of the fight sequence. Thankfully I had bought enough fabric from one of my favourite suppliers to make two of his main coats. At the time of the purchase I had no firm idea of where I would use it, so it was fortunate there was enough! Our Textile Artist & Dyer, Paula Collier, and her team did additional dyeing work on it, turning it into a beautiful, aged gold with a hint of green.

Ann Maskrey, Costume Designer

1

2

3

4

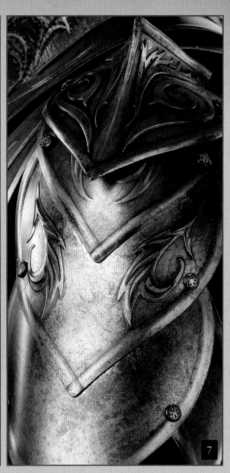

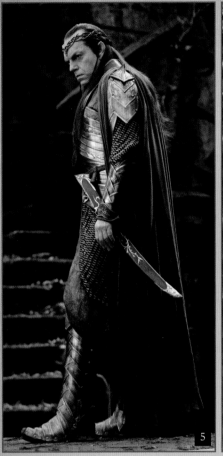

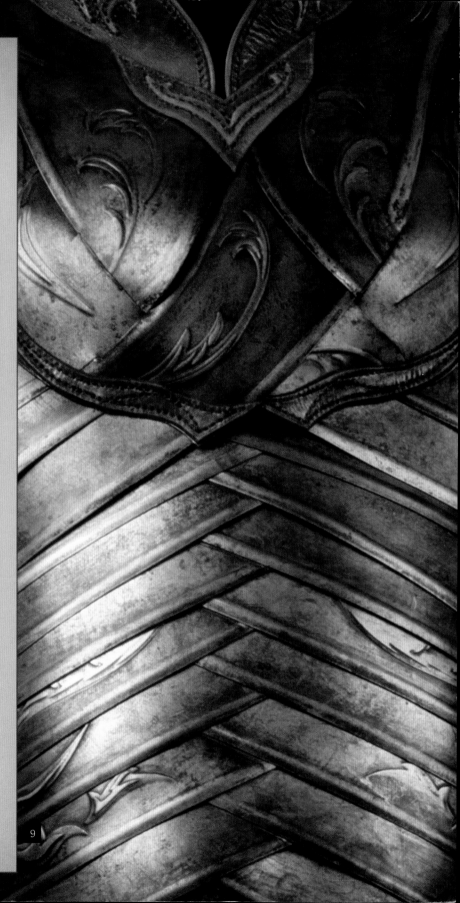

We saw Elrond in a great suit of armour when he was riding down Orcs in the first film, but when it was time to go to Dol Guldur we figured that a simple Orc hunting outfit just wouldn't cut it. You're going up against the Necromancer, dude. Dol Guldur was the kind of place with a dress code. You have to show respect, put in some effort and break out the bling.

I think the filmmakers just wanted a new look, something special rather than something we had already seen, and from our point of view it was an excuse to make an awesome new suit of armour. Once again, Hugo Weaving rocked it.

Matt Appleton, Weta Workshop Costume Supervisor

1. *Hugo Weaving as Elrond in his gold Dol Guldur armour.*
2. *Hadhafang, Elrond's sword.*
3. *Elrond's coat, worn beneath his armour.*
4. *Detail of Elrond's Cloak.*
5. *Hugo Weaving on the Dol Guldur set.*

6. *Detail of Elrond's Elven maille.*
7. *Detail of the pauldron of Elrond's armour.*
8. *Detail of Elrond's leather boot.*
9. *Detail of the chest plates of Elrond's armour.*

SARUMAN THE WHITE

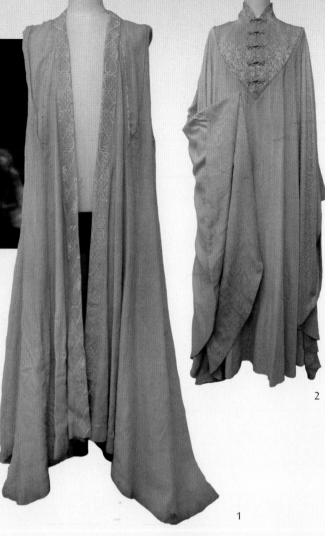

The work I did for *The Hobbit* was shot in England. It was too far for me to travel to New Zealand. Peter, Fran and Philippa had a six-week break from filming in New Zealand and came to England, with Director of Photography Andrew Lesnie, where we shot my scenes against a green-screen. It was like coming back into the family again for me and I was so pleased to have the opportunity to be involved, because Saruman did not appear in the book of *The Hobbit*. Peter and his team added that aspect of the plot dealing with Gandalf investigating the Necromancer, based on Tolkien's later writings.

Saruman of *The Hobbit* was different to Saruman of *The Lord of the Rings* because he was still on the side of good, of the angels, if you will, because that is what the Wizards were. Tolkien called them Maiar, but they were akin to angels in his world, beings sent by the Valar to Middle-earth to unite and counsel the Free Peoples in their struggles against Sauron. Saruman accompanied Radagast, Elrond and Galadriel to Dol Guldur when Gandalf's investigation and capture revealed to them that the Necromancer was in fact none other than Sauron returned. So, when Saruman fought the Ringwraiths in Dol Guldur he was truly fighting them. He was their enemy and there was a tremendous battle which reinforces which side he was on at that time. When Galadriel spent her power protecting Gandalf, Saruman told Elrond, 'Take her back to Lothlórien. Leave Sauron to me.' He intended to deal with Sauron.

His turn to evil would come later. At some point between then and the events of *The Fellowship of the Ring*, he was ensnared by Sauron. It was never explained exactly why it happened, but he decided that he wanted to be the Lord of the Rings, himself. Tolkien wrote that he tried to make his own Rings of Power.

In *The Lord of the Rings* we found out that he had spent a great deal of time looking into a Palantír, the Seeing Stone of Orthanc. It is clear that he had been in communication with Sauron by the time Gandalf came to him to talk about the One Ring being in the Shire. By looking into the Palantír Saruman knew what was going on everywhere, but what he did not know was that that vision was influenced by the Dark Lord. Ultimately he abandoned his mission to resist Sauron, instead telling Gandalf they should join Sauron while at the same time secretly seeking to become his rival.

Sir Christopher Lee, Actor, Saruman

1. *The silk damask coat of Saruman's layered robes.*
2. *Under-layer of Saruman's robes.*

THE PALANTÍR OF DOL GULDUR

1

The Palantír in Dol Guldur was a relic of an earlier version of our script, when the trilogy was going to be just two films. We were going to use it to make Gandalf aware that there had been some communication between Sauron and Smaug, and that he was aware of Thorin. It was a way of sending Gandalf off on a chase to stop it, but it was a bit too much like a telephone. In the end, Thrain served that purpose for us more meaningfully, so the Palantír wasn't needed, but the prop was there on the set and added to the texture of the world. Without deviating from the books, I think it is conceivable that there might have been a Seeing Stone in Dol Guldur. If there were, it would have had to have been the Ithil Stone that Sauron claimed and had taken with him there, then later transported to his rebuilt fortress in Barad-dûr.

Philippa Boyens, Screenwriter & Co-producer

The Palantír props we made for *The Lord of the Rings* were actually wooden. We painted them with many coats to build up the depth and shininess seen on screen. We also had glass ones that could be lit. This time round they were cast and once again painted in lots of coats to get that highly polished, deep look.

Nick Weir, Prop Master

1. *Palantír prop.*

STUNTS & FIGHT CHOREOGRAPHY

Choreographing the fights and stunts for these films, we worked closely with Peter. Everything began with a conversation with the director. I would go away with an idea and within our Stunt Team we would workshop it, shoot a video of it and then bring it back to him to review and give notes on.

When starting any new piece of battle choreography, I would look at the characters, what their background was, their history, their nature, where they came from, where they had been, anything that might affect their physical and mental state and therefore influence how they might fight. What were they wearing that might affect their ability to move? What weapons did they have? How did they move? I would talk to Terry Notary, the movement coach, who had devised characteristic styles of movement for all the races, and inject that into their fighting style as well.

Once I had an understanding of that context the team and I could develop fighting styles and moves that were appropriate for each individual, as well as how that was represented at a platoon level, and even scaling up to entire armies. The next step was to look at the battlefield itself and understand how a particular race or character might use that terrain, how the environment might affect their formations, how they would approach it and where they would put themselves.

Thinking about individual races, even though they might all use swords, the kind of sword a Dwarf might use compared to what sword an Elf would use, or a Wraith, or an Orc, would be very different, and so would how they used it. The long span of time that we were working on the trilogy meant we had the opportunity to really get to know all the Middle-earth races and work on understanding the answers to these sorts of questions. Over the years I worked up a library of moves that we could draw upon and try with different characters, adapting them to suit a particular character and their specific weapons. It is no exaggeration to say we developed literally hundreds of potential routines for characters like Tauriel, for example, building up a kind of fight routine catalogue, always trying to stay ahead of what was immediately needed so that we could respond quickly and offer ideas when called upon.

Terry generally worked directly with the actors on their movement style. We would warm them up and he would go through their movement with them. In the stunts and fighting team we would train them and be responsible for their fitness and safety. If they came to work with an injury or some other limitation we would be aware of that and choreograph around limitations as we needed to. Approaching characters in fights, Movement Coach Terry Notary would generally create a foundation for them in terms of their particular way of moving and carrying themselves – how grounded were they, how fast or what they would lead with.

Once that was established, I would take it on board to help define their fighting style, and pass that information on to my stunt team members as a brief. Once they had the backbone of the fight and understood the movement characteristics of the characters involved, then together we could develop the details and get into specifics. I also talked to the actors. Together we would go through what we felt the character would be doing and how, talking through the broad strokes of their fighting style and what we wanted to accomplish. The stunt team members would work directly with the cast to come up with the specifics of the fight, blow by blow.

As much as I would have loved to have been involved to that degree with every single one, the nature of the project and its sheer size meant that just wasn't possible, but I could review what they had come up with and suggest changes if necessary. Fortunately we had a great stunt team who all enjoyed excellent relationships with their respective cast members.

Once everyone was happy we would take it to Peter for his input or approval. I'd also be on set when the action was filmed, usually with the main unit under Peter's direction, but also with Andy Serkis and the second unit team if there was particular action going on there. It was an involved process, but a very creative and fun one.

For the attack on Dol Guldur, we choreographed unique action for each of our heroes. Saruman had his staff, and we really wanted to show that he knew how to use it. Hugo Weaving was back as Elrond. His fighting style had been established in *The Lord of the Rings*. He was a mover, and quite efficient in his action. There were times when he had to spin and step across cracks in the set, which was very broken and had multiple levels, so we incorporated those into his sweeping moves. The level changes on the set enabled us to design a fight that could go all over the place, making it much more interesting and opening up avenues for inventive shots. In terms of figuring out the moves, we would work out Elrond's twists, turns, cuts and strikes, negotiating the cracks, and get that looking fluid and really good, first. Then we brought in our Wraiths to throw the blows that needed to match those strikes and blocks, so the hero characters' action drove the choreography across the broken terrain. Peter even used a top-down shot to really show off what Elrond was doing, which was great because you could see his cloak swirling as he spun and cut.

Glenn Boswell, Stunt Co-ordinator

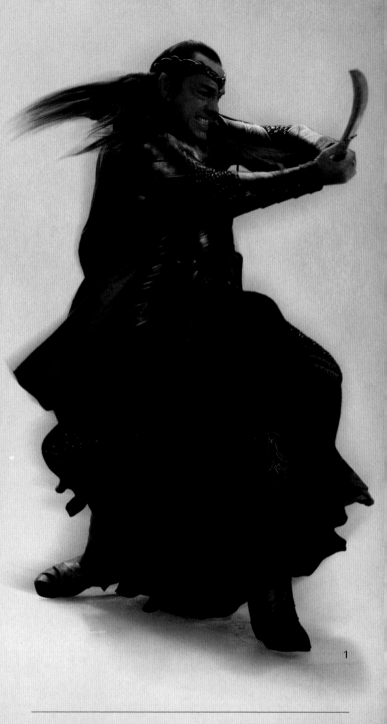

1. *Hugo Weaving, in costume as Elrond, wields* Hadhafang *in battle against the Ringwraiths in Dol Guldur.*

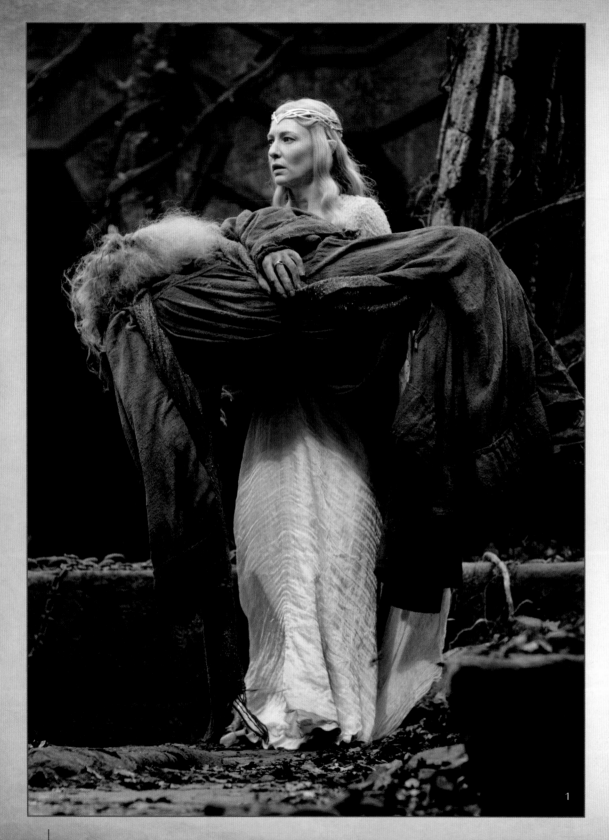

DUMMIES

One of the services Weta Workshop offers is the creation of very life-like dummies for filmmakers to use as props or set dressing. Sometimes these are made in the likeness of specific characters and sometimes they are generic backgrounders.

For *The Hobbit* we supplied both. Among the generics were mummified Dwarves for a scene inside Erebor, but we also made versions of the main characters for use in sequences such as when the Dwarves were suspended upside down inside cocoons, when Bombur was asleep and being carried through Mirkwood forest, or for the big scene in Dol Guldur when Gandalf was being carried by Galadriel. Galadriel was an Elf so she was very strong, but so that Cate Blanchett could pick him up, we supplied a lightweight dummy of Gandalf. It was made out of a rigid but very thin foam shaped into an articulated humanoid configuration and strung together at the joints with rope. We cast silicone hands out of our stock moulds and took the actor's face cast, which we already had from back in *The Lord of the Rings* days, and poured a fresh cast in Plasticine. This was then re-sculpted so that it held the correct expression, moulded again and reproduced in silicone.

For the ten or so Erebor Dwarf dummies that Thorin came across as he and the others were running around, hiding from Smaug, we sculpted and cast heads with basic bodies built out of tube and shaped sheet foam-construction. They had jointed piping armatures that could be posed as necessary by the set dressers. The hands were created using silicone Dwarf hand prosthetics that had come back from set in good enough condition, modified and cut to appear shrunken and contorted in their final moments.

Jason Docherty,
Weta Workshop Special Make-up and Prosthetics Supervisor

We sculpted the Erebor Dwarf victims' heads very quickly. Some were based on head casts while others were sculpted from scratch. They had to look as though they had died of asphyxiation, either from smoke or lack of oxygen in the air due to Smaug's fires, and been preserved in the dry, still air. At first the brief was to make them look serene, but later this changed to giving them expressions of pain and anguish. We had adults, children and infants. It was actually pretty sad, but that was the point of the scene.

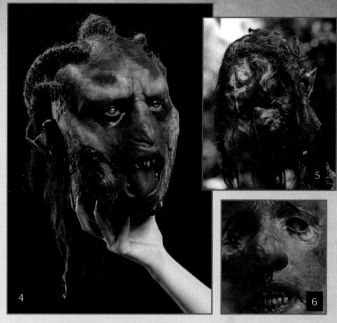

1. Cate Blanchett as Galadriel carries the Gandalf dummy on the Dol Guldur set.
2. Mummified Erebor Dwarf dummy heads.
3. The sleeping Bombur dummy afloat in the enchanted stream.
4. Yazneg's severed head prop.
5. Orc head on a spike outside Beorn's home.
6. Detail of a mummified Erebor Dwarf head.

We looked at a few different reference sources as the idea evolved, including images of various ancient South American above-ground burials – mummified, dry bodies. One in particular that influenced what we were doing was a European mummy of a child that was very well preserved. The overall idea was to make them look dead and mummified, but not to the point where they were grotesque or skull-like. They had to still look like people and the audience had to feel some sympathy for them. The 3Foot7 Costume and Make-up and Hair departments dressed and haired the dummies and they were supplemented on the set with living extras in make-up.

Jamie Beswarick, Weta Workshop Designer and Sculptor

For the filming of the destruction of Lake-town we created eight or nine dummies that were used in and around fire. In this instance we sourced that basic mannequins and modified to be able to pose in a naturalistic way.

Alastair McDougall, Weta Workshop Speciality Costume Maker

In the second film's extended cut Bombur ended up asleep and having to be carried all over Mirkwood by the other Dwarves. We took the head-casting that we had of Bombur and poured a Plasticine version, which we tweaked so that he looked like he was asleep, recast it and pulled out in silicone. A wig and beard were supplied to us by the 3Foot7 Make-up and Hair Department to be pinned on and we hair-punched around the margins of these to blend them into the dummy's face naturally. He had a very lightweight, hollow foam body made for him in a basic human shape which was then dressed in one of Bombur's fat-suits so that it had all the bulges and rolls in the right places, matching Stephen Hunter in his fat-suit and costume. We made a quick armature over which we pulled a pair of Bombur's prosthetic silicone hands and then the whole thing was dressed by the Costume Department. We kept our components as light as they could be so that he could be dragged around on the set without too much trouble.

Decapitated heads were a common request in both Middle-earth trilogies. Most actors don't come with detachable heads so we created dummy ones of Fimbul, Narzug and Thror for their respective 'just a head' scenes in *The Hobbit*. Narzug's head also got reused and redressed as some gnarly set dressing outside Beorn's home.

**Jason Docherty,
Weta Workshop Special Make-up and Prosthetics Supervisor**

Narzug's decapitated head was a prop that we made and painted, matching the colours that would be applied to the make-up on set. Funnily enough though, the make-up was foam latex while the head was silicone. Silicone is translucent while foam isn't so it's actually a lot easier to make skin look believable in silicone than foam, but it's heavier and more complicated to produce.

Dordi Moén, Weta Workshop Prosthetics Painting Team Leader

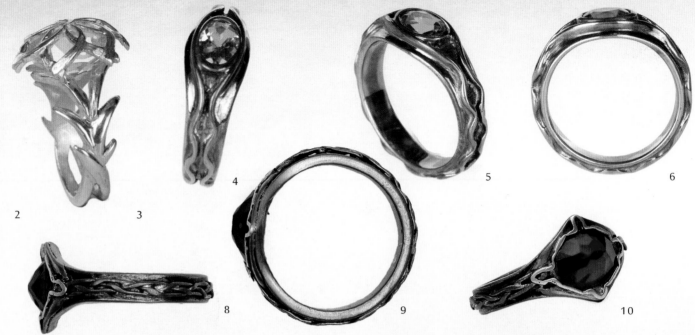

1

2

3

4

5

6

7

8

9

10

Though casual fans may not have grasped the full significance of the gathered parties in Dol Guldur, for those well versed in Tolkien's Middle-earth lore the presence of all three of the Elven Ringbearers in one place, confronting Sauron and the Nine, was an epic event. Though not worn openly, and identities of the bearers of the Three were secret, Elrond, Galadriel and Gandalf each benefitted from the power of their Rings.

Galadriel's ring, Nenya, was called the Ring of Adamant. It was associated with the element of water, hence the character's theme and part of the reason that Philippa was drawn to a drowned look for Galadriel's transformation. Nenya's qualities were of healing, haven and protection. It was partly by the power of Nenya that Lothlórien, her home, remained warded from incursion by the forces of darkness.

Elrond's ring, Vilya, bore a blue stone and was associated with the element of air. Vilya's power complemented the Elf Lord's wisdom, Rivendell being a haven of learning and council in Middle-earth. The Ring was first worn by the Elf-king, Gilgalad, who died in battle against Sauron during the Second Age. He was glimpsed twice, briefly, in the prologue sequence of *The Fellowship of the Ring*. The beautiful 18ct yellow gold ring with its Ceylon sapphire was produced by silversmith Thorkild Hansen of Jens Hansen Gold & Silversmith Ltd., the same company responsible for both trilogies' One Ring props.

Gandalf was the only Wizard to bear one of the Three, and even Saruman did not know that he had it, though the White Wizard likely suspected and probably wasn't too happy about it, being the Head of the Order of Istari. The Elf shipwright

Círdan, briefly glimpsed in *The Lord of the Rings*, gave Narya to Gandalf. Círdan recognized Gandalf's purpose and need as befitting the bearer of the Red Ring, which was all about marshalling courage and heroism in others, kindling the fires of their hearts to achieve greatness, hence its association with the element of fire.

The significance of the Three Rings became more apparent in the extended edition of the film when the Orc dungeon-keeper attempted to take the Ring from Gandalf's hand, finger and all, as had been done with Thrain. Galadriel, of course, turned up in the nick of time to save him.

Daniel Falconer, Weta Workshop Designer

There were many new rings made for *The Hobbit*, but amongst them were some old favourites that came back again. I remade Gandalf and Galadriel's Rings, essentially replicating the beautiful work that had been done for *The Lord of the Rings* by jeweller Jasmine Watson with design input from Costume Designer Ngila Dickson and Concept Artist Alan Lee.

Dallas Poll, Costume Jeweller

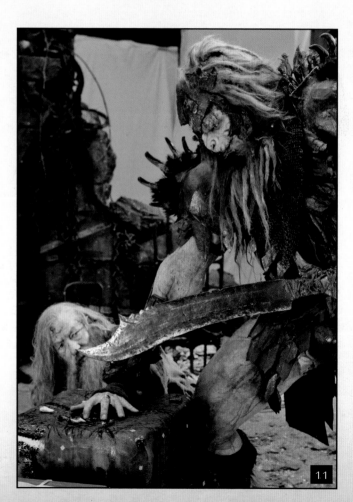

1-3. Nenya, Galadriel's Ring. 4-6. Vilya, Elrond's Ring.
7-10. Narya, Gandalf's Ring.
11. Sir Ian McKellen as Gandalf and Conan Stevens as the Torturer of Dol Guldur on set shooting the attempted collection of Gandalf's Ring of Power.

11

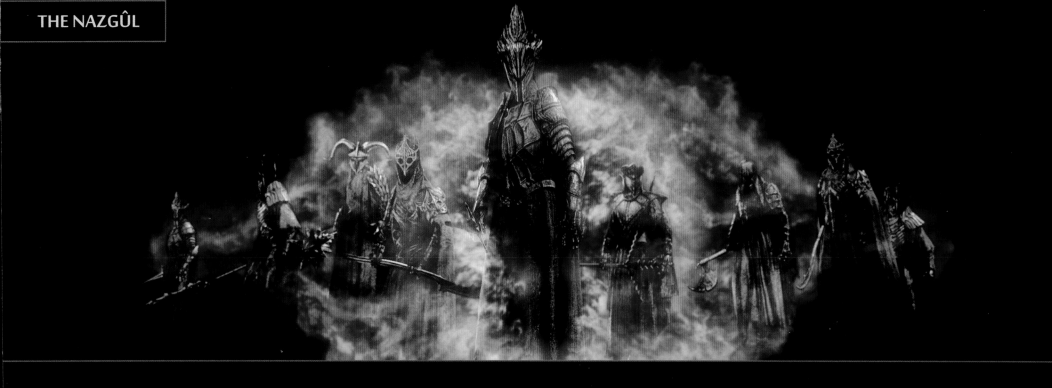

The Ringwraiths were reimagined for *The Hobbit*. Peter had a lot of specific thoughts about them, how they would move and attack. Their new looks recalled what had been seen in *The Lord of the Rings*, but with more individuality. Their Dol Guldur manifestations were conceived as earlier, more spiritual incarnations compared to the hooded black riders of the first trilogy, something like their pale wraith-world forms, but now armoured for war.

Elrond and Saruman had arrived to help Galadriel, and Radagast was along with his bunny sled to take Gandalf to safety. Together they confronted the Ringwraiths in a battle that was both physical and magical, with Galadriel cradling Gandalf while Elrond and Saruman fought off the Wraiths.

The Ringwraiths' particular movement came about as a combination of certain things Peter that asked us for and us running those ideas through some tests with iterations to present back to him for his feedback. Peter liked the idea that they weren't all the same. Nazgûl Number One, for example, Peter imagined as really annoying. He would keep coming back. He zipped around like a hornet that you might try to swat but could never quite get. Finally Elrond stabbed and held his sword in the wraith. It almost appeared like he was being electrocuted, vibrating into the ground like a beetle that shakes its way into the sand.

There was another whose limbs flew off out of frame in all directions once Saruman had impaled him with his staff. It was a pitched battle with a frenetic energy and these quick gags flew past so quickly that the audience barely had time to register them.

The day the scene was shot we had grey suit-wearing stunt people standing in for the Ring wraiths so that Elrond and Saruman had someone to hit, react to and spar with, but their action wasn't something that we used as reference for our animation of the wraiths. There were five or six of these big tracking fight shots in which we had to remove the grey-suited performers to be replaced with digital Ringwraiths. But rather than painstakingly paint the grey suits out, we actually found it was easier to rotoscope the heroes out of the on-set footage and replace the entire set with a digital version. We then put the live-action heroes back into the shot along with new digital Nazgûl adversaries for them to fight. So, in those specific shots, Galadriel, Elrond and Saruman were the performers, live on the set, but the set itself and Ringwraiths were all digital.

Matt Aitken, Weta Digital Visual Effects Supervisor

While the Ringwraiths were digital characters, it was important to provide the hero characters on set with someone to fight so that they weren't just miming. We do sometimes mime without an adversary if a specific effect shot requires it, but most of the time we try to have someone there that they can interact with. It's usually obvious if someone is miming hits or trying to stab something that isn't really there because there is no body reaction or physics involved. We try to have something or someone there to make it look more realistic.

Glenn Boswell, Stunt Co-ordinator

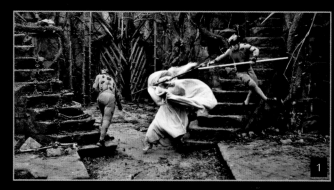

1. *Stunt performers on the Dol Guldur set, shooting a clash between Saruman and two Ringwraiths.*

1-9. Digital reference turntable images of the Ringwraiths, including helmet details and weapons: 1-3, Ringwraith #1, 4-6, Ringwraith #2 (Witch-king of Angmar), 7-9, Ringwraith #3.

We had some great artwork provided by Weta Workshop to build the digital Nazgûl from, but a lot of it was suggestive so we had to invent some of the details. I remember talking to Nick Keller, the designer who had drawn the wraith we were working on at the time. Nick did some extra drawings of what he imagined the details to be. We did our best to make sure what we built was like what he had in mind, but we also had to work around the fact that there was going to be a very heavy effect applied over the top of the Ringwraiths. We had to figure out how much to put into the model without it becoming a mess under the effect, which had a lot of contrast. We found that it didn't need to be super detailed, and that if we did go overboard on the detail it would start to break apart.

Our modellers bashed out ideas and we had the artists work over the top of their models with drawings, providing direction so that we could present some different ideas to Peter.

We ended up modelling six completely unique designs with no shared elements. They were draped with a simulator because the designs were between seventy and eighty per cent cloth versus hard armour. I thought they ended up looking very cool in the film.

Marco Revelant, Weta Digital Models Supervisor

I loved the designs for the Nazgûl; they were each unique, with creepy armour that suggested the cultures they had come from when they used to be men. We used a little bit of motion-capture for their descent down the stairs, looking threatening, but when it came to the battle we key-frame animated them. Peter wanted them to move weirdly, but he hadn't locked down on a specific style of movement when he shot the live-action elements on the Dol Guldur set with Elrond and Saruman. He shot a lot of the actors and stuntmen fighting and doing all kinds of exciting moves. Those plates turned out very well. There were some great camera moves, but Peter wasn't really sure how he was going to integrate the Nazgûl and what they would be doing, exactly, so we got to play.

10-18. Digital reference turntable images of the Ringwraiths, including helmet details and weapons: 10-12, Ringwraith #4 (Khamûl the Easterling), 13-15, Ringwraith #5, 16-18, Ringwraith #6.

He gave us about a dozen long takes and we assembled as many animators. Then we did what we call post-viz, in reference to previz (see page 216), where we didn't put them through the full Weta Digital pipeline, but instead just worked up some rough camera moves and threw the Ringwraiths in with loose rotoscoping, enough to get a sense of what the shots could be.

As things went along Peter's thinking on the fight solidified and he told us to think about poses, moves, spins and jumps that referenced Asian fighting films. From that inspiration came specific things such as some of the Nazgûl having a teleporting ability so they could materialize elsewhere after having been struck down. There were also some unusual effects such as waves of energy that would pre-empt powerful strikes,

allowing the action to be very fast because the eye understood the arc and wouldn't lose it in the strike's supernatural speed.

There was a relentless, inhuman quality that Peter wanted from the Ringwraiths. When Elrond struck them, their weapons would fly out of their hands and float away in a slow-motion effect, but when they rematerialized their weapons would summon to their grasp just in time to complete an attack.

We provided Peter with a dozen full-length post-viz takes from which he cut the sequence together. In some cases only small snippets were used, but sometimes an entire take was used and eventually went back into the pipeline to be reproduced as fully finished, featured shots in the sequence.

Each wraith had a unique fighting style particular to their weapons of choice. One had two swords, so we were able to do lots of swirling arcs and attacks with him, while the one with the heavy mace focussed on big overhead strikes that would crash against the ground. Another had a spear, while there was one with a trident. There was plenty of diversity, which kept it interesting and presented opportunities for us to do new and unexpected things, plus it was a pleasure to have these two characters, Saruman and Elrond, who are usually so dignified, fighting and looking so cool in action.

David Clayton, Weta Digital Animation Supervisor

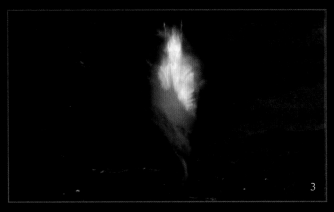

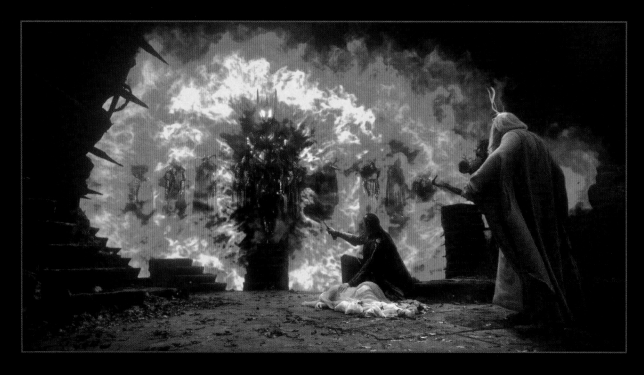

The final stage of the conflict in Dol Guldur came to a head when the Necromancer himself rose up, and it was revealed beyond any doubt that it was indeed Sauron. He and Galadriel had a kind of mental battle which caused the destruction of parts of Dol Guldur itself. There was originally more envisioned to this sequence as Peter described it to us, though that extra material wasn't turned over to us to work on and include in the theatrical edition. Dol Guldur was going to be almost completely destroyed by the shockwaves of the energy that Galadriel was blasting at Sauron. What we saw in the cinema wasn't quite on the same scale, but her power was still enough to overwhelm him and send him fleeing, presumably banished to Mordor.

Peter had a number of ideas for how Sauron could appear at the point at which he was blasted away, so it took a while working with him to hone that particular moment. One idea involved the clouds being knocked apart as he went through them, but there wasn't the room in the frame to have him follow that path. In the end we would see Sauron vanish behind the clouds in a fiery glow and track across the sky.

Matt Aitken, Weta Digital Visual Effects Supervisor

In the book, the entire Necromancer storyline occurred, to use a film term, off-camera. This particular plot was an extrapolation that Peter brought to his adaptation of *The Hobbit*. I think it provided the audience with an eye into the much larger world in which Bilbo's adventure was happening, demonstrating the kind of level at which Gandalf operated and what he was concerned with but it became clear to me that I would need an education on Sauron and his history in order to be able to perform the character. The Supervising Dialect Coach on the films, Leith McPherson, gave me a crash course in Black Speech and we went for it together.

It was a wonderful collaboration; we went crazy and tried all sorts of things. At one point I said, 'I'm going to try and do this backwards. I'm going to try and do this on an in-breath and backwards so that you can then relay it forwards as a very odd out-breath.' The remit for this character was that he was like a black hole. He was a kind of fallen angel, on par with, or even greater than, a Wizard, but gone wrong. At this point in the story he was a kind of half-creature because he couldn't achieve a physical form anymore. He would become what we later saw as the Eye of Sauron.

In a most extraordinary piece of casting synchronicity, Alan Howard, who voiced Sauron in the eerie Ring-world sequences in *The Lord of the Rings*, actually played my father in *Parade's End*, so I had just worked with him before I went to work on *The Hobbit*. I brought a little bit of his voice in every now and again, to hint at the evolution going on in him and what might be to come.

Benedict Cumberbatch, Actor, Smaug & the Necromancer

worked with Benedict Cumberbatch when he was developing his Necromancer performance. The Necromancer was a very complex character, probably one of the most difficult anyone could aspire to play. He doesn't do anything, but he does everything. How much of the physical performance translated to the screen, I don't know, but it was very important to all of us, and certainly to Benedict, that he explore and understand the nature of the character.

The Necromancer was like a black hole, absorbing all the energy from a person, feeding upon hope and life. This was particularly evident in the confrontation with Galadriel in which she used her weapon; pure light. They were essentially polar opposites. It was a battle between how much he could take in and how much she could project. The entire fight was about energy. How much could he continue to absorb? How much could she give? And how do you play that? It was neat to see Benedict play this, and the success of it comes down to presence– not acting. It was a particularly difficult challenge, but Benedict pulled it of masterfully.

One of the most challenging things is to draw into yourself to the point where you almost feel things being drawn toward you, as if you are sucking up all the energy in the room. We did a lot of sitting in the chair and breathing and drawing in. Benedict was brilliant. He is theatre-trained. The best actors I have worked with have always been theatre-trained. They know the process. They wait. They know it's going to come and don't try to force it. Benedict was able to move and do things but still maintain that sense of drawing in.

We had fun hooking him up to bungees with a strap around his chest that he was able to lean forward into, creating a sense of a force hitting him that he was absorbing. He could dance and play, leaning into the bungee, creating an almost weightless, formless sense to the character. He would swell and morph into these forms, drawing in and not breathing out, which created a very interesting effect.

We talked about shadow images and the kinds of forms he could create, some almost human, but with extended, thin limbs. We imagined the Necromancer existing in a different dimension, and how his presence in this world would be distorted and constantly shifting in an uncomfortable way. This being doesn't even think like a human, is completely alien, a thing of pure evil whose purpose is to consume and destroy.

The day before we did the Necromancer motion capture I had a twenty-five-foot square scrim brought in and a spotlight, which we had a guy wheel along as Benedict moved, casting his shadow. I had him playing with form and shape, experimenting with eurythmic timing and breaking up familiar patterns of movement and rhythm. We had him walk across the

scrim then morph into different things, and then come back up. He would assume the form of man when he needed to communicate to man, but in other ways he was formless and unstable. I filmed it and then had him walk backwards and do the same thing, which we reversed and played forwards. That gave the performance a very unique feel.

Terry Notary, Movement Coach

Because of his state, the remit was that energy was being sucked into him, so I had to walk in, imagining that the scene was actually coming towards me or going through me. We played around with bungees so that I was walking forwards but feeling an energy pulling me back as well, the notion being that energy was actually coming through me and it produced a kind staggered, ghostly advance upon my object of destruction, and with that this sort of intake of breath mixed with curses. We saw that there was something human about Sauron, as glimpsed in the first film, but he changed, shifting to become a dead space and then take on a vague humanoid shape again. He couldn't quite get a purchase on being a complete physical entity and his voice had to come out of that place as well. Having an elasticated tether behind me created the sense of not quite being able to step into the full human form, a physical aid as I tried to convey the psychology of the character through the performance. It was actually quite physically intense and cardiovascular work, both for The Necromancer and Smaug, but I absolutely loved the experience. It was great fun being in Middle-earth, and I think, compared to some of the cast who had such elaborate costumes and make-up, I got off lightly!

Benedict Cumberbatch, Actor, Smaug & the Necromancer

1. *Concept art of Sauron's manifestation at the Dol Guldur South Tower by Concept Art Director John Howe.*
2-3. *Concept art by Concept Art Director John Howe.*
4. *Concept art of Sauron's banishment and subsequent flight across the sky, as seen from Gandalf's vantage point on the outskirts of Dol Guldur, by Concept Art Director John Howe.*

"You are nameless, faceless, formless!"
- GALADRIEL

For Sauron we provided a model to the Effects Department and they used it as a guideline for all of their effects work on him. The design was based on his armoured appearance from *The Lord of the Rings* with a few changes to his proportions to make the effects work. Peter liked the idea that his shape made a kind of cat-eye slit so we had to make sure that the head wasn't too big and the shoulders weren't breaking the silhouette that he was looking for. The shoulder spikes got smaller, but otherwise he was fairly similar.

Marco Revelant, Weta Digital Models Supervisor

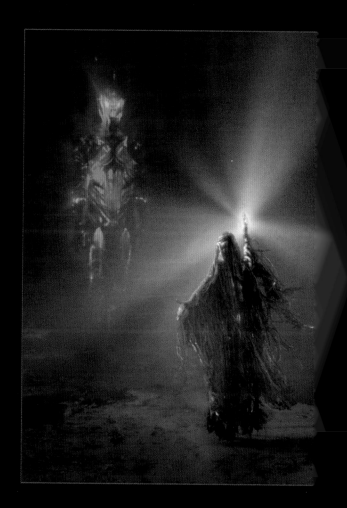

GALADRIEL, REVEALED IN WRATH

Galadriel's battle with Sauron came at a great cost to her. She spent all her energy and he was beginning to drain her life, to take control of her. Sauron would have liked nothing better than to twist her into a dark queen. The perversion of an entity such as Galadriel would have been his ultimate triumph. Saruman spoke in *The Lord of the Rings* about how the Orcs came into being: 'They were Elves once, taken by the dark powers, tortured and mutilated, a ruined and terrible form of life.' That fate could have been Galadriel's, had she failed. That was what she was risking for Gandalf.

Philippa Boyens, Screenwriter & Co-producer

From a hair point of view, Galadriel was essentially the same in *The Lord of the Rings* and *The Hobbit*. It was in fact the very same wig, because a wig like Galadriel's is a rare and exquisite thing! However, this time we also had her remarkable transformation scene in Dol Guldur, which was an opportunity for us to have some fun and do something new. When it actually came along, we only had half an hour to style her. I think that turned out to be a good thing, because we could easily have spent three hours on her and done too much. Having so little time meant we had to be efficient and extremely thoughtful about what we were doing, and I think the result was really fantastic.

Peter King, Make-up & Hair Designer

Galadriel's 'dark' costume utilized the most expensive fabric of the entire trilogy, even incorporating tiny pieces of Tiger's Eye, but it was well worth it. Given its value and beauty, it seemed barbaric to be slashing into it, but it offered us the perfect raggedy textural base for the costume. Knowing we would be filming it in a situation in which there was going to be a wind effect, with her hair and clothing flying against the sucking evil of the Necromancer, we tested its aerodynamics in the fitting room with a borrowed wind machine.

Ann Maskrey, Costume Designer

1. *Detail of Galadriel's Dol Guldur costume (dark version).*
2. *Galadriel's Dol Guldur dress (dark version).*
3. *Galadriel's Dol Guldur coat (dark version).*
4. *Studio photography of Cate Blanchett in costume as Galadriel in her dark form.*

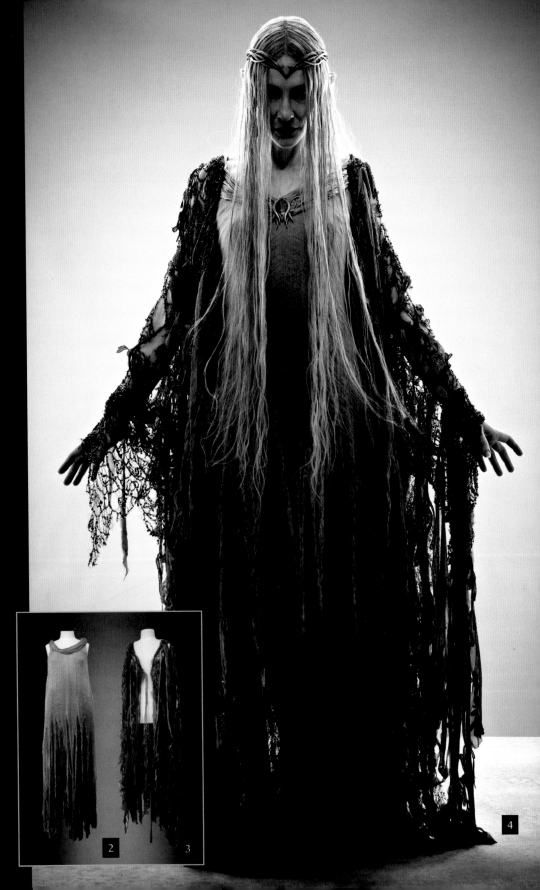

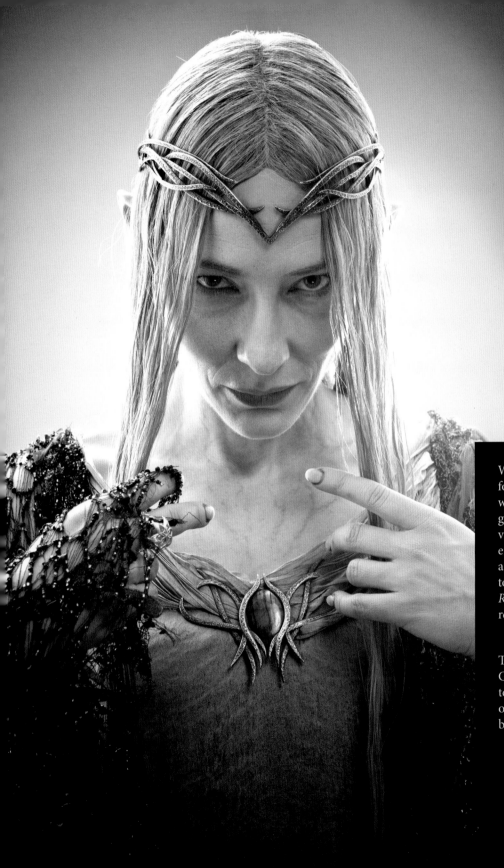

6

We created two versions of Galadriel's brooch and crown for use in her Dol Guldur transformative scene. There was a bluer, simpler version of her crown as well as the glittery one, and her brooch had both dark and light versions. All had the same texturing. The brooches had either labradorite or moonstone at their centre and, while a totally new design, were intended to be of a similar style to the mother of pearl brooch she wore in *The Lord of the Rings*. We had that piece brought out of storage for our reference.

Dallas Poll, Costume Jeweller

The delicate, ambient phial Galadriel took with her into Dol Guldur was the Light of Eärendil, which she would later give to Frodo: 'Let this be a light for you in dark places, when all other lights go out.' That line should have extra meaning now, because that is precisely what it was for her in Dol Guldur.

Philippa Boyens, Screenwriter & Co-producer

5

7

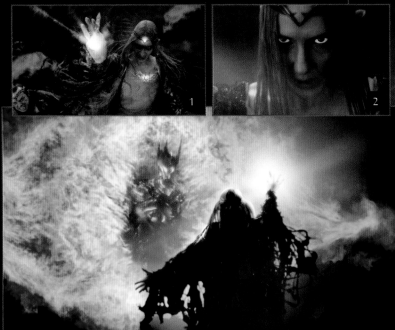

1

2

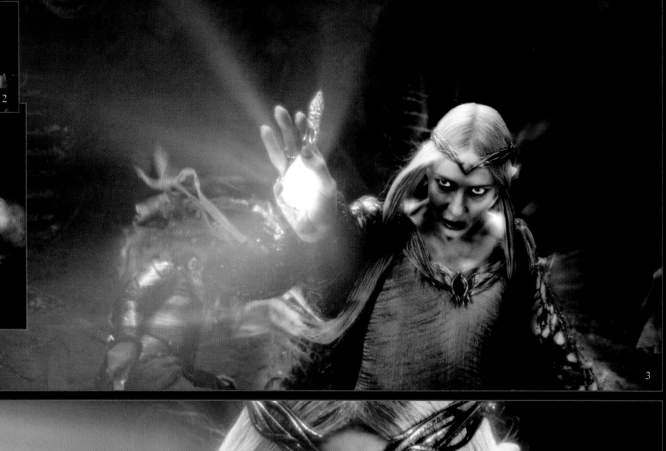

3

There were two things at work when Galadriel began to transform and took on her dark, drowned look. I think it is a truism on some level that in order to meet and destroy something, you have to assume some of the characteristics of that power. Drawing all that corrupting energy into herself, Galadriel became utterly destructive and was able to turn that power on Sauron, but it was also a gamble, because it permitted Sauron's influence to seep into her. He was beginning to take her, to consume her with the force of his will, and she was approaching the tipping point of becoming that very thing that in *The Lord of the Rings* she told Frodo the Ring would make her, terrible and lovely at once, but utterly corrupted. In her glade with Frodo, she knew that power, having sampled it in Dol Guldur, and when he offered her the Ring she had to face it again and make the ultimate choice that would define her destiny, to accept that power or allow herself to diminish and go into the West. I hope that scene in which she tells him 'All shall love and despair,' has greater meaning now.

The battle of wills that she undertook with Sauron utterly drained her. Much of her power was spent and she could not hope to match Sauron again, which is why Saruman told Elrond to take her away to safety. I think in the back of his mind Saruman understood that Galadriel had been lessened and the ambition in him was kindled, knowing he could fill that void.

Philippa Boyens, Screenwriter & Co-producer

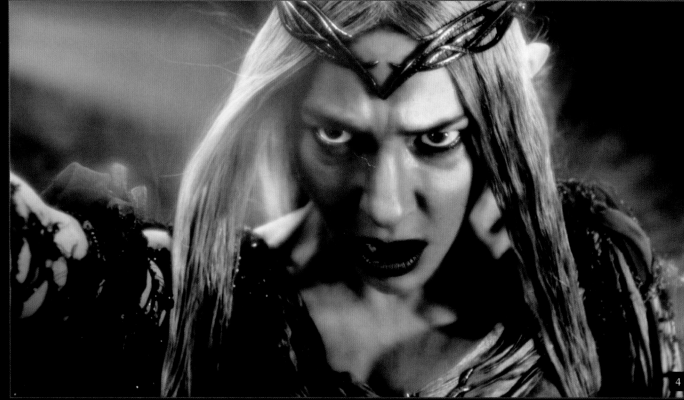

4

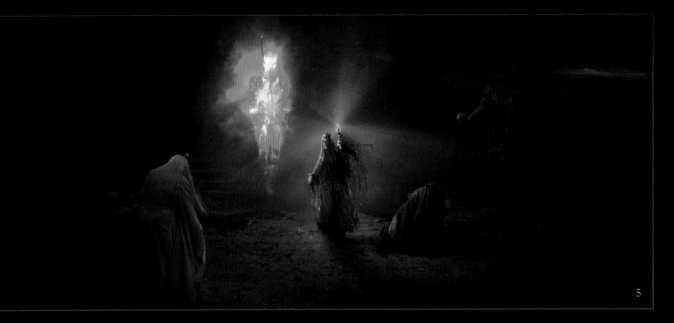

5

1. *Concept art of Galadriel's transformation by Concept Art Director John Howe.*

2-5. *Concept art for Galadriel's transformation by Park Road Post VFX Department.*

As we began working on concepts to show to Peter for how the effects on Galadriel's transformation might look, there were really two schools of thought that emerged; one idea had her going very dark and frightening, while the other accentuated her Elven qualities and made her even brighter and more striking. We presented them as still concepts, painting over frames from the live-action photography.

For the brighter look we played with things like pumping up the intensity of her eyes to make them the focal point of the shot, becoming very bright and saturated, and also explored ideas such as making the jewels in her costume glow powerfully. We tried playing with the glows around her, adding sparkles to her dress to enhance her ethereal look.

Thinking about a darker interpretation, we deepened the shadows and pushed the contrast to extremes; her eyes and lips becoming dark, almost black, with black veins running across her skin.

Peter reviewed our ideas and his main point was that Galadriel's transformation had to echo what had been done in *The Lord of the Rings*. He had liked that effect and was really looking for something similar, but perhaps even a little darker and scarier for the scene in Dol Guldur in which she confronted Sauron. With that direction in mind, we explored how far we could take her look as we pushed her towards this dark and horrible, but powerful being. Peter really wanted to feel that the effect was building up through the scene, so we explored possible colour changes as her transformation built towards a crescendo, with a big release, and then faded again.

We knew we had this powerful, red hot, fiery energy in Sauron, so we thought about Galadriel in terms of a cool power with icy blue tones that could stand in opposition. We wanted the light that she was holding to be the brightest thing in the frame, resisting Sauron, so our initial conversations were really about tone and how to use light and colour to help demonstrate what was happening here in the story of their psychic battle, because they weren't fighting with traditional weapons.

The make-up that had been done on Cate Blanchett was phenomenal; she already looked very cool, which helped us a great deal. We started with that and digitally extended it, enhancing the make-up to pull out the features of her face. There was a subtle distinction between her looking powerful and angry, which is what we were trying to achieve, or evil, which wasn't. We also wanted to keep her beautiful and not to lose the sense of her being an Elf.

Once we had something that Peter liked and we all felt that the beats and timing were working, we started iterating directly on to the shots, applying our digital effects across them in 3D.

Michael A. Miller,
Park Road Post Senior Visual Effects Supervisor

THE ROD & RABBITS OF RADAGAST

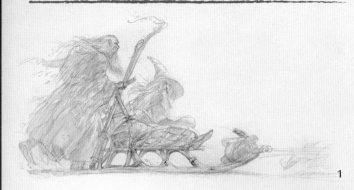

1

Radagast came swerving into Dol Guldur on his bunny sled. He was the getaway driver. We had stuntmen standing in for the rabbits and pulling Radagast's sled in one of the shots. The hardest part about that was convincing them to wear the bunny ears we bought for them from a variety shop!

Glenn Boswell, Stunt Co-ordinator

Gandalf's staff was broken in Dol Guldur, but Radagast gave his own staff to his friend and from that point onwards that's what Gandalf carried. It was the very same one he used in the beginning of *The Lord of the Rings*. By the time we saw it again in *The Lord of the Rings* it had lost most of its little twiggy bits in various battles and he carried his pipe where Radagast used to put the crystal, but otherwise it was the same.

Nick Weir, Prop Master

Gandalf's staff was broken, so he clearly needed a new one. I loved the idea that Radagast quite openly and honestly acknowledged that Gandalf's purpose in that moment was greater than his, and gave his own weapon to the person who could do the most good with it.

Philippa Boyens, Screenwriter & Co-producer

1. *Concept art of Radagast and Gandalf on the rabbit sled by Concept Art Director John Howe.*
2. *Detail of the head of Gandalf's new staff, formerly Radagast's, in* The Battle of the Five Armies.
3. *Detail of the head of Gandalf's staff from* The Fellowship of the Ring.

2 3

THE FORTIFICATION OF EREBOR

While Bilbo and his Dwarf companions watch with numb horror from the lookout of Ravenhill the unleashing of Smaug's vengeance upon the Long Lake, Thorin, their leader and King Under the Mountain, has eyes only for the green walls of Erebor, and a mind only for the treasure within its halls. A sickness lies upon the Dragon's hoard, a power that has taken hold of the once-noble Dwarf king and rendered him insensible, consumed by need for the gold. Even the safe return of Fili and Kili, Thorin's sister sons, cannot break the sleepless fever that burns within him. Worried glances pass between the Company's members, and as Thorin's fury over the missing Arkenstone mounts, accusations fly.

Only Bilbo, in whom Thorin confides his doubts and fears, escapes his wrathful suspicion. Guilt and worry gnaw the hobbit; to turn over the stone to his friend or not, and at what cost?

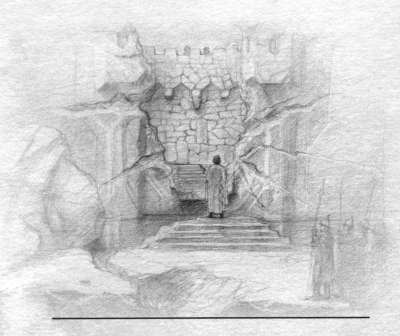

gan the third film of *The Hobbit*, Fili, Kili, Bofur
were on a mission to get to the Mountain. Thanks to
erful Tauriel and a degree of good fortune we four,
stayed behind in Lake-town when the others went
had survived the Dragon's flames. Oin's personal
as to find out if his brother Gloin, or any of the
was still alive, a sentiment shared by the others. At
here were lines in the script about their duty to get
others.

g in Erebor, the four companions were confronted
mensity of what it was they had signed up to find. As
hobbit ushered them inside they found themselves
e spectacle of Erebor and before them lay heaped,
hey could see, the incredible wealth of the Dwarves.
as for the incomprehensible treasure hoard and
mystical value of the Arkenstone, the reason Oin
d the quest was to reclaim that lost heritage. It was
overing what so many generations of Dwarves had
which had been taken from them when the Dragon

John Callen, Actor, Oin

Erebor and seeing this amazing place as he walked
it was a big deal for Ori. He had grown up hearing all
about where the Dwarves had come from and who
to be, but it wasn't real for him until they got there.
ey was a big, fun adventure and a way to try and get
under Dori's watch, a chance for sheltered little Ori
ething with his life, but then, being there and seeing
s, the meaning of it all finally sunk in.

Adam Brown, Actor, Ori

t art for the interior of Erebor by Concept Art
ohn Howe.
banner prop.

With the interior of the Mountain kingdom basically being
a maze of green marble columns, stairways and arches, we
created reconfigurable set elements that could be rearranged
and reused in new ways. We had a little table top model that
turned out to be a very effective tool. When we had finished
shooting a particular set piece, we'd bring in our model.
Peter would reconfigure it to show us what he wanted for
his next set-up. Overnight our crew would pull the set apart
and rearrange the pieces, putting a staircase over there and a
column over here, lifting this up, pushing that down, etc, then
our set dressers would go in and make it look lived in.

Dan Hennah, Production Designer

The Dwarves began organizing the treasure of Erebor, taking
the ramshackle giant mound of gold, stacking and making
aninventory of it all. We free-stacked coins, goblets and other
items of treasure to dress the set. You can't make treasure
purely out of gold and jewels; you need to have other elements
in there to enhance it and offer some texture and contrast. We
included paper props like manifests and lists as well as rich
fabrics, like velvet, amongst the treasure. Hanging tapestries
and heraldic banners helped soften and add some life to the
space, suggesting that people lived and worked there. You'd go
mad if you had to stare at green stone walls forever.

Ra Vincent, Set Decorator

3. Concept art depicting the treasure room by Concept Art Director John Howe.
4 -5. Concept art concerning the Dwarves' attempts to begin accounting the Erebor treasure hoard by Concept Art Director John Howe.
6. Concept art for Erebor banner by Weta Digital Concept Designer Aaron Black.
7-8. Calligraphic set dressing by Graphic Artist Daniel Reeve for Erebor's interiors.
9. Gems in sorting trays, Erebor interior set dressing.
10. Soft Furnishing Machinist Jill Donaghy creating Dwarf heraldry.
11. The 3Foot7 Art Department Concept Room Erebor installation.
12. Sculptor Anneke Bester sculpting Dwarf statuary.

There were any number of examples of this throughout the films, but when we shot on those amazing sets I was struck by the grandeur of Erebor. I would be walking through and notice a tiny corner in which something had been set up, a beautiful arrangement of set dressing that would probably barely be glimpsed on screen, but which had been artfully composed with love and incredible attention to detail.

Peter Hambleton, Actor, Gloin

Erebor was achieved through a combination of live set elements and CGI. The spaces were simply too vast to be practically achieved so many of its cavernous halls were entirely digital. At Weta Digital we approached Erebor in much the same way as the Art Department with their physical build, which is to say we built components. We had stairs, columns, statuary, arches and many other pieces. There were over 470 modular elements which our Layout team, working with John Howe, Alan Lee and the Art Department, could assemble into new chambers within the Mountain, as needed. It was the most efficient way of doing it and meant that any time a new space was devised we maintained the design integrity that had been established for Erebor, preserving the flavour while still being able to invent variation in our new spaces. It provided us with architectural consistency throughout all of the Mountain interiors.

Matt Aitken, Weta Digital Visual Effects Supervisor

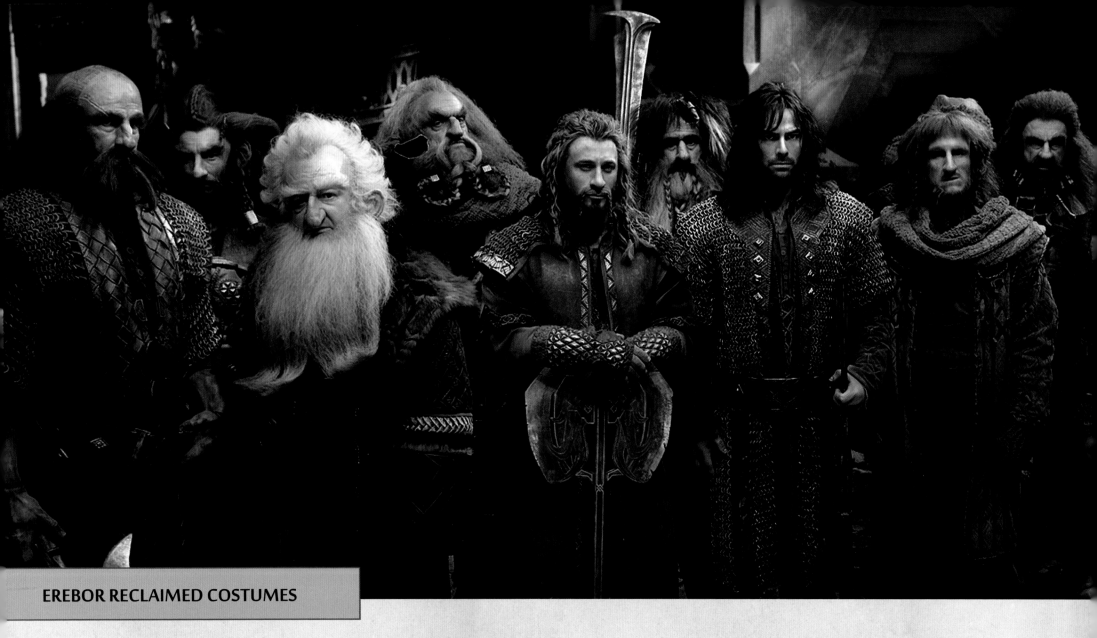

EREBOR RECLAIMED COSTUMES

The Dwarves had many different looks throughout the films, beginning with their fresh costumes in Bilbo's kitchen and the various stages they went through on the journey, losing pieces until they ended up in Lake-town in their underwear. There they received fresh clothes, but it was not until they got to the Lonely Mountain and began sorting through the treasure that they got to put on proper Dwarf costumes again, what we referred to as their regal costumes.

There were stages to these new costumes too, and we broke them down into three distinct versions which were worn at different times. The Stage 1 regal look, later called the 'Erebor

reclaimed' look, was what the Dwarves first dressed themselves in once they retook the Mountain.

Stage 2 was truly regal. This was the armour they donned when preparing to go to war, fully armoured and resplendent, but possibly a little over-dressed (see pages 66–83).

The battle dress of Stage 3 was a stripped back version that was less armour-plated but more mobile, which they ultimately fought in. In most cases it was very similar to the Stage 1 costume, with varying amounts of new components included.

Jamie Wilson, Armour & Weapons Production Manager

Upon reclaiming the Mountain from the Dragon, the Dwarves began settling back into their home, which included reclaiming their identity by putting on real Dwarf gear that they found in the abandoned city and treasure hoard. In terms of the preservation of old clothing, Erebor under Smaug's dominion was probably an ideal place, because it would have been warm and dry. We nonetheless imagined the garments would be a little bit moth-eaten and dusty so we had our Breakdown team put lots of character and history into them.

Bob Buck, Costume Designer

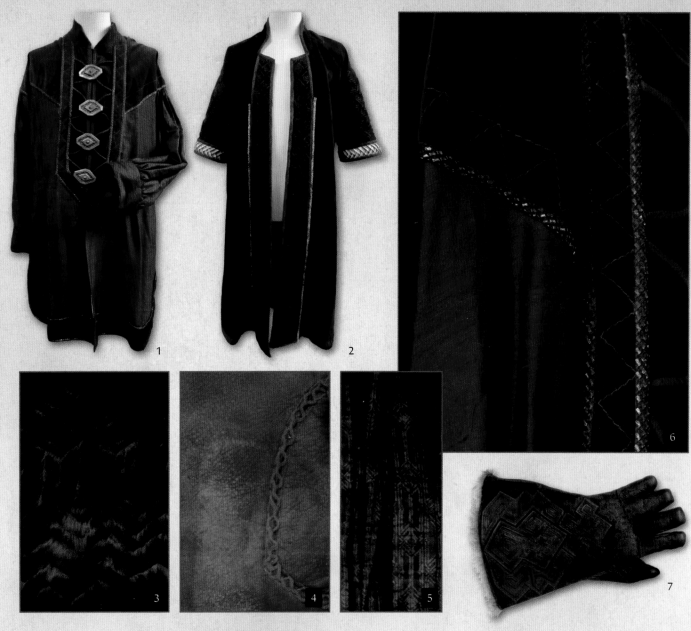

Approaching the breakdown of the Dwarves' Erebor costumes was complex. We had to try and find a look that suggested it was hundreds of years old but had never been worn.

Hamish Brown, Costume Art Finisher

There were a lot of conversations about how that would look. We offered samples and discussed the ideas with the designer. We wanted to age them realistically, but at the same time we didn't want to lose all the beautiful colour by simply covering it all in grey or brown dust, so it was quite a thoughtful process.

Thomas Caddy, Costume Breakdown Supervisor

Creating the Dwarves' Erebor costumes required a close working relationship between the Textiles, Costume, Props and Workroom teams. We might dye something, send it up to the workroom to be quilted and then get it back for foiling or some other process before it would go back again. There was a lot of back and forth rather than the usual handover, after which we might not see a garment again. It was harder and more involved, but the resulting costumes were incredible.

Paula Collier, Textile Artist & Dyer

1. Balin's shirt.
2. Balin's coat.
3. Balin's trimmed fur shoulder mantle.
4. Detail of Balin's leather gloves.
5. Detail of Balin's cummerbund.
6. Detail of Balin's shirt.
7. Balin's glove.

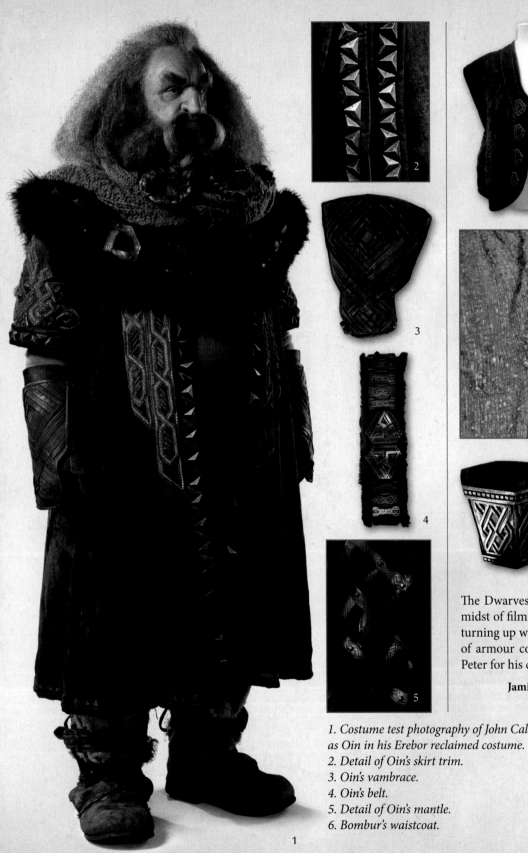

The Dwarves' armour was being made while we were in the midst of filming on location, so we had Weta Workshop crew turning up while we were out in remote places with crates full of armour components to try on actors and put in front of Peter for his critiquing or approval.

Jamie Wilson, Armour & Weapons Production Manager

1. Costume test photography of John Callen as Oin in his Erebor reclaimed costume.
2. Detail of Oin's skirt trim.
3. Oin's vambrace.
4. Oin's belt.
5. Detail of Oin's mantle.
6. Bombur's waistcoat.
7. Detail of Bombur's trousers.
8. Detail of Bombur's tunic.
9-10. Dwalin's wrist cuffs.
11. Dwalin's ring.
12. Kili's tunic.
13. Detail of Kili's shirt sleeves.
14. Dori's coat.

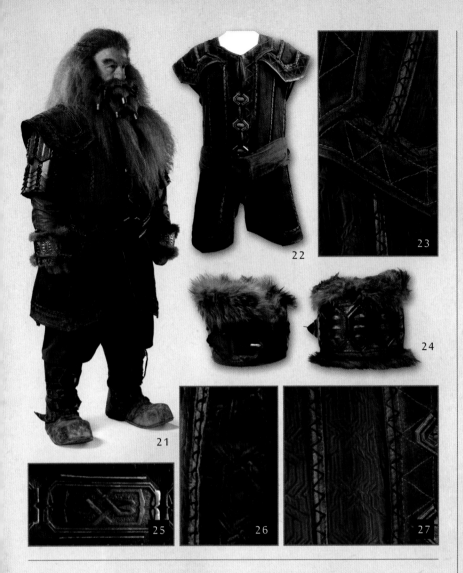

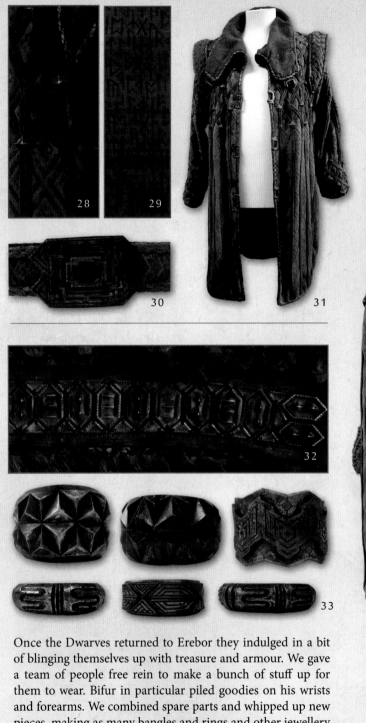

> ## "Never underestimate Dwarves."
>
> - THORIN

15. Detail of Dori's coat.
16-17. Dori's rings.
18. Detail of Dori's skirt.
19-20. Dori's wrist cuffs.
21. Costume test photography of Peter Hambleton as Gloin in his Erebor reclaimed costume.
22. Gloin's coat.
23. Detail of Gloin's coat.
24. Gloin's wrist cuffs.
25. Detail of Gloin's belt.
26. Detail of Gloin's skirt.

27. Detail of Gloin's coat.
28. Detail of Ori's coat.
29. Detail of Ori's sash
30. Detail of Ori's belt.
31. Ori's coat.
32. Detail of Bifur's belt.
33. Bifur's bracelets.
34. Costume test photography of Adam Brown as Ori in his Erebor reclaimed costume.

Once the Dwarves returned to Erebor they indulged in a bit of blinging themselves up with treasure and armour. We gave a team of people free rein to make a bunch of stuff up for them to wear. Bifur in particular piled goodies on his wrists and forearms. We combined spare parts and whipped up new pieces, making as many bangles and rings and other jewellery as we could before being told to stop. Anything that didn't end up on a hero character once selections were made was potential set dressing, so we just went for it.

Dallas Poll, Costume Jeweller

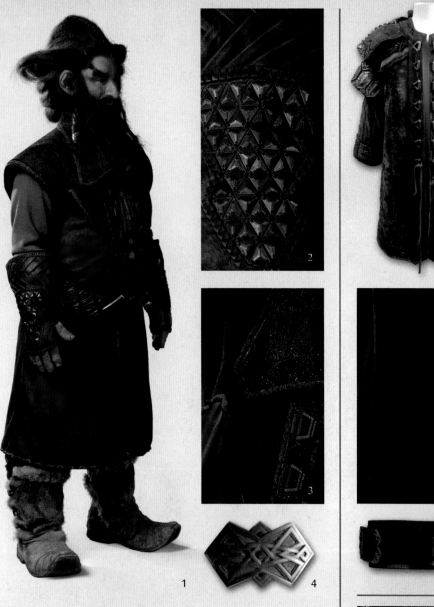

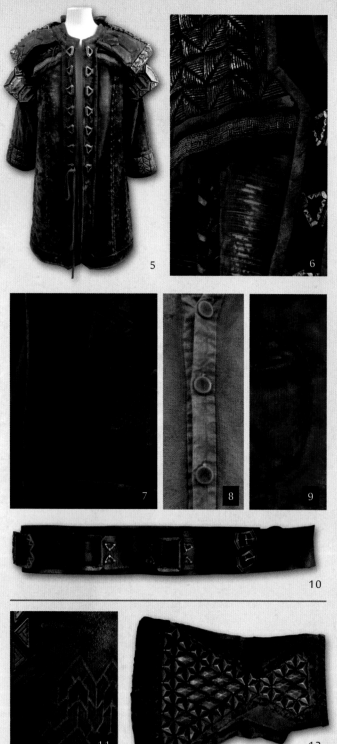

Fili and Nori both had fingerless gloves in their new Erebor costumes. We made these to fit over their silicone prosthetic hands. Balin and Oin had full gloves, which we padded to make them look as if they were filled by big meaty Dwarf hands. In essence, they were really just like the big body suits that our team constructed to change the Dwarf actors from normally proportioned humans into stocky Dwarves, only in miniature!

Hayley May, Milliner

For Thorin's Erebor reclaimed costume I started weaving up strips of leather to create a dark tunic that would be worn over gold. It was almost like a cage, trapping the gold against his chest (lots of symbolism there) and had a certain streetwise quality to it, a roguishness which was something we wanted. The gold was bringing out the mean streak in Thorin so a certain thuggish, biker-gang quality to his coat subtly reinforced this shift in character.

Beneath the leather Thorin wore a velvet tunic to which we attached his chainmaille, something which came about with a lot of input from Peter and produced a staunch, unfussy look. Thorin's great cloak with its fur collar gave him an even bigger presence. It was always intended that this was formerly one of his grandfather Thrór's cloaks and by wearing it we were showing how Thorin was taking on Thrór's mantle both literally and figuratively, and with it, assuming all of Thrór's problems as well. Just as was done for Thrór before him, the cloak was designed to add mass to the actor's shoulders. We put huge folds in the back to give it more breadth. It is ironic that we ended up putting more and more on these characters, making them bigger and bigger, in order to achieve making them look short!

Bob Buck, Costume Designer

1. Costume test photography of Jed Brophy as Nori in his Erebor reclaimed costume.
2. Detail of Nori's gauntlet.
3. Detail of Nori's coat.
4. Detail of Nori's belt buckle.
5. Bofur's coat.
6. Detail of Bofur's coat.
7. Detail of Bofur's shirt.
8. Detail of Bofur's undershirt.
9. Detail of Bofur's gloves.
10. Detail of Bofur's belt.
11. Detail of Fili's tunic.
12. Fili's gauntlet.
13. Detail of Thorin's belt and buckle.

MAKING MOULDS

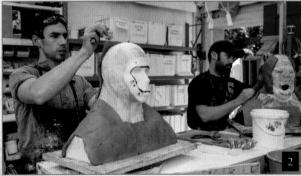

1. *Weta Workshop Mould Shop Supervisor Luke Hawker with a hobbit prosthetic leg mould and core.*
2. *Weta Workshop Mould Shop Supervisor Michael Wallace and Mould Shop Technician Brad Cunningham prepare prosthetic busts for silicone casting using potter's clay.*

The Weta Workshop Mould Room is where anything that needs to be reproduced comes to be moulded, which is almost everything the company produces. There were a few things on *The Hobbit* that were what we called working props, items that a prop maker might create as one-offs that weren't moulded, but almost everything else came through us. During *The Hobbit* the department was overseen by Mould Shop Supervisor Michael Wallace. Mike had the job of juggling crew and managing multiple mould-making projects, sometimes very complex, and often on tight schedules, an exercise in multi-tasking and logistics!

Often the reason we are moulding a particular item is so that it can be reproduced in durable or lightweight materials, such as with armour, and frequently in large numbers. We might also reproduce items like weapons in materials other than metal for safety reasons. Basically what we do is make negative representations of objects to enable someone to cast positive reproductions in urethane, fibreglass resin or whatever casting material they require.

We have a wide range of materials that we use to create moulds. As a general rule, if what we want to cast is soft we'll produce a hard mould, whereas if the object to be cast will be hard we'll use a soft mould so it's easy to get out. Most often we mould with silicones, sometimes with jackets made of fibreglass to hold them together, or, in the case of many prosthetics, we would create the entire mould in fibreglass. We also made light, but very strong, epoxy syntactic moulds, and still use good old-fashioned plaster and casting stone, like Ultracal, for moulds that will be used to produce foam castings which have to be baked and breathe.

On *The Hobbit*, urgency of delivery frequently affected what kind of mould we made. If it was needed the next day we'd sometimes create what we called a brush-up mould, basically painting the original with a layer of silicone, whereas if we had a week we could go to the trouble of creating a matrix mould with a silicone pour that had time to settle for the best possible results.

Where things begin to get more complex for us is when an armature is required. For example, to cast a urethane sword for *The Hobbit* we would develop a mould that would allow a rigid three-millimetre steel armature to be mounted inside it with pins to hold it in place while the mould was filled with urethane. The result would be a urethane sword with a rigid core to reinforce the weapon for use in stunts and prevent it from flopping around like a sausage.

Things like Dwarf armour components usually required relatively simple one-sided moulds into which urethane would be sprayed. The cast pieces would only ever be seen from one side so the back could look like goo and it wouldn't matter. Weapons, shields or other objects with two sides needed multi-part moulds, resulting in seams on the raw cast props. Urethane is like sticky honey when sprayed under pressure into a mould, so we had to design them to squish together and allow the excess material to escape; so where the join went was both a technical and artistic choice. We had to decide where best to put the seams to reduce the amount and difficulty of clean-up required on the cast pieces after demoulding, avoiding creating ugly lines across the props such as those seen on a cheap plastic toy. It is very difficult to clean a seam line off a cast prop if it runs across what is supposed to be a smooth surface. Cleaning it off a hundred copies because of a single bad mould would exponentially increase the workload, which is why we had to be thoughtful with our choices.

We frequently had moulds to make that included cores, because the object we were casting had to be worn and therefore be hollow with very delicate thickness tolerances. An example would be our hobbit feet prosthetics, which were like giant silicone socks that slipped over the actors' feet and up their legs as far as the knees. The core was made in the shape of a human leg and foot, but there was no way we could get a foot down into the mould in one piece. The core had to be cleverly designed to come apart in seven pieces and stay in perfect alignment during the casting process or we'd have prosthetics with inconsistent skin thickness – really complicated stuff!

On top of all that, we were often working under crazy deadline pressures, so it wasn't always possible to spend as long as we might want, designing and executing a complex mould. Our schedules had to accommodate certain processes that couldn't be hurried. Chemicals require a set time to complete their reactions. For the silicone to properly cure in a very big mould we might need twelve hours, so we had to work our schedules around immovable things like that, which meant we often worked unconventional hours; all part of the joys and challenges of making moulds!

Luke Hawker, Weta Workshop Mould Shop Supervisor

DRAGON SICKNESS

The dragon sickness – it has its own name, but I think it is a psychology we can all relate to in some way. It's avarice, a greed, which clouds good judgement and makes a good person choose badly. It is an unpleasant aspect of the human condition. After everything Thorin and his people had gone through to get to the Mountain, the journey itself and the decades of hardship, living homeless in exile, and the weight of his grandfather's legacy, all hung heavily on Thorin. In that closed world of Erebor, this empty, cavernous city that we had taken back, filled with an insane wealth, Thorin became fixated to the exclusion of all else.

Though it was played big, I think at the heart of it the situation speaks to a lot of people's experiences in their own lives. We can be so single-mindedly focussed on achieving something that we lose perspective, taking the most important things for granted, and ultimately risk losing them. Those things, family, friends, loyalty, and the sharing of experiences good and bad together, are free. Thorin divorced himself from those things and became a lesser person. The sense of injury he carried for all that he and his people had suffered blinded him to the needs of others, and just like anyone who won't acknowledge another's religious or political point of view, he fortified his position on shaky principles of honour and dug in for war. It's an ugly side to human, or in this case Dwarven, nature, but it is real.

Graham McTavish, Actor, Dwalin

One of the great lines in the book of *The Hobbit* describes Bilbo's surprise at Thorin's perplexing behaviour in Erebor: '… he did not reckon with the power that gold has upon which a dragon has long brooded, nor with Dwarvish hearts.' It is one of those lines that can pass by unnoticed within the context of a children's story and yet is so apropos with regard to so much of the canon of the world of Middle-earth, which is to say, being over concerned with wealth in itself and with its accumulation is a sickness. It was a gift to us as screenwriters.

Echoing Smaug, Thorin said, 'I will not part with a single coin.' His obsession had become single-minded to the point where there was no room for rationality. He could think of nothing else but preserving this immeasurable wealth, beyond sorrow or grief. Riches can have power over a person, as we know in the real world. I am so impressed by philanthropists who give away so much. They recognize it for what it is and give it away to do good, but the converse also occurs in our world, when people allow their need for possession to overwhelm them.

Thorin had been powerless for so long. The quest was all about reclaiming the Mountain, and now that he had it, it had power over him. He allowed it to define his worth, and the Arkenstone the ultimate crowning prize.

Philippa Boyens, Screenwriter & Co-producer

Thorin witnessed his Grandfather experiencing the sickness of the gold; it had been coming to him, something he feared. In Bag End, during the first chapter of our story, Thorin expressed his fear to Balin. It's dangerous – with gold comes trouble, it attracts evil. A hoard of such a size is relative to the amount of ill will imminent, but Thorin was compelled to take the Quest nevertheless.

The gold was a huge draw for all the Dwarves. As Beorn said, 'They are greedy'. With that wealth came a kingdom, with the Arkenstone came the right to rule; to a disenfranchised people, who had lived in the wilderness, in exile, longing for a return to their former glory, the lure of a chance to take it back was strong in them.

I saw the sickness as a mental disease which manifested itself in an irrational mind in a degenerative way. Thorin did not recognize himself or those around him. There was forgetfulness, fury, sudden clarity, memory loss, memory gain, but it was also a kind of fever. When close to the gold,' Thorin felt its heat, and when it was distant he craved its warmth, like a drug addict. The gold was restorative and regenerative, but had side effects, draining him, fatiguing him, slowing him down.

Richard Armitage, Actor, Thorin

Dwarves are very loyal beings by nature, but Fili's loyalties were tested when Thorin chose to push on to the Mountain while ordering Kili to stay behind in Lake-town. He had to choose between loyalty to Thorin and the quest or to his brother. Fili was young and he wasn't as caught up in the idea of reclaiming their homeland, but I think he also recognized a distinction between loyalty to Thorin and to Thorin's ambitions, which were beginning to twist at that point. By defying Thorin and telling him that he would stay behind with Kili, Fili was trying to make the point of this being about family, because that was more important than the goal of getting to the Mountain. Thorin wanted Fili by his side when they opened the door to Erebor, but he wasn't willing to leave Kili behind to satisfy his uncle's ambitions.

For Fili, even though he believed that Thorin was doing this for the greater good of their people, in that moment his brother's well-being was more important to him and their relationship more life-affirming than gold. That is why he stayed behind in Lake-town when the others left.

So, after being separated and enduring the Dragon's attack, finally getting to the Mountain and finding their friends and family alive should have been a celebratory moment for Fili and Kili, but it wasn't. It was a shock to find Thorin so changed, so consumed by what he wanted. It wasn't the triumphant reunion that they had imagined. Instead it was actually sad and really confusing for them, especially after just having come through the harrowing events in Lake-town.

There is that moment when you are growing up when you suddenly see your parents as real people for the first time. All your childhood they had been on these pedestals, then suddenly you realize they make mistakes and are prone to all the same failings as everyone else, and it's hard to assimilate that understanding. Suddenly Thorin, who was always someone they looked up to with a kind of awe, had fallen to become this shadow of who he should be.

Fili fell in line with his kin and even though everyone was looking sideways at each other, they went along with it, at least at first, because to do otherwise would be to stand against the group and go against their king, which would be an even more serious move. I liken the position he found himself in to when someone disagrees with a war, but they fight anyway because they want to protect their brothers in arms. But then Thorin went too far, ordering Fili to throw Bilbo over the parapet, and he couldn't do it. There's no way he's doing that.

Dean O'Gorman, Actor, Fili

Gloin always held strong opinions. He wasn't shy about expressing his dissatisfaction with some of the decisions made or about how the mission to reclaim the Mountain took its various twists and turns, but fundamentally he was as loyal to their cause as any Dwarf. Thorin was his cousin and his king, so Gloin felt very conflicted when the gold fever began to affect their leader. Gloin had an innate respect for the hierarchy of Dwarf society, for the way things should be, and he both respected and admired Thorin, but his leader's actions saw that faith tainted by serious doubt and worry concerning where things were heading.

Gloin was the biggest grump in Middle-earth, but he was also a compassionate figure underneath it all and had a sense of justice. What happened to the people of Lake-town shook him. He was all for the honour and pride of the Dwarves, but Gloin also had a child and a family, so there were protective urges in him that would have been stimulated by the plight of those poor and vulnerable people. Under his crusty exterior Gloin had a good soul.

Peter Hambleton, Actor, Gloin

Bifur didn't always know what was going on, but he was lucid enough by the time they were in Erebor that Thorin's reluctance to fight when it was clear that they should be was troubling to Bifur. He mightn't say much, but he was very deeply troubled. The Dwarves were all suffering; Thorin was their leader, a great leader, and they couldn't understand what was happening to him. They were caught in the agony of indecision, not knowing how far he would go, but not wanting to usurp or undermine his kingship; but when Thorin went so far as to actually want to throw Bilbo from the ramparts, Bifur cried out, 'Lu!' which is 'No' in Khuzdul; this was too far.

William Kircher, Actor, Bifur

That gold madness was a real eye-opener for all of the Dwarves. This wasn't what Dwarves were about. We'd come to reclaim our homeland, but our homeland was more than just the gold and it wasn't just about Erebor. The quest had been about reclaiming who we were as a people. We were a race of warriors and our fellows were out there getting slaughtered. We were all so angry with Thorin at that point, that he was letting them get smashed up for us while we sat inside with the gold, so when he finally came around and he rid himself of that gold lust, we were ready for that fight, to do anything, even charge into death. It was a very well-written situation, both in the book and in the film.

Jed Brophy, Actor, Nori

We were so lucky to have Ken Stott play our Balin, truly one of the great actors of our time. Thorin's rising madness was difficult for all the Company, and certainly for Balin, who had seen it before. History was repeating itself. He wept for Thorin, but also for all their people. The quest had been about reclaiming their home, but it was also about reclaiming a new future. The Dwarves were always a proud people, jealously guarding what they possessed, but that pride was rooted in their ability to craft beautiful things, to be creators and in turn remain powerful and secure. Now it was no longer a creative energy, but an obscenity, a jealous, pointless need.

Philippa Boyens, Screenwriter & Co-producer

There was a real kindness that Ken Stott brought to Balin. I always thought of Balin as the sympathetic, compassionate voice of someone who had been through a lot and seen a great deal in their long life. Balin was someone you could go to and confide in, one of the most sympathetic characters in the films in terms of his emotional understanding of the situation. I felt Ken's scenes showed how much the violence of the past had affected the character. He could be openly bereft and in that way he was different from some of the other older Dwarves. We saw that when he was weeping over what had become of Thorin in the Mountain.

Like Aidan and me, I think Fili and Kili were sometimes a bit irreverent and would have some fun with a few of the older Dwarves, playing a prank or giving them some well-meant cheek, but not with Balin or Ken. There was a respect there that just came out of who he was and who the character was.

Dean O'Gorman, Actor, Fili

THORIN'S REGAL ARMOUR

Thorin, being such an important character, went through a lot of development. His costume had to reflect the journey he was going through internally. Peter, Fran and Philippa had specific ideas that they wanted to see emerge from the costume, and Richard Armitage was also very involved in that process. It was critical that he felt comfortable in the costume and that it fit with his portrayal. When actors have input like that, it can be fantastic.

I have witnessed actors change the instant a costume goes on and it is a remarkable transformation to see occur. You can see their eyes playing over their reflection and watch them becoming the character.

We looked at a few different motifs for Thorin's armour. For a while it was going to be based on a golden ram (see page 256). We went a long way down that path in fact, but the theme was so visually strong and yet, at the same time, a bit meaningless. It drew attention to itself and you found yourself asking, 'What's the ram thing about?' If there was going to be an icon, then it had to be something that spoke to what Thorin was going through.

An obvious one that was explored for a while was a Dragon motif, given he was suffering the Dragon-sickness, the gold-lust, but then the question was, 'Why would Dwarves make armour that celebrated their enemy?'

Peter, Fran and Philippa went back to the lore for a solution, and that is where the raven theme came from. The Dwarves of Erebor have always had a close relationship with the ravens of the Mountain; they were very important to their culture. The Dwarves can talk to them, so it was a nice touch to reference that relationship with the costume, and it was dark. The entire costume was gold and black, a really fitting metaphor for how the gold was changing Thorin.

The other cool thing was the link we could build between Thorin and Thrór, who wore almost identical armour. Thorin would look at himself in this armour and see his grandfather. There could be a moment there in which he would recognize the same sickness that corrupted Thrór and make the choice not to be the same.

Matt Appleton, Weta Workshop Costume Supervisor

For the crown design that both Thorin and Thrór would wear we began with a head cast of actor Jeffrey Thomas, who played Thrór and was filmed first in the schedule. We were able to do a wig-wrap for a head-sizing based off the plaster head with Plasticine over the top representing the extra volume of the prosthetics. We made an educated guess as to how much bulk the wig was going to add. The crown was engineered with some room for adjustment so that we could be confident it would fit onto his head.

We were lucky with Thrór – the size was right and fit pretty much perfectly after just one fitting. One of the key things we were cognizant of as we fitted it was ensuring the two raven's beaks remained lined up right in the centre of his forehead, which was achieved by pinning it to the wig.

Rob Gillies, Weta Workshop Supervisor

Jeffrey Thomas and Richard Armitage had different head shapes and wore very different prosthetics and wigs so there were challenges associated with making the crowns that had been designed for both of them look the same when worn. I made half a dozen of them for use in different situations, first fitted for Thrór, and then later for Thorin. The main difference people might notice is the distance between the ravens at the front, which was adjustable. The beaks were closer together on Thorin, whose head volume with prosthetics and wig was less that of Thrór's.

Alex Falkner,
Weta Workshop Props Model Making Supervisor

1. *Thorin's regal armour.*
2. *Thorin's crown.*
3. *Detail of Thorin's regal armour, back.*

4. *Thorin's regal armour components.*
5. *Detail of Thorin's regal armour.*

Thorin's armour was awesome in the true sense of the word. To see him clad in gold, glinting in the sun, would have been a spectacularly fearsome sight. Ultimately he threw off that cladding of wealth and fought in his skin. I imagine the armour would have slowed him down. There are historical accounts of armour being shed in favour of mobility, but I nonetheless loved the ceremonial armour which Weta created.

That suit went through an extensive design process. I was screwed into it and could fall asleep inside it and remain standing! I think everyone involved in creating the costumes, weaponry, sets and astonishing artistry of all kinds for these films are deserving of all the plaudits they have received for their work. Everything that they produced was exceptional in detail and authenticity.

Richard Armitage, Actor, Thorin

3

4 5

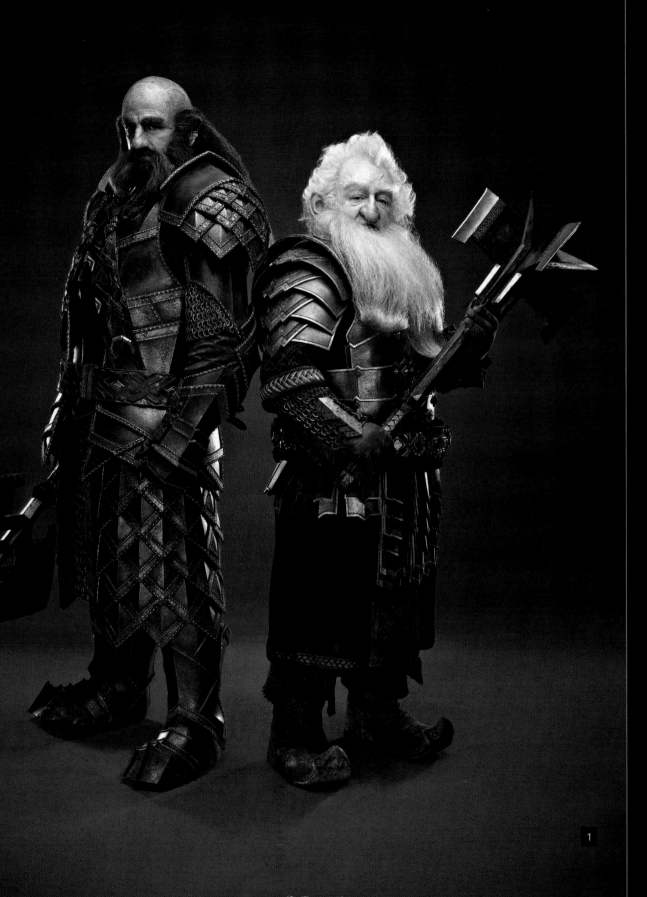

BALIN & DWALIN'S REGAL ARMOUR

When there was talk of war, Thorin had his Company suit up in gleaming regal armour, pulled out of the Erebor armoury and dusted and polished. I thought they all looked amazing in their full regal armour. Seeing them all standing there, we were witness to the full power and majesty of the Dwarves as they once were, in all their pride and glory.

Emily-Jane Sturrock, Armour & Weapons Lead Stand-by

The regal armour suits we made for the Dwarves were all based on concepts by Weta Workshop Designer Nick Keller. One of the issues we faced when building them was the fact that the cast were all shooting on location around the time we needed to be fitting their costumes. That required a number of our team, including Specialty Costume Maker Alastair McDougall, Costume Supervisor Matt Appleton and me to jump on planes to travel to the remote locales where the production was shooting; grabbing moments with the cast when they weren't needed on set to try on armour components.

We aspired to create a heightened level of regal splendour with the Erebor armour so that there was a real sense of contrast between their state before they reached the Mountain and what they found within. Every one of the thirteen different suits had to look like they were the result of the highest level of Dwarven master-craftsmanship, possibly taking years to be made and based on thousands of years of passed-down armour smithery, but in reality be achieved by a handful of film costume technicians in just a few weeks!

Thankfully we were able to draw on the incredible benefits of our integrated physical and digital prototyping pipelines here at Weta Workshop. Our 3D digital modelling 3D and milling teams were able to produce complex componentry on a very ambitious schedule. Had we been reliant on only traditional armour-making techniques there is simply no way we could have made the deadline and maintained such a high quality of manufacture. All of the shapes were constructed by first 3D modelling them, milling them out of Sebatool, a chemically-bonded urethane wood analogue, then detailing and finishing them with model-making techniques, moulding and casting them, before finally painting and assembling them on specifically devised rigging systems.

I couldn't have been more proud of the work produced by our team when it was all done; the Dwarves, to a character, looked splendid. I think it was some of our best work.

Richard Taylor,
Weta Workshop Design & Special Effects Supervisor

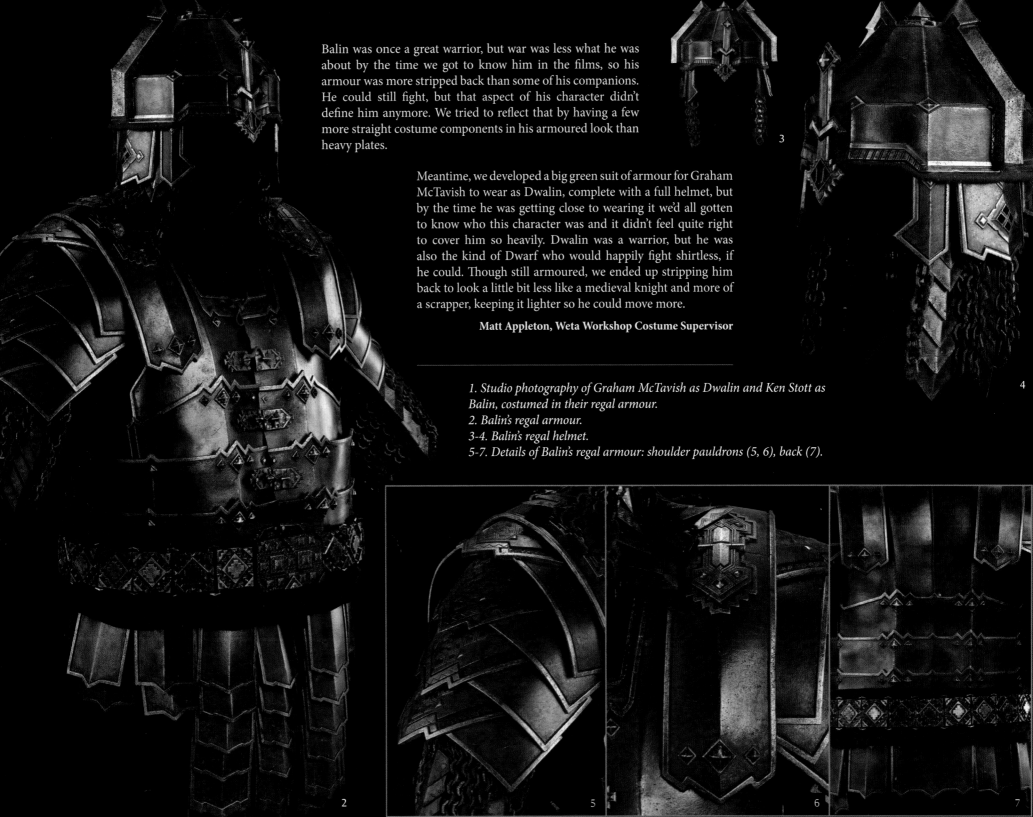

Balin was once a great warrior, but war was less what he was about by the time we got to know him in the films, so his armour was more stripped back than some of his companions. He could still fight, but that aspect of his character didn't define him anymore. We tried to reflect that by having a few more straight costume components in his armoured look than heavy plates.

Meantime, we developed a big green suit of armour for Graham McTavish to wear as Dwalin, complete with a full helmet, but by the time he was getting close to wearing it we'd all gotten to know who this character was and it didn't feel quite right to cover him so heavily. Dwalin was a warrior, but he was also the kind of Dwarf who would happily fight shirtless, if he could. Though still armoured, we ended up stripping him back to look a little bit less like a medieval knight and more of a scrapper, keeping it lighter so he could move more.

Matt Appleton, Weta Workshop Costume Supervisor

1. *Studio photography of Graham McTavish as Dwalin and Ken Stott as Balin, costumed in their regal armour.*
2. *Balin's regal armour.*
3-4. *Balin's regal helmet.*
5-7. *Details of Balin's regal armour: shoulder pauldrons (5, 6), back (7).*

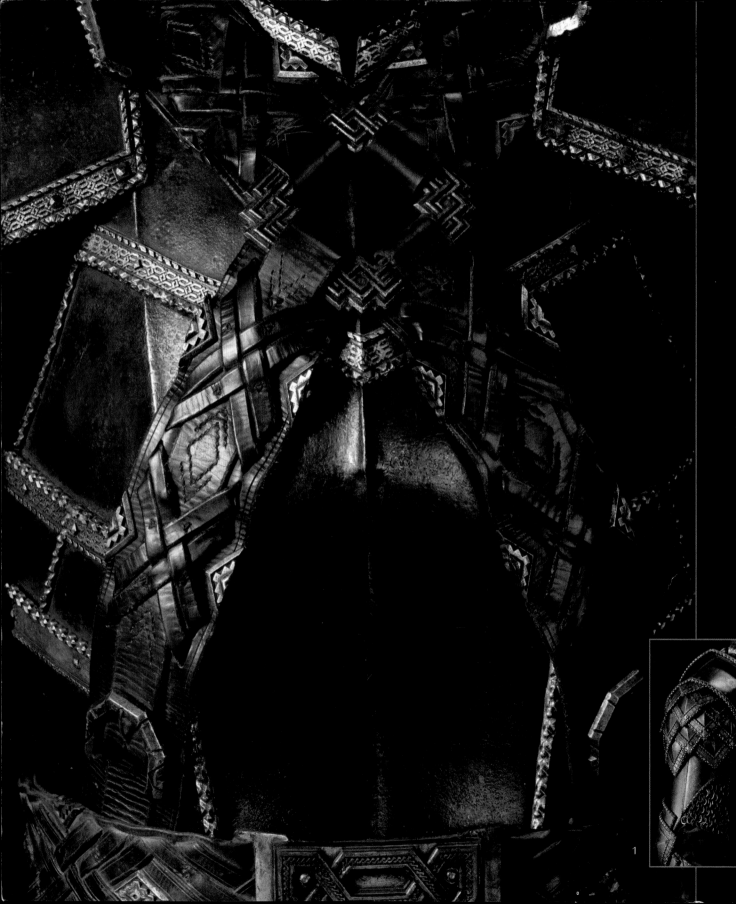

There really were two key aspects to Dwalin's character that we saw in the final chapter of *The Hobbit*: the gruff, dour warrior that we had come to know throughout the trilogy, and a man of intense loyalty with a huge heart. That loyalty was pushed to its limits by what he witnesses from Thorin. Like the rest of the Company, he donned his resplendent armour and prepared to fight for his king, but Thorin's actions shook his faith, and he couldn't stay silent. Unable to watch his king and closest friend descend into madness, he confronted Thorin in the throne room.

Dwalin had always been Thorin's good sergeant major, seeing the orders of his commander carried out with unquestioning loyalty, standing front and centre, shoulder to shoulder with Thorin in any battle, never doubting his motives or integrity. He was a true believer in their cause, in what it meant to be a Dwarf of Erebor, but Thorin's actions once they had reclaimed the Mountain gnawed Dwalin. The return to the Mountain should have been a celebration, but it was falling apart. There was a growing sense of shame, which he could not abide.

In the end Dwalin was really the only one who could confront Thorin, and he could only do it alone. He would never shame Thorin in front of the others, but by being alone with him he could tell him the absolute truth: 'I have followed you to the end, but now...' There were some lines we shot that didn't make the theatrical cut of the film, but which I loved. Thorin said to Dwalin, 'I am your King' and my response was, 'By my consent you ruled.' What Dwalin was saying was not that he could take over, but that he and the others followed him willingly, not out of duty but because they believed in Thorin, because they trusted him, but that was gone now. We weren't fighting, we weren't in a big crowd – it was a very nice, intense scene between two characters that have been through so much together.

Graham McTavish, Actor, Dwalin

1 2 3 4

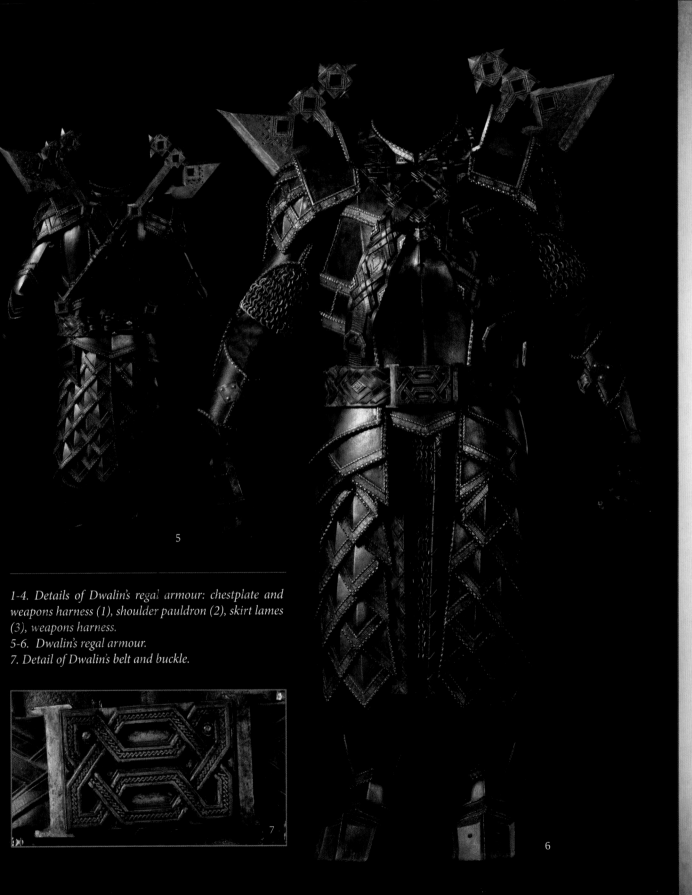

1-4. *Details of Dwalin's regal armour: chestplate and weapons harness (1), shoulder pauldron (2), skirt lames (3), weapons harness.*
5-6. *Dwalin's regal armour.*
7. *Detail of Dwalin's belt and buckle.*

PAINTING ARMOUR & WEAPONS

The work of the Weta Workshop paint-shop was very different on *The Hobbit* compared to *The Lord of the Rings*. That project had really been the genesis of the department. We learned a huge amount on it and since. The major difference this time around was time, or the lack of it. The whole project operated on a much tighter time frame than the first trilogy. We found ways to respond to the condensed delivery schedule by having much tighter, more concise reference material in the form of designs that were very detailed. It was a bit more 'by the numbers' than it was a decade ago, plus we now knew the materials so much better and how to get the best results from them. Our processes had been honed so we had an understanding of which paint products worked with the urethanes in which we cast out our armour and weapons.

If we knew what effect we were trying to achieve, what material it was intended to resemble and we got the right reference material, then we usually had an existing process for how we would achieve the desired look, be it a wood grain, leather, tarnished metal, or high polish.

Jonathon Brough, Weta Workshop Senior Paint Technician

There was a lot more variety of colour in the armour and weapons of *The Hobbit* than last time we visited Middle-earth, especially in the Dwarves' regal costumes. The introduction of thirteen Dwarves encouraged variety because colour became an important way to distinguish them, but even the basic Dwarf soldiers had a lot of colour that gave their metal armour more life than if it had all been grey. We often introduced blue. The Dwarves had lots of unusual metallic finishes in their costumes.

Sourisak Chanpaseuth, Weta Workshop Paint Supervisor

1. *Jonathon Brough, Weta Workshop Senior Paint Technician, with Balin's regal armour shoulder pauldron.*

There was an effort to have a wide variety of metals present in the armour of *The Hobbit*. On *The Lord of the Rings* we usually painted things to look like steel or bronze, but in *The Hobbit* we had others, like copper, or, in the case of the Elves, we assumed they were using some magical alloys that might not be instantly identifiable. The Mirkwood Elves had colouring that was bronzey, or a metallic mossy green, but also had an element of camouflage so they blended into their environment. A metal paint finish is generally only ever as good as the surface it is on. The camera loves texture, the guys making the armour and weapons always tried to give us enough texture for the paint effects to read well and 'sell' a urethane prop as metal on screen, but not so much that it looked like it had been sand-cast when it was supposed to have a bright finish. Props that were intended to be wood on screen were often made from wood originally, so when they were moulded and cast the wood grain texture was in the casting, which made our job easier.

Jonathon Brough, Weta Workshop Senior Paint Technician

The degree of ageing we put on a weapon or piece of armour sometimes seemed excessive to the eye, but the camera tended to clean things up. Our rule of thumb was to take it to a certain level, but then let the on-set team add more as they judged appropriate on the day, down at the set. That was usually their own mixture of colour or mud and shellac, depending on what tied in with the set and made sense for the scene. Had the characters been in the rain, up a mountain, or in the desert? Peter would very rarely ever send anything that we had painted back. He approved pretty much everything. He was rigorously critical during the design stage and I think we got to a point where we could interpret the designs pretty accurately, so there wouldn't be any surprises for him in what we delivered.

Sourisak Chanpaseuth, Weta Workshop Paint Supervisor

1-2. Weta Workshop Paint Supervisor Sourisak Chanpaseuth (1) and Paint Technician Kiri Packer (2) paint regal armour.

"I will not hide behind a wall of stone, while others fight our battles for us!"
- KILI

FILI & KILI'S REGAL ARMOUR

Fili had brigandine armour, which is essentially a heavy cloth of some kind with small plates attached or sewn into it, the idea being that it remains light and flexible but still provides some protection. There was a particular shape we were trying to achieve, and it was difficult to get the fabric to fall exactly the way we wanted, with the right thickness to the brigandine and the plates. It went through the Workshop very quickly. I recall that when the Dwarves' regal armour was being worked on we were trying to get it all done in time for a Christmas deadline; intense but fun work! Fortunately we didn't have to create small-scale versions of the regal armour, though we did for their battle costumes.

Rob Gillies, Weta Workshop Supervisor

1. Detail of Fili's regal armour brigandine tunic.
2. Weta Workshop Costume Technician Lee Williams works on Fili's brigandine tunic.
3. Detail of Fili's regal armour, shoulder pauldron.

Kili's armour was very much a classic arrangement of chest, back plates, pauldrons, gauntlets and chainmaille. It was also one of the more form-fitting suits of the group. We designed it to be tight-fitting and to cut a nice heroic, youthful, triangular physique with the narrow waist and broad chest. The lines of the chest and back plates were all created with that in mind.

Rob Gillies, Weta Workshop Supervisor

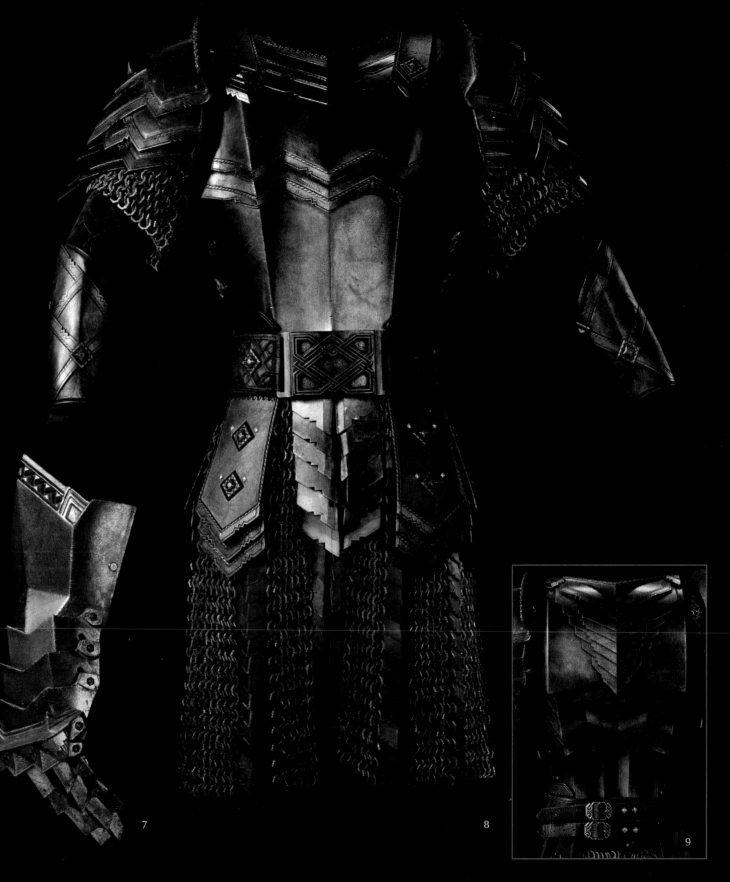

4-6. Fili's regal helmet.
7. Detail of Fili's regal armour, gauntlet.
8. Kili's regal armour, front.
9. Detail of Kili's regal armour, back.

6

7

8

9

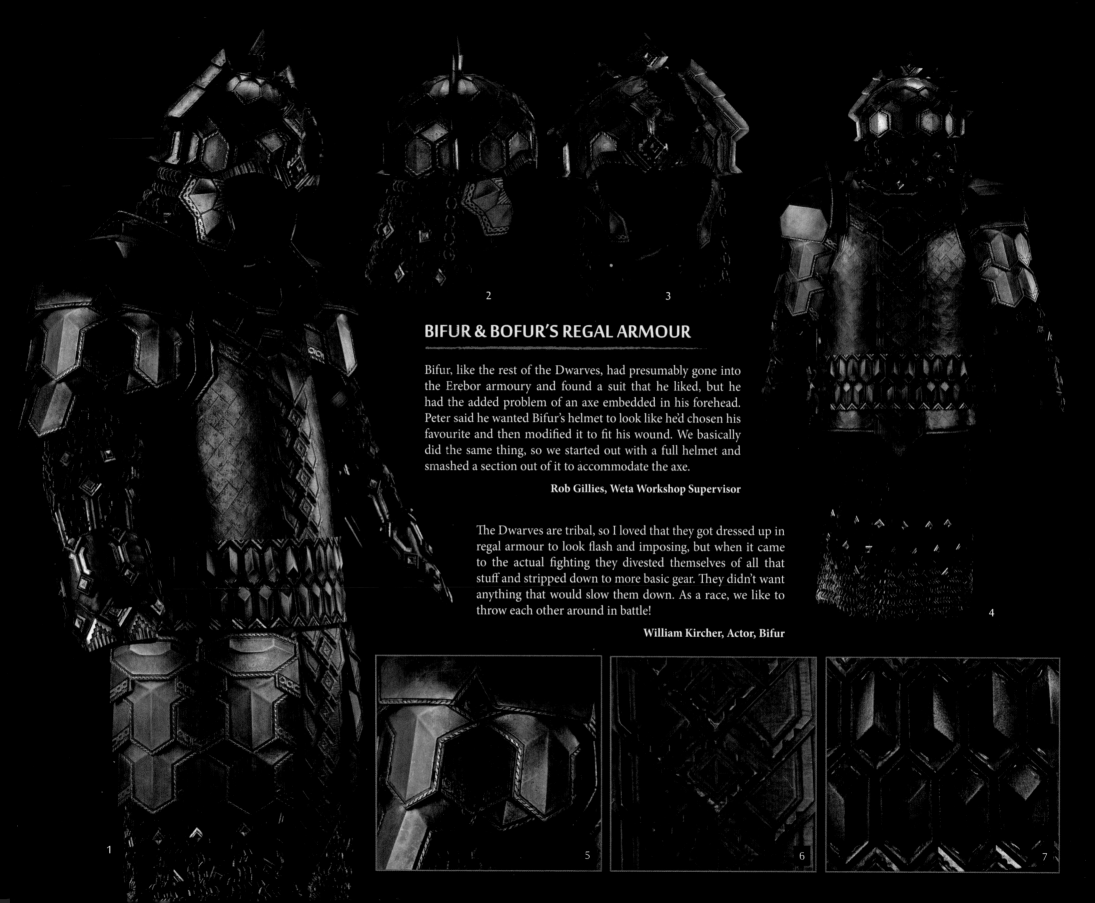

BIFUR & BOFUR'S REGAL ARMOUR

Bifur, like the rest of the Dwarves, had presumably gone into the Erebor armoury and found a suit that he liked, but he had the added problem of an axe embedded in his forehead. Peter said he wanted Bifur's helmet to look like he'd chosen his favourite and then modified it to fit his wound. We basically did the same thing, so we started out with a full helmet and smashed a section out of it to accommodate the axe.

Rob Gillies, Weta Workshop Supervisor

The Dwarves are tribal, so I loved that they got dressed up in regal armour to look flash and imposing, but when it came to the actual fighting they divested themselves of all that stuff and stripped down to more basic gear. They didn't want anything that would slow them down. As a race, we like to throw each other around in battle!

William Kircher, Actor, Bifur

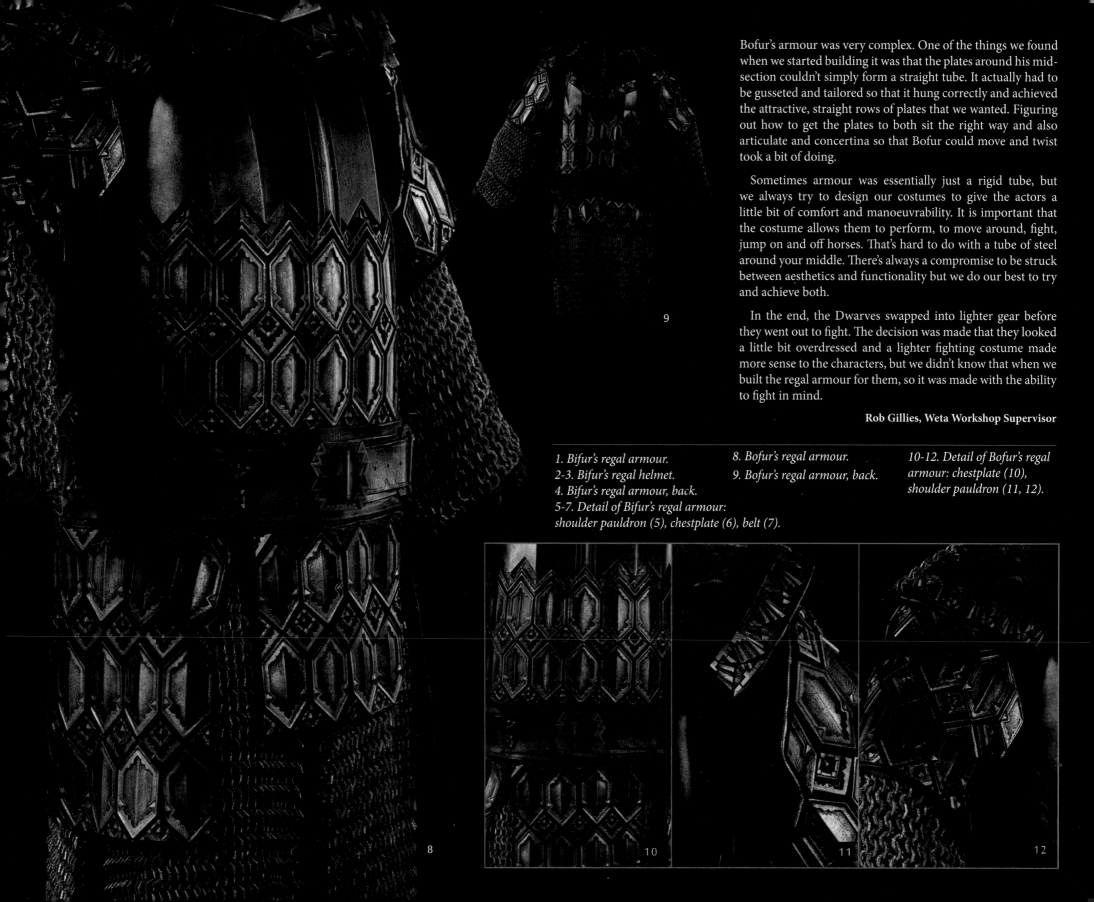

Bofur's armour was very complex. One of the things we found when we started building it was that the plates around his mid-section couldn't simply form a straight tube. It actually had to be gusseted and tailored so that it hung correctly and achieved the attractive, straight rows of plates that we wanted. Figuring out how to get the plates to both sit the right way and also articulate and concertina so that Bofur could move and twist took a bit of doing.

Sometimes armour was essentially just a rigid tube, but we always try to design our costumes to give the actors a little bit of comfort and manoeuvrability. It is important that the costume allows them to perform, to move around, fight, jump on and off horses. That's hard to do with a tube of steel around your middle. There's always a compromise to be struck between aesthetics and functionality but we do our best to try and achieve both.

In the end, the Dwarves swapped into lighter gear before they went out to fight. The decision was made that they looked a little bit overdressed and a lighter fighting costume made more sense to the characters, but we didn't know that when we built the regal armour for them, so it was made with the ability to fight in mind.

Rob Gillies, Weta Workshop Supervisor

1. Bifur's regal armour.
2-3. Bifur's regal helmet.
4. Bifur's regal armour, back.
5-7. Detail of Bifur's regal armour:
shoulder pauldron (5), chestplate (6), belt (7).

8. Bofur's regal armour.
9. Bofur's regal armour, back.

10-12. Detail of Bofur's regal armour: chestplate (10), shoulder pauldron (11, 12).

8

9

10

11

12

BOMBUR'S REGAL ARMOUR

I loved Bombur's regal armour. The green paint job, with its patina and washes, was outstanding. It had a green enamel quality to it and reminded me of an unripe acorn. The shape was also fantastic. It was designed to have a huge, tear-dropped bowl shape that could accommodate Bombur's belly and was mirrored in his big round helmet.

Rob Gillies, Weta Workshop Supervisor

1-2. Bombur's regal helmet.
3-4. Details of Bombur's regal armour: shoulder pauldron and elbow guard (3), belly plate (4).
5. Bombur's regal armour, back.
6. Bombur's regal armour.

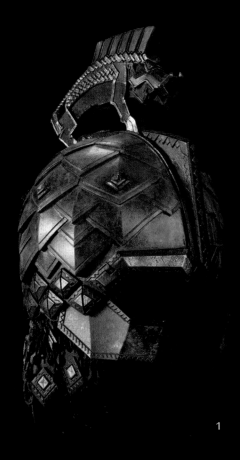

1

2

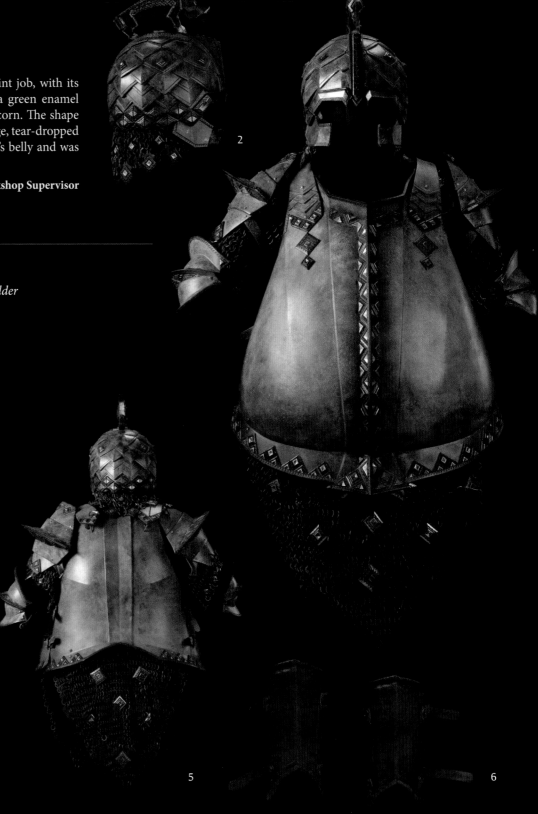

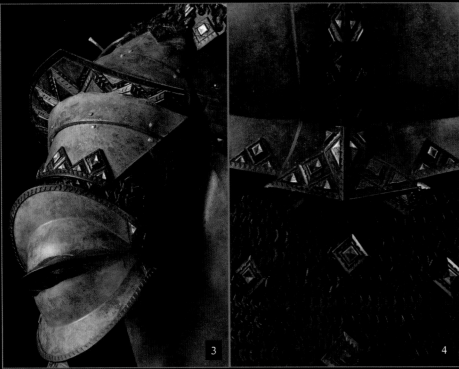

3

4

5

6

We put a lot of R & D into getting our armour to fit the actors properly, usually starting with several sessions using quick, vacuum-formed plastic pieces to establish the fit and then incorporating what we learned into our costumes, as we were making them. A well-fitted suit of armour is easier to wear and perform in than one that isn't, so that was important, but Bombur's belly plate couldn't be big enough for Peter. He really wanted it to be huge and hilarious, so we went through three or four iterations before we got it to a size he liked.

The green patina the painters achieved on Bombur's armour was astonishing. I thought it was one of the best and most interesting paint jobs of the three films.

Alex Falkner,
Weta Workshop Props Model Making Supervisor

Painting the Dwarven regal armour, we worked closely off the designs, but it turned out that the initial round of designs were perhaps too singularly uniform in colour. Peter wanted each Dwarf to be more distinctive in their various hues, like they had been when the journey began.

We looked for ways to add a little more intensity to the colour, in some cases pushing them to the point of almost being ludicrous, but with so many Dwarves and without knowing exactly how far Peter would later take it with his colour grading of each scene we decided that we could afford to be bold. Bombur's armour, for example, began in coppery-browns, as did most of the other Dwarves, but we ended up painting it quite a strong green in the end.

Jonathon Brough, Weta Workshop Senior Paint Technician

The regal armour became much more colourful as it went through the process of manufacture. Some, like Bombur's, were very elaborate, with lots of golden trim and sculptural helmet crests. It was thought that the Gundabad Orcs might try to break into them because they thought they were Easter eggs and there might be delicious chocolate inside, but it turned out that last bit was untrue…

Matt Appleton, Weta Workshop Costume Supervisor

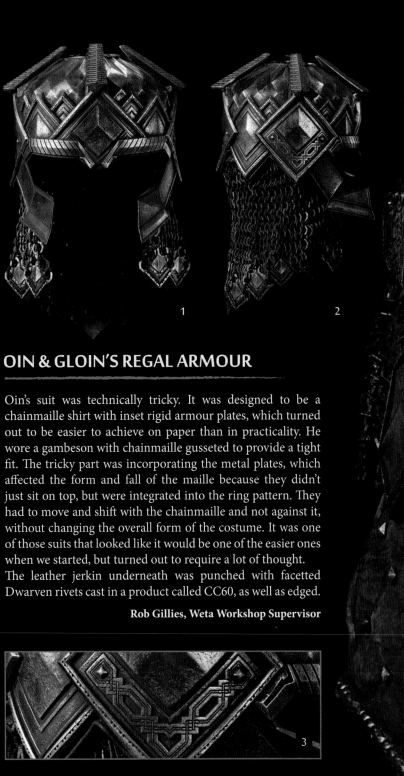

OIN & GLOIN'S REGAL ARMOUR

Oin's suit was technically tricky. It was designed to be a chainmaille shirt with inset rigid armour plates, which turned out to be easier to achieve on paper than in practicality. He wore a gambeson with chainmaille gusseted to provide a tight fit. The tricky part was incorporating the metal plates, which affected the form and fall of the maille because they didn't just sit on top, but were integrated into the ring pattern. They had to move and shift with the chainmaille and not against it, without changing the overall form of the costume. It was one of those suits that looked like it would be one of the easier ones when we started, but turned out to require a lot of thought. The leather jerkin underneath was punched with facetted Dwarven rivets cast in a product called CC60, as well as edged.

Rob Gillies, Weta Workshop Supervisor

1-2. Oin's regal helmet.
3. Detail of Oin's regal helmet.
4. Detail of Oin's regal armour, maille and jerkin.

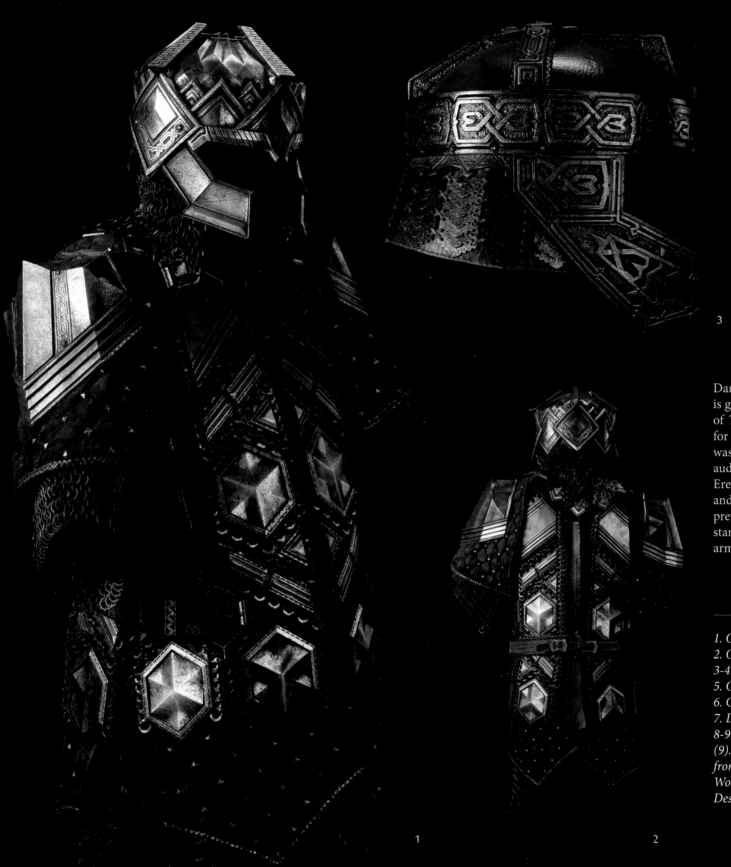

Darin Gordine did a very fine job with Gloin's armour, which is great because he was with Weta Workshop back in the days of *The Lord of the Rings* and was involved in making pieces for Gimli as well. The whole idea, which I thought was lovely, was that Gimli, as Gloin's son, was wearing a helmet that the audience would come to realize actually came from Gloin's Erebor armour. Darin looked after the building of the suit and a new helmet. Our processes had come so far since the previous trilogy that we were able to remake the helmet to stand up to the HD and 3D scrutiny alongside the other regal armour. We couldn't have simply reused the old helmet prop.

Matt Appleton, Weta Workshop Costume Supervisor

1. Oin's regal armour.
2. Oin's regal armour, back.
3-4. Gloin's regal helmet.
5. Oin's sword.
6. Gloin's regal armour.
7. Detail of Gloin's regal armour, glove and gauntlet.
8-9. Details of Gloin's regal armour, chestplate: front (8), back (9). The iconography includes shapes and motifs extrapolated from the helmet, designed a decade earlier for Gimli at Weta Workshop in collaboration with The Lord of the Rings *Costume Designer Ngila Dickson.*

3

4

1

2

It's lovely to have been part of the connective tissue between *The Hobbit* and *The Lord of the Rings*. I know it means a lot to people who love the world that these connections are observed so attentively. It wasn't telegraphed in dialogue or anything like that, but the little things like Gloin having the helmet Gimli would later wear mean a lot, as evidenced by the letters, cards and contact I have enjoyed with fans of the films and books at conventions. They have expressed their love of the sense of continuity that the filmmakers have lavished on the films and they recognize and appreciate the family likeness between Gloin and Gimli. It is humbling and gratifying to be part of that connection.

Peter Hambleton, Actor, Gloin

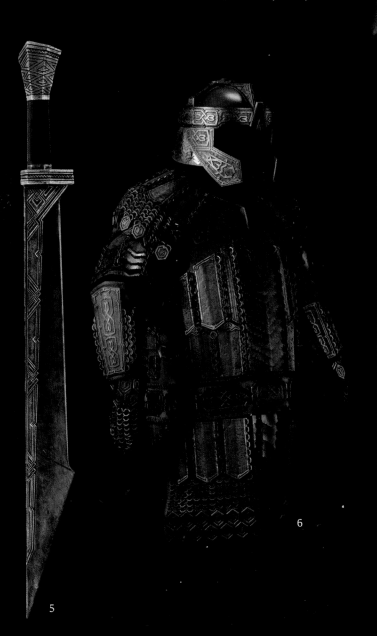

5

6

7

8

9

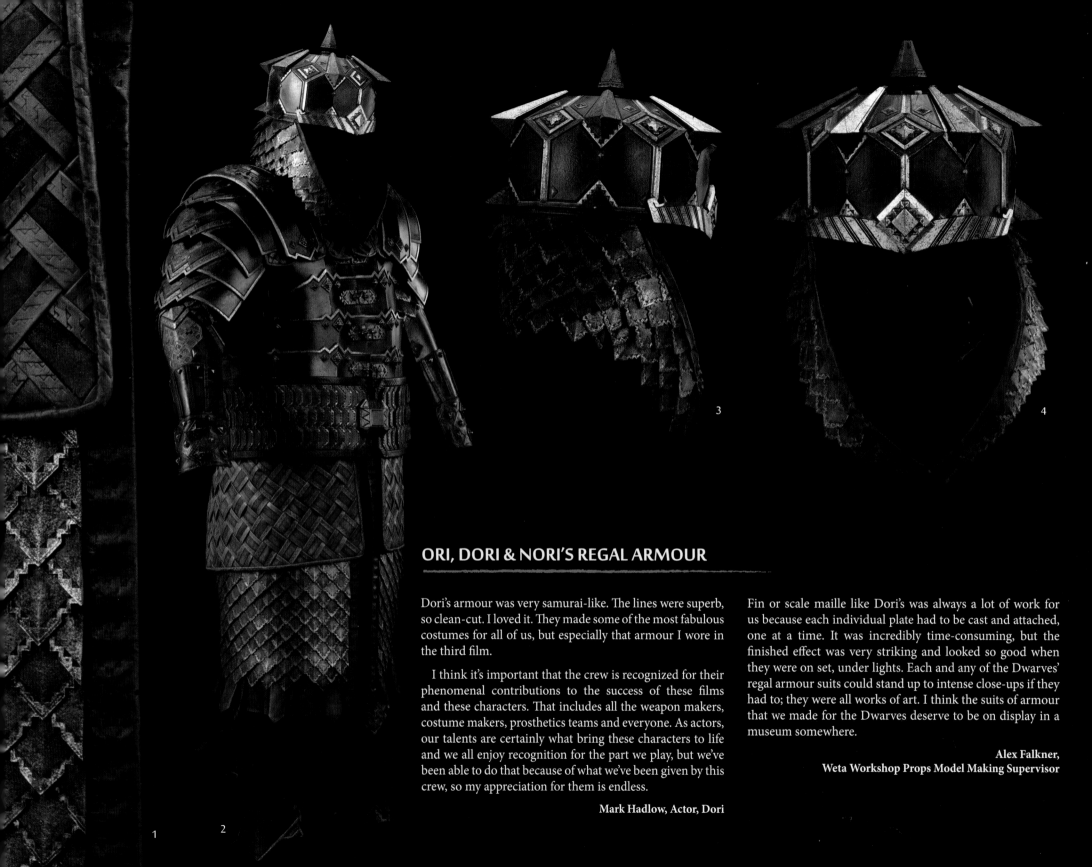

ORI, DORI & NORI'S REGAL ARMOUR

Dori's armour was very samurai-like. The lines were superb, so clean-cut. I loved it. They made some of the most fabulous costumes for all of us, but especially that armour I wore in the third film.

I think it's important that the crew is recognized for their phenomenal contributions to the success of these films and these characters. That includes all the weapon makers, costume makers, prosthetics teams and everyone. As actors, our talents are certainly what bring these characters to life and we all enjoy recognition for the part we play, but we've been able to do that because of what we've been given by this crew, so my appreciation for them is endless.

Mark Hadlow, Actor, Dori

Fin or scale maille like Dori's was always a lot of work for us because each individual plate had to be cast and attached, one at a time. It was incredibly time-consuming, but the finished effect was very striking and looked so good when they were on set, under lights. Each and any of the Dwarves' regal armour suits could stand up to intense close-ups if they had to; they were all works of art. I think the suits of armour that we made for the Dwarves deserve to be on display in a museum somewhere.

**Alex Falkner,
Weta Workshop Props Model Making Supervisor**

1

2

3

4

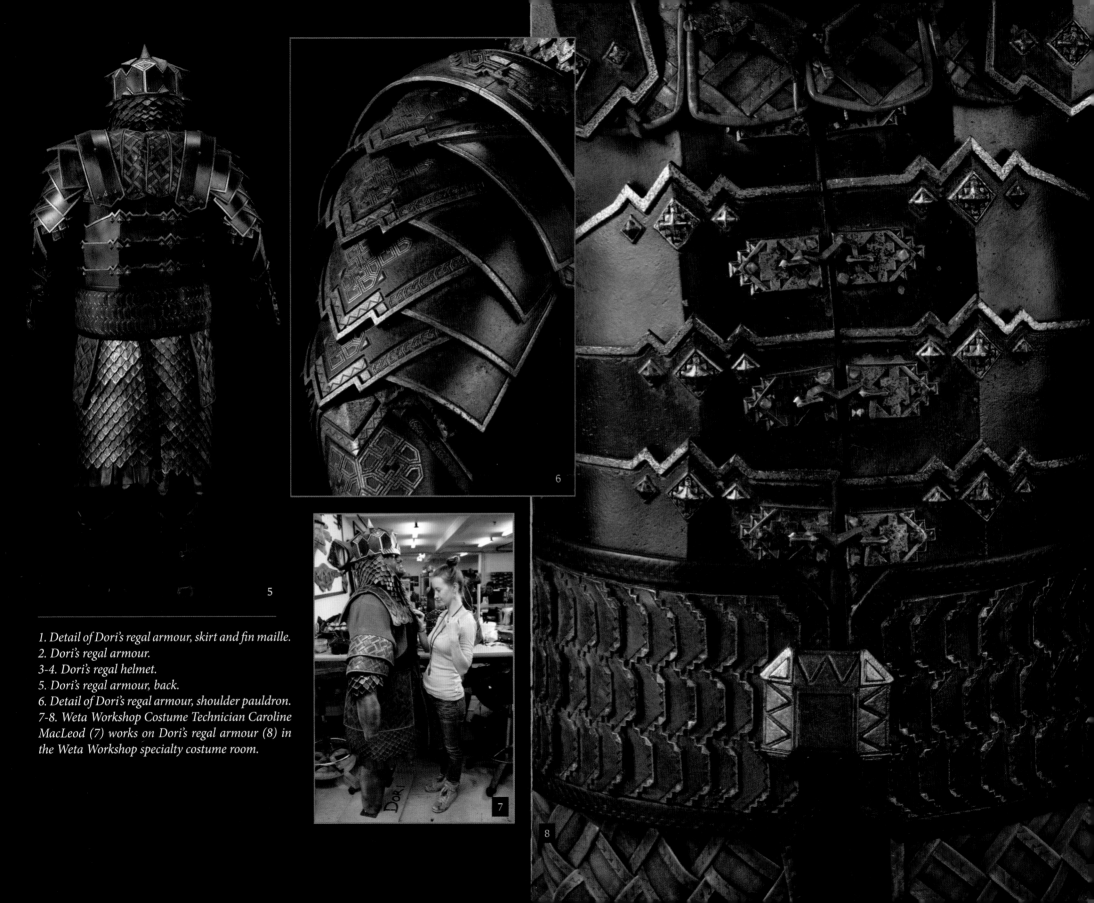

1. Detail of Dori's regal armour, skirt and fin maille.
2. Dori's regal armour.
3-4. Dori's regal helmet.
5. Dori's regal armour, back.
6. Detail of Dori's regal armour, shoulder pauldron.
7-8. Weta Workshop Costume Technician Caroline MacLeod (7) works on Dori's regal armour (8) in the Weta Workshop specialty costume room.

We developed the Dwarven chainmaille to be something different to the regular round rings we had used on other cultures in both trilogies. The Dwarves were master craftsmen so we imagined they would have something that was different and maybe a step above what a lot of other cultures could create. We designed octagonal rings with runic patterning on the surfaces. The pointed, facetted look was something that was evident throughout Dwarven design so it was a good way to create a distinction.

We made two different scales so that it could be used in the manufacture of small-scale costumes as well. The individual rings were cast with little hooks so that in assembly they could be clipped together and glued efficiently. We had a team of around twenty people assembling the chainmaille suits at the height of the project.

There's was a lot of maille on Ori's costume. He was the baby of the group and had a relatively light suit compared to some of the other guys. The heavier use of maille in his costume was intended to create a softer look that complemented his character and recalled all the knitted stuff he wore at the beginning of the adventure. We included metal plates that broke up the chainmaille in rows, allowing for plenty of flexibility and movement.

Ori's armour was a really peculiar colour. It was coppery, but with a purple wash; I'm not sure if there is even a word for that colour. It was something that the paint shop had developed and one of the last suits that went through our processes, so we were looking for ways to make it different. Someone suggested an oily, purplish patina wash and it worked well. The purple also called back to the same sorts of shades he wore in his very first costume.

Nori's regal armour was challenging because all the plates overlapped to form a tube around his torso. Getting them to stay level and in line, without being able to gusset them or have any gaps and yet still articulate so that he could move, was tricky. It had to slide and concertina so that he had full movement through the waist. The pauldrons, which were an arrangement of upside-down plates that complemented what was going on in his torso and tassets, were probably the most challenging aspect of the armour to understand and create. It was a great suit: really powerful looking and aggressive with its jagged silhouette.

Rob Gillies, Weta Workshop Supervisor

1. *Detail of Ori's regal armour, chestplate and coif.*
2. *Ori's regal helmet.*
3. *Ori's regal armour.*

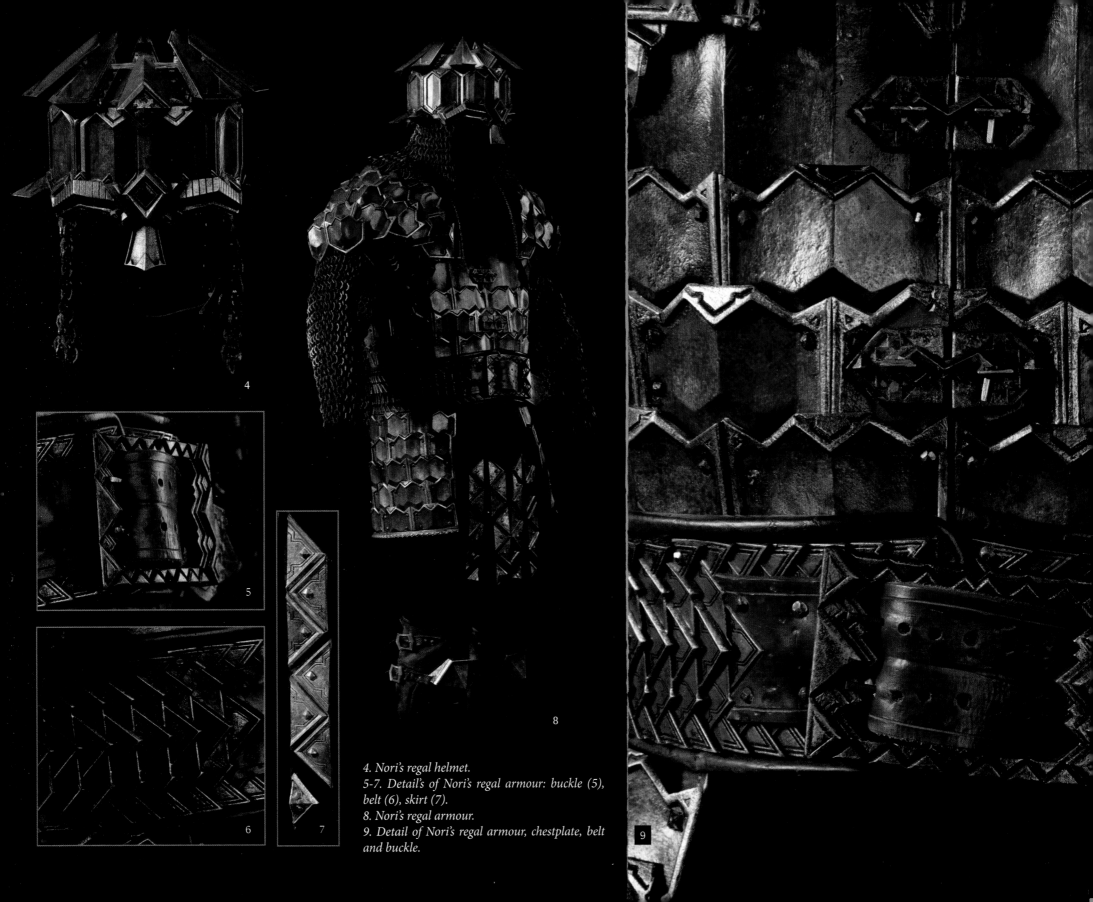

4. Nori's regal helmet.
5-7. Detail's of Nori's regal armour: buckle (5), belt (6), skirt (7).
8. Nori's regal armour.
9. Detail of Nori's regal armour, chestplate, belt and buckle.

THE ARKENSTONE

The Arkenstone crowns all. We unashamedly borrowed that powerful phrase from Shakespeare's *Troilus and Cressida*: 'The end crowns all.' What we wanted to say was that even with all the wealth of Erebor, Thorin could not rest until he had the Arkenstone. This one peerless jewel was the thing that, in Thorin's estimation, bestowed kingship upon its possessor. Without it he was not whole. He had invested so much meaning in the Arkenstone that without it he felt his identity and legitimacy were incomplete. In the end, as impressive and otherworldly as it was, the stone was just a material object, a bauble, a trinket. Its power was attributed and not innate. Though he does not understand it, Thorin has given that power to the stone and trapped himself.

Philippa Boyens, Screenwriter & Co-producer

The story already had the Ring and the gold, so another talisman might have been one too many, but the right to rule, it being 'The King's Jewel', is where the power of the Arkenstone lay. I think Tolkien realized at the same moment the Dwarves did that once they were in the Mountain they had a serious problem. What on earth did they do next? They couldn't shift the gold, and they couldn't shift the Dragon sitting on it; they could drive him out, but to certain disaster. In that sense the Quest was haphazard and precarious. The pursuit of the Arkenstone was a way for Thorin to raise the kingdom once again; troops of Dwarves would rally to the holder of the Arkenstone. It wasn't so much rational, but another obsession.

Had Thorin found and claimed the Arkenstone I'm guessing he would have stood on the ramparts, held it high above his head and cried 'I am the king, go home!' Then Dain would have turned up and acknowledged his return. That occurred nonetheless, but it was much messier, which I loved. Ultimately the Arkenstone was just a gem and the power of loyalty was beyond a talisman.

Richard Armitage, Actor, Thorin

Fran wrote the scene in which Bilbo almost told Thorin about the Arkenstone; what great tension there was! Bilbo was about to tell Thorin and then he saw his face. It was the moment Bilbo understood what he had to do. He knew that he had to sacrifice his friendship for a greater good, to accept the more difficult path, understanding that his obligation is to something bigger.

Philippa Boyens, Screenwriter & Co-producer

The biggest trust story for Thorin is with Bilbo Baggins – from a beginning rooted in great mistrust of Gandalf's choice for the 14th member of the company, to Bilbo being the only one in whom Thorin feels he can confide and trust. This journey is shattered at the Mountain when Bilbo betrays Thorin to prevent war. It's a great relationship curve for these two characters to go on.

Richard Armitage, Actor, Thorin

While the Arkenstone was in large part an otherworldly digital effect, there was a basic physical prop that we made and a mechanism which we had to devise so that it could be very quickly released from its setting above Thrór's stone throne in the opening flashback scenes of the first film. The basic physical prop didn't have any of the glittering effects that the digital version would have, but it had the same shape with a translucent finish.

Paul Gray, Props Making Supervisor

1

1. The Arkenstone physical prop, prior to augmentation with digital effects.

DIGITAL DOUBLES

In addition to all the many entirely digital creatures and characters in the films, we also had some very high-level digital doubles for every member of Thorin's Company. On all five of the previous films there had been a pick-up shoot in which actors were brought back and additional scenes or sequences were filmed to provide Peter with whatever extra material that he found he still needed as he was finessing his edit, but there was no pick-up shoot for the third film of *The Hobbit*. That meant that if there were additional shots required to bridge existing material in Peter's story then those new shots automatically became entirely digital, and populated by digital doubles of the hero characters.

An example was a reasonably close shot involving three or four of the Dwarves rummaging through treasure in search of the Arkenstone, early in the film. Obviously anything revealing the grand scope and scale of Erebor was similarly all digital for practical reasonss.

Matt Aitken, Weta Digital Visual Effects Supervisor

Digital doubles have become something of an industry standard now because there are so many times when they can be so useful to have. Sometimes they were so good that I couldn't point out which was a double in a shot and which was an actor. For us in Models, the job was to make them as correct to the characters as possible, so we had to make sure that for each one the facial puppet was correct. That meant not just getting the look of the face right but also how it moved. No matter how good the animator was, if the facial puppet they were working with wasn't accurate then it wouldn't look right.

Then there were the variables of shading and lighting that those departments had to think about. Any of those could be slightly off and the character wouldn't look right. Even adding fog or other atmospherics could sometimes flatten out a digital double and suddenly make it less realistic, to everyone's surprise.

People see faces every day. We are attuned to the most subtle differences and details so even if we don't consciously know what's wrong, the tiniest thing can ruin our belief in a digital version of a person. It is much harder to get an audience to accept a human-looking character, and especially one that copies an actor, than to believe in something totally new, like Gollum or Smaug.

Marco Revelant, Weta Digital Models Supervisor

Digital doubles were certainly a great tool to have at our disposal. We had very realistic digital versions of all our main characters. If there was an action scene then sometimes we used the digital doubles to accomplish what would have been difficult or impossible to achieve live. We would also sometimes, when necessary, replace specific body parts of characters in a live-action shot. Sometimes, for example, when an actor would swing a sword at a bad guy there was a certain pulling of punches just because they weren't really trying to kill the stunt person, or carry a strike through after cleaving; so, to make those sorts of hits more violent and to get the right swing through, on occasion we would digitally remove and replace an entire arm while leaving the rest of the performance untouched.

Joe Letteri, Weta Digital Senior Digital Effects Supervisor

The most common places for our digital doubles to show up were in wide establishing shots where they were quite small in frame against huge environments. We used digital doubles in shots when the environments were extended digitally in order to grant depth that was impossible to achieve on a real set. There was one in which the Dwarves were climbing the stairs onto the brick-work battlements they had constructed across the entrance to Erebor, but there wasn't the depth in the set to create the full staircase, so, as the Dwarves walked in, fully half were digital, walking up digital steps. It's satisfying as an effects artist when the delineation between CG and physical characters is so blurred that it isn't obvious, even to very effects-savvy audiences, which is which. Often that's because we have both in a shot together, working successfully.

David Clayton, Weta Digital Animation Supervisor

The doubles were never created in a vacuum or without careful attention to matching the actors' intentions for their character. It was always critical to us that we achieved pose integrity, so we made heavy use of reference shot on set or in motion capture sessions.

Aaron Gilman, Weta Digital Animation Supervisor

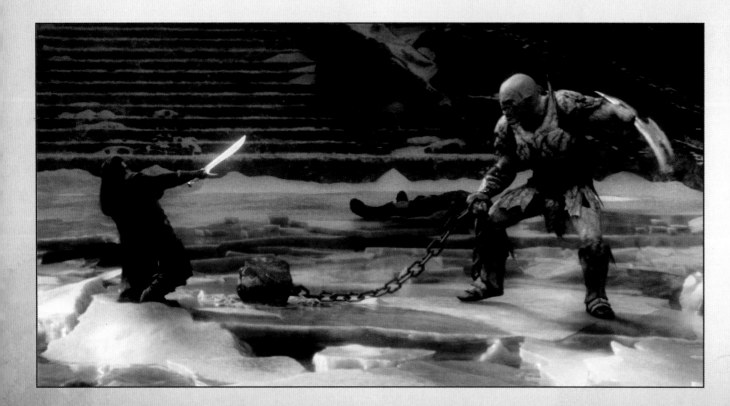

THE RAVEN

ACTS OF HOPE

Din's prophecy of the birds returning to the Mountain from the first film was fulfilled at the beginning of the third when Ravens could be seen flying over Ravenhill toward Erebor in the wake of Smaug's death. It was one of those subtle things that many casual moviegoers probably missed, but it was there for the fans who understood its importance.

Similarly, though its significance would become clear later, when Bard rode up to the gate of Erebor to speak with Thorin a raven was seen flying away towards the east. Thorin, of course, had sent the bird on a mission to contact his cousin in the Iron Hills, and the raven's return later would herald Dain's imminent arrival.

Considering he was only in a handful of shots, we were pleased with the way the raven turned out. We had a very good group of people working on him. The shaders written for the feathers were particularly lifelike, with beautiful iridescence. There was some inherited benefit that came from all the work that had gone into developing the feathers for the Great Eagles in the first film.

For the shot of the bird over Thorin's shoulder we were able to spend the time to individually groom the feathers to help sell the reality of the bird. It was also important that there was some suggestion of subtle communication between Thorin and the raven. In the book it was established that the Dwarves and ravens of Erebor could talk to one another. The level of performance that Peter wanted would have been difficult, if not impossible, to achieve with a trained bird on set.

Matt Aitken, Weta Digital Visual Effects Supervisor

The raven was supposed to be a photo-real bird, but we were able to push the performance a little bit in the close-up where it put its beady eye on Thorin, and gave him a weird look, leaning in toward him. It was enough to suggest there was a communication going on there at some imperceptible level, which fans of the book would realize heralded the arrival of Dain's army. It was a cool moment, but it might not have worked, had we had the raven literally talking. Peter has made some clever choices with the talking creatures in The Hobbit. There were more in the books, but it seems like the more fantastical the creature, the more we can accept them speaking. Animals we recognize would be harder to accept, so that led to them using an unspoken communication. Sometimes no words are better. Peter isn't afraid to use silence.

David Clayton, Weta Digital Animation Supervisor

1. Work-in-progress digital raven.

1

Thorin witnessed Bilbo cradling something in his hands, and for a moment we played that scene as a fake-out, creating a moment of tension in which the audience might think he had caught Bilbo with the stolen Arkenstone. It spoke to Thorin's madness that he was so quick to accuse, but in this instance it was not the missing stone that Bilbo was looking at, but a humble acorn. Bilbo confided that it was a nut he had kept from Beorn's, and that he planned to plant it when he got home.

The acorn was both a nod to Samwise planting his trees when he returned from the war, a Hobbitish thing to do, but it also had more meaning. Bilbo wanted something to remind him of all that he had experienced. Thorin called it a poor prize. A poor prize? An oak under which children would play and generations would live beyond Bilbo's own lifespan?

Instead, during the darkest hour, when all seemed lost, there was a moment we wrote that would have happened somewhere in Dale that book-ended Bilbo's scene with Thorin. In some ways it recalled the scene between Gandalf and Pippin in Minas Tirith from *The Return of the King*. We were keen not to repeat ourselves. Bilbo was not Pippin and it would have seemed forced, so the scene was written with Bilbo electing not to take the acorn home with him, but to plant it then and there, in the frozen ruins of Dale.

The idea of the acorn was influenced by a young girl we met named Harriet Rowland. Harriet had a terminal cancer and didn't know whether she would see her twentieth birthday. Very sadly, she did not reach her twenty-first. Before she passed away, she wrote a wonderful book called *The Book of Hat*. What do you do in the face of death? You go on living. Harriet understood that the cancer would claim her, but she always thought more about what the effect of that would be on the people around her, whom she loved, rather than being concerned with her own mortality. It was profoundly moving. Everything Harriet did was an act of hope in the face of death, not for herself, but for others. She was always looking to give this gift of life because she understood it more deeply than others. Bilbo's acorn scene was written in honour of Harriet's philosophy. 'I'm going to plant this because I'll never live to see it grow, but somebody else will.' That was Harriet's philosophy.

Philippa Boyens, Screenwriter & Co-producer

STONE WALLS & HEARTS

Anticipating unwelcome visitors, Thorin ordered his kingdom fortified. Thorin was commanding his 'army'. I think his paranoia about the many coming to claim a share of his gold was valid – indeed, that was exactly what was happening – hence the need to shore up the gates and wall himself in. Interestingly, the situation mirrored what Thorin witnessed so many years earlier, when Smaug first attacked Erebor and burst through the gates to take the Mountain from his people. Perhaps he feared that history would repeat itself; once bitten, twice shy? The Dwarves had been deceived and abandoned before, particularly by the Woodland Elves. As for them and the Men of the Lake, no one assisted Thorin's people when they needed help the first time the Dragon attacked. Thorin bore a grudge. Added to that the effect that the gold was having on him, it was easy to see how covetous he became over every single piece of that hoard. I don't think it was selfish or greedy, it's not as if he could spend any of it, but he wanted to keep it. There was a moment cut from the theatrical release of the film that I loved playing in which he told Bilbo he could take his 'one fourteenth share'. He could take his share, but not a single piece of the gold was leaving the Mountain. They were all prisoners in Erebor.

Richard Armitage, Actor, Thorin

1

2

3

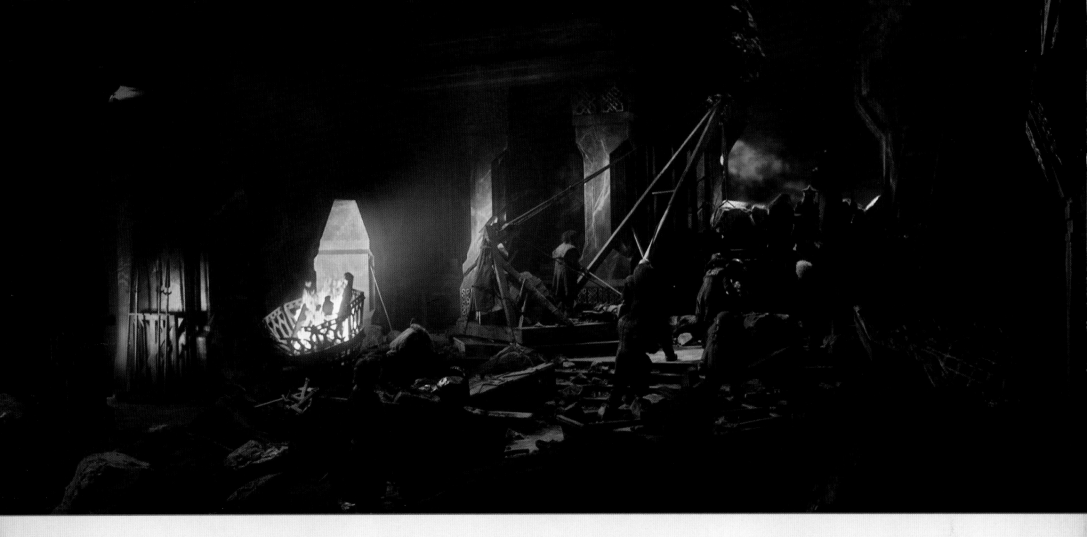

Thorin's position when he sealed the door of Erebor wasn't entirely unsympathetic. It was an abhorrent statement, when he proclaimed, 'Those who have lived through Dragon fire should rejoice. They have much to be grateful for.' Yet it was not entirely untrue, as he who had lived through as much and more could attest to. He was saying, in essence, 'You have suffered, but try living through what we have suffered.' When he said that he bartered away his birthright for blankets, that was also true. There was a shred of reason in his position, even if he was callous. The real fall was yet to come, when he wanted to move the gold deeper underground. It was at this point that the madness had taken over and the Thorin who had once been was buried beneath it.

Philippa Boyens, Screenwriter & Co-producer

Thorin was unreasonable, which was exactly what Thranduil expected of the Dwarf. As a fan of these stories, I find the Dwarves very moving. I find the story of a culture that is dying out, which is desperately clinging to a place in this world, very meaningful and touching. The Dwarves are refugees. That story resonates with meaning, but my character Thranduil would look at the Dwarves and see a short-sighted, avaricious people who collected a huge hoard of wealth and attracted a Dragon. 'What did you think would happen, if you hold that much money, if you hoard that much gold away?' A Dragon could smell it and was going to come. No good could come of hoarding such wealth for its own sake. In Thranduil's mind the Dwarves got what was coming to them and he spared them no pity.

Lee Pace, Actor, Thranduil

"This mountain was hard won –
I will not see it taken again." - THORIN

The moment when Thorin was going to throw Bilbo off the wall was a big one for us, when everything changed. It was the realization for us all that this guy who had put himself on the line for us so many times was about to be discarded because he told the truth. I don't think we thought it was wise that he gave the Arkenstone over, but I think we all understood why he did it, and were horrified by Thorin's reaction.

Jed Brophy, Actor, Nori

1. *Digital reference turntable image of Erebor's great bell.* 2. *Concept art of Erebor's fortifications by Concept Art Director John Howe.*

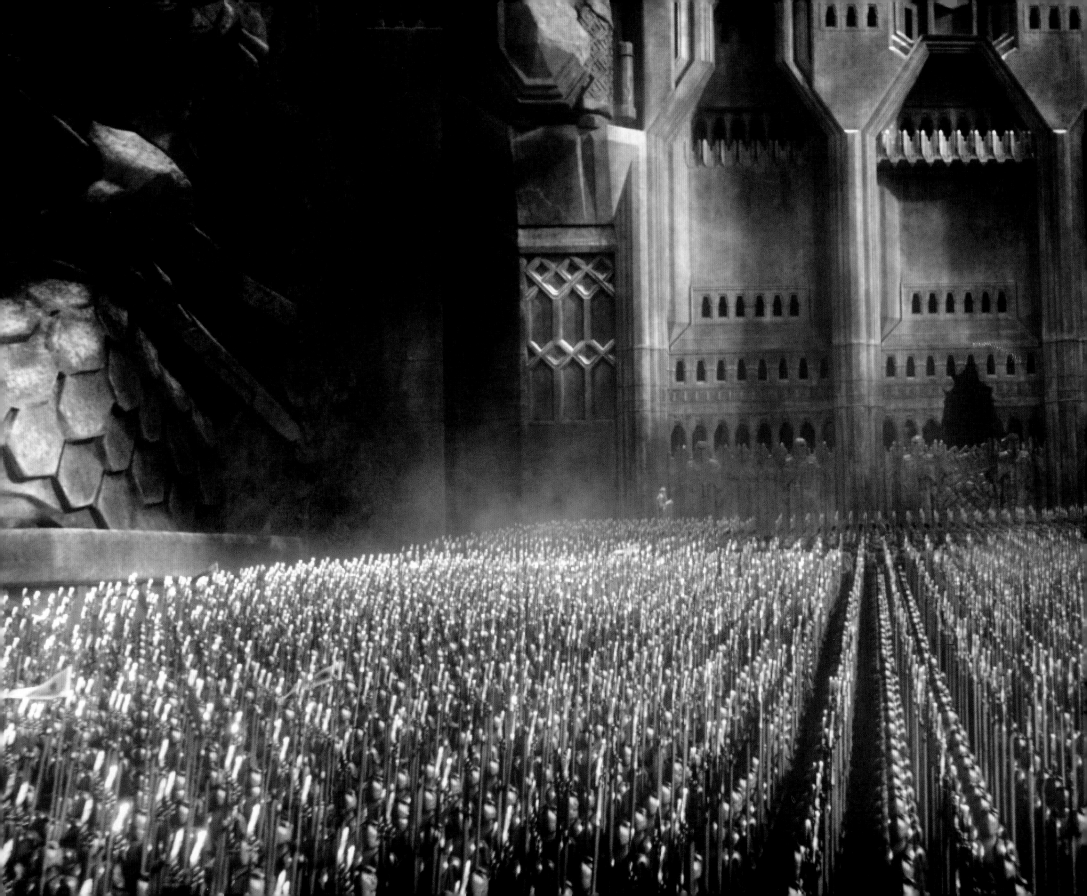

THE MIGHT OF MIRKWOOD

When King Thranduil learns that the Dragon Smaug is dead he leads a great force of Elves from the Woodland Realm to march upon the Mountain. The Elven-king's followers ease the suffering of the dispossessed people of Lake-town that they find amid the ruins of Dale. Food and protection they give, but Thranduil's true goal is the Dwarf-kingdom of Erebor and the treasure that is buried there. Deep within the hoard of Thrór are precious white gems, the jewels of Lasgalen, prized by Thranduil above all else, and which Thorin smugly withholds.

The King of Mirkwood parades his gleaming golden soldiers before Thorin's gate, an impressive show of force that might cause lesser hearts to quake, but this only hardens Thorin's resolve to deny him.

Bearing long, curved swords, bright shields, tall spears and longbows, the perfectly ordered ranks of Thranduil's great army are a shimmering portrait of Elven discipline, courage and might; steely, eagle-sharp eyes staring impassively from beneath the arched brim of each golden helm.

Thranduil was very different to the Elves that I think people had become familiar with in the Middle-earth films. Like Elrond, he had been alive for a very long time and seen a great deal of war and change, but his experiences had shaped him into a very different character with a very different outlook. He was over 3,000 years old by the time we met him in *The Desolation of Smaug*. From what research I have done into Tolkien's rich world history, he lived well into the Fourth Age that followed, as well.

Tolkien sketched out Thranduil's character in *The Hobbit* and the appendices of *The Lord of the Rings*, but it was a great deal of fun to fill in the gaps and help build a full character around those clues. One thing I loved about working on these movies with Peter, Fran and Philippa, and also Richard Taylor at Weta Workshop, was how collaborative everyone was, and how interested they all were in working together to come up with something cool on every level.

In the films we, as an audience, witnessed Thranduil for just one year of his long life. The picture painted was of a greedy, complicated ruler, which weren't things we might have anticipated from an Elf, based on those we had met up until then. Contrasting that avarice, he also demonstrated great wisdom and patience. Thranduil wanted the jewels inside the Lonely Mountain very badly. In his opinion, the power that the wealth of the Mountain conferred upon him that held it would be safest in the hands of the Elves. Who could know what might happen if Men or Dwarves possessed such power? Thranduil also harboured a very personal stake in a particular set of jewellery that lay inside the Mountain, the famed Lasgalen gems, which were his wife's and which Thrór had withheld from him. Until Thorin crossed Thranduil's path, that treasure wasn't going anywhere. Being immortal, the Elf-king knew that he would eventually outlive both the Dragon and the Dwarves, so his notion was simply to wait them out.

I've done a lot of thinking about what it means to be immortal and what the stakes are when you live forever. Dwarves, hobbits, Men, even Dragons, come and go, but Thranduil endured. He didn't have to engage with their agendas or be friends, because he knew he would be there long after they were forgotten. It's a very interesting point of view. He had withdrawn into his protected realm where he could safeguard his people and become an isolationist, content to let the world go on around him so long as it didn't interfere with his agendas.

Lee Pace, Actor, Thranduil

The Elven-king needed a unique look. One of the first things I did when thinking about Thranduil's make-up and hair was to look at Lee Pace's impressive and imposing eyebrows and imagine plucking them. I produced some concepts for Peter, Fran and Philippa to look at, all of which involved some reshaping and plucking, which they were in favour of. Of course, the first thing Lee said when he arrived in New Zealand and we met was, 'Hello, I'm Lee, nice to meet you. Now, about my eyebrows...' He didn't want us to touch them!

In the end what we did was make a deal. I resisted the urge to pull them out beyond a little bit of tidying around the edges, and instead we lifted Lee's brows by pulling the skin back behind his wig, which worked very well. I think his dark brows actually worked nicely to contrast his ash-blond hair, which was so stark. He looked almost kabuki-like with his pale skin, straight, near-white hair and voluminous robes. In essence, what we did was a subtle beauty make-up. Not plucking the brows also avoided Thranduil losing his masculinity. Back in the days of *The Lord of the Rings* we did a lot of plucking and I wonder now whether it feminized some of our male Elves and softened them too much? Elves are beautiful and light, but they are also capable of being ruthless killers and hardly lacking backbones. This was especially true of the Elves of Mirkwood in our films, like Legolas and Thranduil, so I believe keeping Lee's eyebrows resulted in a stronger-looking character than we might have had.

Peter King, Make-up & Hair Designer

When it came to make-up, I had little to complain about. The actors playing Dwarves had almost every inch of themselves covered. They had so much stuff to wear. I had gelatine ears and a great wig, something Peter King got absolutely right. The colour was great and it fell in this wild way. Thranduil was intimidating, severe and formidable. When the wig fell into place it made so much sense. This Elf was not ethereal like Galadriel, nor did he exhibit Elrond's sense of chivalry. The wig conveyed his qualities perfectly: severe, untamed and intractable.

Lee Pace, Actor, Thranduil

1. *Studio photography of Lee Pace in costume as Thranduil.*

Hair can be expensive. It can be two to three thousand pounds per kilo, according to length and colour. Thranduil's wigs, in particular, were among the more expensive that we had to have made because they were composed of such exquisite, almost silver hair. It was important that he appear to be something quite special, and we also wanted to retain a kinship with Legolas. That was why we made him blond, but in Thranduil's case it was a white-blond, cold and stark, just like he was.

With colour defined, length became our next challenge. We made the wig, but, because Lee was very tall, it wasn't long enough. We made ladders to extend the hair and get it all the way down his back, which gave him great height.

The Make-up and Hair Department worked very closely with the Costume Department. In fact, Costume Designer Bob Buck had one of our wigs in his office for weeks as his team was developing Thranduil's costumes. We benefitted greatly by being only a short stair climb away from each other, so we could constantly and easily check how the make-up and hair were working with the costumes that were being developed.

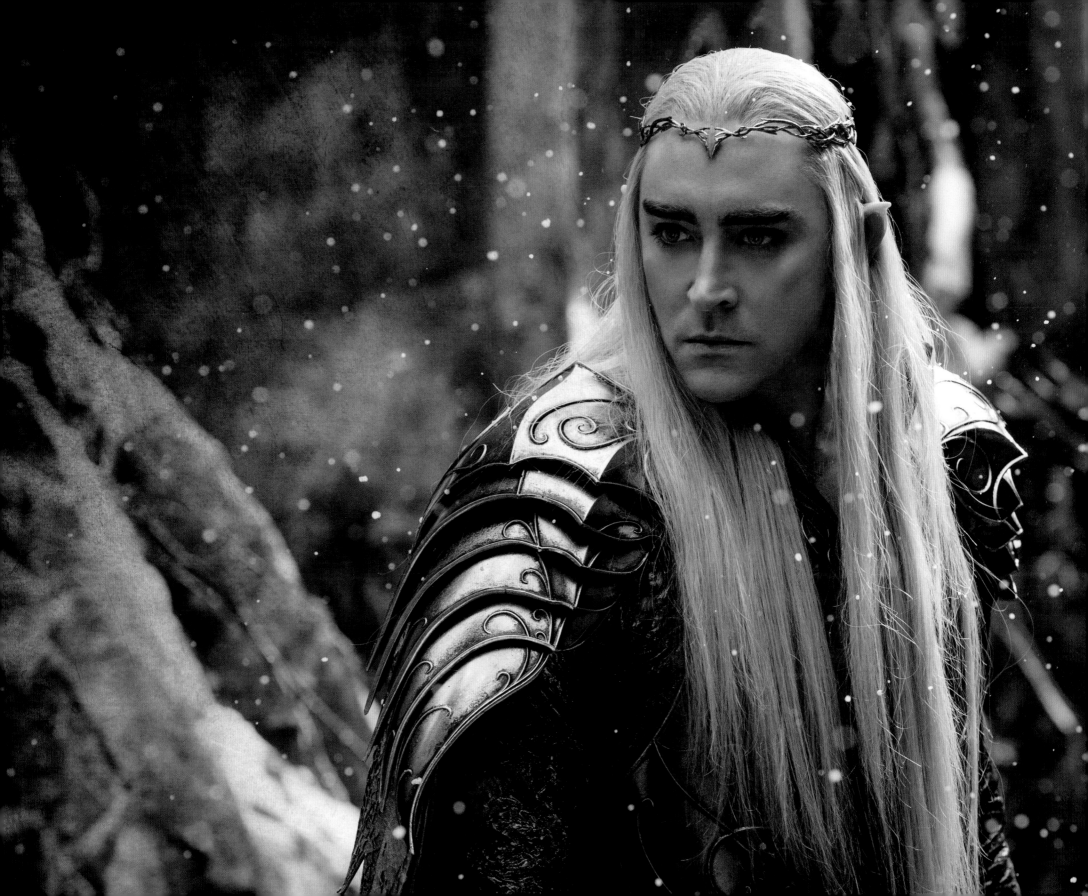

THRANDUIL'S COSTUME & WEAPONS

Thranduil's armour was so beautiful. It was ancient and had elements wrought in mithril. The Weta Workshop and Costume Department teams did an amazing job of making my costume look like it came out of another time. I could easily imagine Thranduil, who was every bit as ancient and powerful, dusting off this incredible relic and donning it for battle.

Lee Pace, Actor, Thranduil

Thranduil's armour was modelled off the standard body form that we had generated for a regular Elf soldier, so we were able to do our initial fitting with Lee Pace and size him up using this generic armour. The troubleshooting had already been done on that design so it gave us a boost going into his unique suit. We had the form already, upon which to then work up our unique filigree. It came together fairly quickly. The forms were milled on our computer-driven milling machine in a product called Sebatool, which is a dense foam that can be worked and carved. We then cast the filigree into acrylic moulds, laid it all on and glued it down by hand. The various pieces of armour were then moulded and cast as single units.

Essentially the finished Thranduil suit had the same proportions as the regular soldier's armour – the same curve to the chest and the same way that it was cinched in around the hips. Our Costume Supervisor Matt Appleton facilitated the fittings and pretty much looked after Thranduil's armour from start to finish.

Rob Gillies, Weta Workshop Supervisor

Lee carried himself in such a manner that cooperated fully with the construction of the suit and really made it work. He knew how to move to exploit everything the costume had to offer. He knew exactly how to make it look good.

It was a firm suit of armour and it would hold him in a certain pose. Rather than fight it, he went with it and adopted it into his character, embracing every aspect of it. The result was a striking figure and a riveting performance.

Emily-Jane Sturrock, Armour & Weapons Lead Stand-by

1-6. Details of Thranduil's armour and costume: front of chest plate (1), etched leather leaves and feathery shoulder lames on his back (2), back plate (3), greave (4), shoulder lames (5), with ombré and devoré velvet cape (6).

2 3 4 5 6

Being of Elven fashioning and slightly magical, Thranduil's beautiful, clean-cut armour was designed not to have obvious fastenings. In reality it was fastened with tiny screws, but come the end of a particular day of shooting when we were taking it off the actor, the head of one of those little screws became stripped. We had to get Lee out but couldn't trash the armour in the process. It didn't take long to drill the screw out and free him, but it was one of those tense moments when I missed having a great, big ugly buckle instead!

Elves being lithe, slim people, their tight-fitting armour tends to be unforgiving in fit, and it wasn't always possible to have a double or stunt person standing in for an actor of exactly the same size. . In the case of one of our doubles we had to resort to clamps, cable ties and extensions to wedge the poor man into a suit of armour that had been made for an actor of a very different shape! He had to run around all day in it, poor chap. I'm sure he slept well that night but would have been pretty sore the next day.

Jamie Wilson, Armour & Weapons Production Manager

Thranduil was the King of the Elves. He had to look striking when he went to war, and his cape for *The Battle of the Five Armies* was probably my favourite fabrication project. It was made out of silvery leather leaves and velvet.

We were very busy at the time and Costume Designer Bob Buck trusted me to run with the concept and make it work. We had some stunning silver leather. I worked with the graphic designer and we had laser-cut stamps made. We combined that with devoré, a technique in which we burnt a pattern out of the velvet, and the result was very successful.

The velvet on that cloak was some of the most beautiful I had ever worked with. We wanted to put an ombré effect on it, so it would fade from dark to light across its length. We didn't have an inexhaustible supply and at times it was nerve-wracking. I preferred not to know how much it cost!

I dyed a length of velvet silver with a deep charcoal coming in from the bottom, dried it and took it to Bob. We put it on a mannequin and the effect was stunning. It was like molten metal! It had an incredible quality and we knew at that moment that it was going to be an exquisite costume. Then I had to go away and repeat exactly what I had just done, which was no simple task!

We had different versions of Thranduil's silver cloak for use depending on whether he was to be mounted in a shot or not. We cheated it to be longer in some instances, depending on the context of the shot and what looked best.

I was able to be present when Lee first wore the costume in front of the filmmakers. He strutted about and really sold it beautifully. It was a wonderful moment, seeing it all come together so successfully and to witness their reactions.

Paula Collier, Textile Artist & Dyer

Thranduil's battle crown was made in copper and plated. Taking all the interwoven elements and extrapolating them into a pattern that could be cut and woven to come out at the right size was quite a challenge! We were fortunate that it fit actor Lee Pace fairly well the very first fitting we had, so the tweaking was limited to chopping a small bit out at the back to achieve an ideal fit.

Dallas Poll, Costume Jeweller

Thranduil's sword was a beautiful piece with an elaborate hilt and latticework-etched blade. It was probably one of my favourite weapons, alongside Sting and Orcrist. Originally he was only going to have one, but the only thing better than one fabulous sword is two fabulous swords, so in *The Battle of the Five Armies* actor Lee Pace got to unleash lots of slashy, murderous death with the pair of them. He was like a dervish, making these sweeping helicopter attacks through his enemies. The swords were both delicate and beautiful, but unmistakably lethal, especially in Thranduil's hands.

Jamie Wilson, Armour & Weapons Production Manager

Thranduil's swords were a technical challenge, both in aluminium and steel, but especially the steel because the fine detailing on them had to be so precise. We milled the basic shape on a machine, but there is only so much a two-millimetre bull-nose bit can accomplish; so most of it had to be done by hand using files and metal-working tools. It was important that the integrity of the detail be consistent.

Paul Van Ommen,
Weta Workshop Props Model Making Texture Artist

1-4. *Thranduil's battle crown (4. Detail).*
5. *Thranduil's scabbard.*
6-7. *Thranduil's coat. Subtle variants on the costume existed to be worn with (6) or without (7) armour.*
8. *Thranduil's black leather boots.*
9. *Detail of Thranduil's armour: point of chestplate at waist.*

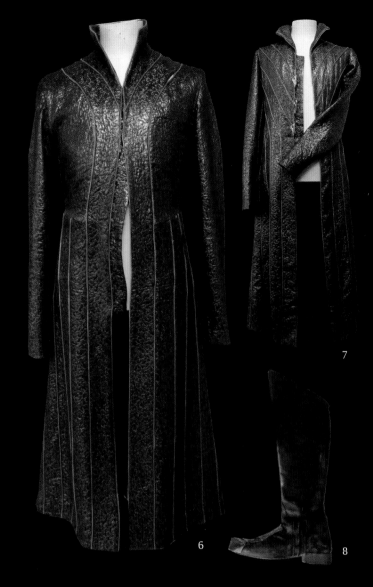

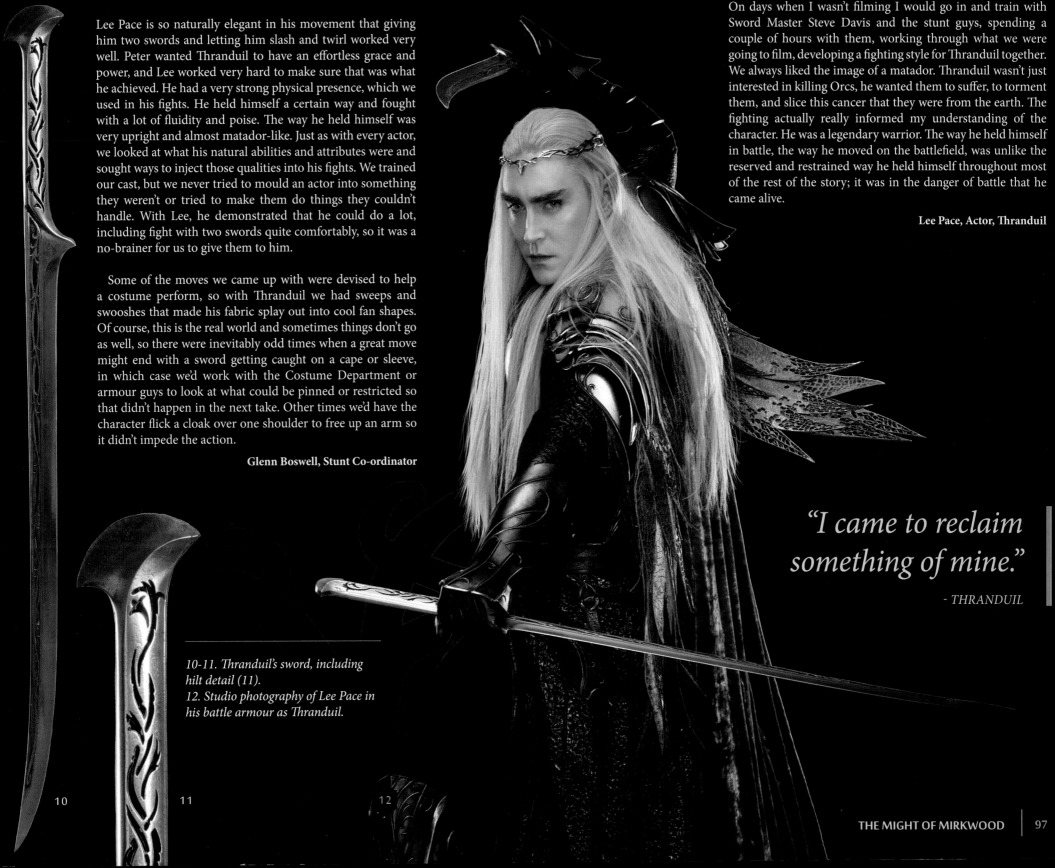

Lee Pace is so naturally elegant in his movement that giving him two swords and letting him slash and twirl worked very well. Peter wanted Thranduil to have an effortless grace and power, and Lee worked very hard to make sure that was what he achieved. He had a very strong physical presence, which we used in his fights. He held himself a certain way and fought with a lot of fluidity and poise. The way he held himself was very upright and almost matador-like. Just as with every actor, we looked at what his natural abilities and attributes were and sought ways to inject those qualities into his fights. We trained our cast, but we never tried to mould an actor into something they weren't or tried to make them do things they couldn't handle. With Lee, he demonstrated that he could do a lot, including fight with two swords quite comfortably, so it was a no-brainer for us to give them to him.

Some of the moves we came up with were devised to help a costume perform, so with Thranduil we had sweeps and swooshes that made his fabric splay out into cool fan shapes. Of course, this is the real world and sometimes things don't go as well, so there were inevitably odd times when a great move might end with a sword getting caught on a cape or sleeve, in which case we'd work with the Costume Department or armour guys to look at what could be pinned or restricted so that didn't happen in the next take. Other times we'd have the character flick a cloak over one shoulder to free up an arm so it didn't impede the action.

Glenn Boswell, Stunt Co-ordinator

10-11. *Thranduil's sword, including hilt detail (11).*
12. *Studio photography of Lee Pace in his battle armour as Thranduil.*

On days when I wasn't filming I would go in and train with Sword Master Steve Davis and the stunt guys, spending a couple of hours with them, working through what we were going to film, developing a fighting style for Thranduil together. We always liked the image of a matador. Thranduil wasn't just interested in killing Orcs, he wanted them to suffer, to torment them, and slice this cancer that they were from the earth. The fighting actually really informed my understanding of the character. He was a legendary warrior. The way he held himself in battle, the way he moved on the battlefield, was unlike the reserved and restrained way he held himself throughout most of the rest of the story; it was in the danger of battle that he came alive.

Lee Pace, Actor, Thranduil

"I came to reclaim something of mine."

- THRANDUIL

10 11 12

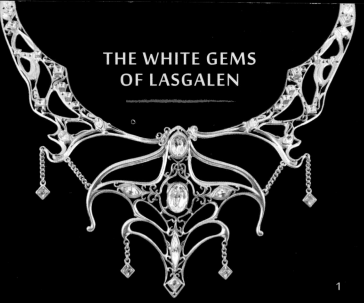

THE WHITE GEMS
OF LASGALEN

1

2

3

1-3: Lasgalen Jewellery by Prop Maker Steph Lusted.

Thranduil was very old, but with that immortality came a sadness. I have always thought about it in the sense that he was spoiled by his immortality. He lost his wife years ago, and all that he thought he had left of her were the jewels that ended up locked inside the Mountain – the white Lasgalen gems which were part of the Dragon's hoard.

So, at the centre of this cold character was profound heartbreak, knowing he was destined to live an immortal life without her. It was a secret that Peter, Fran and Philippa gave me which helped motivate Thranduil's avarice concerning those gems, why they meant so much to him and why, in the end, he was even prepared to risk Elven life to reacquire them.

Lee Pace, Actor, Thranduil

Where did Thranduil's withdrawal from the world come from? Why did we learn nothing about Legolas's mother? The answer is probably because Professor Tolkien never got around to defining those details in his already incredibly deep world, but as we sought to build a full character around the Woodland King we began exploring the question of that backstory for Thranduil. Initially it served only as a history that the actor could draw upon to anchor his performance, but grew into something that we loved.

Thranduil had led armies of Elves in battle before. He had proven himself a willing participant in the definitive battles of Middle-earth's history. Had we the chance, I would have loved to have had him in the Battle of the Last Alliance, in the prologue sequence of *The Fellowship of the Ring*, because he was there and he fought in that battle. Somewhere along the way, something in Thranduil changed, and he wouldn't

make that choice anymore. Instead, he had retreated into his kingdom, underground, to wait out the world.

In approaching this question of what had happened we used the fact that there was nothing written or mentioned as something in itself. There was no word, no name spoken, no grave for his wife, nothing of this woman who was in both Legolas and Thranduil's past.

I had forgotten about Gundabad, but when it came up we went looking into the history of the place and there seemed to be an opportunity to connect it with the question of Thranduil's missing wife. It made sense to send Legolas and Tauriel there to witness Bolg's army marching forth and prompt Legolas to mention his mother. There was something interesting in him looking at this place and understanding that it was here where she died. Perhaps it was all he truly knew about her. Perhaps the pain of that loss was too much for Thranduil to share, so he never spoke of it. It informed a lot about Legolas. In a way he was as withdrawn as his father, and this unspoken loss gave us some rich material to fuel the dramatic triangle between our three lead Elves.

We loved the notion of a love that ran so deep that it couldn't be spoken of. Thranduil could not go near it, he could not touch it, but it burdened him with a profound understanding of loss. Loss for an Elf is a more dangerous prospect than it is for a human.

Mortal men had been granted, as Tolkien calls it, the gift of death. For an Elf, there is no death. For an Elf, loss was forever, and that meant forever. In his own dysfunctional way, Thranduil was protecting Tauriel from the loss he had experienced by denying her feelings for the Dwarf, Kili. 'What

do you know of love? You think this is love? It's not real,' he told her. When he witnessed her grief he understood it, and she began to understand him. At that point, like him, Tauriel didn't want it anymore. It was only then that Thranduil acknowledged her love and her loss. 'It was real.' Her grief moved him to a new place of understanding, and I think that is what motivated him to break the gulf of silence between him and Legolas, and tell his son about his mother. 'She loved you more than anything, more than life.' He is telling Legolas that his mother died for him, to protect him.

Philippa Boyens, Screenwriter & Co-producer

Those jewels were all that Thranduil had left of the woman he loved so deeply. Until he could come to terms with that ineffable loss, his only way to hold on to her was by reclaiming the white star-lit gems that were once hers, which the Dwarves had been commissioned to craft into silver jewellery. Thrór had withheld them from him, presumably in some pig-headed dispute over matters of payment, honour or fealty. Thrór considered his dominion over all ordained by possession of his phosphene-spangled Arkenstone, the king's jewel, and Thranduil was no less proud. This enmity between Dwarves and Elves was an old tale and seemed fated to repeat itself.

I think the events of the great battle were an epiphany of sorts for Thranduil, and saw him not only acknowledge and engage with his son, but also end his isolationist policy and reconnect with the world. This was to manifest later by him fighting against Sauron's forces in the north while Gondor lay under siege in the south, something that happened in the books and presumably off camera in our films as well. He got his precious jewels back, but he also found something more valuable.

Daniel Falconer, Weta Workshop Designer

THRANDUIL'S ELK

Lee Pace was one of the loveliest actors I have worked with. It was very gratifying to see him looking so good in the finished film, wearing the armour we had made for him, owning his scenes.

I thought he looked particularly amazing astride his elk, which, amusingly enough, was in fact a very large horse named Moose on the set. A horse named Moose played an elk – there's a book to be written there.

Matt Appleton, Weta Workshop Costume Supervisor

Weta Digital's artists transformed Moose into a prehistoric elk. That animal was huge. He was the biggest horse I had ever seen and might well be the biggest horse in New Zealand. He never had to run on the set, but I had him up to a trot when Thranduil made his entrance in Dale. Moose wasn't really interested in doing that, but he did it nonetheless.

There is something magical about being on a horse. During the scene we shot beneath the walls of Thorin's front gate, negotiating with the Dwarves, Gandalf and Luke Evans as Bard on his white horse beside me, it really did feel like that moment was happening. Even though so much of it was created later, replacing the green screens that were there when we shot it, it felt real, sitting there astride this huge horse that would become an elk. It felt like we were actually there, living it in Middle-earth.

Lee Pace, Actor, Thranduil

We saw Thranduil's elk in the first film, but only for a few seconds and he didn't really do anything. This time he got prime time so we went back and gave him a lot more attention, especially the groom of his coat. He was based on a type of prehistoric elk but there were also some features that were not very elk-like. Peter wanted something quite fierce. An elk's eyes and nose don't really do what he wanted. There was this look of terror that he wanted, which was something a horse or cow does. You can see more of the white of the eye and the nostrils flare out. It can look quite freaky, so we put some horse and cow into our elk's nose and eyes.

We also added scars and some matted fur so he didn't look so perfect. It definitely made him feel more aggressive and expressive.

Marco Revelant, Weta Digital Models Supervisor

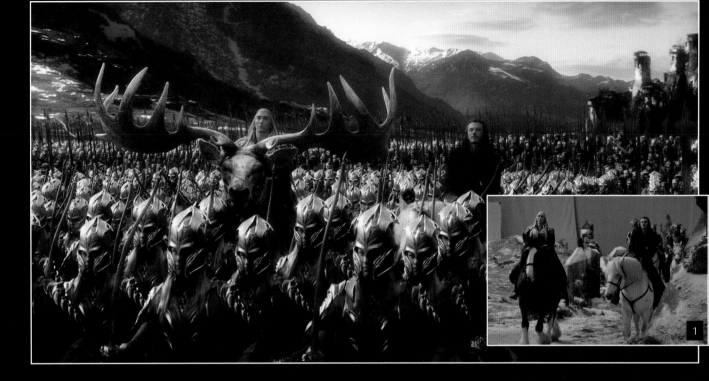

There was a giant prehistoric Irish elk called Megaloceros that had huge antlers which was the inspiration for Thranduil's mount. We really wanted to create something that was very majestic and powerful-looking.

Peter wanted lots of battle scars on the elk's antlers. I had an idea based on scrimshaw, where I thought perhaps his antlers might be richly engraved with Elven filigree, something quite original and beautiful, though tragically I never had the chance to get it under Peter's nose.

We referenced real-world animals to help build realism into all our creatures, and for the elk a friend had given me some beautiful red deer antlers. We made scans of the surface of these antlers and used them for colour and displacement on Thranduil's. Joe Letteri really liked the colours that we managed to get in there.

We have a huge library of textures that we have scanned over the years which we use all the time. There are so many samples and I am always on the look-out for more. We've used a lot of interesting textural leather pieces for skin textures on different digital creatures, even handbags can be a great thing to look at.

**Gino Acevedo,
Weta Digital Textures Supervisor/Creative Art Director**

Peter was very specific about the colour and texture of the elk's fur and the details of his antlers. We went through a number of iterations before we nailed what he was looking for, but once we had it right it looked great.

Sometimes Lee Pace was filmed riding a horse and sometimes he was on a green-screen-clad riding rig. The horse provided us with some nice motion to key to as we replaced it with our digital elk. The one thing we discovered, however, was that while it was all well and good to film Lee wheeling around on his horse, doing his thing, once we inserted the elk over his horse we had these massive antlers in each shot, which hadn't been taken into account in the composition of the frame. There was one shot in which Thranduil was talking to Bard and both were filmed on horseback. Once we matched the elk to the position of Lee's horse, the antler completely filled the camera lens! We had to subtly tweak the elk in situations like that so that his head was turned or the antlers were cheated so as not to destroy the shot.

Matt Aitken, Weta Digital Visual Effects Supervisor

1. Plate photography of Thranduil and Bard astride their horses on set, and the final shot with Thranduil's elk, army and full environment.

Amid all the elk and Thranduil shots there was a huge amalgam of live action, key-framing and motion capture. It was critical that we accurately match-moved our digital elk to the horse Lee was filmed riding on set or we would lose the saddle connection. This was the approach used for scenes in which he was riding about. For any shots in which Thranduil and his elk were fighting or ramming, including the antler-assisted Orc head-slicing-and-tumble that he does after the elk was killed, there were no live-action components. Everything, including Thranduil himself, was key-framed so, in these sorts of instances, Thranduil would be a digital double.

The elk started with a horse motion-capture walk-cycle, which got slowed down and modified a little to feel more like a heavy deer.

Aaron Gilman, Weta Digital Animation Supervisor

Brainstorming Thranduil's arrival in Dale provided two notable moments that made it all the way into the finished film. The first was Thranduil's grand, multiple-Orc beheading. In one move the elk collected a whole bunch of Orcs in one action, scooping them up by their chins between the tines of his antlers, and then Thranduil beheaded them all with one swipe. It was a gag that would get the audience clapping and cheering, but I remember sitting down in that brainstorming session and having no concept of what we needed to do. We knew that Thranduil was an effortless killing machine, and that what we had to show was something that demonstrated his capability, but how would we do that without gaining an R rating? How do you cut off the heads of so many people and not show it? From that point of view that gag was very successful, but it was immediately followed by a costly loss, which was the second thing to come out of the brainstorming – the elk had to die.

Randy Link, Weta Digital Previs Supervisor

An interesting observation about brainstorming: as soon as someone says something and someone else laughs and makes a joke, you know you are onto an idea with emotional weight. There is a trigger in humans that compels us to dispel tension. It is in our nature to try to make everyone comfortable, and we do it with humour, so someone making a joke to dispel the tension in a brainstorming situation that occurs when an emotionally charged idea is floated is a sure tell that there's something worth looking at. Sometimes the person suggesting it can take offence, but in my observation that joke is an unconscious acknowledgement of the idea's potential emotional power.

So, when the notion of the elk dying was suggested and the room erupted in jokes, I took that as a sign we were on to a potentially good idea.

Jamie Beard, Weta Digital Previs & Animation Supervisor

1. Thranduil's saddle.
2-3. Digital reference turntable image of Thranduil's elk.
4. Previs depicting Thranduil's gallop and the elk's death.

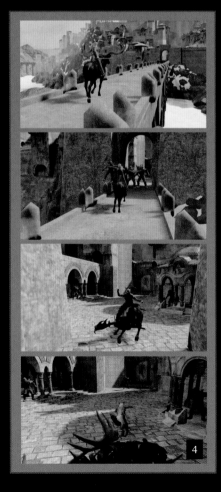

MIRKWOOD ELF SOLDIERS

When Thranduil went to Erebor, he went in force, taking with him a vast army of super-trained Elf soldiers. These guys were serious fighters who posed a real threat to the Dwarves holed up in the Mountain with all their loot. They had to look the business, and yet still be as lithe and elegant as we had come to expect them to be from the previous films. Essentially, the Mirkwood army needed to wear something that looked like serious armour yet was also very sleek, which has always been a challenge to achieve.

Matt Appleton, Weta Workshop Costume Supervisor

We met Legolas in *The Lord of the Rings* and in *The Desolation of Smaug* we were introduced to the culture he came from, the Elves of Mirkwood. But we never got to see them as a real military force until the last film of *The Hobbit*; and it turned out they were a force to be reckoned with. We had created Elven armies before, but each time we tried to offer something new and different, while still drawing on many of the same design tropes that have become synonymous with the race. A fresh influence this time around for us was the photography of early twentieth-century German, Karl Blossfeldt, who produced the most amazing close-up pictures of plant forms.

Elves have always been tricky to armour because of the conflicting need to cover them in protective gear while still keeping them supernaturally elegant and agile, without falling into something that appeared too science-fiction. Often it came down to resolving something in the shape of their helmets that was unique and original, yet still within what we define as Elven style, and then applying those shapes through their armour. The new helmet designs of the Mirkwood soldiers was iconic enough to be recognizably distinct from those of Elrond's Rivendell guards, or Celeborn and Galadriel's Galadhrim warriors, but still unquestionably Elven; those same shapes, lines and textures that were in the helmet also appeared in the shields, armour and weapons, uniting them under one defining style which came to be the Mirkwood look.

Richard Taylor,
Weta Workshop Design & Special Effects Supervisor

1-2. Mirkwood Elf soldier helmet.
3. Detail of Mirkwood Elf soldier shoulder pauldron.
4. Detail of Mirkwood Elf soldier chestplate.

1-4. Details of Mirkwood Elf soldier armour: fin-maille skirt (1), back plate (2), belt and buckle (3), vambrace (4).

The soldiers of Mirkwood had long capes. That was a fun dyeing project for us. There was silk we had to dye, their cape fabric that had to be dyed, and heavily patched autumnal cloak linings that were very graphic. They looked like the floor of a forest with leaves on the ground. There were logistics to work out regarding the colours and the meterage of velvet, and how best to cut it so that we could make capes for everyone. They were costumes to be worn by extras, but the numbers kept changing at the time when we needed to start work, so we didn't know whether we needed to create enough fabric for 60, 80 or even 120. We planned for the worst-case scenario and went for 120. Being an army they would all be the same, so we created a bit of a production line and even though it seemed daunting on paper to produce this quantity of fabric in just a few days, once we started we powered through them and

Film deadlines can sometimes seem insane, but they can also be incredibly exciting because out of them can come something so amazing. It's a testament to the strength of character of our costume designers who often have to stare down these deadlines and not let compromise undermine their designs. Sometimes things are added late in the process. It would sometimes drive us crazy because things were so tight already, but you have to trust the designer's eye and in the end what you have is something beautiful, with depth and layers, the product of so much thoughtful consideration, lots of hard work and attention. It is enormously satisfying to see that work on screen and see it looking so good, knowing all that work was worth it.

Paula Collier, Textile Artist & Dyer

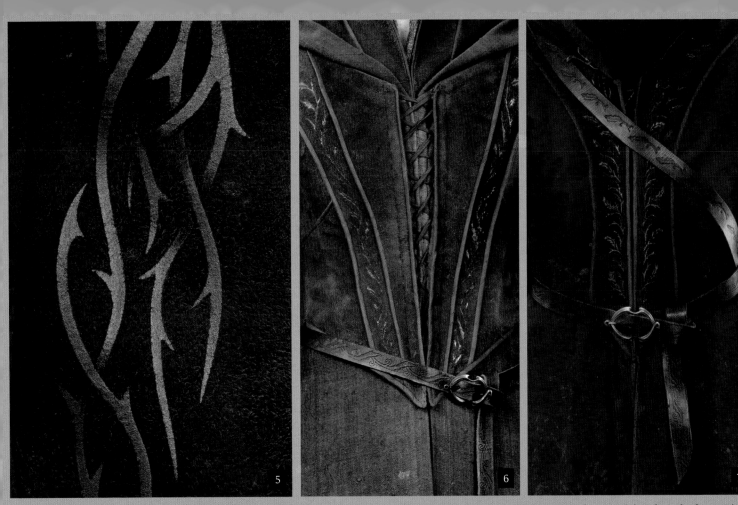

5-8, Details of Mirkwood Elf travelling costumes: print on green male tunic (5), green female cuirass (6), brown male tunic (7), velvet cloak trim (8).

With all respect to the pointy-eared race, Elves are my least favourite to cast because all the associations people have with them mean they can tend to be preening, narcissistic, aloof and hard to find! There are just not that many supermodels in New Zealand: go figure.

Liz Mullane, New Zealand Casting Director

Creature casting is different to casting humans because we have to look for different things. Hobbits and Elves often have incredibly specific requirements, usually to do with their faces, or size. Elves tended to always need to be tall, and certainly that was the case on *The Lord of the Rings*, but in *The Hobbit* we have some shorter Elves. The Mirkwood variety aren't as towering, it turns out, which gave us a little more leeway with our casting.

Miranda Rivers, New Zealand Casting Director

I remember being on set in Dale and we had three Elves faint. A lot of the new people freaked out, those who hadn't been with us during the first Middle-earth trilogy, but I remember saying, 'Dude, Elves faint. It was the same on *The Lord of the Rings* ten years ago. They fall over.' They were tall, willowy people with low blood pressure standing in the sunshine in armour. The armour wasn't too tight – I know because I checked them. It's just the nature of the physical type that we have cast, along with the context we have them in. These are six-foot-two, size eight people standing for long periods. The Orcs and other races being shot on the same sets didn't faint, but Elves did. I told our new people, 'Don't fret, just look after them and be thankful we have no seven-foot-tall vegan Ringwraiths on this set.'

Emily-Jane Sturrock, Armour & Weapons Lead Stand-by

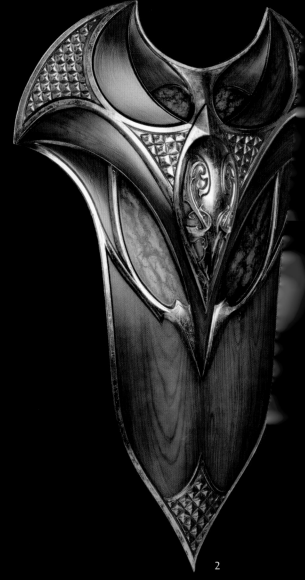

2

The Elves had a history. We had seen them b
of the Rings, so we had a base to begin from i
fighting styles for *The Battle of the Five Armie*
their style was elegant and crisp, with ver
accurate movements and no wasted energy.
superior, honed over hundreds of years, th
superior, and their agility was superior. The
them getting taken out was when they wer
numbers.

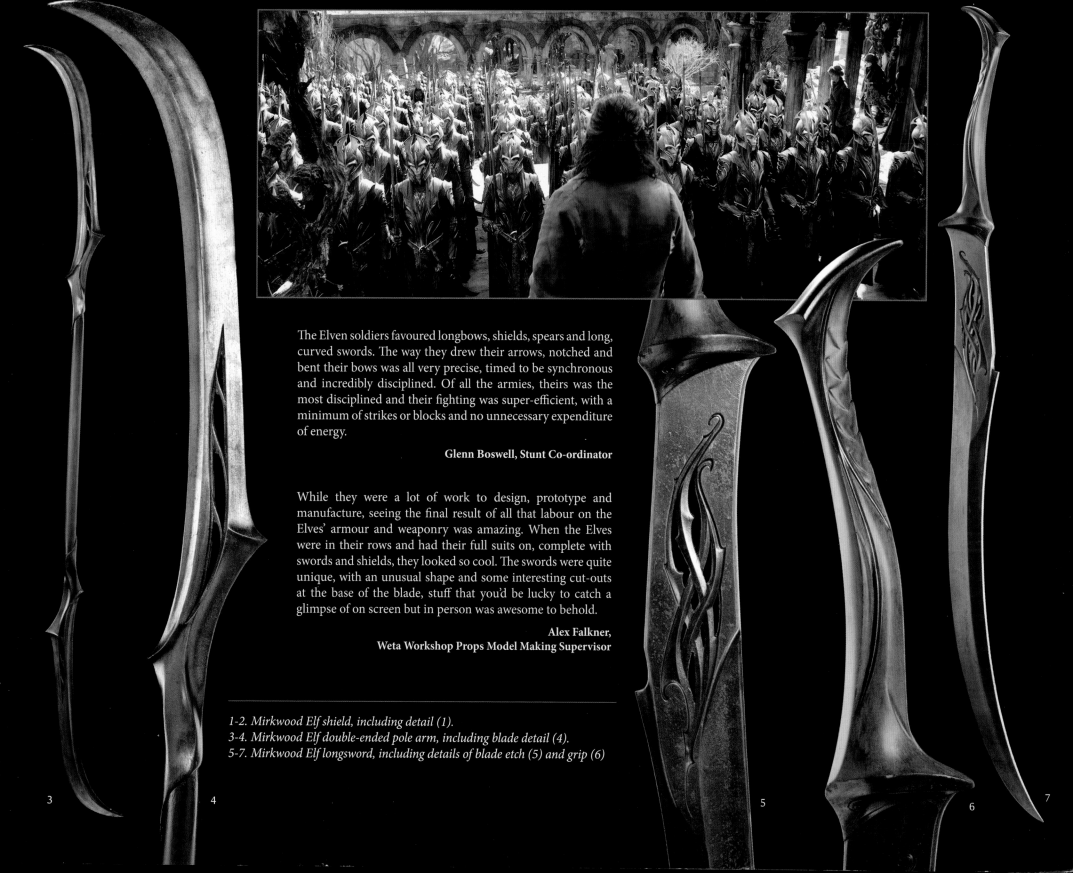

The Elven soldiers favoured longbows, shields, spears and long, curved swords. The way they drew their arrows, notched and bent their bows was all very precise, timed to be synchronous and incredibly disciplined. Of all the armies, theirs was the most disciplined and their fighting was super-efficient, with a minimum of strikes or blocks and no unnecessary expenditure of energy.

Glenn Boswell, Stunt Co-ordinator

While they were a lot of work to design, prototype and manufacture, seeing the final result of all that labour on the Elves' armour and weaponry was amazing. When the Elves were in their rows and had their full suits on, complete with swords and shields, they looked so cool. The swords were quite unique, with an unusual shape and some interesting cut-outs at the base of the blade, stuff that you'd be lucky to catch a glimpse of on screen but in person was awesome to behold.

Alex Falkner,
Weta Workshop Props Model Making Supervisor

1-2. Mirkwood Elf shield, including detail (1).
3-4. Mirkwood Elf double-ended pole arm, including blade detail (4).
5-7. Mirkwood Elf longsword, including details of blade etch (5) and grip (6)

3 4 5 6 7

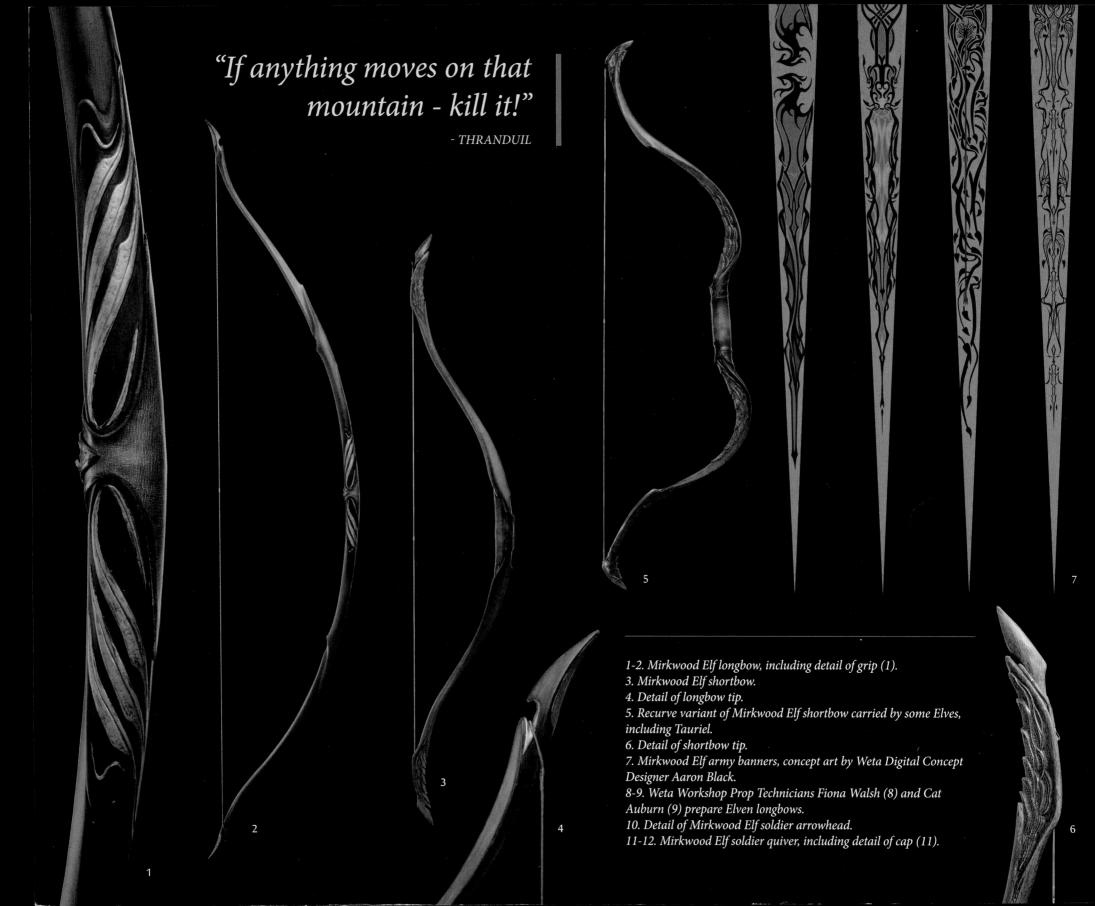

> *"If anything moves on that mountain - kill it!"*
>
> *- THRANDUIL*

1-2. *Mirkwood Elf longbow, including detail of grip (1).*
3. *Mirkwood Elf shortbow.*
4. *Detail of longbow tip.*
5. *Recurve variant of Mirkwood Elf shortbow carried by some Elves, including Tauriel.*
6. *Detail of shortbow tip.*
7. *Mirkwood Elf army banners, concept art by Weta Digital Concept Designer Aaron Black.*
8-9. *Weta Workshop Prop Technicians Fiona Walsh (8) and Cat Auburn (9) prepare Elven longbows.*
10. *Detail of Mirkwood Elf soldier arrowhead.*
11-12. *Mirkwood Elf soldier quiver, including detail of cap (11).*

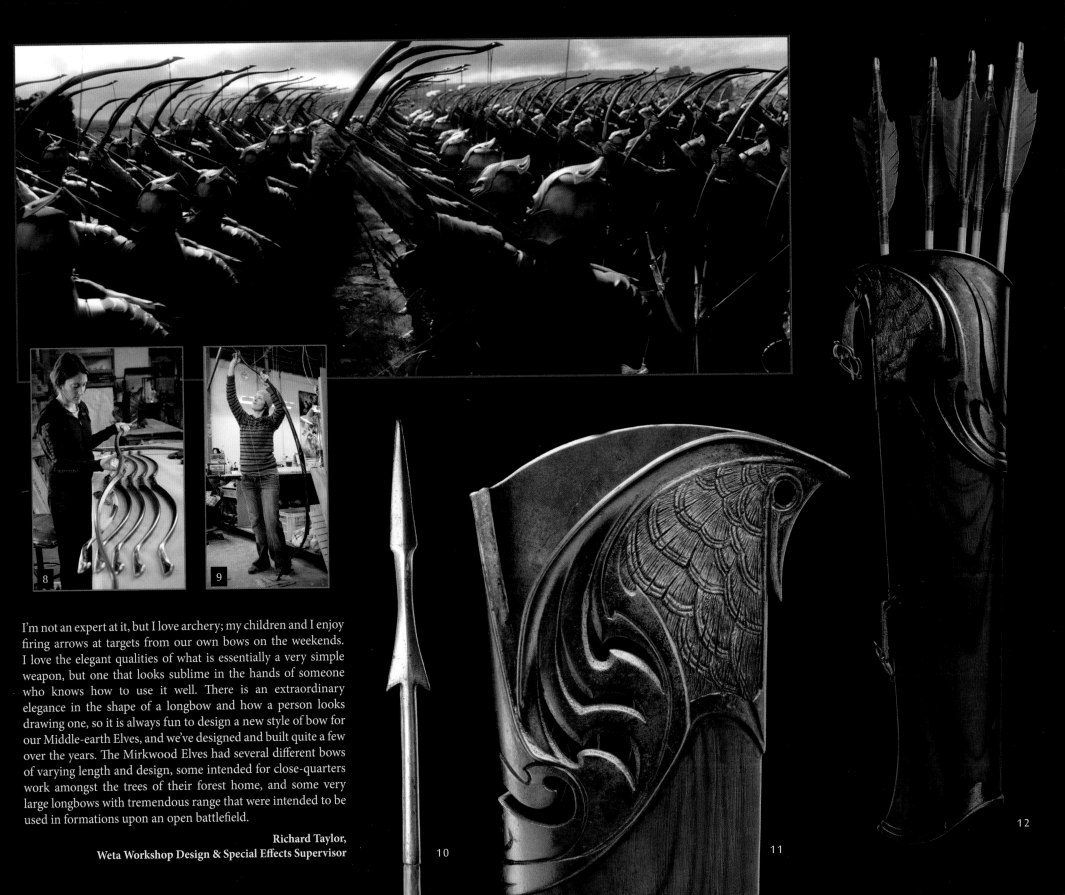

I'm not an expert at it, but I love archery; my children and I enjoy firing arrows at targets from our own bows on the weekends. I love the elegant qualities of what is essentially a very simple weapon, but one that looks sublime in the hands of someone who knows how to use it well. There is an extraordinary elegance in the shape of a longbow and how a person looks drawing one, so it is always fun to design a new style of bow for our Middle-earth Elves, and we've designed and built quite a few over the years. The Mirkwood Elves had several different bows of varying length and design, some intended for close-quarters work amongst the trees of their forest home, and some very large longbows with tremendous range that were intended to be used in formations upon an open battlefield.

Richard Taylor,
Weta Workshop Design & Special Effects Supervisor

8

9

10

11

12

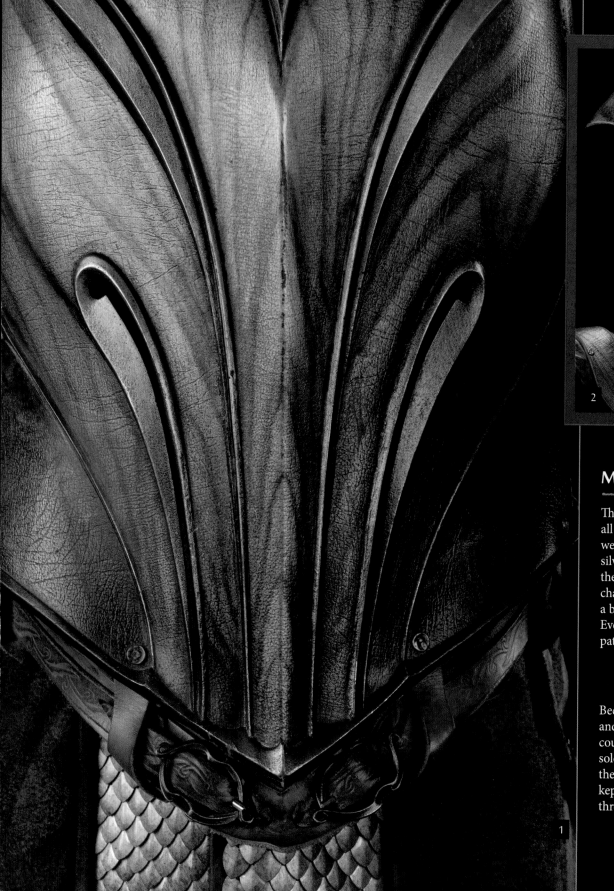

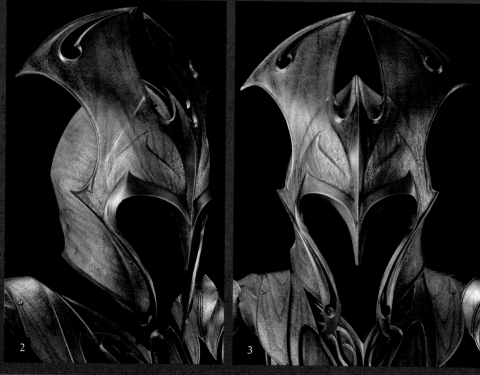

MIRKWOOD ELF CAPTAINS

The main bulk of the Elven army's weapons and armour were all painted in the bronzes and greens of sapling trees, what we considered the Mirkwood Elf palette. Thranduil was in silver, so in between we had the officers, who wore essentially the same components as the regular troops but with a colour change that had more grey and silver. Their helmets were also a bit different, with a wider crest and different cheek guards. Even with the colour change, we still had the woodgrain pattern running through their armour, which looked so cool.

Rob Gillies, Weta Workshop Supervisor

Because we were trying to create helmets that fit very snugly and added the minimum possible bulk, we went through countless fittings and 'show and tell' sessions for the Elf soldiers. Peter and Fran were very specific about the look they wanted to achieve, and that meant tight costumes that kept the Elves looking very narrow. The helmet changed three or four times as the story developed.

**Alex Falkner,
Weta Workshop Props Model Making Supervisor**

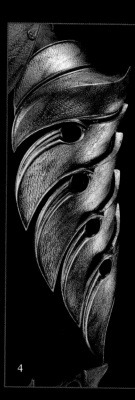

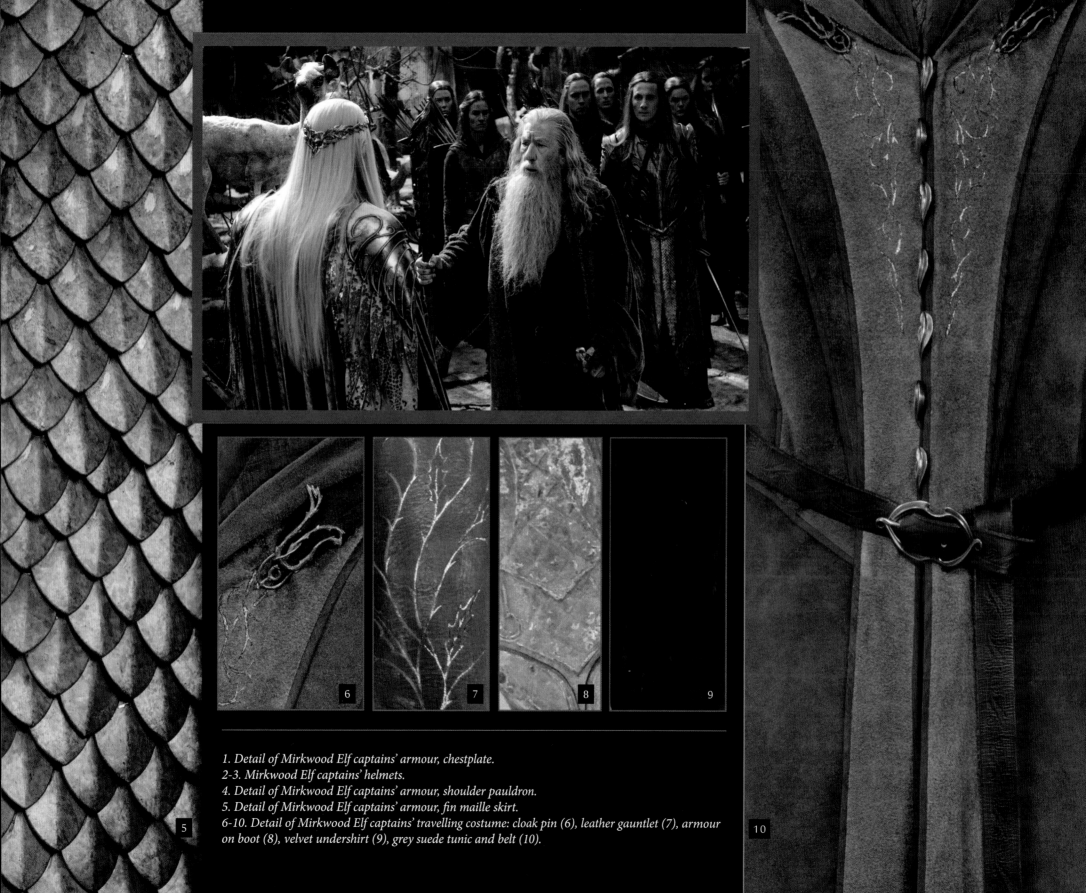

1. Detail of Mirkwood Elf captains' armour, chestplate.
2-3. Mirkwood Elf captains' helmets.
4. Detail of Mirkwood Elf captains' armour, shoulder pauldron.
5. Detail of Mirkwood Elf captains' armour, fin maille skirt.
6-10. Detail of Mirkwood Elf captains' travelling costume: cloak pin (6), leather gauntlet (7), armour on boot (8), velvet undershirt (9), grey suede tunic and belt (10).

6

7

8

9

5

10

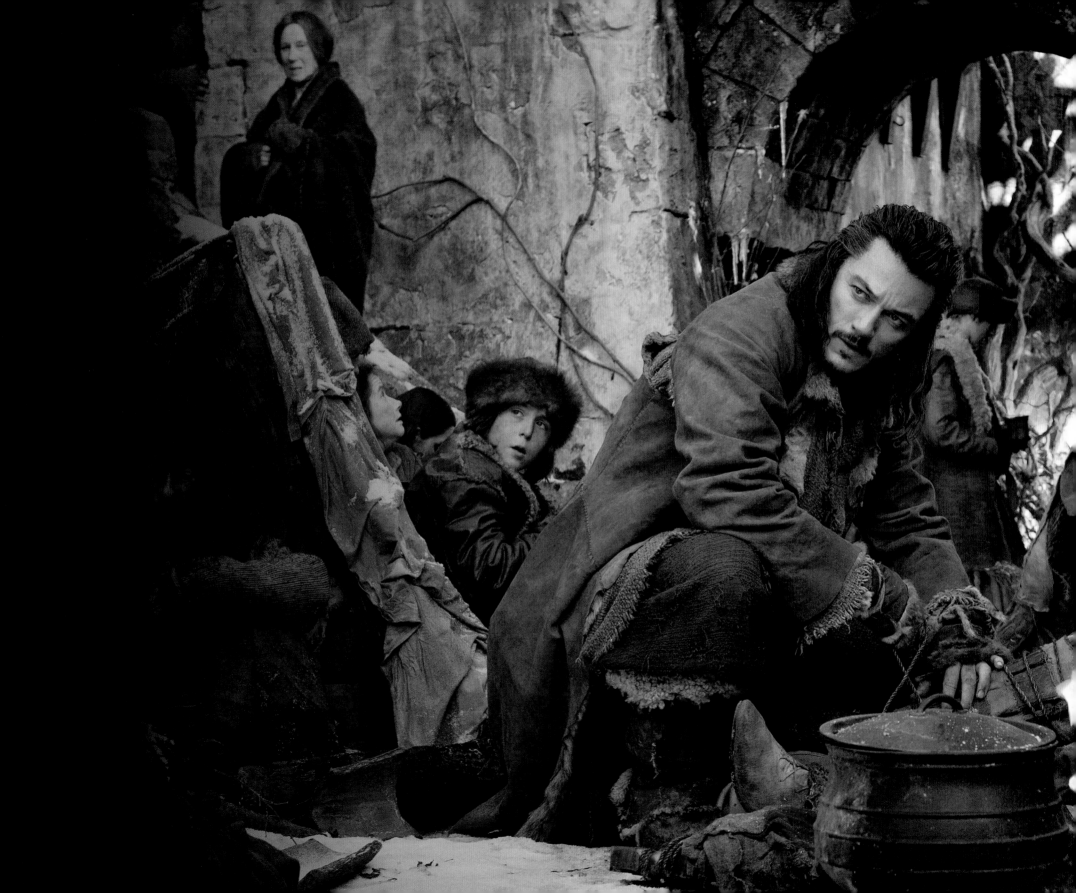

ORPHANS OF THE LAKE

Cold and hungry, tthe bereft survivors of Lake-town are led by their saviour Bard to the ruins of Dale upon the doorstep of Erebor in search of shelter. Amid the broken stone buildings, blackened streets and frozen dead; reminders of Smaug's first attack generations before, the raw-nerved homeless find corners in which to camp and cellars in which to hide from winter's rapid advance. The people are succoured by the unexpected arrival of the Elves of the Woodland Realm, bringing food and supplies; King Thranduil installing himself in the broken dome of what was once the great hall. In the armoury of the deserted city the survivors uncover racks of armour and weapons, dusty but intact; Dale's defences having been overwhelmed before its defenders could even arm themselves. With hope's fire rekindled, all eyes look to their reluctant leader, Bard.

Smoke arising from Erebor surprises everyone; there are Dwarves yet within the Mountain kingdom, and Bard goes as emissary to the fortified entrance to seek restitution and aid for his people. When Thorin proves immovable, Bard returns to Dale to find Thranduil preparing for war. Gandalf the Grey Wizard rides into the courtyard with prophecies of greater doom and imminent threat from an invisible army of Orcs, and though they fall on deaf ears with pointed tips, Bard is less swift to discount the old man's warnings.

Bilbo suddenly appears at Thranduil's council, having slipped from the Mountain and made his way by stealth into the Elven encampment. Most remarkable of all, Bilbo bears a token that may prevent the besieging of Erebor, drawing from his coat the King's Jewel, Thorin's most treasured and desired possession, the Arkenstone.

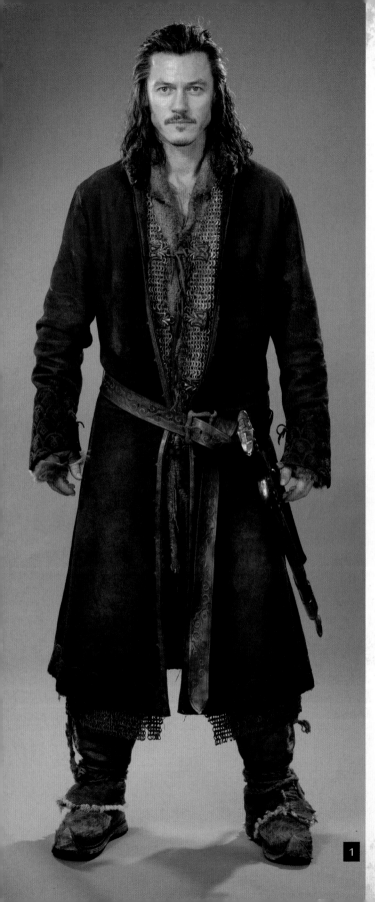

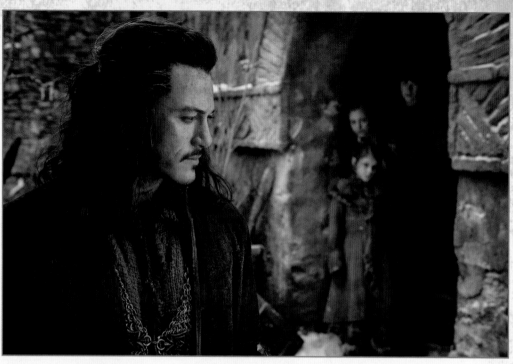

BARD, LEADER OF MEN

I think when Professor Tolkien was writing Bard he was formulating ideas about a character that would eventually reside in Aragorn. There is very little time devoted to Bard in the book, and yet he is such an important character: he kills the Dragon!

For the film we had to develop Bard into a much more rounded character. Fran had a very strong sense of what was informing his character. He was a reluctant though natural leader, but we didn't want to repeat the Aragorn story of the reluctant leader which we had already told. Fran always saw the essence of Bard's story as set against examples of bad leadership. Against the corrupt despotism of the Master and later the Dragon-sick actions of Thorin, we had a man who acted instinctively to do the right thing for his family and his people. He was someone in whom people could trust and hope, who would go where he commanded them, even into death, because they knew instinctively that he would never ask more of them than he was willing to give.

Bard never submitted to the blandishments of Alfrid. That was in fact the reason why we came up with Alfrid's character. He confronted Bard and renounced it all as a waste, accusing Bard of wasting the power bestowed upon him because he did not use it to his own advantage, but Bard wasn't politic. Some times call for men who are politic, clever and wily, but sometimes they call for a different kind of leader. What Alfrid

didn't understand was that no one would put their lives on the line for someone like that. 'For what did you do this?' The answer is for all the right reasons: for love, for love of his family, and to protect, to give his last to defend his people. Bard was a protector, a provider, and a defender.

Philippa Boyens, Screenwriter & Co-producer

Bard would never have put himself forward as someone to lead an army. He was always a father and widower concerned with taking care of his family. Peter always said that Bard's children were everything to him, and I kept that in the forefront of my mind in every scene. I think that humble drive is what motivated the natural progression from a man looking after his family to a man who eventually came to be looking after an entire town of people needing someone to protect and lead them. What was lovely is that we saw in flashbacks of Girion leading the defence of Dale that Bard's leadership qualities probably come from his ancestry.

Bard wasn't interested in accolades or crowns, which is why the people were so quick to rally to him, having lived under the Master for so long. He was a working-class man, practical, caring and the kind of man you would want as a leader because you know he'd have your best interests at heart. It was very enjoyable playing him.

Luke Evans, Actor, Bard

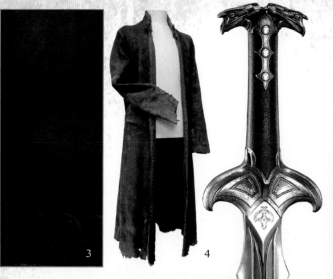

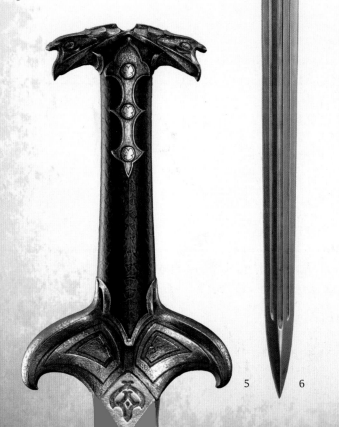

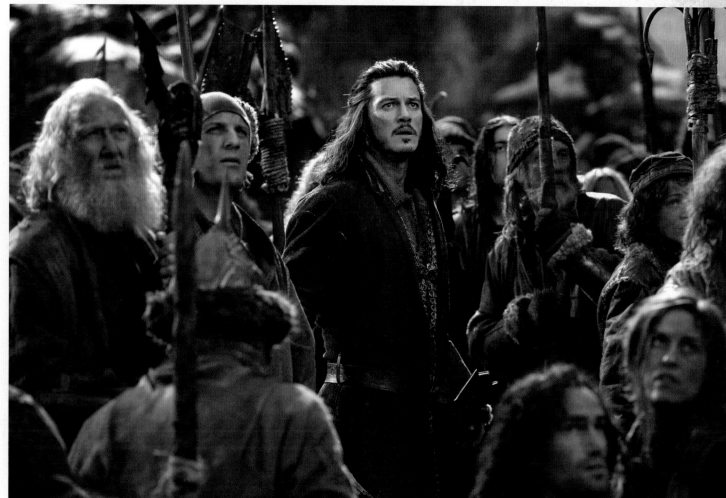

1-2. Costume and make-up test photography of Luke Evans in costume as Bard.
3. Detail of Bard's coat fabric.
4. Bard's coat. Compare this fully broken down version to its less aged state in the test photography.
5-6. Bard/Girion's sword in its pristine state. The sword was heavily aged to represent a weapon having lain in the rubble of Dale for generations.

"Winter is upon us; we must look to our own, to the sick and the helpless." - BARD

Bard's sword was the same one we had made for Girion, his ancestor. There had been the idea that Bard actually went looking for this sword in the rubble of ruined Dale and pulled it out. We aged it heavily because there was talk of a scene in which we would actually see him find it in a rusty state and clean it up for the battle, though none of that ended up happening in the end. It's funny because that sword had quite a history. It was originally designed for The Master, but he didn't need one, so it became Girion's, who we never saw use it, and then finally Bard's.

Alex Falkner,
Weta Workshop Props Model Making Supervisor

We imagined Bard as a courageous character who just did what needed doing. He was the kind of character who would pick up whatever weapon was nearby without reservation and get on with the job, so if it wasn't a bow, a sword would be just fine. He was a skilful mover who could keep his balance, as we saw on the rooftops and when he was crossing boats with ease, but didn't fight with any particular flourish or flashy style. It made sense for his character that Bard be more of a natural fighter than looking like he was trained.

Glenn Boswell, Stunt Co-ordinator

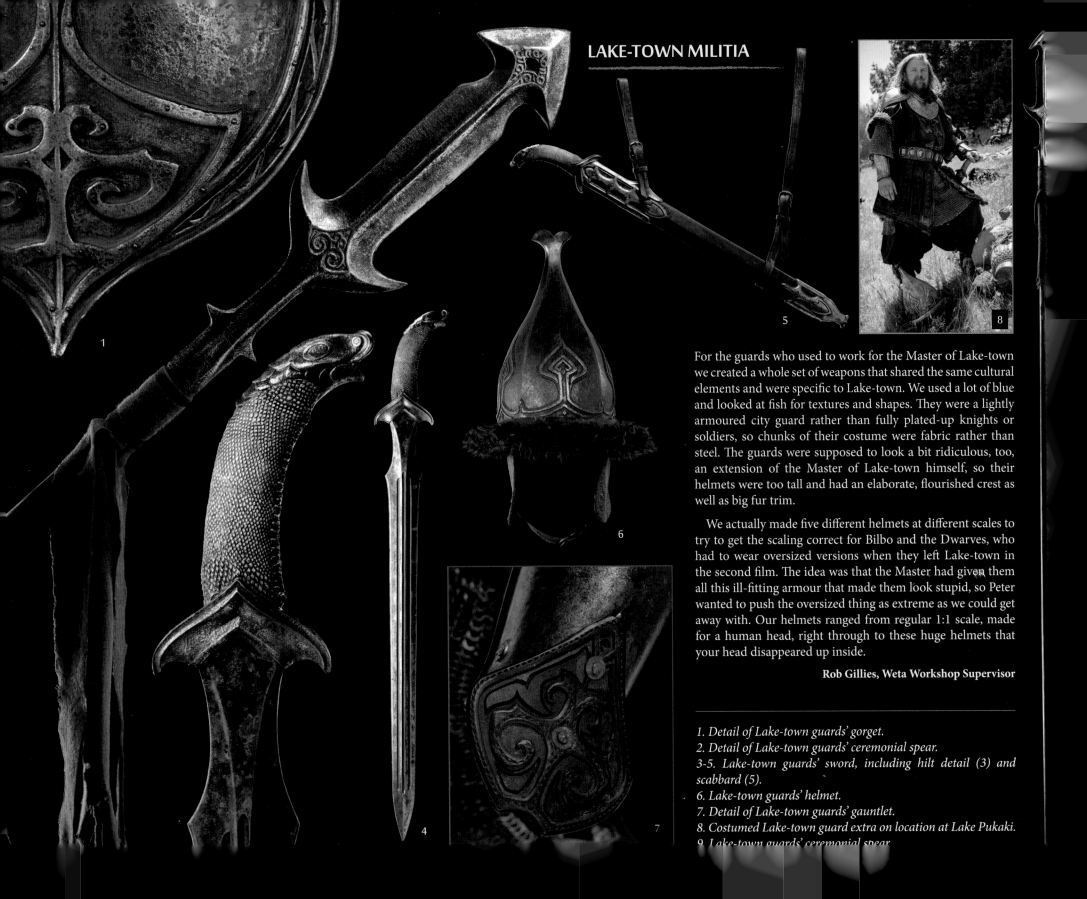

LAKE-TOWN MILITIA

For the guards who used to work for the Master of Lake-town we created a whole set of weapons that shared the same cultural elements and were specific to Lake-town. We used a lot of blue and looked at fish for textures and shapes. They were a lightly armoured city guard rather than fully plated-up knights or soldiers, so chunks of their costume were fabric rather than steel. The guards were supposed to look a bit ridiculous, too, an extension of the Master of Lake-town himself, so their helmets were too tall and had an elaborate, flourished crest as well as big fur trim.

We actually made five different helmets at different scales to try to get the scaling correct for Bilbo and the Dwarves, who had to wear oversized versions when they left Lake-town in the second film. The idea was that the Master had given them all this ill-fitting armour that made them look stupid, so Peter wanted to push the oversized thing as extreme as we could get away with. Our helmets ranged from regular 1:1 scale, made for a human head, right through to these huge helmets that your head disappeared up inside.

Rob Gillies, Weta Workshop Supervisor

1. Detail of Lake-town guards' gorget.
2. Detail of Lake-town guards' ceremonial spear.
3-5. Lake-town guards' sword, including hilt detail (3) and scabbard (5).
6. Lake-town guards' helmet.
7. Detail of Lake-town guards' gauntlet.
8. Costumed Lake-town guard extra on location at Lake Pukaki.
9. Lake-town guards' ceremonial spear.

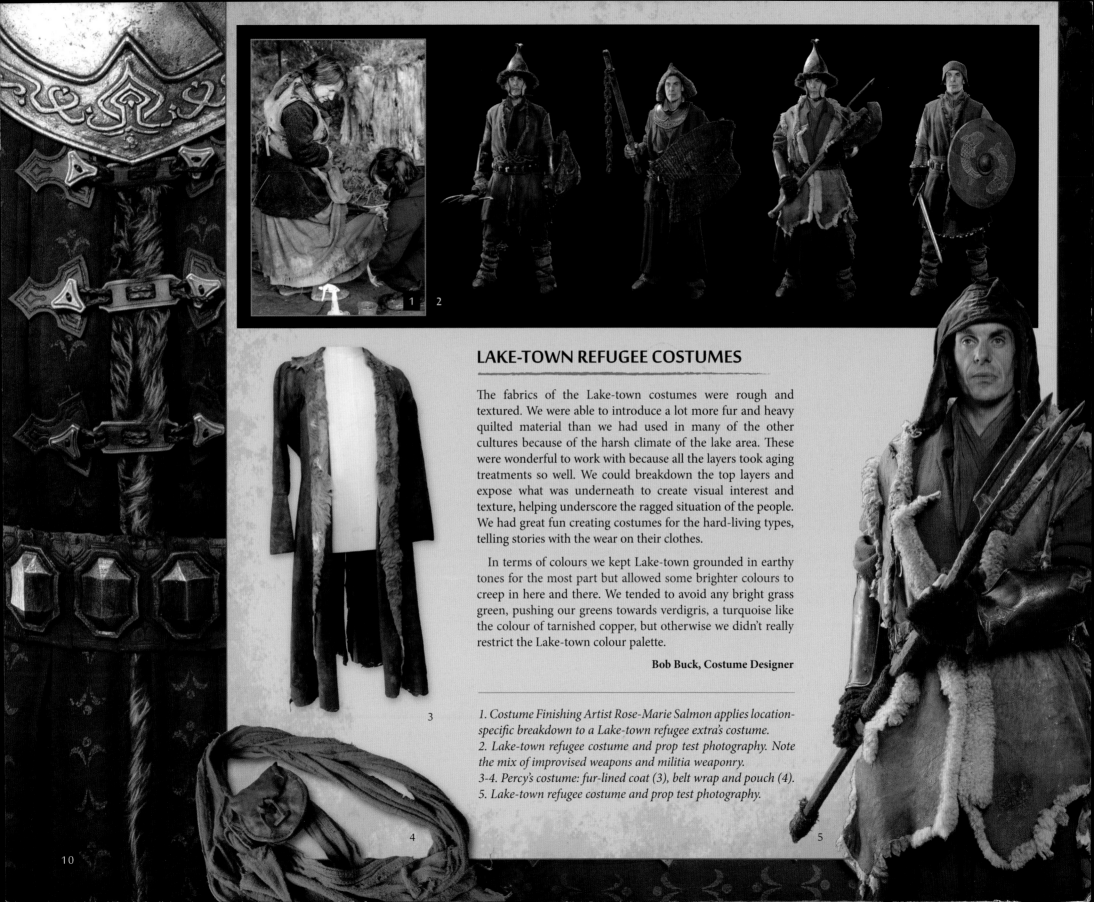

LAKE-TOWN REFUGEE COSTUMES

The fabrics of the Lake-town costumes were rough and textured. We were able to introduce a lot more fur and heavy quilted material than we had used in many of the other cultures because of the harsh climate of the lake area. These were wonderful to work with because all the layers took aging treatments so well. We could breakdown the top layers and expose what was underneath to create visual interest and texture, helping underscore the ragged situation of the people. We had great fun creating costumes for the hard-living types, telling stories with the wear on their clothes.

In terms of colours we kept Lake-town grounded in earthy tones for the most part but allowed some brighter colours to creep in here and there. We tended to avoid any bright grass green, pushing our greens towards verdigris, a turquoise like the colour of tarnished copper, but otherwise we didn't really restrict the Lake-town colour palette.

Bob Buck, Costume Designer

1. Costume Finishing Artist Rose-Marie Salmon applies location-specific breakdown to a Lake-town refugee extra's costume.
2. Lake-town refugee costume and prop test photography. Note the mix of improvised weapons and militia weaponry.
3-4. Percy's costume: fur-lined coat (3), belt wrap and pouch (4).
5. Lake-town refugee costume and prop test photography.

LAKE-TOWN REFUGEES AT WAR

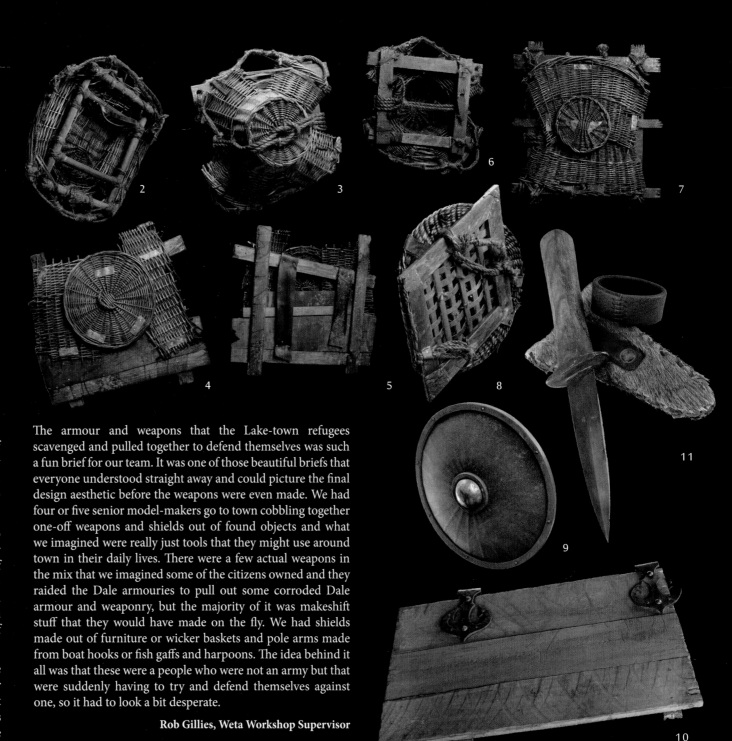

The Lake-towners who took shelter in Dale were not fighters. As per Peter's direction, they had no army, just a bunch of guardsmen who were out of shape and totally outmatched by the Orcs. They'd never had a serious problem to contend with, so they were out of their depth. If the Elves hadn't shown up they would have been history.

The comparative helplessness of the Lake-towners also meant that Bard stood out as different. He was a character with a warrior ancestry who could take care of himself, and of course he was an accomplished bowman. The people of Lake-town needed him to protect and lead them. Most didn't even have weapons. They were able to find some in the armoury in Dale, but otherwise it was all pitchforks and makeshift stuff they could scavenge and put together.

Initially, just the men went out to fight, but in the end the women joined them as well, and it was only by using their wits that they could contend with the Orcs. They had to fight more cleverly, creating traps or ambushes to contain enemies that they couldn't match in brute strength or training. As we designed the action it was all about demonstrating that this was a desperate fight, a fight for survival waged by people who weren't warriors. It had to be a fight they really couldn't win on their own, regardless of how brave or smart they were, thereby reinforcing how important Bard's leadership would be to them.

Glenn Boswell, Stunt Co-ordinator

The armour and weapons that the Lake-town refugees scavenged and pulled together to defend themselves was such a fun brief for our team. It was one of those beautiful briefs that everyone understood straight away and could picture the final design aesthetic before the weapons were even made. We had four or five senior model-makers go to town cobbling together one-off weapons and shields out of found objects and what we imagined were really just tools that they might use around town in their daily lives. There were a few actual weapons in the mix that we imagined some of the citizens owned and they raided the Dale armouries to pull out some corroded Dale armour and weaponry, but the majority of it was makeshift stuff that they would have made on the fly. We had shields made out of furniture or wicker baskets and pole arms made from boat hooks or fish gaffs and harpoons. The idea behind it all was that these were a people who were not an army but that were suddenly having to try and defend themselves against one, so it had to look a bit desperate.

Rob Gillies, Weta Workshop Supervisor

1. Aged, broken down Dale guards' shield.
2-10. Lake-town refugee shields, including improvised items (2-8, 10) and one borrowed from an unidentified Middle-earth culture (9).
11. Bain's knife and scabbard.

You might think that we all know how to move like a person, so someone playing a character from Lake-town, for example, wouldn't need any coaching; but as we found out when we started, it's not that straightforward. People have history. These people have lived in a different way than most of us have experienced in our lifetimes. The harshness of their lives and the sense of community and work ethic they might have all contribute to how they express themselves when moving.

I had the opportunity to work with the Lake-town militia, creating organized formations and movements that were reflective of their society and how they would defend themselves. It contrasted with how the other races moved as armies. The Dwarf army moved in blocks, while the Elves had pyramids with more ornate formations that came out into a wing and then flipped back into a pyramid again, then broke off into threes. They were all about sharp angles where the Dwarves were blocky and stout. The Lake-town militia were ragtag. We made sure they weren't too sharp or too good, but still looked like they had been a polished military at some point. Now it's a day job for them, like any other.

The entire experience has been such an amazing thing, working with Peter. He is so open and willing to embrace new ideas. I can go and pitch some ideas to him, knowing that they are all heard, and that the best ones will be assimilated into the film.

Terry Notary, Movement Coach

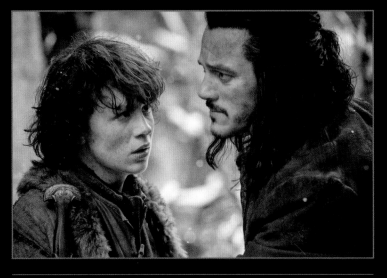

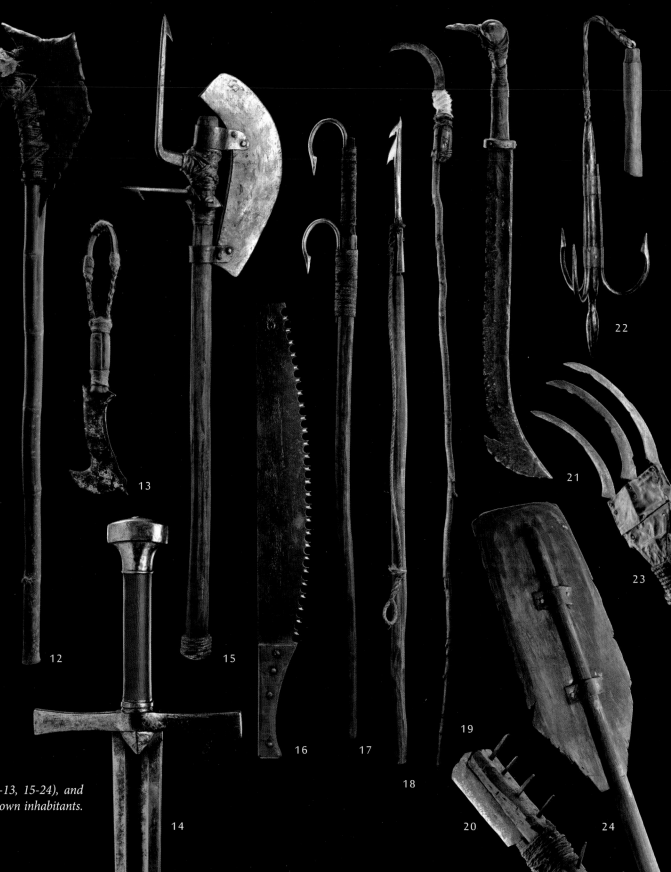

12-24. Lake-town refugee weaponry, including improvised weapons (12-13, 15-24), and weapons borrowed from other cultures (14), presumably owned by Lake-town inhabitants. Lake-town was conceived to be populated by a mix of cultures.

DEFENDING DALE

The ruins of Dale became a home and shelter for the displaced people of Lake-town. It was a grizzly, grim place, frozen and essentially unchanged since Smaug destroyed it and killed almost everyone. We had already built a huge outdoor set to represent Dale in its original condition, so we had a place to start with which was redressed to a state of ruin. It would play stage to a big chunk of the battle in the final film when Orcs broke in and fought Lake-towners and Elves through the streets.

It was important that Dale look authentic. We looked at places that were devastated by a sudden, powerful force, including Hiroshima and Nagasaki. What we learned influenced how we dressed the ruins, though we were careful not to overplay any direct comparisons to what happened in Japan.

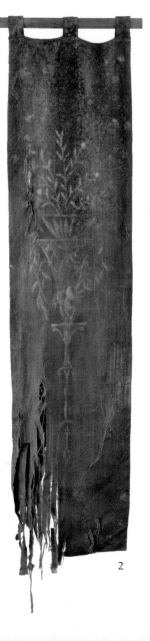

The streets of Dale were dressed with bodies, the concept being that no one had hung around to bury them. Some were skeletal, but others were petrified, as if the Dragon's breath had cooked them instantly, but in the cold, sterile aftermath of the attack they hadn't decayed. There were also places where we created impressions of bodies on walls where they had been incinerated. It was very grim stuff. Probably the saddest sight in the whole set was the destroyed children's carousel with its sculptural animals hanging broken or strewn around.

We took what had been a beautiful, bountiful set that represented a time and place of plenty in Middle-earth and meticulously broke it in a manner that was consistent with the desolation wrought by the Dragon's sudden, ferocious attack. It was a firestorm rather than an explosive attack, so most of the stone structure of the town remained and even some of the timber elements, but it has been flash-burnt and the left to gradually disintegrate. Inside the buildings we had a lot of evidence of broken tiles and collapsed floors or roofs, and everything was blanketed in a layer of snow.

Dan Hennah, Production Designer

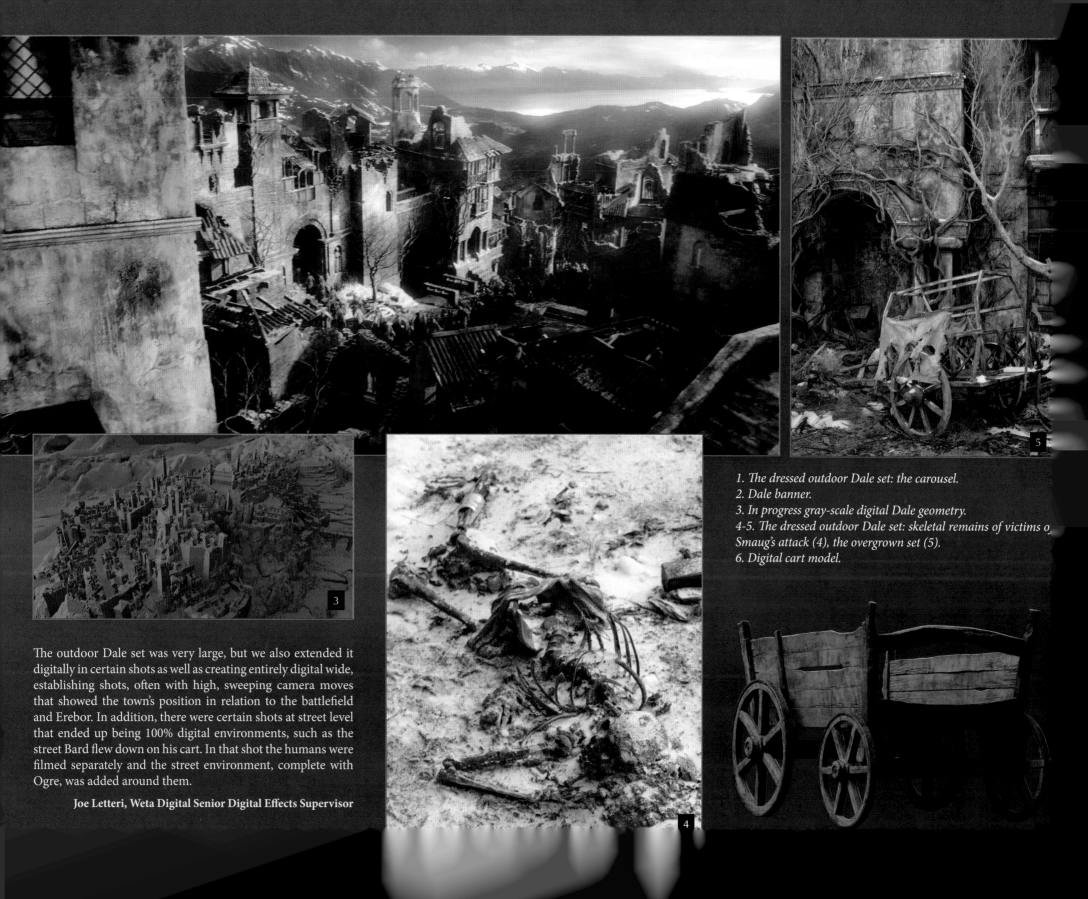

1. The dressed outdoor Dale set: the carousel.
2. Dale banner.
3. In progress gray-scale digital Dale geometry.
4-5. The dressed outdoor Dale set: skeletal remains of victims of Smaug's attack (4), the overgrown set (5).
6. Digital cart model.

The outdoor Dale set was very large, but we also extended it digitally in certain shots as well as creating entirely digital wide, establishing shots, often with high, sweeping camera moves that showed the town's position in relation to the battlefield and Erebor. In addition, there were certain shots at street level that ended up being 100% digital environments, such as the street Bard flew down on his cart. In that shot the humans were filmed separately and the street environment, complete with Ogre, was added around them.

Joe Letteri, Weta Digital Senior Digital Effects Supervisor

Thranduil set up his headquarters tent in the ruins of Dale where he, Bard and Gandalf debated what to do about Thorin. The tent was made with textiles printed by our Soft Furnishings Department, led by Letty Macphedran.

Dan Hennah, Production Designer

I think when Thranduil marched on the Lonely Mountain with his army he did so with no expectation of meeting any serious resistance. He came with an overwhelming force to inspire awe and get what he wanted without having to lift a sword. He expected to meet some refugees and perhaps thirteen Dwarves, assuming they were even still alive. He expected them to be awed into submission by his show of power, so the fight would be over before it could begin. It's the old stag with the grandest rack of antlers in the forest rattling them so that all the young bucks shy away, too afraid to challenge his obvious superiority.

Instead, what Thranduil got was a series of surprises and ultimately a battle that would reshape his outlook on the world.

Lee Pace, Actor, Thranduil

Bard essentially represents the humanity of the story, so when he was confronted by Thranduil, who was a very selfish character, thousands of years old, embittered and willing to go to war over jewellery, I think what we saw was a man trying to break Thranduil's veneer of harsh Elven coldness. Bard had no wish to see more bloodshed, nor expose his children to more terror and pain. Thranduil is like an aristocratic millionaire while Bard is a humble working class man. Beings from two very different worlds, he and Thranduil would never have met had it not been for the situation at the Mountain, so they are forced to collaborate

in order to achieve what they realize are very different but not incompatible aims. There was a lovely scene in which Gandalf was talking and Thranduil looked over at Bard and raised his eyebrows; here we go again; a great demonstration of the understanding they had come to, together.

Luke Evans, Actor, Bard

Thranduil respected Bard. I think in Bard he saw a man with honour, strength and dignity, with whom he could work. What's more, Bard killed the Dragon. What's next? If that doesn't earn respect, what would you have to do? There is nothing but respect and honour for a man who has done something like that.

While we were filming I found that relationship really interesting. Thranduil had fought Dragons, so he knew how hard they were to kill, and this man had killed one, so whatever he needed Thranduil was happy to provide. Thranduil would stand by his side. Besides, Bard might be the solution to the Dwarf problem.

Lee Pace, Actor, Thranduil

1. Detail of Thranduil's tent fabric.
2. Elven glassware and metalwork props from Thranduil's command tent.

THE COURAGE OF HOBBITS

There's no Bilbo like Martin Freeman. I have such admiration for him as a person and as an actor and what he understood about Bilbo Baggins, the courage inside this very normal little man who found himself going through such a wild experience. Martin brought such a great sense of humour and reality to his hobbit. He gave the audience eyes to see these Elves and Dwarves and Dragons. From that point of view I think *The Hobbit* is magical, and Bilbo is wonderful.

I especially enjoyed the moment when Thranduil realized that this little creature, Bilbo, was the one who had stolen into his kingdom and snuck the Dwarves right out of his own dungeon. I don't think that Thranduil had ever seen a hobbit before. He was very, very old and had seen a lot. He had fought Dragons, met the Kings of Men and Elves, he had experienced so much in the thousands of years that he had inhabited Middle-earth, but I don't think he had ever seen a hobbit before, because they didn't venture out much. Thranduil looked in astonishment at this inexplicable thing that Bilbo was doing, bringing the Arkenstone from the Dwarven King. For the Elf it was like looking at an alien. Bilbo was a delightful, perplexing little alien who behaved in an utterly surprising way and completely changed everything with that act of courage. That was an incredible surprise, and, as wild as Thranduil might be, he was not without sensitivity to its significance.

Lee Pace, Actor, Thranduil

Bilbo surprised Gloin. I don't think he had any confidence in this funny little fellow at the beginning. Gloin was a sceptical old fart. How could someone so young, small and vulnerable possibly be anything other than a burden to them? Even if he was hand-picked by Gandalf, well, that didn't necessarily assuage the doubt.

So, when Bilbo put himself on the line for Thorin during the Warg attack in the first film, that was a massive turning point for Gloin and he began to look at the hobbit very differently, seeing his qualities evolve and unfold. Bilbo demonstrated his worth many times during the journey. His inventiveness and courage saved them all, so in addition to acknowledging Bilbo's genuine value to their cause as an asset, Gloin also developed an affection for him, something which only grew once they reached the Mountain.

Martin is a rare actor. I don't think I've ever met or seen an actor at work with such an extensive tool kit. He really is gifted and something very special. He was a privilege to work with and watch.

Peter Hambleton, Actor, Gloin

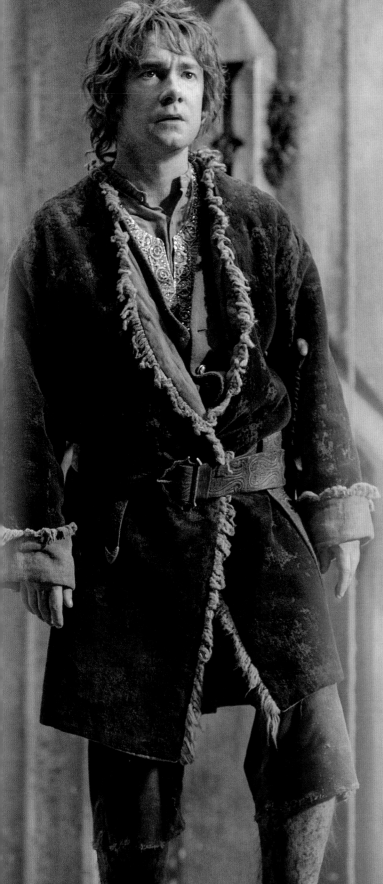

I did the fight training with everyone else, and loved it. General fitness stuff, sword training, rolling around with the stunties and our scale doubles – that went on for ages. I know I wouldn't have been able to cope with some of the shoot as well as I did without the know-how that we all obtained during that time. We got fitter, for a start, which we needed to be, especially the Dwarves in their fat-suits and costumes, which weighed a ton. We also got to know our stunt doubles, and trust that we were in good hands with them. My double, Brett Sheerin, was tremendous. Even though he was fantastically skilled, fit, and brave to the point of foolhardiness, he always let me do my own stunts. He literally never did a single one. He went to Italy twice on holiday, because he knew he wasn't needed – a helluva guy.

Martin Freeman, Actor, Bilbo Baggins

What a phenomenon Martin Freeman is. He was the heart of the journey; Peter cast that role superbly. When he went into battle and pulled out his sword, you could see in his body that he knew he was going to die, you could see the decision and resignation going through his mind. There is that expression about wearing your heart on your sleeve. Martin's Bilbo, more than any character in these films really did that. His character carried the audience through the films and presented the barometer for how things were. It was an outstanding performance.

Jed Brophy, Actor, Nori

In preparing for the moment at the beginning of the first film of *The Hobbit*, where Gandalf returned to Hobbiton in search of the small burglar who would be crucial for the Dwarves' Quest, I suggested an earlier scene in which Gandalf and the boy Bilbo might meet and we could see the beginning of their bond; it would explain Gandalf's initial disappointment when he met the grown-up Bilbo, devoid of childish vigour and curiosity, now a staid stay-at-home who didn't like adventures. Here we saw the genesis of their friendship and the potential that lay within the character of Bilbo, if only he were given a little 'shove out of the door'.

Perhaps it was easy for an actor of Martin Freeman's ability to imagine a character who discovered himself through the varying exploits of his journey to the Lonely Mountain, but I don't know anyone of his generation who could have displayed it with such sensitivity and believability. Watching him up close, in front of the camera, was always fascinating for this actor who is still trying to learn how best to accommodate the intimacy of the relationship between actor and camera.

Sir Ian McKellen, Actor, Gandalf the Grey

Bilbo's journey as a fighter was probably the most extreme of any of the characters. When he began in the trilogy Thorin described him as a grocer. He was completely raw and we got to see him grow into his role, fighting to save his friends and gaining courage and confidence as he went. He developed in his ability to use his little sword until by the end you could see he was comfortable with it in his hand, even if he wasn't a warrior. His was the biggest arc we had to deal with in terms of fight training and showing his progression, but we didn't want the hobbit to end up as some kind of kung-fu master by the final film. It was important that Bilbo's arc was realistic, so while he might become more comfortable fighting, it was really a reflection of his emotional state, his courage and gradual improvement that came with familiarity with his weapon. When he began the journey he was completely out of his depth, but by the end he had figured out ways to get himself out of trouble.

Brett Sheerin was Martin Freeman's double. The two had a great rapport. We would work out a sketch of a fight with Brett and then he'd talk it through with Martin, who would add his own layer of Bilbo's character. We'd re-rehearse it and then put Martin through the routine until he felt it was good enough to be signed off. Martin's style was what I would call accidentally acrobatic. It wasn't as if he set out to be that way, but with the impromptu style that Martin employed with his physical humour, that is the way Bilbo ended up.

In addition to using Sting, Bilbo was a pretty good rock-thrower, which seemed to be a thing for hobbits in these films. He didn't do a lot of it, but not having a bow and not really being someone who would want to get into close combat with these huge Orcs, he used what he had at hand to try to keep them at bay for a little while before being knocked out.

Glenn Boswell, Stunt Co-ordinator

GANDALF THE GREY IN DALE

Throughout his many years in Middle-earth Gandalf has undertaken his mission of caring for its varied inhabitants by establishing close relationships with all the different races. He was the sort of diplomat whom everyone trusted and who enemies did not underestimate. Hence, Gandalf's real power; he may have been the bearer of the Ring of Fire and a Servant of the Secret Fire, but his individual strength seemed to come more from his personality and genuine concern that everyone should get on for the common good.

Gandalf's journeyings to and fro have brought him into regular close contact with the high, the mighty, the low and vulnerable, to such an extent that they occupied his every waking moment. Gandalf had no private life away from his mission; no secret domesticity; was always on duty. His reward was the friendship, even love, of people as varied as Galadriel and Frodo.

Sir Ian McKellen, Actor, Gandalf the Grey

It was fun to disagree with Gandalf. Thranduil was powerful and he simply disagreed with this Wizard whom he was convinced was simply meddling, stirring up a problem where there wasn't one. Mithrandir had been aiding the Dwarves all along, and it was time that came to an end. As far as Thranduil was concerned, the 'children' were no longer going to be running Middle-earth, because that was how he saw them, as children. Dwarves, Men were lesser beings lacking the wisdom of ages that the Elves possessed. They were so inexperienced, and he had the power with his grand army to put a stop to it, which he was happy to do without hesitation and without any concern for whether the Wizard liked it or not.

It was very simple to Thranduil. He was coming to get what he wanted. He wasn't talking politics and he wasn't interested in what the Dwarves might be after or trying to accomplish. It was all immaterial to him. He didn't care. Now that the Dragon was dead he wanted his jewels back and that was all.

Lee Pace, Actor, Thranduil

Bard might not have understood everything that Gandalf was trying to achieve or where he was coming from, but he had respect for him because the Wizard was trying to prevent a war. Gandalf came riding in out of nowhere, but he had knowledge and was talking sense, so I think Bard was quick to appreciate that he was someone to listen to and work with.

Luke Evans, Actor, Bard

1. Sir Ian McKellen as Gandalf and Luke Evans as Bard, on set in Dale, shooting a moment during the defence of the city.
2. Director Peter Jackson reviews the script with Martin Freeman as Bilbo and Sir Ian McKellen as Gandalf the Grey and the battlefield set.

Jonathan Costelloe was Gandalf's stunt double. Jono doubled Sir Ian McKellen back in *The Lord of the Rings* as well, so he was very confident with the sword and staff combo. Much of that work had originally been devised with Jono, so that was good, because he had Sir Ian's movement down to a fine art. We wanted Gandalf to appear very capable and efficient in his movements, but it was also important that he remain in character, which is where a close working relationship between the actor and their stunt double is important. We picked certain moves that Sir Ian was proficient at and shot those with him so that they could be intercut with his double doing bigger, flashier moves in a manner that still felt very much like it was Gandalf and he hadn't suddenly become a superhero. Peter also framed tight battle shots that were close on Ian as his sword went whizzing by with speed and power; this helped keep it all feeling very contained so that there was no jarring switch between the actor and double. Ian was actually capable of doing quite a lot, but we were naturally cautious because we didn't want to risk him hurting himself doing something a stunt person could do, and then not have him available for his dramatic scenes.

Glenn Boswell, Stunt Co-ordinato

1

Among Dwarves there was a natural distrust for anyone that wasn't of the same race, but that was less inherent in Fili's nature, in part because of his youth and inexperience, but in terms of knowing the Wizard, Gandalf was probably always something of an unknowable entity. Thorin distrusted him, knowing that he was never showing his entire hand, but I think with Fili and Kili there was more of a simple healthy scepticism of anyone's abilities or motives until they're proven. It wasn't a distrust grounded in experience like Thorin's might have been. If anything, the way that Sir Ian McKellen played Gandalf was always quite charitable and protective towards us younger Dwarves. I think Fili and Kili were happy to have a Wizard along with them on the quest.

Dean O'Gorman, Actor, Fili

I loved Bilbo's relationship with Gandalf. Gandalf of course, was the one who got Bilbo on the journey, so he was very protective of him. He remembered Bilbo as a small boy who loved to hear tales of adventure, and knew that somewhere inside him was still that boy, more Took than Baggins; more his mother's daring side than the staid man he had become.

I think Gandalf really wanted Bilbo to experience the world, for better and worse; he didn't lie to him. At the very beginning of the journey, in Bag End, Gandalf told him that if they survived, he wouldn't be the same hobbit he was before. That scared Bilbo, but it excited him too. Gandalf was right, and Bilbo was more than he knew himself to be, as we saw by the end.

2

DWARVES OF THE IRON HILLS

The raven's return heralds the arrival of Dain, cousin to Thorin and Lord of the Iron Hills, a Dwarf Realm to the east. Astride a burly, armoured boar, Dain Ironfoot trots down the flank of the Mountain to hurl insults and threats at the host of Elves and Men assembled outside his cousin's gate.

In short order battle commences and the army of several hundred grim-faced soldiers of the Iron Hills descend the slope to match their axes against the swords and spears of the Woodland Realm. Thunderous, ram-drawn Dwarf war chariots clatter onto the battlefield, flanked by nimble-footed mountain goats bearing Iron Hills riders armed with spears and short, straight swords. Dwarven countermeasures fly to tear Elven arrows from the sky, and squat, doughty, bearded foot soldiers hurl abuse and guttural taunts in Khuzdul at their impassive, silent Elven adversaries.

Though the clash is brief, interrupted by the sudden eruption of Azog's were-worms, it is bloody and brutal, and both Elven and Dwarven dead lie upon the field before the forces unite against their common foe.

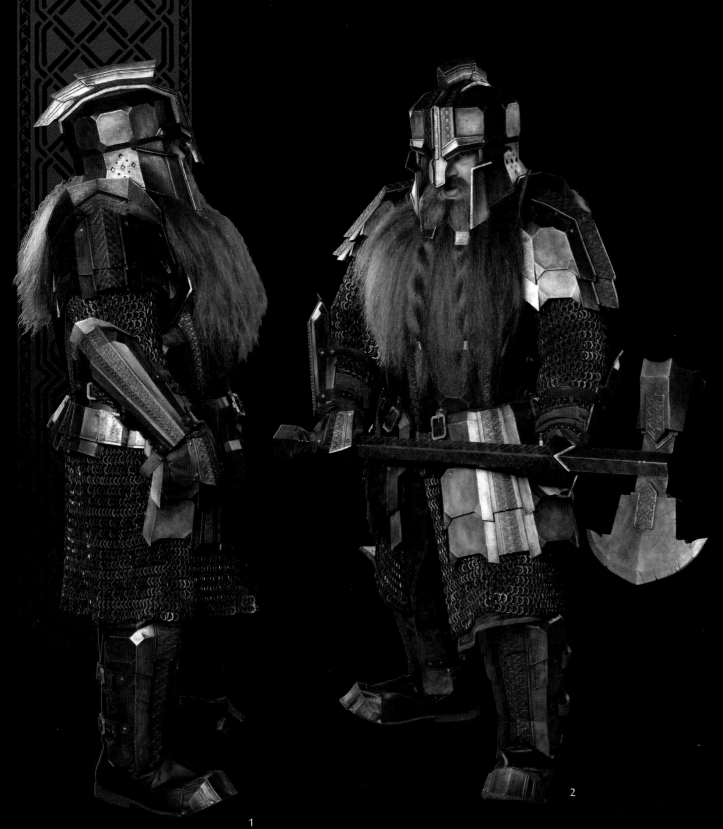

DWARF SOLDIERS OF THE IRON HILLS

We went through a few colour changes on the Dwarf armour before settling on the bluish steel patina. We had made so many armies for Middle-earth by this point that coming up with a totally new colour scheme that wasn't crazy took some time. It went around and around a bit, bouncing off other armies we had done, while we looked for something that could become iconic to the Dwarves of the Iron Hills. In the end it came down to a bluish steel with red-brown trim.

Rob Gillies, Weta Workshop Supervisor

Dain's Iron Hill Dwarves were mostly dark haired or grey. We intentionally avoided including warmer colouring, like Gloin or Bombur had, because we wanted the army to appear grim, dark and fierce, and also permit Dain to stand out as strikingly different with his screaming red beard. It was important that Dain and the other hero Dwarves be easily distinguishable amid the mayhem of battle and stand apart from the rank and file soldiers, hence the more muted tones on the army in comparison to our heroes' brighter hues.

Peter King, Make-up & Hair Designer

1

2

3

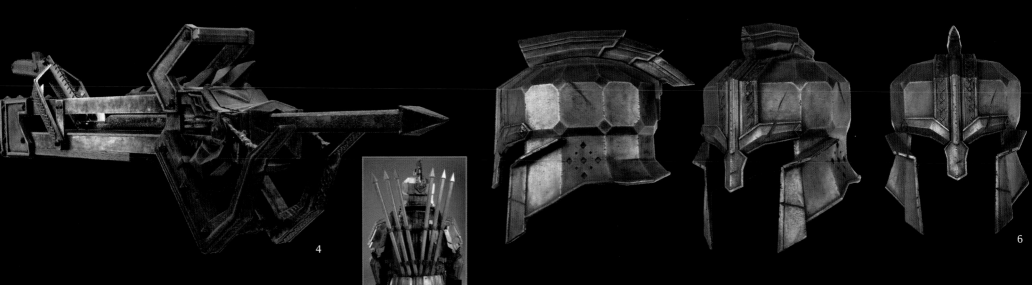

The Dwarves were a very grounded race, so they were never going to be leaping around doing kung fu. Everything with the Dwarves was heavy. They were a tough race and so their movements were disproportionately strong compared to humans. We imagined them as a brave people with a history as a warring nation. They knew how to fight, and that became part of their choreography.

As an army they were like little bull terriers, all gristle and muscle, fearless and grunty. We had them slamming their shields down into a wall formation. Everything they did was carried out with a lot of power. They weren't as synchronized as the Elves, or as fast, but they were very strong, with firmly planted feet.

One of the most important things about the Dwarves was that we wanted them to feel like they could truly take the blows when they came, blocking and countering well. So, in terms of their fighting moves, the basic routine we had was a block and strike. To simulate the impacts of the Orcs rushing the Dwarf shield formation, we went crazy, hitting the Dwarf stunt guys with giant punch-bags or whatever we could swing at them to send the poor buggers flying and make the impacts look solid.

The Dwarf army had a range of weapons including different axes, hammers, spikes, swords, shorter knives and long spears. While their armour was fairly uniform, their weapons were quite varied. There was also a kind of crossbow with under-slung arms that looked like pig tusks.

Glenn Boswell, Stunt Co-ordinator

We developed practical, firing crossbows and made them at two different scales for the Dwarf army. They were single-shot weapons with a cranking mechanism at the back which would crank forwards, tensioning the bowstring. Unlike a conventional crossbow with its outstretched, horizontal arms, on the Iron Hill projector the arms were made to look like boar tusks and hung down. It had a system that was almost like a counterweight, so as the crossbow was cranked the tusks would rotate upwards and then slash down and forward when the trigger was released, the bolt firing out of the boar's mouth. It was a really cool and original design. There was also a back rig that was devised that held extra bolts for reloading.

Rob Gillies, Weta Workshop Supervisor

The Dwarves' crossbows were very complicated to build. Part of the challenge was the volume, because we needed something like twenty at Dwarf scale and then another twenty for the small-scale doubles. The first twenty were made in barely two weeks and the second batch in even less time, so it was an intense period of activity for our crew. Peter was keen to see something that was different to a conventional crossbow with its horizontal bow, so Callum Lingard created a unique mechanism for our Iron Hill weapon here at Weta Workshop and then we designed and built the crossbow around it.

They were functional props, able to fire a light bolt a reasonable distance or a heavier one a shorter distance with enough force to puncture a slab of polystyrene twenty centimetres thick.

We smashed them out very quickly. It was a high energy time and the pressure was on because we were delivering so much for all of the armies at the same time, but we still had a ball making them. We created a production line with everyone doing their specific task and it flowed very well.

Lee Pace's brother Will was one of our team members, and Lee had a bit of time to spare in his afternoons after completing his photography in the mornings, so he actually came in and spent a few days with us, helping to make Dwarf crossbows. He came into Weta Workshop and just hung out with us, having fun and joining in on our assembly line to help us bust out the bows; a very humble and unassuming guy enjoying making cool stuff with us.

Alex Falkner,
Weta Workshop Props Model Making Supervisor

1-2. Iron Hills Dwarf soldier, costume and make-up test.
3. Iron Hills Dwarf shield.
4. Loaded Iron Hills Dwarf 'boar-lista' crossbow.

5. Crossbow bolt back rig.
6. Iron Hills Dwarf helmet.
7. Detail of Iron Hills Dwarf crossbow, unloaded.

1 2

While the standard trooper had brownish-red trim lines running through his armour, we made officer variants that replaced this with an oxidized brass look, so it was greenish gold. The officers also got their own type of helmet, which had stylized boar crests complete with bristly razorback Mohawks. There was more gold trim on their cheeks and nose guard than the regular infantry as well as some chain.

Rob Gillies, Weta Workshop Supervisor

1. *Iron Hills Dwarf officer armour, back.*
2. *Iron Hills Dwarf officer helmet.*
3. *Detail of Iron Hills Dwarf officer armour, front.*
4. *Iron Hills Dwarf shortsword and scabbard.*
5. *Iron Hills Dwarf officer armour.*
6. *Loaded Iron Hills Dwarf crossbow.*
7. *Iron Hills Dwarf shortsword.*
8. *Iron Hills Dwarf axe.*
9. *Detail of Iron Hills Dwarf spearhead.*
10. *Iron Hills Dwarf spear.*

3 4

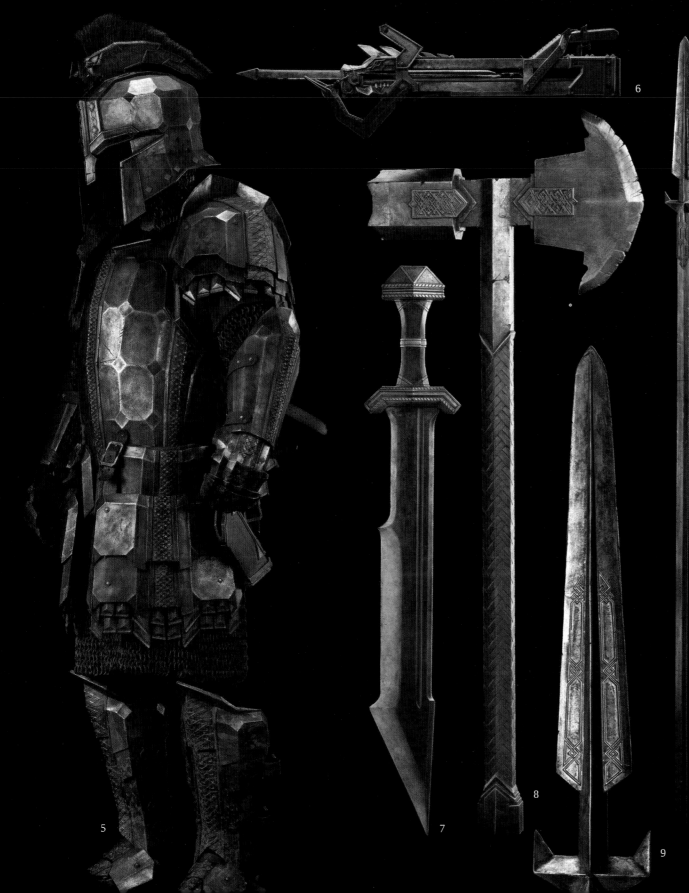

6

5

7

8

9

10

Throughout the filming of the trilogy we had the looming Battle of the Five Armies in the back of our minds, knowing it was coming towards the end of the shoot. Our on-set armour and weapons team imagined that a lot of responsibility would fall our way during that period. In early discussions we were looking at days with possibly as many as 500 extras, but as it turned out, that wasn't the case. Filmmaking has advanced now to the point where computers can be used to populate a battle scene more economically than shooting vast armies of extras. Back in the days of filming *The Lord of the Rings* we had days with 650 extras, but our biggest day on *The Hobbit* was something like 150 extras. It makes more sense now to take a small group of people, shoot them, and then replicate that group multiple times with some tweaks and changes to look like many more, or use entirely digital extras. There is significant work involved in that, but at the same time you haven't had to find, co-ordinate, transport, costume, make-up, feed, water and toilet 650 extras.

Another issue we had to consider was that of performance versus aesthetics. Big armour looks amazing, and in the case of the Dwarves in particular, the idea of these little tanks being covered in plate armour was very appealing. Dwarves are small and stumpy, but they're supposed to be muscly and able to fight just as energetically as anyone less encumbered, bouncing around like little dervishes even under heavy plate. As lightweight as armour can be made using modern materials, there's only so much energetic performance you can coax out of someone wearing that much stuff, because real human beings get tired. Because Dwarves are supposed to be short, their action is shrunk as well, so an actor's giant leap becomes a little jump when scaled, meaning a lot of energy is being expended for very little on-screen pay-off and potentially exhausting the performers. Add in fat-suits and bulky weapons and it would be a struggle for anyone to perform as big as perhaps Peter might imagine when designing eye-popping action sequences for the battle. Digitally animated soldiers can be directed and adjusted right up until final delivery of the film, so they grant the director even more control over his vision. As much as we all love practical movie-making, it was a no-brainer to lean more and more on this approach, and the result has been a greater reliance on digital characters, not only to fill out the army and give the battle appropriate scale, but also to stand in for actors where the action required is physically challenging or impossible. Consequently, the Battle of the Five Armies wasn't the overwhelming ordeal for us in the armour, costume and prop or weapon wrangling departments that it might have been or that we had feared.

Jamie Wilson, Armour & Weapons Production Manager

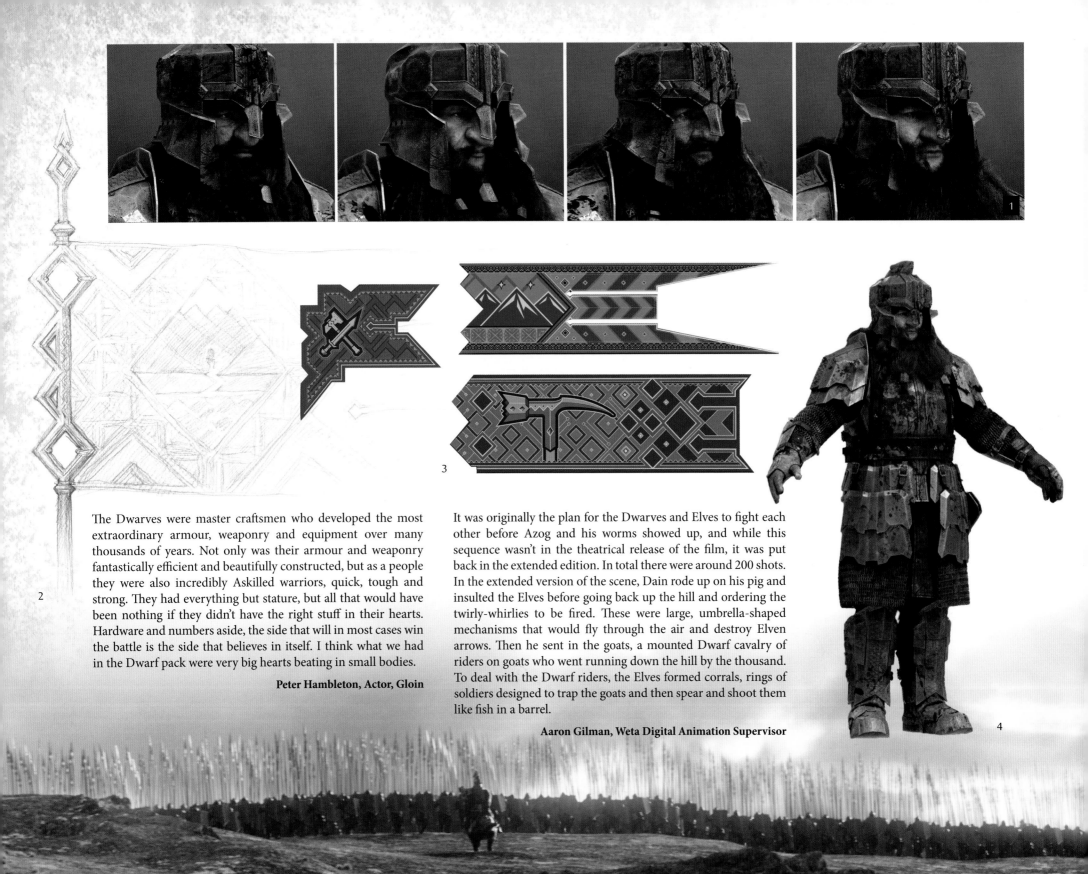

The Dwarves were master craftsmen who developed the most extraordinary armour, weaponry and equipment over many thousands of years. Not only was their armour and weaponry fantastically efficient and beautifully constructed, but as a people they were also incredibly Askilled warriors, quick, tough and strong. They had everything but stature, but all that would have been nothing if they didn't have the right stuff in their hearts. Hardware and numbers aside, the side that will in most cases win the battle is the side that believes in itself. I think what we had in the Dwarf pack were very big hearts beating in small bodies.

Peter Hambleton, Actor, Gloin

It was originally the plan for the Dwarves and Elves to fight each other before Azog and his worms showed up, and while this sequence wasn't in the theatrical release of the film, it was put back in the extended edition. In total there were around 200 shots. In the extended version of the scene, Dain rode up on his pig and insulted the Elves before going back up the hill and ordering the twirly-whirlies to be fired. These were large, umbrella-shaped mechanisms that would fly through the air and destroy Elven arrows. Then he sent in the goats, a mounted Dwarf cavalry of riders on goats who went running down the hill by the thousand. To deal with the Dwarf riders, the Elves formed corrals, rings of soldiers designed to trap the goats and then spear and shoot them like fish in a barrel.

Aaron Gilman, Weta Digital Animation Supervisor

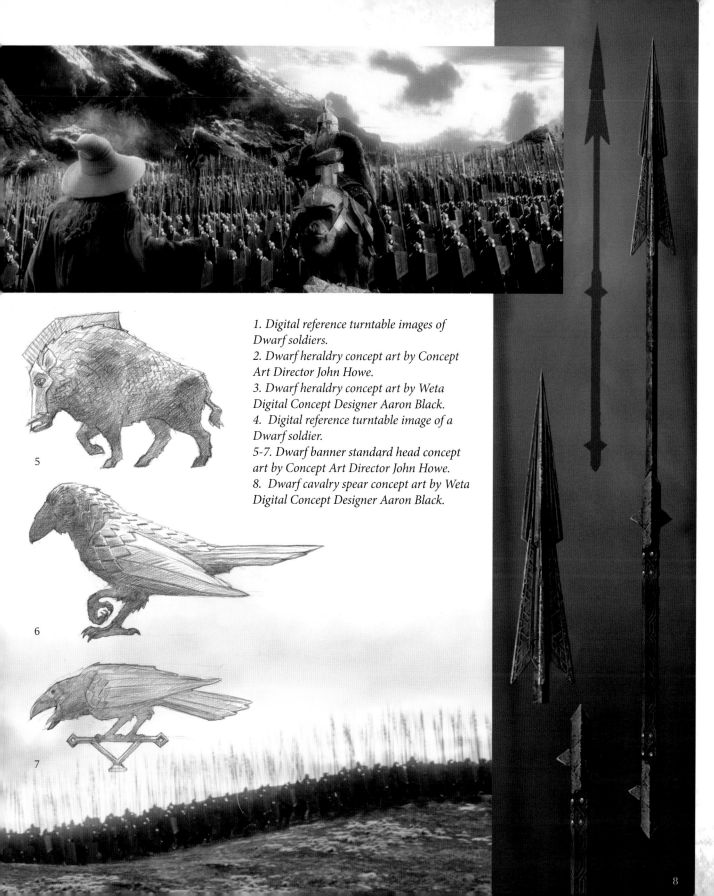

1. *Digital reference turntable images of Dwarf soldiers.*
2. *Dwarf heraldry concept art by Concept Art Director John Howe.*
3. *Dwarf heraldry concept art by Weta Digital Concept Designer Aaron Black.*
4. *Digital reference turntable image of a Dwarf soldier.*
5-7. *Dwarf banner standard head concept art by Concept Art Director John Howe.*
8. *Dwarf cavalry spear concept art by Weta Digital Concept Designer Aaron Black.*

5

6

7

A KING'S PIG: DAIN'S BOAR

Dain's pig went through a few iterations. We actually started out with a much bigger pig, a huge war pig with big tusks, but Peter said he was thinking of making Dain's appearance more of a funny event. He thought it would be funnier to have him waddle in on what was quite a small pig for his size. We tried different sizes to see how small we could make it before it didn't work. Fitting Dain on it with his armour was tricky. We had to enlarge his saddle and push the back of it out several times to fit him into it. It was a cool creature and I know quite a few of the guys in our team enjoyed working on it.

Marco Revelant, Weta Digital Models Supervisor

Dain's pig mount was basically a big Kunekune pig, which was something Peter was adamant about. We had sourced pig reference material and animated a little piggy trot but Peter wasn't satisfied until it looked like the specific breed of pig that he had in mind, the Kunekune. It turned out that one of our animators, Victor Huang, had a Kunekune named Fatty, so we used Victor's pet as reference and Peter approved it right away.

In terms of character, Dain's pig had a lot of armour on its back. Kunekunes actually have very floppy ears that go all over the place when they run, but ours had armour so they didn't move as much. We wouldn't want an Orc lopping them off in battle.

Aaron Gilman, Weta Digital Animation Supervisor

1. *Digital reference turntable image of Dain's boar.*

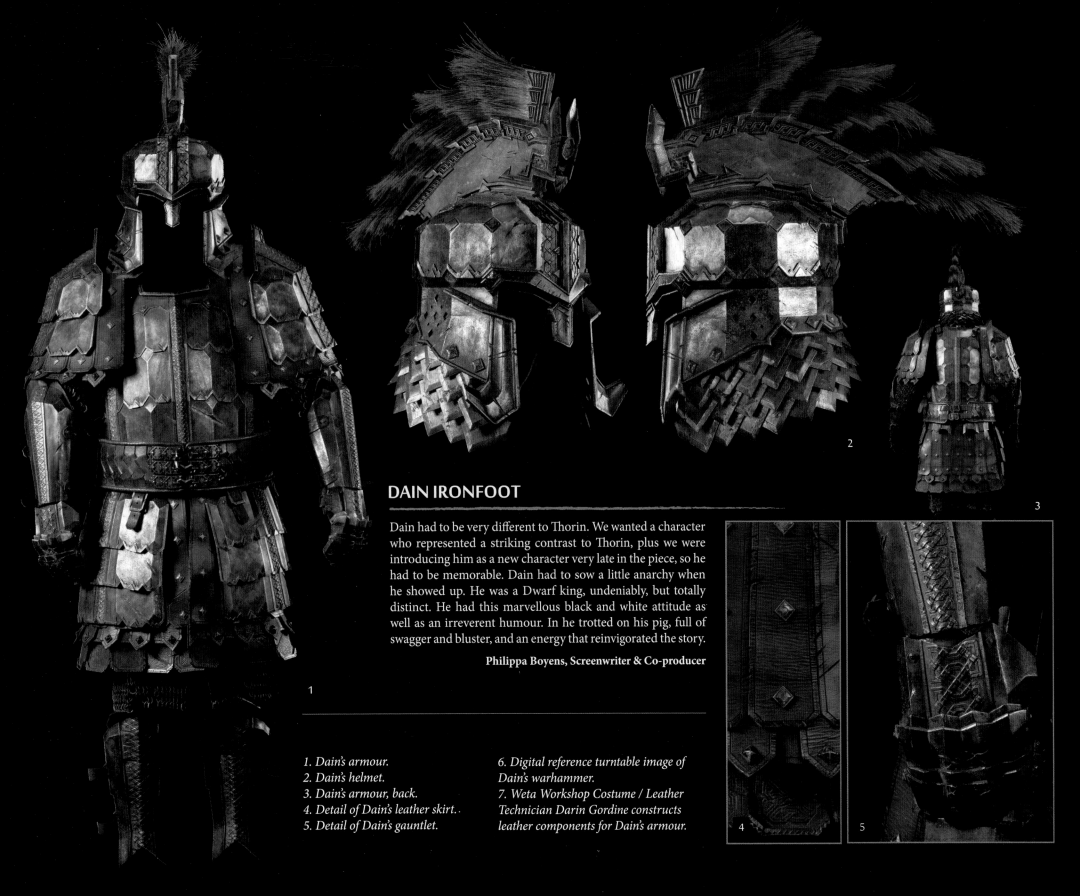

DAIN IRONFOOT

Dain had to be very different to Thorin. We wanted a character who represented a striking contrast to Thorin, plus we were introducing him as a new character very late in the piece, so he had to be memorable. Dain had to sow a little anarchy when he showed up. He was a Dwarf king, undeniably, but totally distinct. He had this marvellous black and white attitude as well as an irreverent humour. In he trotted on his pig, full of swagger and bluster, and an energy that reinvigorated the story.

Philippa Boyens, Screenwriter & Co-producer

1. Dain's armour.
2. Dain's helmet.
3. Dain's armour, back.
4. Detail of Dain's leather skirt..
5. Detail of Dain's gauntlet.

6. Digital reference turntable image of Dain's warhammer.
7. Weta Workshop Costume / Leather Technician Darin Gordine constructs leather components for Dain's armour.

Dain's unique suit of armour was modelled on the basic Dwarf soldier's suit but with lots of embellishments. We incorporated gold and bronze elements as well as rich red leather trim around the pauldrons and skirt to help him stand out from his troops. Going with the boar motif, his helmet had golden tusks and a huge crest with red-tipped black bristles projecting backwards to cut a really striking and jagged silhouette like the back of a razorback pig.

We made a big red axe for him, the idea being that it was cut from a single slab of blood-red stone with subtle veining running through it. It was based on a stylized boar, again, with inset gold eyes. The weapon ended up changing to a digitally-generated hammer in the final film so the axe wasn't seen on screen, but it was a very cool prop.

Rob Gillies, Weta Workshop Supervisor

I got to choreograph Dain's fight. One of the really cool things about Dain was the air of humour that was behind everything he did. There was a joke behind his eyes, a swagger in his step. He would posture and strut around in front of the Elves, and in battle he'd throw himself at the Orcs, quite literally, and had no fear of death.

Terry Notary, Movement Coach

"Tell this rabble to leave, or I'll water the ground with their blood!"
- DAIN IRONFOOT

8. *Dain's warhammer concept art by Weta Digital Concept Designer Aaron Black.*
9-10. *Dain's red stone axe prop, not seen in the film, and detail of the prop's boar motif axe head with gold inlay eye (10).*

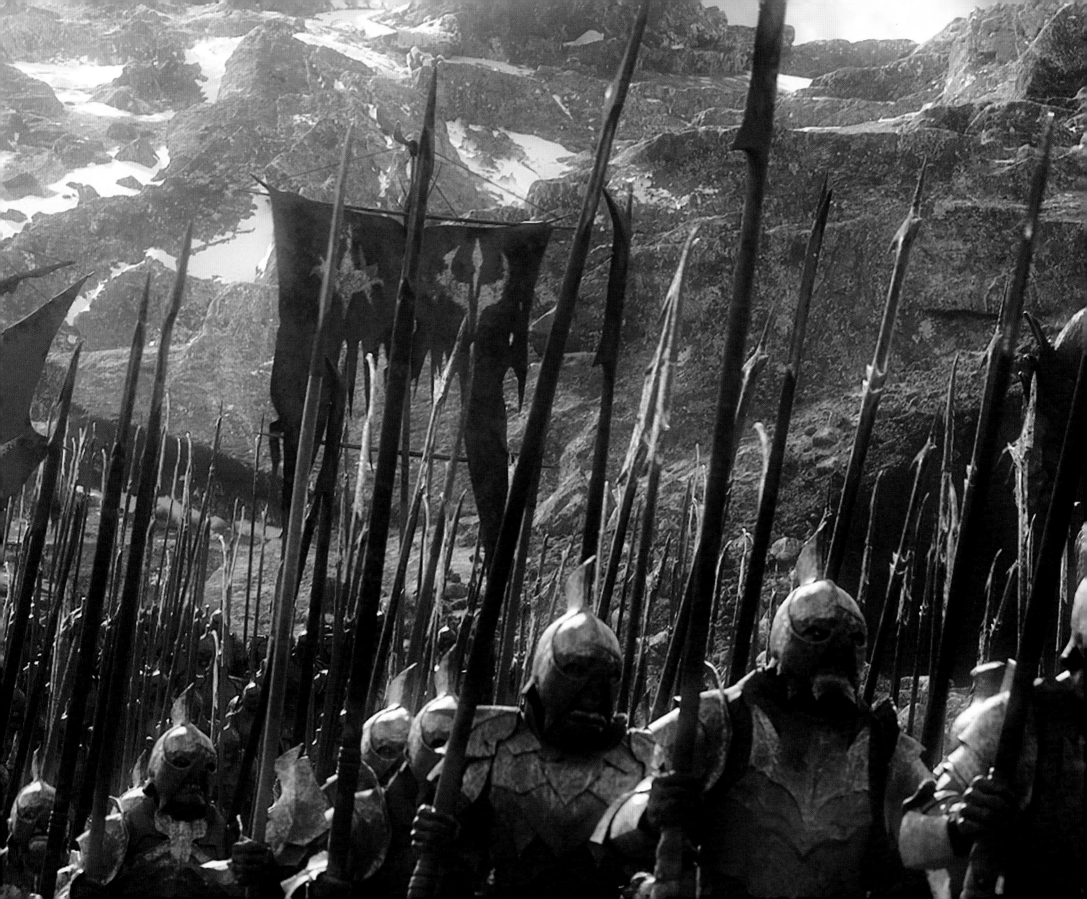

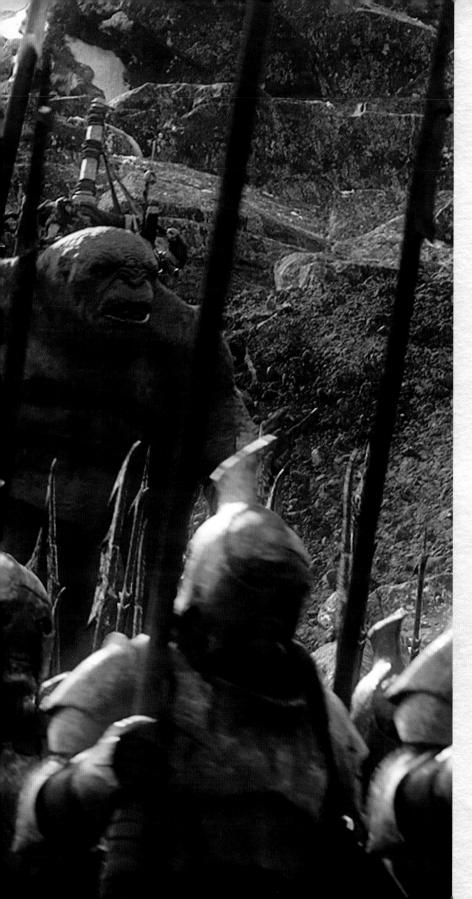

AZOG'S LEGIONS

Colossal were-worms burst from the mountainside, shattering stone and spewing rubble, stunning the assembled armies of Elves, Men and Dwarves, before retreating from the light, back into their holes, from which erupt innumerable ranks of troops. Tall, iron-clad Orcs march in columns bristling with long, barbed spears, while Ogres herd huge, lumbering Trolls bearing war machinery and siege equipment manned by insectile Goblins, scampering across their backs like vermin. While the Siege Trolls smash their way through the defences of Dale, spilling Orcs into the streets, teams of Ogres tackle Dwarf charioteers and Orc lines crash against the allied lines of Dwarves and Elves now fighting in unison in the valley. Giant battle Trolls with blades on their arms wade through the field of battle, scything their way through Elves and Dwarves as if harvesting grain.

Having advanced in secret and gained the summit of Ravenhill, Azog the Defiler, commander of legions and architect of a master battle plan surveys the plain of war. Overlooking Dale and with clear vantage across the bowl of the battle valley as far as the Erebor gate, Ravenhill affords Azog and his war lieutenants an ideal site from which to command their forces. Orders conveyed by signals and horns, the Pale Orc gleefully conducts his vast orchestra of war creatures in a symphony of carnage from this strategic highpoint.

War has come to Erebor, but this is not some disagreement over treasure; the fight Azog brings with him is a battle the allied and outnumbered warriors of Lake-town, Mirkwood and the Iron Hills must wage for survival. Azog seeks nothing less than their utter destruction.

AZOG THE DEFILER

Azog was fuelled by hate; that of itself was its own fire. He was alight with an utter and all-consuming hatred, a cruelty that made him powerful and drew other dark things to him by sheer force of personality and intimidation. There was a similar magnificence about Smaug, even a beauty and grandeur, though underpinned by complete and undeniable evil. It made Azog an ideal instrument for Sauron's purposes. It took us a while to find our ideal Azog. A lot of what worked and helped make him stand out was what Manu brought to the role. It was the way Manu moved. He carried himself a certain way, brutish, but fluid and not without grace. That wasn't perhaps what you might instinctively go with for an Orc character, but I think it was good to play against the bent, deformed stereotype that had been established.

Philippa Boyens, Screenwriter & Co-producer

Manu Bennett performed Azog on the motion-capture stage and also wore markers to provide facial performance capture. In addition to specific shots and action, for efficiency's sake Peter also shot a lot of extra facial capture with Manu that was invaluable later on, providing a library of Azog-specific performance that we could reference or use where we had gaps in our material. We also had some very good facial artists who were so adept that they could supplement facial capture with keyed animation that was indistinguishable.

On the live set with Richard Armitage Peter had stunt double, Michael 'Big Mike' Homick, playing Azog's part in the fights. Mike is very tall and broad so that worked well.

Manu has owned Azog since he stepped into the role and there was a reason why Peter kept calling him back. Manu brought nuances to the role that defined Azog as a personality beyond just being the big, bad Orc of the film. To help sell Azog's size, we scaled everything Manu did on the stage down by twenty to twenty-five per cent in speed. Manu could act naturally, at a pace appropriate for his own size, and we would scale his motion accordingly so that it worked for the giant he was playing.

Aaron Gilman, Weta Digital Animation Supervisor

1-2. Digital reference turntable image of Azog in his armour.

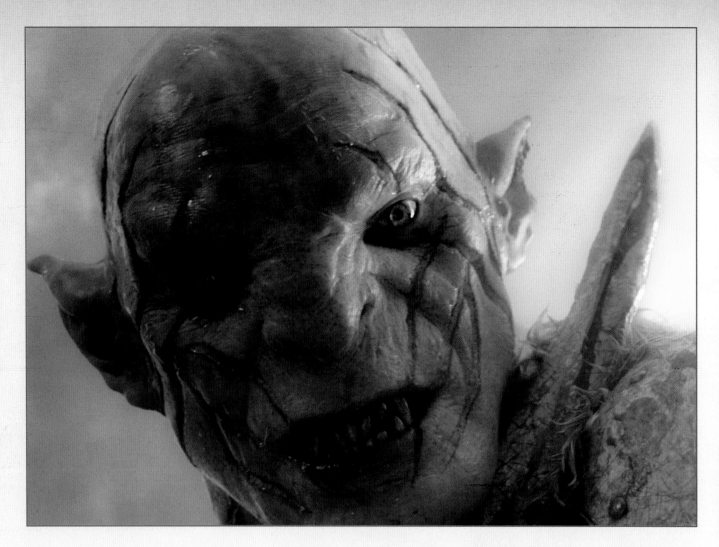

> *"Azog the Defiler is no ordinary hunter. He is a commander, a commander of legions."*
>
> *- GANDALF THE DESOLATION OF SMAUG*

Though there was a certain amount of translation work that had to occur to transpose Manu's expressions onto Azog's unique face and make sure the performance was exactly what Peter was looking for, essentially the core of Azog's performance was Manu Bennett's characterization. I would throw my top animators at it to see who could pull off the best work, but essentially in any animation performance you have to find the key characteristics of that character, his particular expressions, understand them, become familiar with them and use them.

Michael Cozens, Weta Digital Animation Supervisor

When we had to key-frame the character we were thinking about his physicality and personality. Azog was a huge dude with massive weaponry, and he was mean. At first when animating Azog's attack on Thorin at Ravenhill, prior to their final confrontation on the ice, I had pursued a very heavy-footed approach with him, but Peter wanted speed. He wanted Azog to charge out very fast. My concern was that his legs would be moving so fast and those feet swinging so far that he'd look out of scale or feel too light and lose his sense of mass and power, but in this case I think it worked well. Peter's instincts were correct, because it made Azog suddenly very dangerous. Here was a huge character that could move with surprising speed and ferocity, which really put Thorin on the back foot and raised the energy level of the fight. He was terrifying.

Aaron Gilman, Weta Digital Animation Supervisor

Azog got new armour and a new skewer for his arm – this time he had a fighting blade. We stuck that in his arm and made sure it would perform as we wanted in his shots. It was bigger than the other attachment so we had to be sure it would actually fit into shot. Sometimes we had to tweak it a little to make it work, but it didn't really present us with any problems. The armour took a little bit of time to figure out because it was articulated, so that meant modifying his body a little bit underneath to suit. You always try to be as accurate as possible when animating so that you don't create intersections, but to make that as simple as possible we tried to make sure the armour slid and fit properly when he moved.

Marco Revelant, Weta Digital Models Supervisor

The metal on Azog's armour was interesting. Originally we had it looking very much like the rest of the gun-metal grey plate armour his soldiers wore, some metallic steel and some rusty bits, but Peter said, 'He's supposed to be the Pale Orc so the metal of his armour should be white as well.' I thought that was very interesting so I went looking for reference and found all sorts of different stuff, from silvery looking, pale metals to enamelled white surfaces like old stoves or kitchen ware. He ended up with a very pale metal finish, but not flashy or silver. It was quite matt, worn and aged. It was a really nice touch and helped him stand out from everyone else on his side.

**Gino Acevedo,
Weta Digital Textures Supervisor/Creative Art Director**

If the viewer was to look carefully when Bolg and Azog are sitting astride their Wargs at the entrance to the were-worm tunnels, discussing the earth-eaters, they might catch Azog feed something to his Warg off the end of his sword-arm. This unfortunate creature is in fact a hedgehog. As the longer version of this macabre scene was conceived, it was to begin with a close-up of Sebastian, Radagast's hedgehog friend from *An Unexpected Journey*, writhing on the end of Azog's spike. Poor Sebastian!

Matt Aitken, Weta Digital Visual Effects Supervisor

1

2

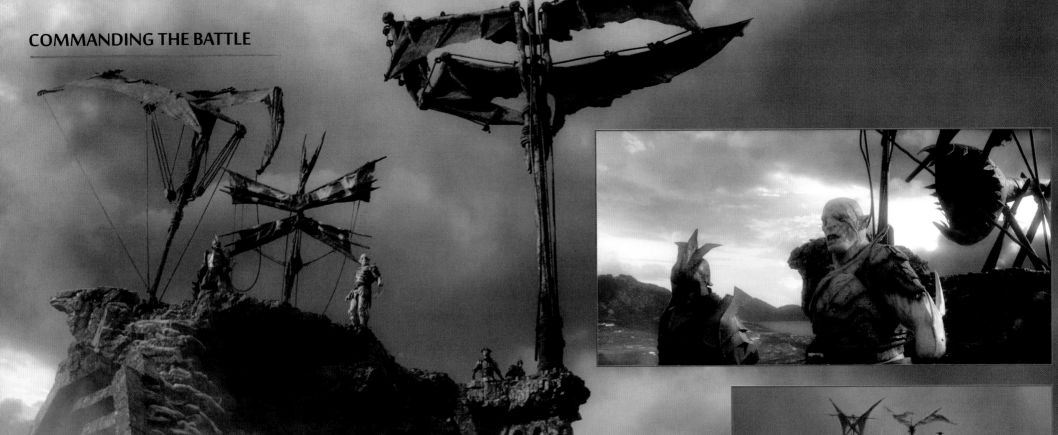

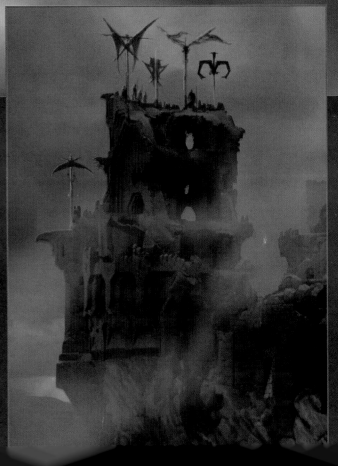

In the battle we saw Orcs behaving in a way that we hadn't seen before: still psychotic, but more intelligent and organized and therefore much more dangerous. These Orcs weren't just a mindless rabble. The difference was Azog was controlling them and orchestrating the battle from Ravenhill with his signal flags. Peter wanted that intelligence to be very clear, so a lot of thought went into how the Orc formations would move and what Azog's strategy was.

Michael Cozens, Weta Digital Animation Supervisor

Azog assumed a commanding position amid the ruins of Ravenhill, a Dwarf-built watchtower perched on a spur of rock on one of the Lonely Mountain's five arms. With excellent views towards Lake-town, across the valley before the Front Gate of Erebor, and over the town of Dale, it was an ideal command post from which to orchestrate the battle.

Erecting a signal tower with flags and using a mighty horn to communicate with his vast legions of warriors and creatures below, the Defiler could move his armies like pieces on a giant table top game board, dividing the defenders, cutting off

Azog kept distinctively armoured lieutenants and runners at his side, barking orders to them. Like no other Orc of the Age, Azog inspired obedience and his mind was keen. His appearance at the Lonely Mountain was the key difference that made the mustering and orchestration of such a large force possible, fulfilling Gandalf's prescient words when he described the Defiler as, 'No ordinary Orc'. Azog was, as he put it, a commander of legions.

Daniel Falconer, Weta Workshop Designer

We had a few different flag designs and configurations. We rigged them based on our understanding of the design intent and then provided Peter with a 6,000-frame-long animation of the flag rig doing a variety of different things. Peter went through that and made selections based on what he thought looked cool, and these became the key signals that Azog used to direct his army's manoeuvres.

Michael Cozens, Weta Digital Animation Supervisor

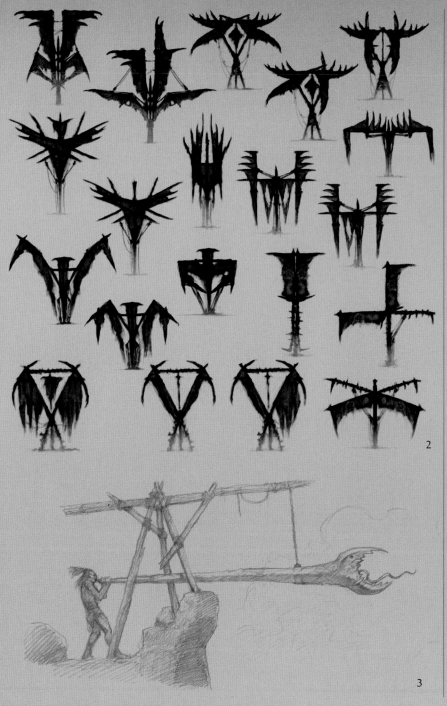

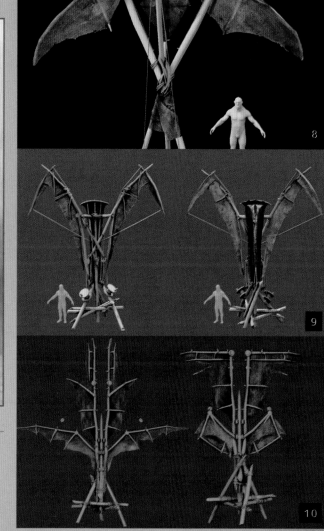

1. Concept art for Azog's command post atop the Ravenhill ruins by Concept Art Director Alan Lee.
2. Signal flag concept art by Weta Workshop Designer Nick Keller.
3. Orc war horn concept art by Concept Art Director John Howe.
4. Orc war banner concept art by Weta Workshop Designer Andrew Baker.
5-6. Orc signal flag and weaponry concept art by Weta Workshop Designer Nick Keller.
7-10. Signal flag textures concept art by Weta Digital Concept Designer Aaron Black working over renders of the digital models.

AZOG'S WARRIOR ORCS

The idea behind the Orc army was that they had been issued with a standard, basic suit of armour that was fairly uniform, but there were additional adornments and variations that would break it up and make each Orc a little bit different to the guy next to him. The basic breastplates, pauldrons, vambraces, tassets, greaves and back plates were mostly standardized, but we made a range of helmets that were variations on a theme and could also be customized for more uniqueness. In overall look Peter wanted something that looked a bit like the Uruk-hai from *The Lord of the Rings*, that was maybe a precursor to the Uruk-hai, but also distinctly different.

In Japanese military history you see armoured warriors with flags or standards up their backs, waving above their heads. We imagined that the Orcs adorned their armour with trophy heads mounted on spikes on their backs in a similar arrangement. Whether the number of heads was a signifier of rank or how potent a warrior an Orc was, the idea was beware the guy coming at you with ten Dwarf heads on his back! We had a range of skulls, with some that were in advanced stages of decay and others that were very fresh and still had flesh and beards.

In the film, the army Azog brought to the battle didn't have the head trophies, but they ended up being used instead on the army that Bolg led from Gundabad. When we were designing and building the army, they were all the same thing.

The Orcs themselves went through a few design and test rounds as well. For a while they were going to have stiff, hedgehog-like hair or quills down the backs of their heads. Peter was looking for ways to make them a bit different and, for a while, we even looked at giving them beards.

Rob Gillies, Weta Workshop Supervisor

1. Orc helmet variants.
2-6. Orc swords variants.
7. Orc dagger.
8. Detail of Orc spearhead.
9-10. Orc daggers.
11-12. Orc halberds.
13. Orc shield.
14. Mummified Dwarf head war trophy props.
15-17. Early Orc armour colour tests, including an alternate Orc prosthetic make-up sporting porcupine-like quills and a beard.
18-19. Orc costume and make-up test photography, featuring Stunt Performer and good-natured Weta Workshop guinea pig Shane Rangi.

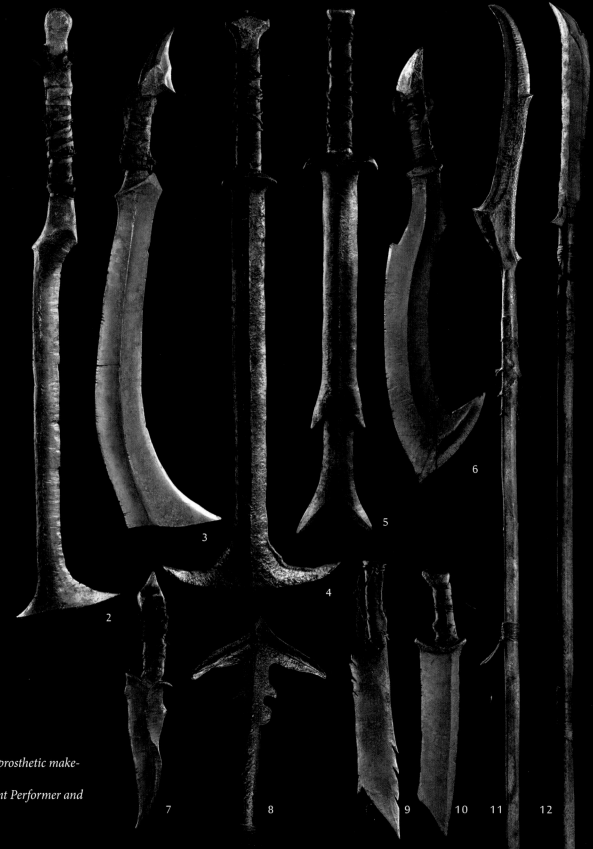

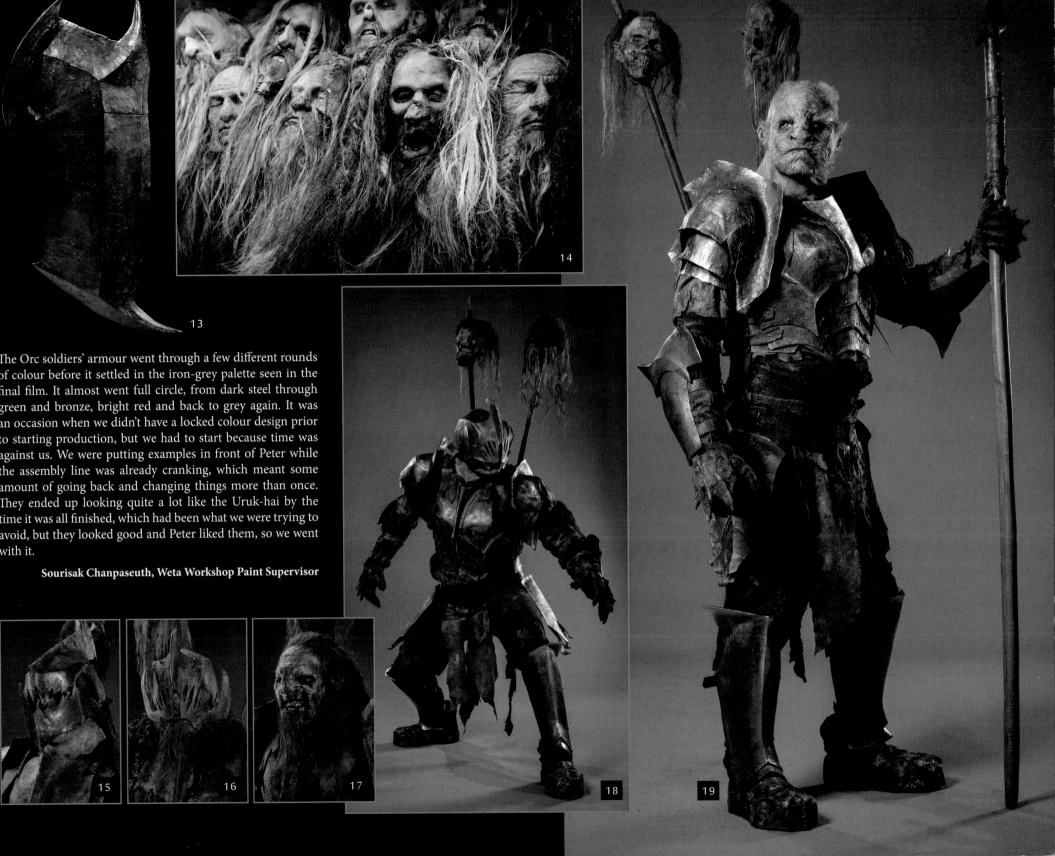

The Orc soldiers' armour went through a few different rounds of colour before it settled in the iron-grey palette seen in the final film. It almost went full circle, from dark steel through green and bronze, bright red and back to grey again. It was an occasion when we didn't have a locked colour design prior to starting production, but we had to start because time was against us. We were putting examples in front of Peter while the assembly line was already cranking, which meant some amount of going back and changing things more than once. They ended up looking quite a lot like the Uruk-hai by the time it was all finished, which had been what we were trying to avoid, but they looked good and Peter liked them, so we went with it.

Sourisak Chanpaseuth, Weta Workshop Paint Supervisor

13

14

15　　16　　17　　18　　19

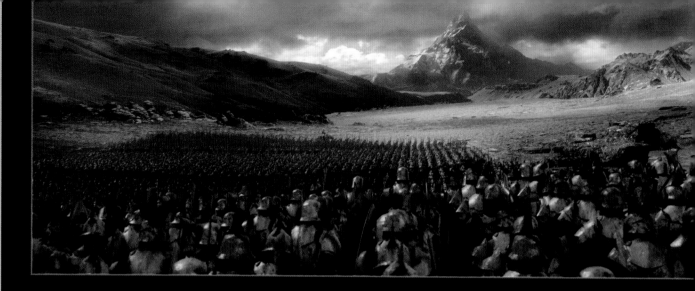

1-2. *Prosthetic Make-up Artist Rachelle O'Donnell and Weta Digital Textures Supervisor/Creative Art Director Gino Acevedo (who also pulled double duties as a Senior Prosthetics Make-up Artist) apply foam Orc prosthetics.*
3. *Make-up and Hair Designer Peter King puts finishing touches on a costumed Orc soldier.*
4. *Weta Workshop Design & Special Effects Supervisor Richard Taylor dresses an Orc soldier.*

The stunt team on *The Battle of the Five Armies* was a huge crew. There were 120 people on the list of names I sent to the Screen Actors' Guild when we were nominated for Best Stunt Ensemble. That's quite an ensemble, and the Orcs accounted for a large portion of our team. There were a huge number of Orcs fighting in Dale. While we had lots of digital Orcs throughout the films, we also had a lot of performers in armour and make-up who were shot live on the set, especially in Dale. Even the digital Orcs were stunt performers, because our team provided the basis of their motion on the capture stage. The six weeks of intense motion-capture that was done towards the end of the project was very hard work, because it was essentially stunt after stunt, all day for six weeks. That is hard on a body. It was like four months of work squeezed into six weeks! I was extremely proud of what our team achieved and the attitude of our crew.

Glenn Boswell, Stunt Co-ordinator

The Orc army we made-up in prosthetics each day really looked amazing. It was not for any fault of the make-ups that digital Orcs were adopted more and more in *The Hobbit*, but because Peter liked the flexibility of being able to direct their performances in post-production, and push their proportions further than we could with prosthetics. In the end Dale was full of both practical and digital Orcs in almost any given scene, and I think most people would struggle to tell which was which.

Tami Lane, Prosthetics Supervisor

Azog's Orc army had armour that was a bit reminiscent of th Uruk-hai from *The Lord of the Rings*. It had quite a uniform metallic look and wasn't as dark as Bolg's army from Gundabad We replicated digitally what had been done at Weta Worksho with the physical suits that they had made, but also introduce a bunch of new helmets and other variations to help break u the ranks.

Gino Acevedo
Weta Digital Textures Supervisor/Creative Art Director

We imagined Azog and Bolg at the top of the Orc characte pyramid as the meanest, nastiest, scariest and most dangerou and then worked our way down. There were tiers of les menacing Orcs beneath them, still dangerous but not a threatening as the guys at the top. It was the same with thei intelligence. Bolg was a lieutenant, so he could think and figur out a plan of action, but the rest of the Orcs were just brute Their whole purpose in living was to fight, with little sense c self. They'd fight and die, but once that battle lust was on then it didn't matter to them. How would you fight an enemy tha didn't care if it lived or died, that just lived for carnage an battle? They were just a mass of brutal creatures that almos functioned like one big writhing monster.

That mindlessness was their downfall too, because a Peter's idea suggested, once the leader was dead, they wer directionless and could be defeated even if they outnumbere the good guys. They depended upon a hierarchy to functior and without it they quickly fell apart.

Glenn Boswell, Stunt Co-ordinato

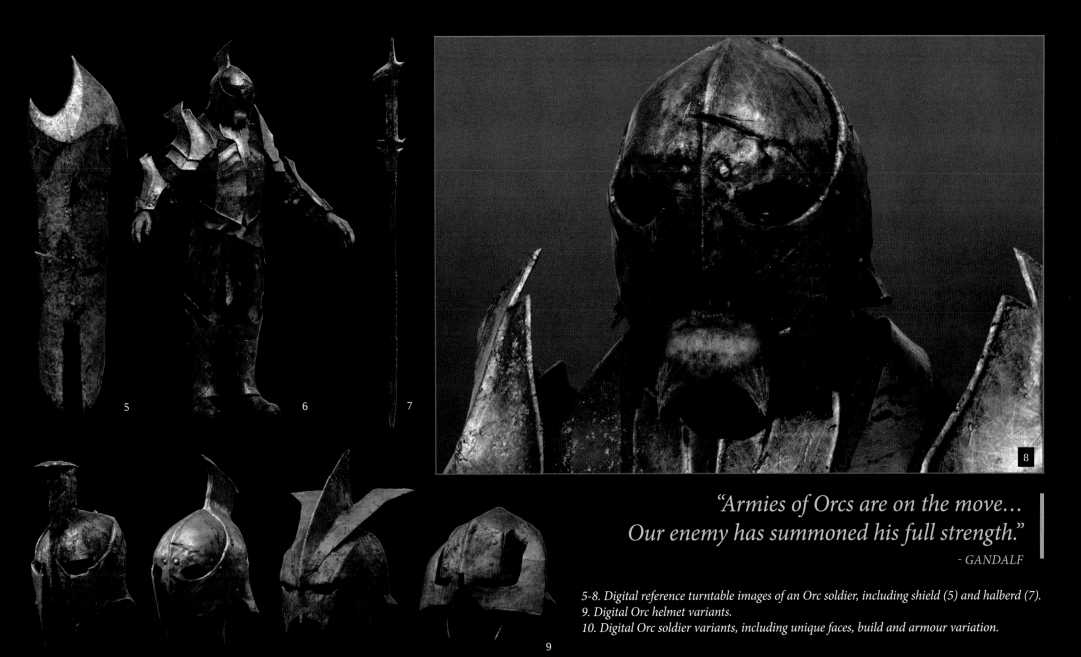

> *"Armies of Orcs are on the move...*
> *Our enemy has summoned his full strength."*
> — GANDALF

5-8. Digital reference turntable images of an Orc soldier, including shield (5) and halberd (7).
9. Digital Orc helmet variants.
10. Digital Orc soldier variants, including unique faces, build and armour variation.

WERE-WORMS

Concept Art Director John Howe had produced a drawing for a possible were-worm that Peter showed to us at Weta Workshop as a starting point to kick off a round of ideas. We had suggested all kinds of creatures in an earlier round but his thinking on the were-worms had developed by this point and he was specifically looking for some kind of large burrowing creature that would serve as a means of getting Azog's army to the battlefield without being seen. The worms themselves wouldn't fight, but they had to be able to eat their way through the ground and crush rocks in their jaws. Peter referenced man-made drilling machines and liked the idea that there would be a rotating aspect to their burrowing action.

Nick Keller, Weta Workshop Designer

1. *Concept maquette by Weta Workshop Designer/Sculptor Jamie Beswarick.*
2-3. *Concept art by Weta Workshop Designers Andrew Baker (2) and Nick Keller (3).*
4. *ZBrush concept art by Weta Workshop Designer Greg Tozer.*
5-7. *Concept art by Concept Art Director John Howe.*
8. *Concept art by Weta Digital Textures Supervisor/Creative Art Director Gino Acevedo using a ZBrush sculpt by Weta Digital Texture Artist Madeleine Spencer*
9. *Concept art for the were-worm tunnels by Concept Art Director John Howe.*
10. *ZBrush concept art by Weta Digital Texture Artist Madeleine Spencer based on a design by Weta Digital Textures Supervisor/Creative Art Director Gino Acevedo.*
11. *Digital reference turntable image of the were-worm.*

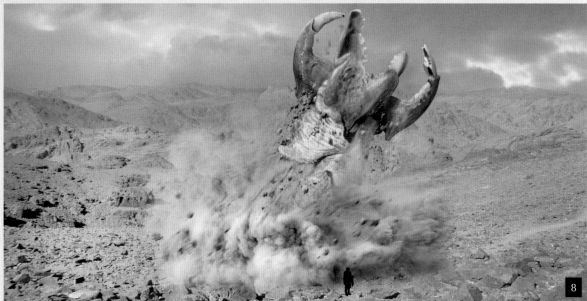

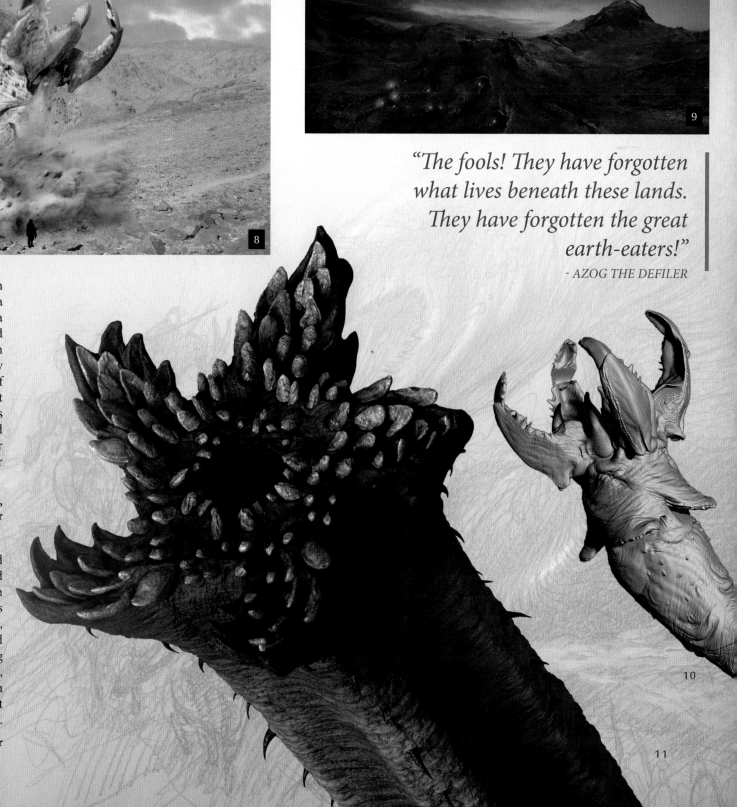

Madeleine Spencer and I both had a pass at some were-worm concepts, trying to hone some of the details. Madeleine is a ZBrush genius so I would do a sketch and she would create a 3D model in ZBrush that I could then paint over. I was inspired by *Tremors*, but I was also thinking about footage I had seen of a dead whale on the ocean floor. There were these lamprey eels that would bite into the decomposing flesh and blubber of the whale and then spin their bodies, tearing chunks of meat out in channels. I thought that maybe the worms could spin as well, tearing through the earth like drills. I thought they could have gill slits that all the debris would spit out of behind their heads as they bored. The gills didn't get picked up but Peter thought the spinning was interesting and passed it on.

Gino Acevedo,
Weta Digital Textures Supervisor/Creative Art Director

Taking a new creature and figuring out how it moves and behaves is always fun. The worms were completely new and Peter imagined them as monstrous, so we were dealing with scale. That meant it had to be sluggish and weighty in its movement to help convey the size. For the sake of some tests, one of our animators, Sebastian Trujillo, modelled and rigged a quick worm based on concept art. We had some interesting deformers on it and had the creature operating like a lung, sucking in and breathing out. We did some effects work with debris and it all went over very well, forming a basis for what we later did with the final, rigged model when it came through.

Michael Cozens, Weta Digital Animation Supervisor

WAR TROLLS

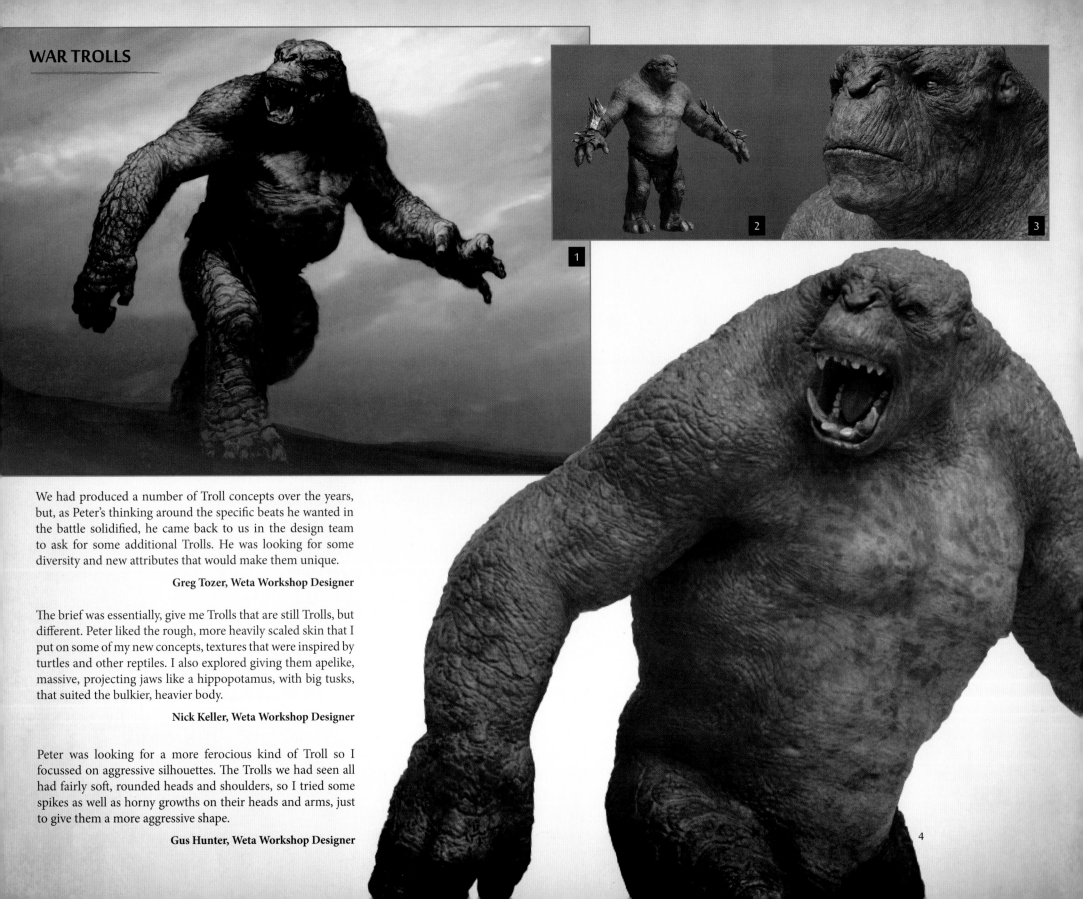

1

2

3

4

We had produced a number of Troll concepts over the years, but, as Peter's thinking around the specific beats he wanted in the battle solidified, he came back to us in the design team to ask for some additional Trolls. He was looking for some diversity and new attributes that would make them unique.

Greg Tozer, Weta Workshop Designer

The brief was essentially, give me Trolls that are still Trolls, but different. Peter liked the rough, more heavily scaled skin that I put on some of my new concepts, textures that were inspired by turtles and other reptiles. I also explored giving them apelike, massive, projecting jaws like a hippopotamus, with big tusks, that suited the bulkier, heavier body.

Nick Keller, Weta Workshop Designer

Peter was looking for a more ferocious kind of Troll so I focussed on aggressive silhouettes. The Trolls we had seen all had fairly soft, rounded heads and shoulders, so I tried some spikes as well as horny growths on their heads and arms, just to give them a more aggressive shape.

Gus Hunter, Weta Workshop Designer

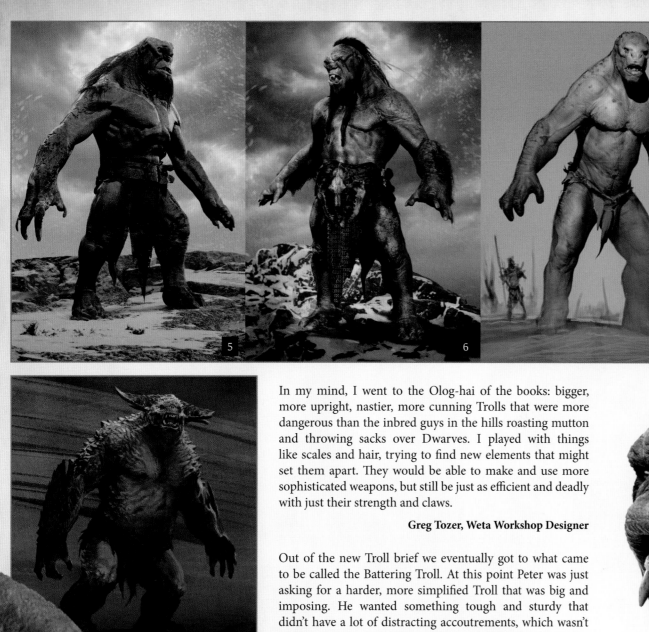

In my mind, I went to the Olog-hai of the books: bigger, more upright, nastier, more cunning Trolls that were more dangerous than the inbred guys in the hills roasting mutton and throwing sacks over Dwarves. I played with things like scales and hair, trying to find new elements that might set them apart. They would be able to make and use more sophisticated weapons, but still be just as efficient and deadly with just their strength and claws.

Greg Tozer, Weta Workshop Designer

Out of the new Troll brief we eventually got to what came to be called the Battering Troll. At this point Peter was just asking for a harder, more simplified Troll that was big and imposing. He wanted something tough and sturdy that didn't have a lot of distracting accoutrements, which wasn't too fancy or engineered. This Troll would stand off with the front lines of troops and charge through to do some damage. Eventually that idea would lead to the idea of the Battering Troll, who was specifically used to break through the walls.

Andrew Baker, Weta Workshop Designer

1. War Troll concept art by Weta Workshop Designer, Nick Keller.
2-4. War Troll digital reference turntable images.
5-9. War Troll concept art by Weta Workshop Designers,
Greg Tozer (5-6), Andrew Baker (7-8), and Gus Hunter (9).
10. Battering Troll digital reference turntable image.

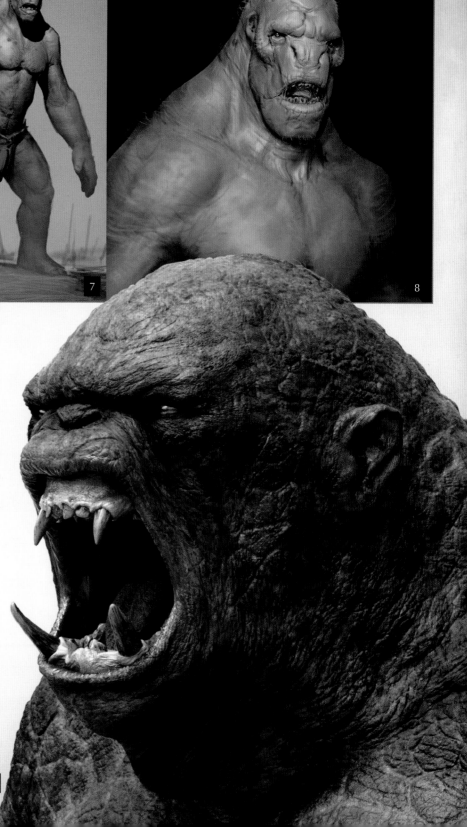

When we came to the siege of Dale, Peter said to us, 'The bad guys have to get into Dale, but I don't want to see ladders again. Come up with something that is fun and shows that our bad guys are clever.' We went away and brainstormed different ideas for how we could get our Orcs inside the walls. We were winging it completely, going down to the motion-capture stage and shooting stunties in different scenarios, coming up with possible gags. The Battering Troll who sprinted up the slope and went headfirst into the city wall was one very fun idea to come out of that process and make it all the way into the final film.

Randy Link, Weta Digital Previs Supervisor

I can imagine that our Battering Troll had done this sort of thing before Dale. I thought of him as like an old boxer – when he was young he could get hit in the face a bunch of times but now that he was older one good hit and he would go down. We motion-captured his run but key-framed his dive into the wall in order to maintain his suspension in mid-air when his head hit the wall. It was important to Peter that he hang for just a moment before catching his feet and keeling over in order to nail that comedic timing.

Aaron Gilman, Weta Digital Animation Supervisor

While fight choreography between humanoids like Elves, Orcs, Dwarves, and even Trolls and Ogres, almost always began with motion capture, certain specific things like the Trolls coming over walls were key-frame animated. Even though they were moving as humanoid creatures, something that motion capture is good for providing, as they broke through the walls they would drop and shift in such an interactive way that it was simply more efficient to key-frame them than try to contrive a mechanical simulation of that interaction on the motion capture stage and then be constrained by that action. Eagles, Bats, Smaug, and other non-humanoid creatures tended to be key-framed with only a few notable exceptions, like the Wargs.

Aaron Gilman, Weta Digital Animation Supervisor

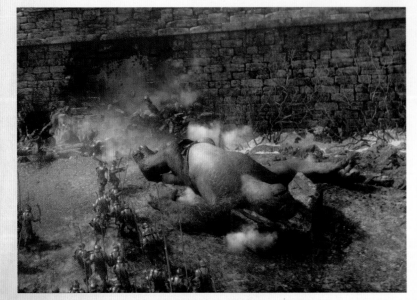

1. Troll leg and foot concept.
2-3. Battering Troll digital reference turntable images.
4. Battering Troll concept art by Weta Workshop Designer Greg Tozer.
5. Detail of digital Battering Troll skin texture.

6-7. Catapult Troll digital reference turntable images.
8. Catapult Troll concept sketch by Concept Art Director John Howe.

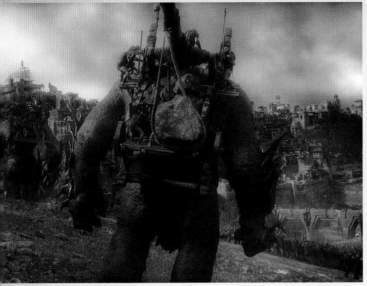

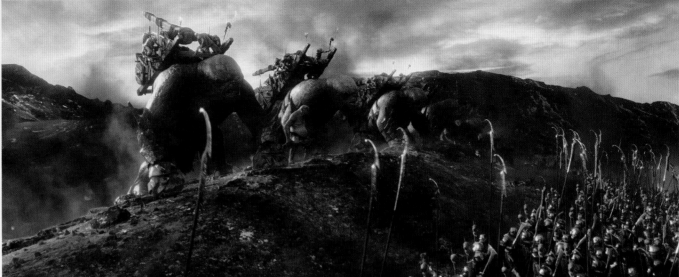

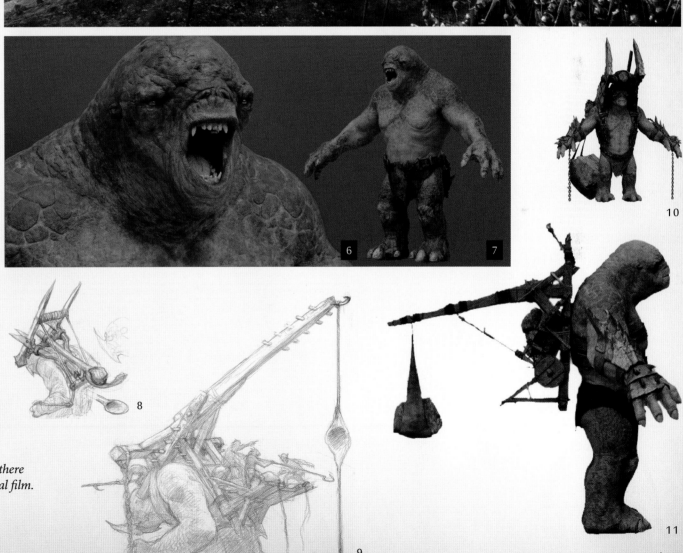

While we were making lots of new Trolls, we also wanted to reference the originals; so at least one of the new guys was a sort of homage to the Cave Troll from *The Fellowship of the Ring*. It was cool to go back to *The Lord of the Rings* and look at those Trolls, and try to keep something of them in our new ones. They were all supposed to be Trolls of some sort, so it was a bit like looking at different types of dogs.

Marco Revelant, Weta Digital Models Supervisor

The Catapult Trolls offer a good example of the relationship between motion capture and key-framed animation. The foundation of the action was them running up the slope and planting their fists in a quadrupedal stance as they hit the crest of the hill. This was done on the motion capture stage, but we then heavily keyed on top of that capture in order to imbue the action with things like the arms reacting to the force of the impact. We also captured the Goblins manning the catapults on the stage. They were shot on a flat surface so we had to offset all of their weight with key-framing in order to make them lean appropriately on the canted decks of the catapults.

Aaron Gilman, Weta Digital Animation Supervisor

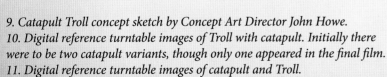

9. Catapult Troll concept sketch by Concept Art Director John Howe.
10. Digital reference turntable images of Troll with catapult. Initially there were to be two catapult variants, though only one appeared in the final film.
11. Digital reference turntable images of catapult and Troll.

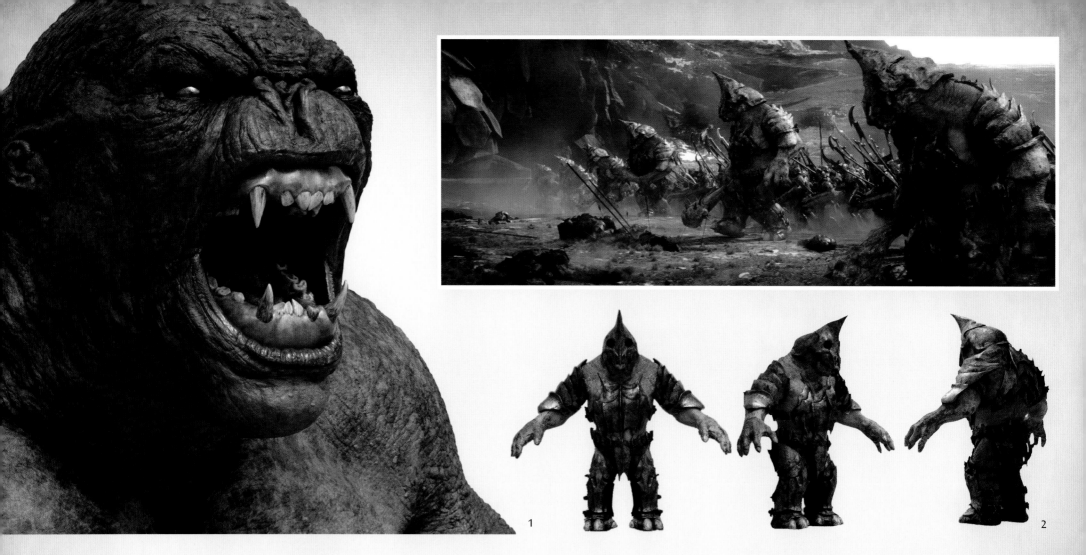

I got to play some Trolls smashing their way through the village of Dale. Trolls aren't the smartest of characters, so I thought of them as being like very selfish, dim-witted children. I numbed out, so they don't react fast to anything, things take a while to sink in. 'Let's smash that little thing. Oh wait, it's still moving, better smash it again.' Even though they are brutal, there is an element of humour to them. Perhaps that's why Peter likes them so much.

The challenge of any big character like a Troll or Ogre is the weight. I dropped my centre of gravity right down and slowed everything down so that everything was motivated, initiated from the ground, so I would work up to a move rather than rushing into anything. That energy had to be built up, momentum that had to be gathered before a swing could come down with force and power.

On the motion capture stage I performed a Troll at the same time as the people I was trying to smash, but because of the size

difference we were offset; so they would run through, trying to escape and I would have to raise my club, and let them take their steps before bringing it down on a sandbag, all timed to coordinate with the person, who was halfway across the stage at this point, being crushed under the hit. We were miles apart, but with the sizes of the characters off set, on the monitor they married up and it looked like I had just crushed them. It was quite tricky and time consuming to choreograph and time the action out that way, but we got it to work.

Our faces weren't being captured so sometimes I would count the action. For things like an ankle trip or pull we would have the person playing the victim on a rig, so as the Troll I would go wallop and they'd go flying. Not actually connecting with someone also meant we could get some really meaty impacts.

Terry Notary, Movement Coach

As per Peter's brief to us, Trolls were strong, heavy and hit very, very hard. We spent quite a bit of time with the stunt guys taking some pretty hard hits on wires so we could send them flying. The Trolls would have heavy weapons which we mocked up as soft as we could when we wielded them to wallop the guys.

Glenn Boswell, Stunt Co-ordinator

1. Battle Troll digital reference turntable image.
2. Armoured Battle Troll digital reference turntable images.
3-5. Armoured Battle Troll variant digital reference turntable images.

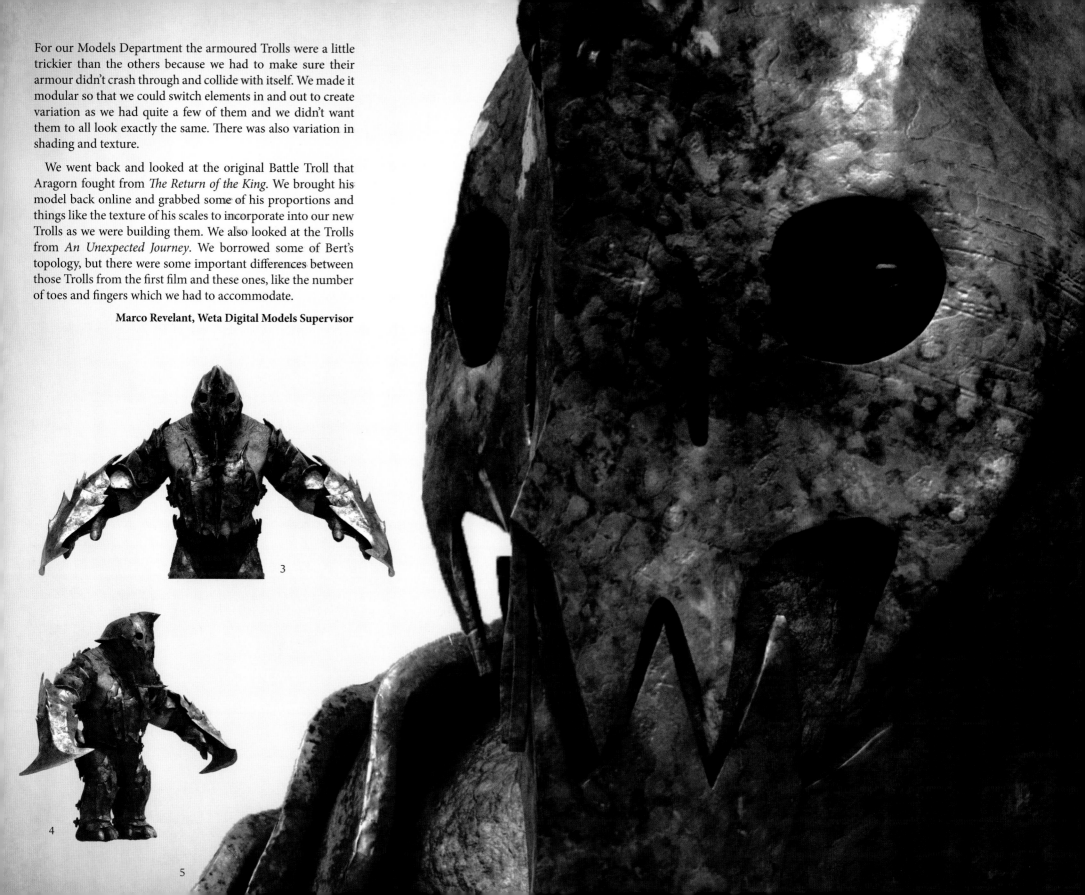

For our Models Department the armoured Trolls were a little trickier than the others because we had to make sure their armour didn't crash through and collide with itself. We made it modular so that we could switch elements in and out to create variation as we had quite a few of them and we didn't want them to all look exactly the same. There was also variation in shading and texture.

We went back and looked at the original Battle Troll that Aragorn fought from *The Return of the King*. We brought his model back online and grabbed some of his proportions and things like the texture of his scales to incorporate into our new Trolls as we were building them. We also looked at the Trolls from *An Unexpected Journey*. We borrowed some of Bert's topology, but there were some important differences between those Trolls from the first film and these ones, like the number of toes and fingers which we had to accommodate.

Marco Revelant, Weta Digital Models Supervisor

3

4

5

OGRES

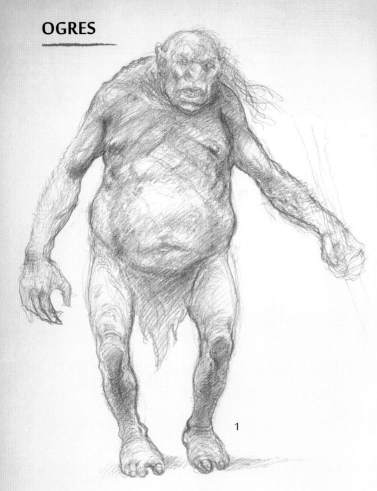

1

Essentially the Ogres were like small Trolls. They were fairly clumsy and heavy, with big clubs for weapons. They were a sort of light infantry version of the big Trolls.

Glenn Boswell, Stunt Co-ordinator

New creatures, the Ogres were smaller and more like humans than Trolls. We had an Ogre minding the Catapult Trolls and menacing Bard's children in Dale. There was also one with a withered arm that almost killed Alfrid but was shot by Bard.

For the extended edition of *The Battle of the Five Armies* we created a sequence in which Ogres operated in squads to take out Dwarf chariots. They flipped chariots, spilling the Dwarf soldiers and running them down to stomp or bash. A number of Dwarves died horribly in that sequence, ending up as Ogre toe-jam.

Matt Aitken, Weta Digital Visual Effects Supervisor

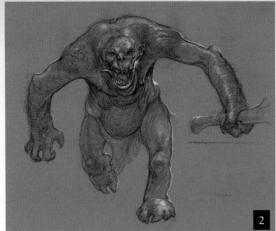

2

There were some great scenarios that were devised for how groups of six Ogres would converge on a Dwarf chariot and slam into it, put the brakes on and then tear the crew off. It was all build-up for a point of action conceived for the chariot chase involving Thorin and his guys. The Ogres were converging on them and it was going to happen again except our heroes blew right through them, lopping off heads.

Michael Cozens, Weta Digital Animation Supervisor

We spent a lot of time on the Ogre threatening Bard's children, settling on a design that Peter liked. He was the first Ogre, so there was some back and forth before he was resolved. At one point he looked like a big baby, not terrifying enough, so they gave him a hair lip and 'meaned him up'. The body changed quite a bit, before settling on the thin-limbed, potbellied look. For a while he was more of a traditional muscleman but Peter liked the idea of something a bit more awkward and 'gawky'. His animation was all key-framed and went smoothly once we had the design locked.

This particular Ogre met his end when Bard came careening down the alley on his cart and flew sword-first into him, momentarily striking what we called the 'Superman pose' in mid-air. That stabbing pose went through a number of iterations. Peter liked the Superman-like nature of it, but it went through some revisions to keep it feeling natural and not have it look like if we threw a cape on him he'd be flying.

3 4

Peter didn't want the Ogres to be lumbering. We already had Trolls, so the point of the Ogres was to have a new type of creature that behaved differently, less lazy and lumbering in movement, more predatory than a Troll and faster than you might expect for something of their size.

We established certain rules that we strictly adhered to when choreographing our fights. One of these rules was that the eye line of the attacking creature never came off its intended target. When animating a lumbering character the shoulders might turn first, leading the head, which imparts a more lazy motion to the whole action, whereas with a predatory creature the eyes would locked in and remain on the target as the shoulder and body moved, guided by that gaze. As per Peter's direction, any time our Ogres were smashing, turning and hitting, they were always focused on a target and their stare never dropped.

Another important fight rule was that when someone died, they let go of their weapon. It meant there was a reaction when a character died, a simple thing that the audience might not consciously pick up on, but key in making the deaths of those digital characters feel real.

Aaron Gilman, Weta Digital Animation Supervisor

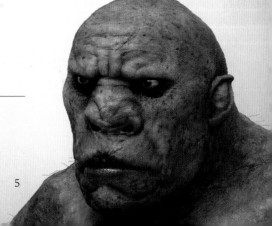

1-2. *Ogre concept art by Concept Art Director John Howe.*
3-5. *Digital reference turntable images of Ogre models #1 (3, 5) and #2 (4).*
6. *Concept art illustrating an Ogre peppered with arrows, a digital paint-over of an unfinished film frame, by Weta Digital Textures Supervisor/Creative Art Director Gino Acevedo.*

5

We had three distinct main Ogres. There were some new drawings done by John Howe, but Peter also had us look at artwork done for other creatures, like Trolls and big Orcs, that he didn't think was working for those creatures but still wanted to use somewhere. He said, 'We'll take some of this and do some experimenting.' The Ogres had basically human hands and feet, and were unique enough in design that we couldn't reuse any Troll topology when building them. They were an entirely new build.

We tried different things for the body. Some had bellies and some didn't. We tried different lengths of arms. We still had to be able to make the animation work so we couldn't go too far. In the end it came down to three basic individually modelled variants in the face and body that we knew we would see in different parts of the film, and the opportunity to create mixes and variations on those if we ever needed more.

Marco Revelant, Weta Digital Models Supervisor

I experimented a little bit, trying different amounts and types of hair on the Ogres. I was trying to find ways to make them look mean and evil. Scars and wounds were other things I explored putting on them, as well as trying different colours. I actually really liked the idea of making them piebald and blotchy.

I had an idea for a funny moment around the Ogre that almost got Alfrid. It didn't make it through, but I thought if he got shot with Bard's arrow in his front, then when he fell down it might be funny to see that his entire back was already covered in arrows! I think Peter really wanted it to be clear that it was Bard's arrow that got him and that idea muddied it.

Gino Acevedo,
Weta Digital Textures Supervisor/Creative Art Director

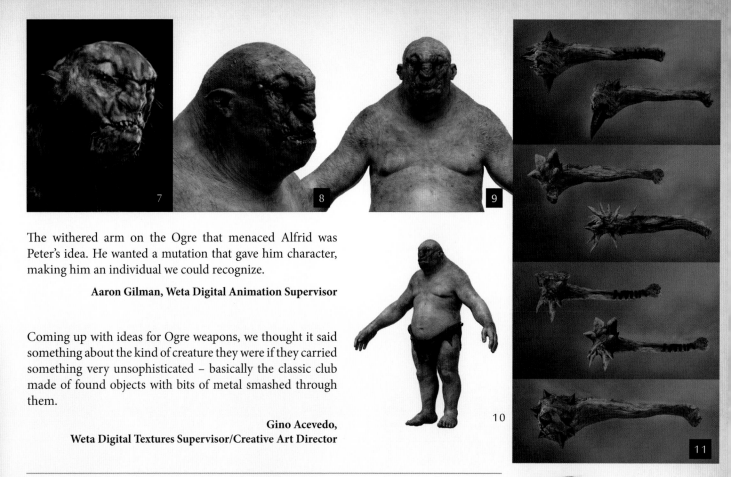

The withered arm on the Ogre that menaced Alfrid was Peter's idea. He wanted a mutation that gave him character, making him an individual we could recognize.

Aaron Gilman, Weta Digital Animation Supervisor

Coming up with ideas for Ogre weapons, we thought it said something about the kind of creature they were if they carried something very unsophisticated – basically the classic club made of found objects with bits of metal smashed through them.

Gino Acevedo,
Weta Digital Textures Supervisor/Creative Art Director

7. Orc concept art by Weta Workshop Designer Paul Tobin, inspiration for one of the Ogres.
8-10. Digital reference turntable images of Ogre model #3.
11. Ogre weapon concept art by Weta Digital Concept Designer Aaron Black.
12. Digital reference turntable image of Ogre model #2.
13. Alternate look exploration for Ogre model #3.

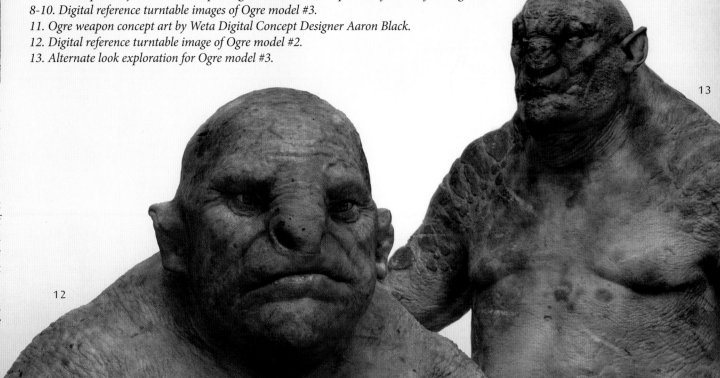

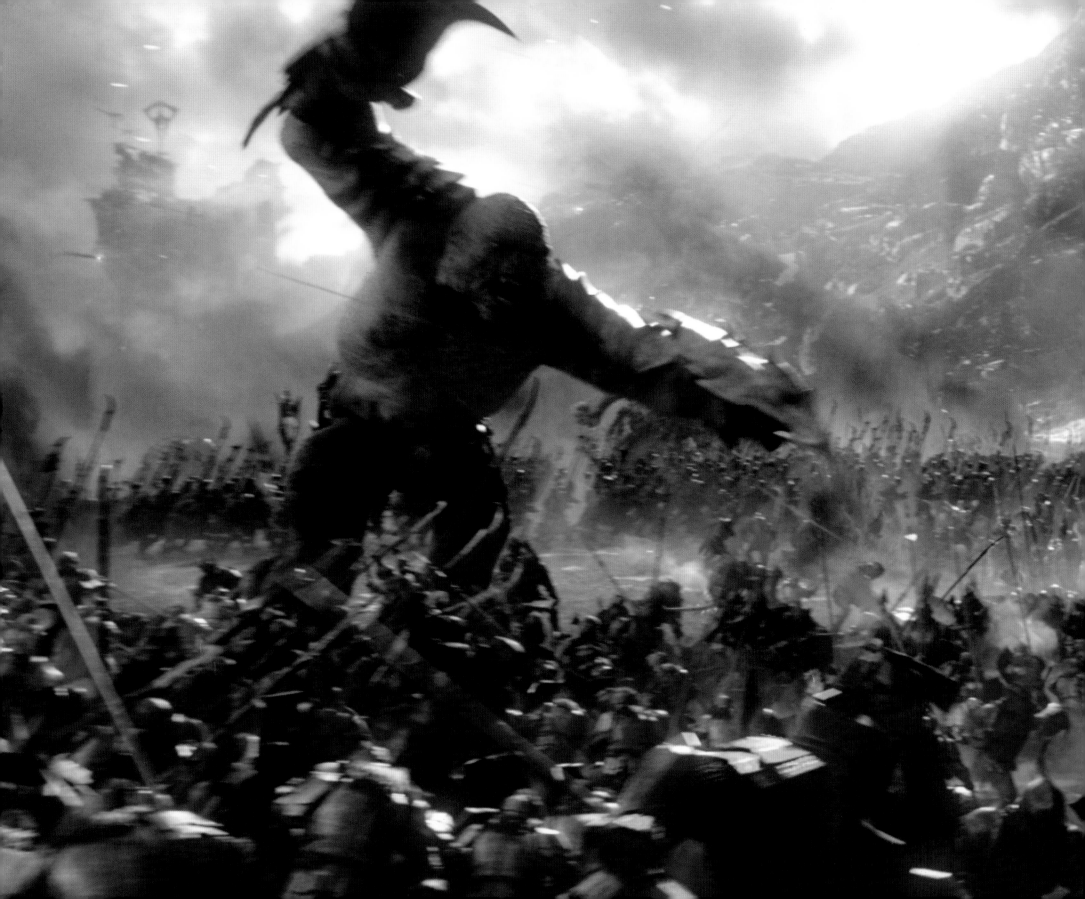

THE CLOUDS BURST

Battle erupts upon the slopes of the Lonely Mountain. Orcs press against ranks of Elves and Dwarves in the valley before the gate of Erebor; in Dale, men and women of the Lake wage desperate running fights through the streets, terrified children and elderly mere feet behind them; and everywhere, monstrous Trolls and Ogres stomp through the melee, maliciously seeking targets of opportunity to crush and mangle.

Out-numbered and beleaguered, Dain's warriors of the Iron Hills retreat towards Erebor, pressed into a thin line between rock and steel. Inside the Mountain, Thorin's Company wrestle with fear and regret, paralyzed by a king who had refused to act, his mind overtaken by the cursed wealth upon which the Dragon long brooded. Yet hope is rekindled and courage stoked anew when Thorin emerges from his gold stupor, again the leader he once was, and rallies his followers to charge forth onto the plain of war to the aid of his kin.

Announced by a mighty blast upon Bombur's war horn and the shattering of their stone palisade, Thorin and his Company charge onto the field in a flying wedge, Orcs and Trolls breaking and falling before their inexorable advance as they cut a swathe through the enemy's lines. Cousins meet amid the fray as Dain's troops rally to the King Under the Mountain and the fight is rejoined with new vigour.

Yet so long as Azog commands his legions the battle cannot be won. Thorin realizes he must take desperate action and lead a sortie to the Pale Orc's command post upon Ravenhill if there is to be any hope of victory against this overwhelming force. Commandeering a war chariot and mounting a goat, the King leads his best warriors in a dash across ice and over stone, fighting his way toward the ruined watchtower.

FIGHTING STYLES & FORMATIONS

One of our biggest challenges on this project was creating the formations for each of our different races' armies. We wanted to have very specific signature formations for each of the races in the battle that were drawn from principles and characteristics native to that culture, so they weren't arbitrarily assigned.

One of the first things Peter said was, 'Come to me with lots of ideas, and good luck!'

I had to figure out how we were going to achieve this. I had twelve people and a motion-capture stage, so I grabbed some graph paper and five different coloured pens and just started putting dots on pages, each representing a person.

The bathroom door of my hotel room had a glass window, so each night I sat in the bathroom and shone a flashlight balanced on a stack of towels from behind to create a kind of jury-rigged light-table. I taped sheets of paper up and worked in layers, creating formation shapes and working out moves, creating repeatable chunks of choreography.

I set up a cadence machine in the studio that created a steady beat, particular and distinct to each race, and, using our twelve performers, we recorded a section of movement and banked it. Then we recorded a different section and synced it up to the first, repeating the process and gradually building out of those twelve people an army moving through formations. Before long we had a thousand soldiers moving in formation, which we then re-created in ten different ways.

Everyone in the team had great ideas, everyone had a voice, and it was very collaborative. We had a smart group of people who figured out the problems together, which made the whole experience, as intense and exhausting as it was, nonetheless very enjoyable and invigorating. Those poor guys must have been so sick of hearing me count, but if they did, they never showed it. They were great.

For every move or sequence of moves, we had our twelve team members do around twenty takes each, which gave us enough subtle variation to disperse amongst our thousand digital soldiers, and it meant that the synchrony wasn't absolutely perfect, which helped it feel real.

After about three weeks we paired up with the animators from Weta Digital. It was so enjoyable working with them because we could analyze and solve problems together, finding transitional moves or solutions where we had gaps in the designs. Peter could see the ideas we had been developing with just a handful of people applied to entire armies and be happy with how it was going. For seven weeks we were constantly working, either together on the stage or just me back in my hotel room at night pushing around dots on graph paper.

The distinct counts that each race used were very important in establishing their unique qualities of movement. Elves were flowing in their movement and we devised patterns for them based on the count of three, like a waltz. They floated through space, but with a solid foundation. They moved from their backs, as if being gently pressed forward from the small of their backs. The Elves have an awareness of their surroundings, so

they saw before they looked, knew before they saw, were never surprised, always centred, alert, but calm and effortless all at the same time.

Meantime, the Dwarves were the blue-collar workers, the brick and mortar of Middle-earth. They had a solid foundation too, but they stayed there, rooted in the ground. They powered along with their weight in their guts. We had them operating on a four-count, regular, solid, thumping: one-two-three-four like little steam-piston-driven locomotives.

The Orcs surged. They were evil creatures that were barely in control of themselves, so we used a jarring five-count for them: one-two-three-four-five. It's hard to find a sense of rhythm in a count of five and it pulled them up short, stopping and starting them in an awkward way, like a creature tugging against a leash, which we found was perfect for Orcs of all kinds.

Terry Notary, Movement Coach

We tried to treat the entire battle as much like a real one as possible, with deployments and formations that made sense so that it didn't feel like a giant mess. We wanted the armies to be working in ways that were reasonable and see characters doing things that made sense, with emotional motivation so their actions had weight instead of just being pointless action. We were telling stories, so it had to be approached thoughtfully.

Glenn Boswell, Stunt Co-ordinator

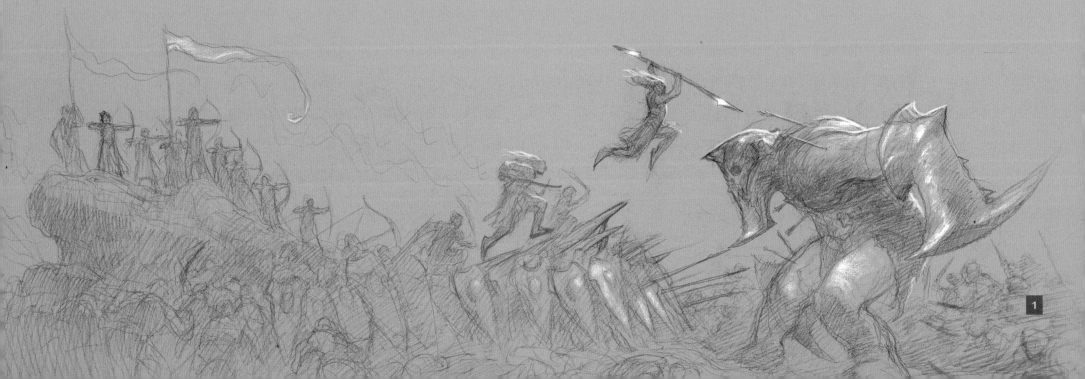

1

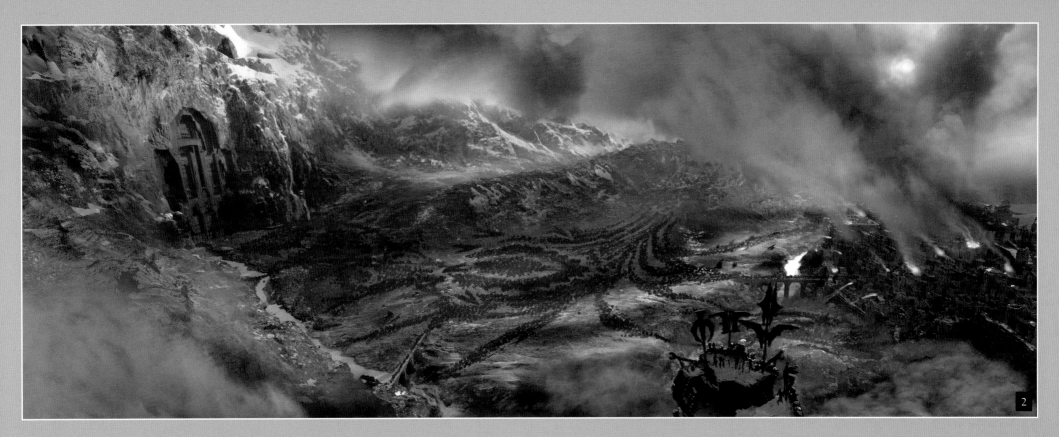

We started by designing military formations for the Elves, whom I imagined would probably be the trickiest. I figured they were organized, structured, and of one mind but organic at the same time. They were disciplined, but not rigid, precise, but also flowing and smooth. I thought of bees, and how they can create such intricate and perfect structure with their honeycombs, or the elegant, organic symmetry of a flower or snowflake. Balance, harmony, synergy – these were my inspiration.

With Elves, we had built their movement cadence on a beat of three, so the idea of building their formations on threes felt natural. If we started with a rectangle and divided it on the diagonal then we had two triangles, which in turn we could split into smaller triangles, with each flowering out until we had units of three Elves apiece. I'm terrible at math, so the graph paper was a big help. As the triangles broke off we could spin them and bring them back together again in really interesting and beautiful star-shapes, and suddenly we had something that was beginning to work.

I blew up the diagrams and took them with me to the mocap stage to show our team: 'Right, this square here? That is you. You spin from here to here and do it in three steps, then another three to the next position,' and so on, moving through a series of three-step moves until we achieved our formations.

Whatever we did had to work from a single Elf through to units of three, all the way up to a thousand soldiers. It was incredibly time-consuming and serious brain work, and fairly constant, too. Even during lunch hour I was madly scratching out the next formation: 'How are we going to do this?'

The Elves were a real challenge because we wanted to create something very unique that would look amazing from overhead, but nailing the idea of units of three was the key. So in my head we would always have swordsmen and pikesmen defending archers. Peter also introduced the notion of corrals, whereby they could control the number of enemies they faced, surround them and pierce them, as if they were in fighting pits or mini arenas.

Our Elven units moved in perfect unison, with spinning, scissoring, slicing actions that were bewildering for their opponents, but each Elf could move with complete confidence, knowing exactly where his or her comrades were and what they were doing at all times. They were like a flower opening, always protecting the centre, the archer. If one of them fell, another would slide in and replace them in order to maintain their unit of three. Without a third, they were vulnerable and two Elves fighting without their other guy would be like a stool that was missing its third leg.

Unlike the Elves, who were all about perfectly synchronized moves, the Dwarves were just slightly out of step with each other and a little more rough-edged. They still built impenetrable walls of defence with their shields and pikes, but when they slammed their shields into the ground, for example, it wasn't all at the exact same instant, like the Elves. I wanted it to feel like a bunch of hard-working people, all slamming blocks down to build a wall, like brick-layers. The four-count worked beautifully for the Dwarves because of its regularity. They were like a heartbeat or the rhythmic thumping of a factory.

To keep it interesting, we had each row of Dwarves start on a different foot, so as they marched there was a scissoring sway that happened in their alternating ranks, like pistons. They were gut-driven, feeling everything, their focus being less peripheral than the Elves and more direct.

Terry Notary, Movement Coach

1-2. Battle concept art by Concept Art Director John Howe.
3. Formation diagrams by Movement Coach Terry Notary.

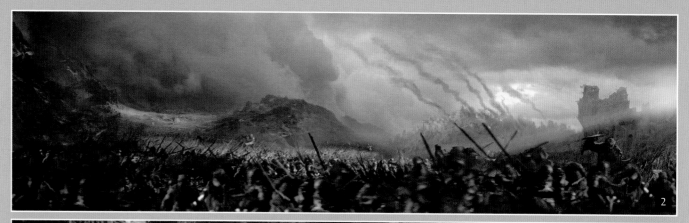

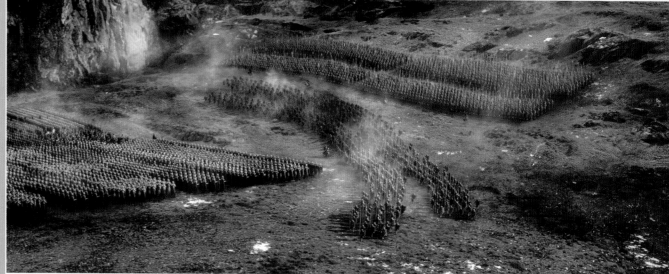

Orc formations were organized, but rough and ragged. It should be clear that each Orc was an individual with his own agenda, held together by their leader's force of personality as much as anything. They fought in a group because they shared a common bloodlust and cause, but they were all out for themselves and wouldn't rely on the guy next to them to have their back. When they attacked, rather than having a wall of Orcs meet a wall of Dwarves, it was more like a swarm of piranha, billowing and mushrooming, deforming and surging. If someone fell, the Orcs behind them would just run over them, so even though they were all working as individuals, as a whole the swarm almost behaved like a single creature, shoving and pushing against the enemy defences, and then pouring through any breach like a waterfall, clambering over one another, engulfing their victims.

I imagined their formations would break into chaos, but periodic commands from above would snap them back into their hard lines again, regrouping for the next attack.

Once the Orcs appeared, the Elves, Men and Dwarves had to work together or they were done for. One of the ways we devised in which we might see this coordination was by the Dwarves forming circular defensive towers, like cylinders, out of which three Elven archers would suddenly pop up, so in effect what they did was create defensive barriers to protect the archers so they could continue to rain down destruction on the Orcs at range.

These were all ideas we offered up and workshopped. In the end, how much Peter would use and how evident it might be in the final film was up to him, but a lot of work and thought into them, so the detail was there for him to draw from if he needed it.

Terry Notary, Movement Coach

1-2. Battle landscape geography (1) and battle (2) concept art by Concept Art Director Alan Lee.

1

3. Edited motion capture performance data is assembled for review in these shots from a hero battle sequence (compare with final shots). The motion from multiple separate capture sessions is applied here to low resolution models of Elven warriors, brightly coloured for the purposes of reviewing the motion. The bright hues help distinguish each soldier for the purposes of identifying any possible problematic intersections where the characters crash together or pass through each other.

The vast majority of the tactical concepts in our battle came from the shoot that Peter did with Terry Notary and Glen Boswell. Terry and Glen worked together with Peter to define the stylistic differences between each of the races, which was very important because there was the risk that the viewer wouldn't be able to recognize who was who in the midst of a battle shot. The races all look different, but it was important that they also move and fight differently.

Aaron Gilman, Weta Digital Animation Supervisor

In the extended version of the film the Dwarves and Elves came to blows prior to the Orcs showing up. Even though this was a fight between 'the good guys', Peter was very insistent that we not think about it as any kind of half-hearted clash. Peter was very clear with us when he said that the fight had to be very violent. Even though the real enemy was going to be the Orcs, there was no holding back – it was a fight to the death. It had to be a bloody battle. It took us a while to realize how far he wanted us to push it. And then, when the Orcs came in and the other races had to team up, we basically gave him a greatest hits of violent deaths.

Michael Cozens, Weta Digital Animation Supervisor

There were two shots in the film of the Elves leaping over the Dwarf shield wall and they probably spent the longest time being worked through the motion-capture process. Motion Editor, André Castelão, who is a kind of genius, worked on those shots and was responsible for much of the technical development of the battle. They were very complicated. Peter has very specific thoughts about what he wanted in the choreography of each Elf jumping. In the motion-capture at one point we had flipping, but Peter nixed the flips. The Orcs were coming in from one direction and the Elves were coming over in three waves from the other. The problem we had was that on the shooting stage the action was captured with perhaps five or six guys at a time and not the mass numbers that would be on screen. Those numbers had to be built up with more and more groups of five or six motion-captured characters. We would have the first wave of Elves leaping over the Dwarves, who had huge, long pikes, and immediately into battle with the Orcs, but then the next wave had to come in, and the third. The problems arose because they were jumping over all these characters that weren't on the motion capture stage and into the middle of an already crowded battle. It was André's task to take all of this footage and essentially make it fit and work, finding gaps into which to land our successive waves of Elves and Orcs without crashing through them and get them straight into the battle seamlessly, each with a meaningful sense of purpose in their action.

As established by Terry Notary, everything to do with the Elves was devised around a three-count, and they operated in trios. Their movements were samurai-esque, precise and clean. Everything was carried out with a practised finesse, but fast and lethal. I called them whirling dervishes, because there was a circular action in their sweeps and movements. We had tonnes of diagrams and would meet two or three times a week with Terry Notary and Glen Boswell as well as with our own team. We would be fed motion capture footage which we would piece together, building larger and larger formations and manoeuvres, identifying flaws and solving them with Terry and Glen, who would provide us with new motion capture in response.

It was like a giant, complicated puzzle. We were trying to anticipate and design every transitional move between positions, much like video game work. The archers might need to rush up to the front line, but they were behind the pikesmen, so how would they do it? Do the pikesmen spin out of the way, like a zipper, each perhaps into the empty space left by the pikesman next to them while the archers stepped through? Did the pikesmen then zip back up behind them again? But then what did that mean for their next move or position? It was very complicated and each solution led to another question.

Aaron Gilman, Weta Digital Animation Supervisor

1

MOTION-CAPTURING CREATURES & ARMIES

Motion-capture is a tool that was used extensively on *The Hobbit* films. Basically, it allows us to capture a physical performance and translate that motion to a digital puppet where it provides a very realistic starting point for animation.

The technology of our motion capture system works by having multiple cameras rigged around an essentially empty stage that track markers attached to our performers. Each performer might have more than fifty markers on their motion-capture suit. The system recognizes each marker and can figure out where it is in 3D space by comparing what each camera sees. Each marker corresponds to a point on the virtual character that they are playing. The position and movement of each marker in relation to its neighbours drives the characters to move, replicating what the performers are doing on the stage, but run through whatever adjustments need to be made for scale or proportion.

We can load any virtual character from our files and apply a performance to them. When a performer and a character are the same size, then the translation is simple, but on a project like *The Hobbit* we frequently had people playing creatures or characters that were much bigger or smaller than they were, so their movements and proportions were scaled to match whichever virtual character they were playing.

When the actors are performing on the motion-capture stage we have monitors that show in real time what their characters are doing in relation to each other, including scaling them automatically; so, for example, if we had Azog dragging Fili across the floor, we needed to see how that looked, appropriately scaled, in case we needed to make adjustments. The system we use allowed us to see a reasonable approximation of how it should look at the correct scale, right away.

The cameras we use aren't recording full pictures; instead we are only interested in the motion data, so that means we only need to see the relative positions of each of our markers. To achieve this, each of the dozens of tracking cameras mounted around the stage has a ring of 850nm infrared LED lights that constantly strobe in time with the shutter. The markers on each performer reflect that light back at the cameras, which have IR filters on their lenses so they only read that wavelength of light. We don't need to record anything else. We also sometimes use wireless active markers which are actually infrared LEDs, rather than reflective markers, depending on the situation.

In our prep area next to the main stage we put our performer through a range of motions so that we understand the relationships between the markers they are wearing, thereby establishing our tracking template. It takes about six or seven minutes to run through with each performer, inputting their information into the system before they go next door to the main capture stage.

Done properly, motion-capture provides very natural, realistic motion on a virtual character that is true to what the performer was doing on the stage and obeys the laws of physics. The translation can be so accurate that sometimes it is possible to recognize an individual performer walking into the room just by the characteristics of their walk!

It's a very smart system and can even deal with a lot of occlusion, such as when a character is lying on the ground, hiding a number of their markers.

The limit to how many performers we could capture at one time on our stage is set to some degree by what they are doing. We could comfortably capture up to ten individuals throwing each other around and falling over one another, though at some point the real time representation of that action on our monitors is likely to starting falling apart. If we didn't have to see a real-time version of what we were shooting, then the only real limit to how many performers we could capture at once would be physical; we could shoot twenty, or thirty, or even fifty people at once, but there would be lots of occlusions happening and we would probably spend much longer cleaning up that motion data than we would if we simply captured three smaller groups and put them together later. Sometimes it was important to have the mass of a large group of performers all bumping into one another, such as when the Goblins were jostling along their paths in the first film. In an instance like that the number of interactions between all of the characters meant shooting lots of performers at once made more sense, but usually it wouldn't.

If we are shooting a performance that requires facial capture as well, we have what we call a facial helmet, which is like a bicycle helmet with an arm that extends out on front of the face with a camera mounted on it that is aimed back towards the actor. It remains framed on their face the entire time unless something knocks it. The actor would have small markers on their face that are tracked in order to capture their facial expressions.

Dejan Momcilobic,
Motion Capture/Performance Capture Supervisor

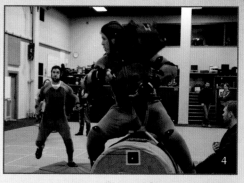

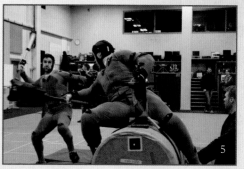

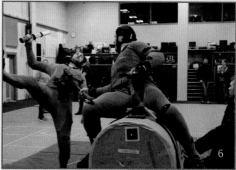

We don't build typical live-action sets on motion capture stages, but we can recreate the geography very closely with scaffolding, platforms and other tangible materials and build them at a relative scale specific to the captures needs. That makes it possible to interact with the environment naturally and instinctively, and thereby avoid the action looking too choreographed or contrived. If you're capturing an action scene and you're performing action at speed, you want to be to throw yourself against the environments when possible, instead of miming the impacts on specific marks.

Isaac Hamon,
Stunt Performer / Motion Capture Performance Coordinator

Doing performance capture work with Peter is always amazing, especially when it is one on one, where he is directing me and we're jamming together on a character. I had the pleasure of performing a few characters through the trilogy and they were all fun. Peter expects a lot, and I always want to give him as much as possible, right up until the last moment.

One particular experience that epitomizes our working relationship and everything to do with these films, because they are so ambitious on every level, was my very last day of filming. We were still shooting and my departure time was getting closer and closer. I worked until the last second, then jumped into a car, still drenched in sweat and peeling off my mocap suit. I had a make-up artist in the car with me removing the registration dots and make-up. I jumped out of the car, wiped my face with a wet towel and ran to the check-in desk with

my passport looking like complete hell, just barely making it before they closed the flight. Looking back, it really was a great and strangely appropriate way to end the experience.

Terry Notary, Movement Coach

1. *The motion capture team creating an Orc charge on the mocap stage.*
2. *Motion capture camera.*
3. *Motion capture team members: (row by row from top left) Vincent Roxburgh, Tim McLachlan, Alan Henry, Scott Chiplin, Min Windle, Rosalie Van Horik, Marky Lee Campbell, Isaac Hamon, Stunt Co-ordinator Glenn Boswell, Mark Trotter.*
4-6. *Capture in action, featuring Mana Davis (Orc) and Marky Lee Campbell (Dain on boar).*

Motion capture is the beginning of the process for us as animators, and it's incredibly valuable, but we never plug raw mocap data in and call it finished animation. There is always more to be done to finesse a performance, and there are also certain practical limitations that require some technical tweaking. One example would be when shooting motion-capture performers on a stage we don't want to hurt them, but at the same time the hits need to appear incredibly violent. This was very important to Peter. He was explicit about us making sure that the weapons felt heavy, that the characters

felt like they were wearing hundreds of pounds of armour, and that when they hit each other it looked like it really hurt. These characters were there to kill each other. Whether swinging foam weapons or not, when that level of ferocity is being accurately portrayed on the capture stage, there's pain involved, so there is a natural instinct to hold back or to anticipate impacts. If you were miming the impact of a blow, your body does something that motivates that performed impact. It's subtle, but these things read in the motion capture. That little bit of anticipation that you might do in one direction in order to then throw yourself in the other is the kind of thing that we don't want. Our animators and motion capture artists became very good at tidying up the motion capture data to clean up the impacts and remove those anticipations, making sure things felt heavy and physical. Similarly, while the motion was generally captured on flat stages, the terrain of the battle was uneven, so foot contacts were another area demanding attention. It was a huge volume of work, but essential.

Aaron Gilman, Weta Digital Animation Supervisor

I absolutely love what a pressure situation motion capture can be. I honestly revel in it. I find tricky and challenging situations are never a negative but only encourage creative and pragmatic thinking and the results are incredibility satisfying. On the capture stage you have to be able to turn on your inner Dwarf, Troll, Ogre or Elf at a moment's notice. There have been many times when in a single day you would perform capture for multiple characters in multiple scenes. Being able to transition from one character to another while still honouring the live-action performance on which it is based is an integral part of what we do in motion capture.

It's also the kind of work that you can unwittingly bring home with you. I could be walking around my home, thinking about a character who might have a peculiar gait, a nervous twitch or other noticeable characteristic and I suddenly physically drop into that character, much to the amusement of my wife and son. I've done it in public too, only realizing once I notice someone staring at me in bewilderment.

Isaac Hamon,
Stunt Performer / Motion Capture Performance Coordinator

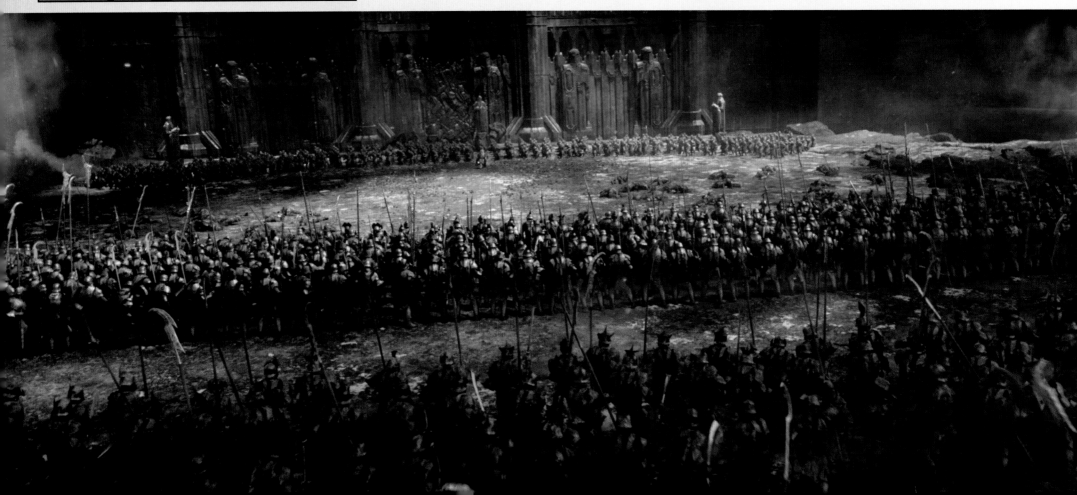

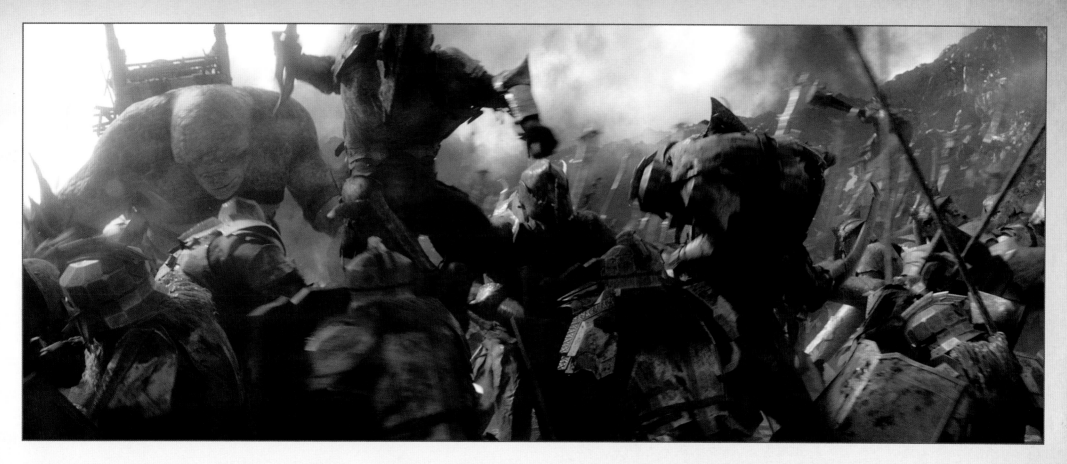

In addition to capturing on our mocap stage, we have also captured actors live on the set, like we did for Andy Serkis when he performed Gollum on the live set with Martin Freeman's Bilbo. We would set up our tracking cameras around the set. Unlike the blank floor of a motion-capture stage, on set there are lots of obstacles, bright lights and other things that can interfere with our cameras' ability to track a performer. We use small cameras in simple black housings so that they are as unobtrusive as possible, because sometimes, in order to get as much coverage as possible, they can end up in the field of view of Peter's main camera. We try to hide them so that they don't have to be digitally painted out later, and we actually got so good at hiding them in the cracks and crevices of the rocks on the Gollum's cave set that our cameras got watered down by the guy with the hose making the set nice and wet for the shoot. Fortunately we didn't lose any cameras that way, but we ended up waterproofing them on the next project!

Every new project throws new challenges at us. We have worked in some outdoor environments that are pretty unfriendly to mocap technology, but it has always seen us develop and evolve our methods and technology to suit, so the frontier continues to advance with each new film. We have

established a good reputation for strong creature performance capture work, starting with what was pioneered with Gollum on *The Lord of the Rings* and growing with every film since, including *King Kong*, *Avatar*, the *Planet of the Apes* films, *The Adventures of Tintin* and now *The Hobbit*. We're definitely a more sophisticated institution than we were when we started.

Dejan Momcilobic,
Motion Capture/Performance Capture Supervisor

The final six weeks we shot was probably the most intense as it was full-on motion capture for *The Battle of the Five Armies*. We were throwing ourselves into battle every day for the entire six weeks. There was so much to get done and it was very intense work. People often talk about how the industry is changing and more and more is becoming computerized, but because of how much motion capture studio work our stunt team does nowadays, which is more intense than being on set, I can tell you it all felt pretty physical! We never stopped. Fight after fight, bashing and crashing – it was relentless.

Glenn Boswell, Stunt Co-ordinator

The entire final battle session we shot with Terry Notary, Glen Boswell and the stunt team was very intense. We were shooting on two floors at the same time and had a limited time to achieve everything. There was some beautifully choreographed work and some of it was quite stunt heavy. It was great watching scenes coming together as we shot one chunk of action, put it in the scene and then shot more, layering all these chunks of action until we had entire armies in action. There were crazy formations and graceful moves. It was certainly an epic, memorable shoot.

Dejan Momcilobic,
Motion Capture/Performance Capture Supervisor

1. *Motion capture performers poised to strike with spears. Movement Coach Terry Notary stands in front of them.*

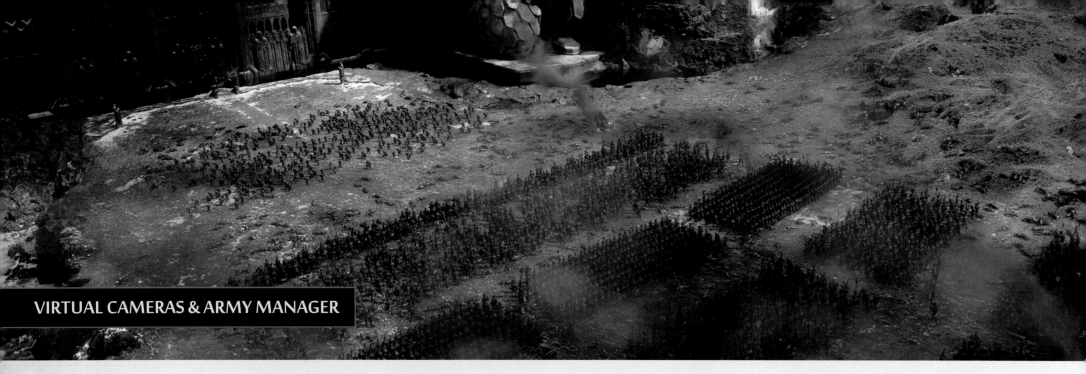

VIRTUAL CAMERAS & ARMY MANAGER

The battlefield on which the Dwarves and Elves, and then Orcs, fought was digital. We scaled bits and pieces from around New Zealand to reconstruct it so it was all authentic scenery, but reconstructed in a configuration that didn't exist in the real world. There was no location that gave us exactly the geography we needed for the battle. Tolkien had laid out a very specific geography and there were things that Peter needed for his storytelling that dictated the shape of the land to such a degree that this was really the only way to do it.

With that in mind, and given that the vast armies we would need to move around on the battlefield would also be largely digital, it made the most sense to shoot it using a virtual camera pipeline. We had worked with virtual cameras before, including on *The Desolation of Smaug*, but Peter employed them to a whole new degree on *The Battle of the Five Armies*. There was something in the range of 350 shots that he did on the virtual stage with a virtual camera.

What virtual production means is that we would supply Peter with a big chunk of blocked-out animation in an environment that he could explore on an empty stage, looking through his virtual camera. He could literally wander the space while the animated action played around him. He could specify all his camera information and choose angles, shooting the virtual action as if it was live action and he was a cameraman amongst it. It granted him total freedom to shoot however he wanted.

Because the environment itself was being designed in reaction to the action, we gave Peter a god's eye view of the battlefield and let him tell us where the armies would be.

Then we built what he described and handed it back to him as something he could walk around on the virtual stage. He put his cameras on it and we re-arranged things where he directed us to do so in reaction to what his storytelling needs were. We reconfigured and rebuilt the battlefield as needed. The hillside the Dwarf army charged down, Ravenhill, Dale, the were-worm hill – each moved several times in order to get the choreography and composition right as shots evolved. For a long time the worms weren't in the film, and then they came back, which meant rebuilding the landscape so that the hillside they emerged from was visible to the armies in front of the Gate, and moving the road going from Erebor to Dale.

Joe Letteri, Weta Digital Senior Digital Effects Supervisor

Virtual production changed how we in the Previs team worked with Peter on these films. Previously our process on *The Hobbit* was more akin to traditional storyboarding. A previs artist would be given a shot, they'd animate a little scene, including placing cameras, and deliver it back to Peter for his feedback. Inevitably there would be changes and a feedback cycle. If there were 100 shots, they would be split amongst eight people, each of whom had their particular strengths. Some might be better at camera, and for Peter camera is a top priority. By taking the camera out of the hands of the previs artists Peter freed them to concentrate on animating master scenes instead. He would handle the cameras himself, which made much more sense.

Jamie Beard, Weta Digital Previs & Animation Supervisor

Peter's embracing of the virtual cameras pipeline removed our need in Previs to second-guess how he might shoot a sequence. We'd animate a master scene, like Smaug rampaging through the forges of Erebor, or Lake-town, without any input as to what the shots were going to be. There's no way in a million years that I would think of the kind of camera shots Peter would use, so it was liberating not to have to worry about that.

Randy Link, Weta Digital Previs Supervisor

Virtual cameras allow Peter to shoot virtual worlds and virtual action the way he would shoot live action, and that's great. It means he is shooting it raw and his shots aren't getting bounced around a room full of technical people and noodled to death. You haven't lost the character and spontaneity that comes with a little camera bump or some other happy accident. The creative vision is clear, unfiltered and it's entirely in Peter's control. More and more tools and more and more technology has a tendency to make things foggier and more complicated than they need to be, but this is one of those rare times when it has done the opposite.

Jamie Beard, Weta Digital Previs & Animation Supervisor

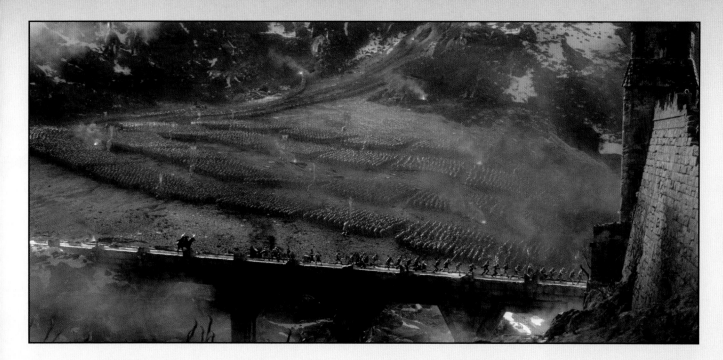

It is worth noting that there were no storyboards for these battle sequences. We had concept art, but none of the storyboards that are typically part of the process for films of this sort and define the shots. We had a much more free-form process with Peter designed expressly to allow him to shoot everything on the virtual stage. We designed massive combat sequences using hundreds of thousands of frames of motion capture and key-framed animation as master scenes with no cameras in mind, knowing he would place them himself, later.

The master shots defined where we were in the environment, which was very important for the battle. There were specific landmarks in the battle that the audience needed to be able to understand in order to follow the flow of the battle in a coherent way. Without those landmarks to anchor the audience the entire thing could just degenerate into a mash of people fighting. Working this way we could define tactical scenarios of the battle portions of the narrative that Peter wanted to shoot on a given day.

For any given scenario we would know where it was, how many soldiers there were and we would have compiled all of the related motion capture footage. That material was generated by a small team of performers, so it had limitations, but we could put it all together using software which we called Army Manager and deliver it to the stage where Peter could stand with a virtual camera in his hand and shoot freely, like a combat photographer in the thick of the action, defining his own cameras and shots as he liked, reacting to the action unfolding all around him.

Weta Digital Layout Research and Development Technical Director, Éric Légaré wrote the Army Manager software in-house for *The Hobbit*. Eric sat with the animators so he could field all of our critiques and evolve the tool into something that the director would find easy to use. Peter loved it. It essentially allowed him to treat filming the battles like a table-top game.

Aaron Gilman, Weta Digital Animation Supervisor

Army Manager gives the director a feel for a shot involving big numbers of troops. It allowed Peter to block in a mass battle shot very quickly. We could get 1,000 or 5,000 guys in a shot, all fighting, and choose where to have tighter, more finished animation with nice choreography that could sustain Peter getting close versus rougher, blocked-in stuff. Peter wanted to have both good animation and lots of soldiers in his shots, so the Army Manager solution was a great way to make that possible while keeping the process light and usable. You can imagine that having several armies' worth of motion-captured soldiers all fighting and performing unique actions could be incredibly heavy and cumbersome to work with. This was the perfect solution to that problem, giving Peter what he needed, but still being quick and easy to use.

Michael Cozens, Weta Digital Animation Supervisor

Essentially, Army Manager is a Previs tool. We could plug in and play basic animation or motion capture for the entire army very quickly. It was only at a very basic level and was baked in, meaning it couldn't be altered, but enough for Peter to be able to get the general idea and design his shots. There was no ability to tweak or manipulate the animation in Army Manager because those controls would add 'weight' and mean the whole thing would require more processing power. The extent to which we could manipulate it was limited to playing back animation and snapping it to the particular terrain, but that was enough. Normally in an animation scene, once we have three puppets things would start to slow down. With this process we could put thousands of soldiers in a scene and still have full play. In computer processing terms it meant keeping it 'light'. Once Peter had put his cameras on it we knew exactly what he wanted and could then adapt all of that material to our official digital puppets, complete the animation properly, bake and render it.

War is a logistical nightmare. Orchestrating where everybody is in relation to one another, the charges, routs, flanks and so on – we didn't want to bog Peter down in the minutiae of having to worry about all of that. Far better that he be able to walk onto a stage and shoot like a combat photographer, doing what he wanted and responding to what he liked.

Aaron Gilman, Weta Digital Animation Supervisor

The technology continues to evolve and speed ahead so that we can do things now that were impossible just a year ago. Everything we do is in reaction to what a script or director is asking for. We figure out what we have to do and then build new software to achieve it, so with every film the frontier advances.

And we are always trying to make the process more creative for the director, whether it's Peter Jackson or James Cameron or whomever we are working for. It's important that we provide them with the tools they need to realize their vision as intuitively as possible within their working style.

Joe Letteri, Weta Digital Senior Digital Effects Supervisor

Working with Peter to find the storytelling beats in the battle was fascinating and exciting for all of us involved in this process. He is so inspiring to work with.

Michael Cozens, Weta Digital Animation Supervisor

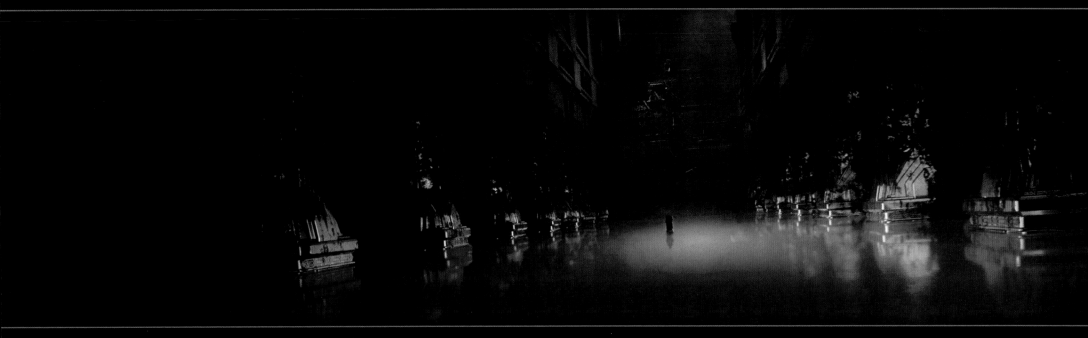

THORIN'S EPIPHANY

We had an opportunity to maintain internal consistency and acknowledge one of the more memorable scenes of the second film with the lake of gold that filled Erebor's tapestry room. At the end of *The Desolation of Smaug* Thorin dumped tonnes of molten gold over Smaug and that gold was still there, cooled and now forming a huge, flat lake that we saw him walk on as he wrestled with the Dragon-sickness afflicting his mind. The pillars on either side still bore the gold splashes of the previous film's scene as well. These were the sorts of things we wanted to preserve as they all help reinforce the reality of the world. Originally, Thorin's epiphany, the point at which he would come to his senses and realize that he was undermining everything he had once stood for, was going to be in the treasure room, surrounded by piles of gold. The idea had been to have him scrambling in the coins, sliding down and being sucked under. We began working on early simulations for that but we hadn't gone too far before the scene changed, I think because it was too literal. Having seen Smaug swimming through the coins there was a danger of audiences interpreting Thorin's nightmarish vision of being swallowed by an avalanche of gold coins as actually physically happening to him, when it was important that it be understood as a psychological battle within his mind. Shifting that scene to the lake formed by the remains of the giant melted gold statue of his grandfather was a fantastic idea.

Matt Aitken, Weta Digital Visual Effects Supervisor

The difficulty of playing deep into the madness and having such a fast recovery was always on my mind. It was down to the filmmaker to solve that. The film used an abstract moment of Thorin alone in a sea of gold, with all the utterances of his friends and colleagues, his enemies too, running through his addled brain. To me, in this moment he was a figure like Macbeth; the army was at the gates and he was nowhere to be seen, a solitary figure in body and mind. In a way, his possession of the gold, the totality of 'everything' he had wished for, which had brought him to this lonely place, was the turning point. Seeing and hearing what he had become reflected back at him, the gold consuming him and sucking him under, his last breath nearly taken, drowning, is as close to death as Thorin had come. It was as if he was jolted awake. Casting the golden crown of Erebor from his head was the beginning of shedding this weight.

He returned to his Company without his golden armour, shedding all the infectious metal to be Thorin again, and to brave what lay beyond the wall free of the weight of the gold. At that point his story was no longer about wealth, but survival, loyalty and willing hearts, just as Thorin had once believed.

Richard Armitage, Actor, Thorin

Thorin reached a point when he had been consumed by the gold, drowned by it. We had to show that, to have a moment when the audience could see it and so would Thorin. Peter has an incredible, natural visual instinct. It is one thing to read a passage like that, but now try shooting it in a way that is gripping and engaging but also speaks to the metaphor of being consumed by greed, literally swallowed. Fran came up with the idea of what was playing in his mind, both the journey that took him to this point and the drowning man gasping for breath to save himself. That was just two great filmmakers putting their heads together. When they do that I just get out of their way!

Philippa Boyens, Screenwriter & Co-producer

THORIN'S CHARGE

The shedding of all the heavy Erebor armour that we initially donned had a powerful symbolic meaning to it. When Thorin came to us, clear-headed after his madness, and asked, 'Will you follow me, one last time?' there was the understanding of what he was truly asking, because it was a hopeless battle at that stage. Yes, we would charge and maybe break the Orc ranks, but we were still hopelessly outnumbered. He was asking the Dwarves if they were ready to die with him. It was a desperate act, a final act in which he was looking for redemption, I suppose, but I think in shedding the beautiful, heavy armour we had all put on when we fortified ourselves in the Mountain, it was a visual expression of us dropping that holed-up mentality. We were leaving behind that state of mind and going into battle with only what we needed, just our weapons and fists, and we were going to go down fighting alongside our Dwarven brothers on the battlefield. We didn't expect to come back, and we were going to die like Dwarves, with our weapons in our hands, not hiding in some cave with our gold.

Graham McTavish, Actor, Dwalin

As a group we talked about the fact that we probably weren't coming back from this charge. Our characters knew that the odds were so heavily stacked against them that when we charged out that gate, there were creatures out there that were probably going to kill us, but we were going to follow our King. We had come this far with him and we weren't going to hide inside while our Dwarf cousins were killed on the doorsteps of Erebor.

I talked to Richard Armitage very early on about wanting to be fit enough to be able to sprint out of those gates. We even discussed the idea of doing a Dwarven version of a haka, the Maori war dance. As it turned out, there just wasn't time to implement that, but that sprint out of Erebor was very important to me.

I had the flu that week, but you wouldn't have known when we did the sprint. I think Richard was no more our King than in that very moment when he looked at me and said, 'I know you've been waiting for this for two years. Let's get it done.' He was amped, he was King Thorin. All of the repression that he had had through the whole story, the pressure of the Quest, the treasure and the legacy, was gone. It was like an explosion of energy coming out of those gates. It was like a finely wound spring finally being let go.

Jed Brophy, Actor, Nori

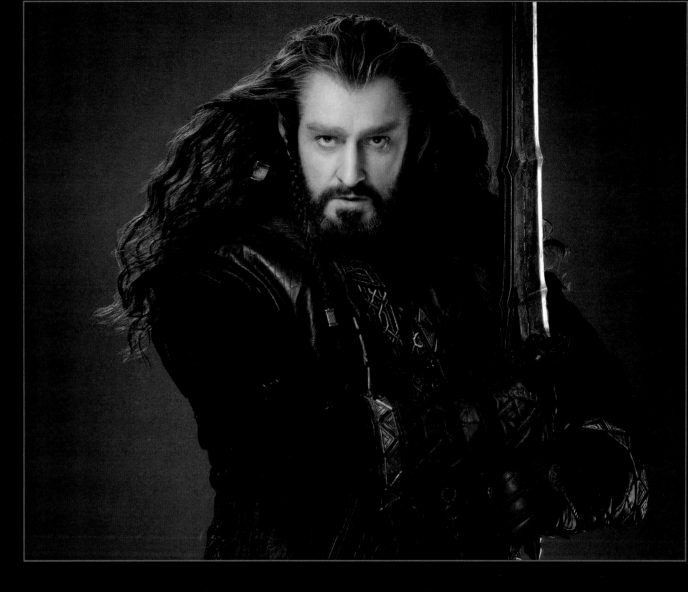

When things developed uncomfortably between Thorin and the humans who had actually helped us in Lake-town, I think Oin found himself deeply conflicted between a sense of honour and justice, and loyalty to the King he pledged himself to. Thorin's emergence from the Dragon-sickness and his question to them all, 'Will you follow me, one last time?' was therefore a source of tremendous relief to Oin. Old bugger or not, and whatever the odds against them, Oin was going to be there at his side when they charged out of the gate.

John Callen, Actor, Oin

The Dwarf retreat and Thorin's charge in V-formation was, in my opinion, some beautiful work. Normally a shot with so many characters like that would be simulated, but in ours 90% of the action was comprised of specific captured performances, which is new ground. Dain and his forces being trapped against the Mountain was in fact one of the last things shot for the film. Peter shot take after take of the guys being backed up using half a dozen performers, and chunk by chunk these six guys, each performing their own individual motion, were layered until we had a wide shot with between 1,000 and 2,000 characters, every one of whom had genuine, real motion.

Michael Cozens, Weta Digital Animation Supervisor

1. Studio photography of Richard Armitage in costume as Thorin.

THORIN IN BATTLE

Thorin's battle costume was very dark, reflecting the serious nature of what was going on with his character. We used black leather for his tunic, which had a rugged quality not unlike Aragorn's ranger costume, only more regal; rough and regal being our touchstones for Thorin. Having stripped away the baubles and bling, Thorin was all business at this point, so it was appropriate that this last costume hark back to his travelling costume; this was the old Thorin coming back from his gold fever.

Bob Buck, Costume Designer

Thorin had a striking armoured black velvet sleeve on his costume. There was armoured plate beneath the velvet and it was all glued and stitched down with the pile removed from areas so that the armour could be seen through the fabric. It was a very nice process and a gorgeous costume.

Paula Collier, Textile Artist & Dyer

2

3

4

5

Like so many of this film's weapons, Thorin's sword was another gorgeous Nick Keller design. The only issues we had with some of these Dwarf weapons was how thick they became. Because the Dwarves were shot to be significantly smaller than the actors really were, if we didn't make their weapons much thicker they would look ridiculously thin and ineffective once they were scaled. In the case of Thorin's sword that resulted in a blade that was about eighteen millimetres at its thickest point, which in turn meant it was a very heavy weapon.

In an effort to keep the weight down so that Richard Armitage could easily swing it one-handed we changed our manufacturing methods so that we could offer lighter-weight versions as well. Where normally the sword would be cast in solid urethane, we actually put a urethane skin around a foam core, which made a big difference to the weight.

Thick weapons can also look blunt, so we had Paul Van Ommen, who is a veteran prop maker and one of our senior crew, take his time going over each hero urethane weapon to clean them up and ensure they had nice, crisp edges that would read as sharp through the camera. We didn't have hero steel or aluminium blades on these weapons the way he might have done in the past – they would have been too heavy and at 48 frames per second in 3D the difference between them and the urethane versions would have been apparent. Instead, all of our Dwarf weapons were urethane so that they appeared consistent.

Alex Falkner,
Weta Workshop Props Model making Supervisor

Thorin's shield was originally made with a ram's motif to match the imagery of his armour, which was also a ram at the time. Later it was redesigned with raven theming, at which point we went back and reworked the shield, model-making raven elements over the top to fix it.

Nick Keller, Weta Workshop Designer

1. *Miriam Silvester, Costume Department Graphic Artist and Off Set Costumes, problem-solving feather-like armour on an early version of Thorin's battle costume. The feathers would later be dropped.*
2-3. *Thorin's battle costume details: coat (2), sleeves (3).*
4-5. *Thorin's shield: front detail (4), back (5).*
6. *Thorin's battle costume.*
7. *Thorin's sword.*
8. *Detail of Thorin's battle costume.*

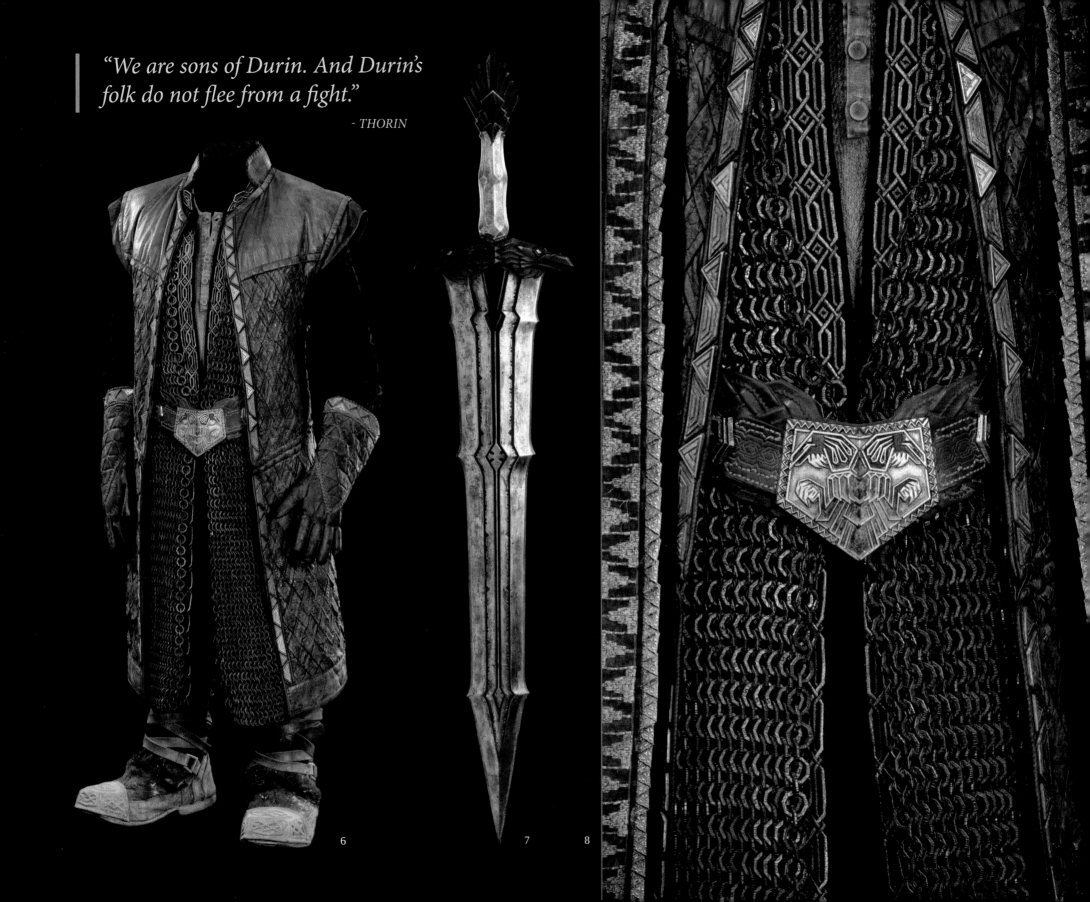

> *"We are sons of Durin. And Durin's folk do not flee from a fight."*
>
> — THORIN

6 7 8

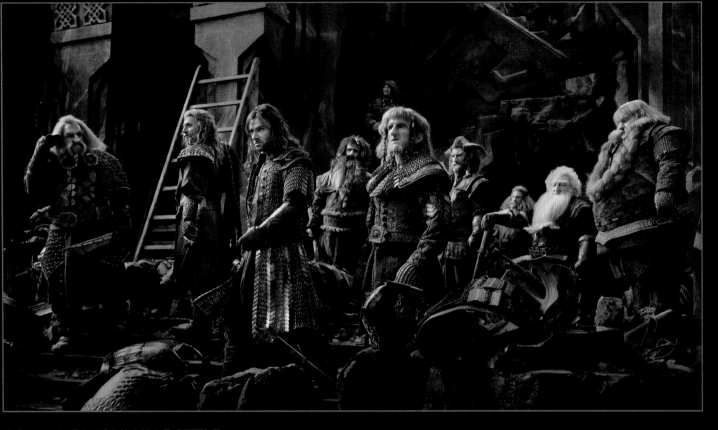

BALIN & DWALIN IN BATTLE

Having stripped off his regal armour, Balin went into battle with just the leather under tunic. There was a practical sensibility to Balin. He might be a Dwarf Lord and proud of his heritage, but he also had a wise, refined humility, so his costume, while appropriately lordly, was also pragmatic and elegantly simple. Contrasting the use of gold in Thorin's costume as an accent, we used silver over Balin's red leather and velvet.

Bob Buck, Costume Designer

Once the Dwarves got dressed for war they all ended up wearing gloves, which was a huge task for me because in addition to each of the leads and their stunties we had scale double to consider as well, so it meant making several dozen new gloves. While I padded them out to give them the appearance of broad Dwarven hands we kept the palms free of padding so that it didn't affect the actors' ability to hold their weapons.

Hayley May, Milliner

Balin used to be a great warrior, but he was older now. We played that experience in his fighting style by making everything he did very controlled and refined.

Glenn Boswell, Stunt Co-ordinator

1-4. Balin's battle costume, details: sleeve and cuff (1), tunic shoulder (2), tunic leather edging (3), glove (4).
5. Balin's multi-bladed war axe/mace.
6. Balin's battle costume.
7. Detail of Balin's battle costume.

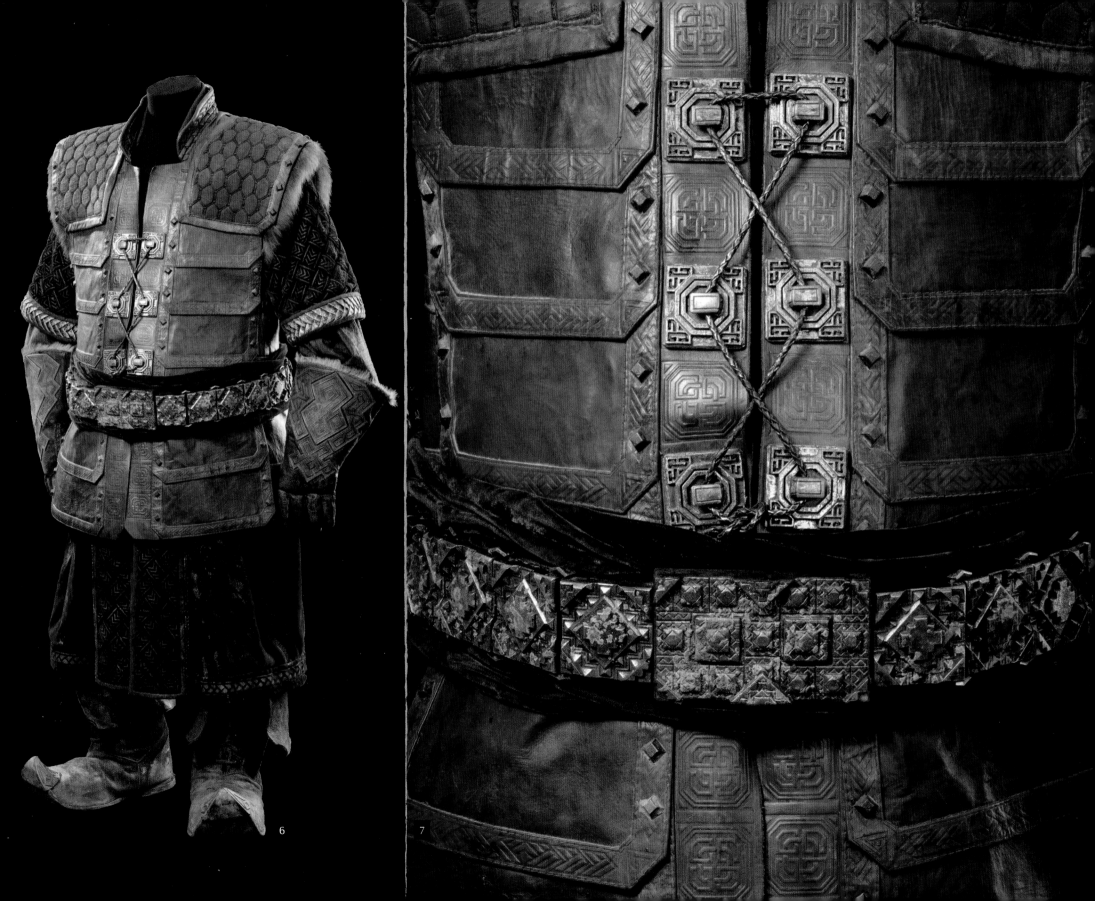

6

7

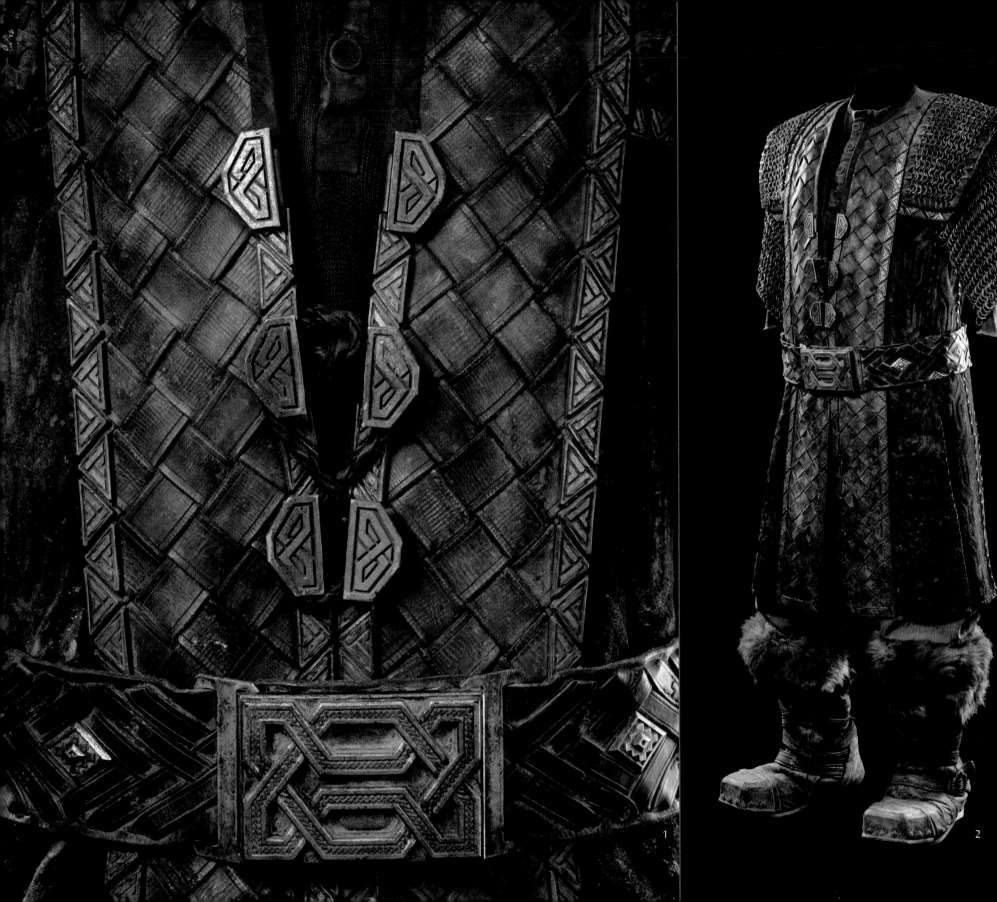

1

2

Dwalin was a warrior who favoured axes, so we devised a fight style for him that was tough and aggressive, with powerful moves. There was some great stuff shot with him fending off and cleaving his way through Orcs.

Glenn Boswell, Stunt Co-ordinator

Dwalin's jade axe and dagger were cast in a translucent green material and then detailed over the top so that the light would read through their edges the way it does with real stone. They were very beautiful props but sadly didn't get seen nearly as closely as they should have.

Dwalin also had a pair of identical stone axes that looked like they were made from a different stone. In their case we found that even though they weren't cast with translucency, they still read very well on camera, thanks to Sourisak Chanpaseuth's excellent paint job.

Alex Falkner,
Weta Workshop Props Model making Supervisor

If Thorin was the serious uncle who Fili and Kili thought was really cool, but who was a bit removed and distant because of who he was and had to be, then Dwalin was the fun uncle. He was the warrior who was always up for some sword play. Part of that dynamic was a result of who Graham McTavish was and how we related to him as a person.

Graham is like a big kid and he loves playing around with swords. His best days were when he got to chop things up with his axe. That energy and enthusiasm was infectious. Graham called me into his trailer before we went to do some scenes and he was watching some medieval movie in which everyone was chopping each other up. 'Doesn't it make you want to go out and do it?' he said. We all got really pumped up and excited ahead of going out to film our fight.

Dean O'Gorman, Actor, Fili

Costume breakdown is an essential part of making costumes look real and lived in, and connecting the characters with the environment they inhabited on screen. When it came to breaking down the Dwarves' battle costumes we found ourselves deep in dust and mud. There was snow too, but that's difficult to show in breakdown so the rule was generally to make things look wet and muddy.

Hamish Brown, Costume Art Finisher

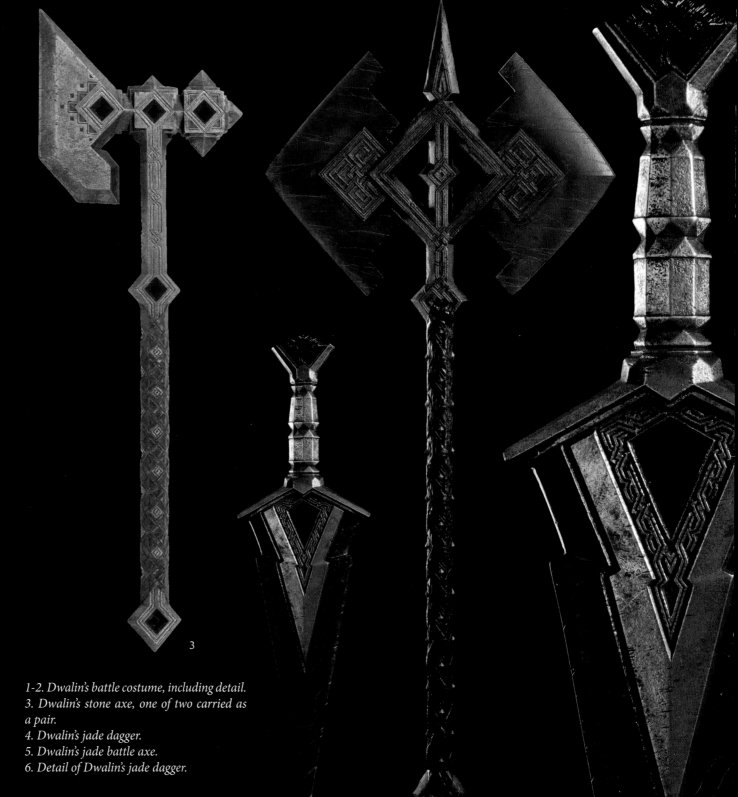

3

1-2. Dwalin's battle costume, including detail.
3. Dwalin's stone axe, one of two carried as a pair.
4. Dwalin's jade dagger.
5. Dwalin's jade battle axe.
6. Detail of Dwalin's jade dagger.

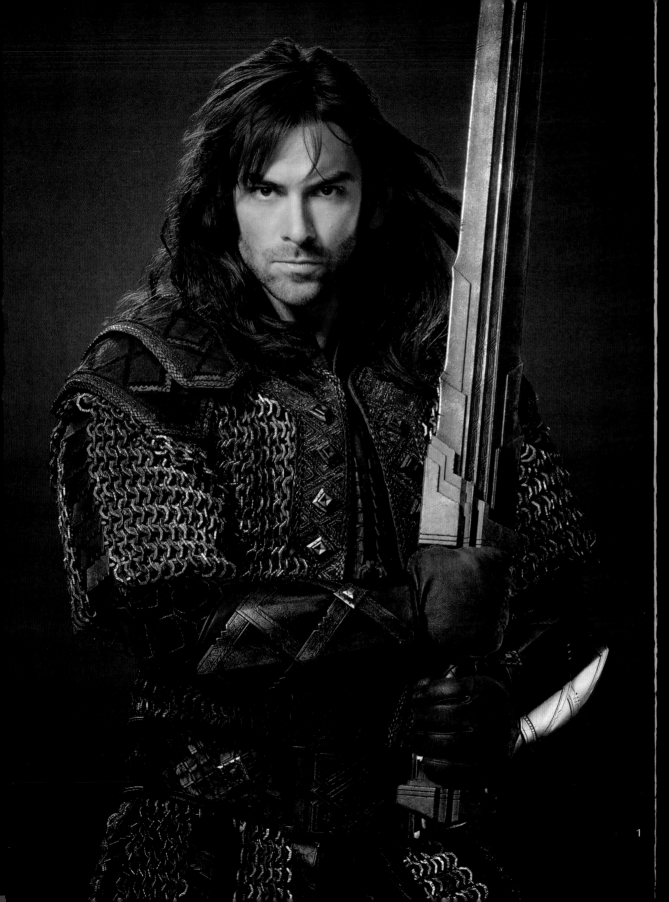

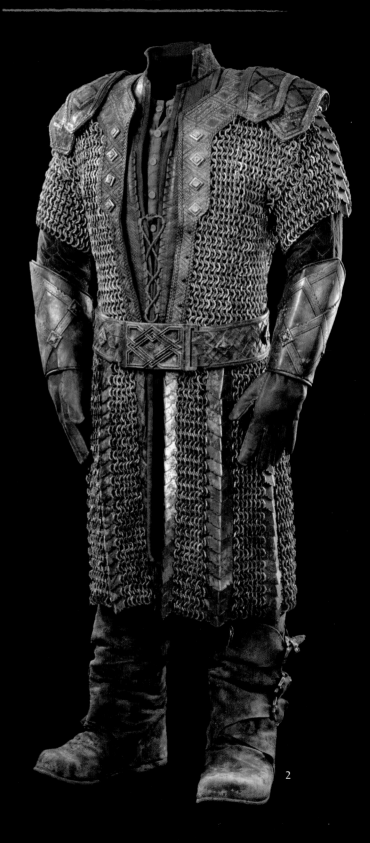

1

2

5

6

3

Fili and Kili were young Dwarves, so it suited them to have a lighter look in terms of armour. In as much as a Dwarf could look sexy, that was part of the goal as well, so we gave them chainmaille. Chainmaille vests or jackets that could be worn open, exposing a little bit more chest which probably doesn't make a whole lot of sense in battle but helped give them a slightly younger, slightly roguish look, a bit like someone wearing a leather jacket.

Matt Appleton, Weta Workshop Costume Supervisor

Although we characterized the Dwarves as a people by their solidity and groundedness in battle, there was also room within that style to find individual expression. Most of the hero

Dwarves fight well in a coordinated way. Given they're at a height disadvantage against pretty much everyone else in Middle-earth it probably helps them to have a pack mentality and to work together. There's a lot of bashing around each other and jumping over, ducking and vaulting in a coordinated kind of way.

Aidan Turner, Actor, Kili

1. Studio photography of Aidan Turner in battle costume as Kili.
2-3. Kili's battle costume, including belt detail (3).
4. Detail of Kili's Erebor sword.
5-6. Details of Kili's battle costume: chainmaille coat and leather

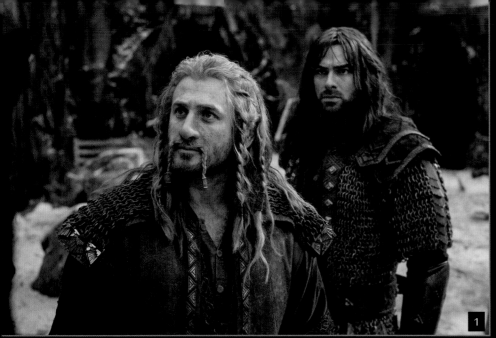

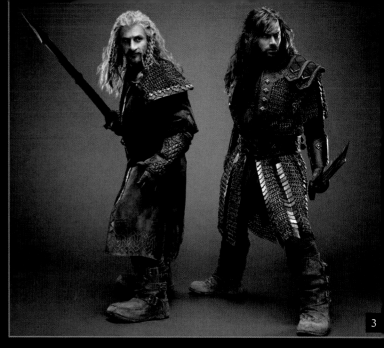

The way that I find a character is very tactile. While there is the theoretical knowledge of a character that comes from backstory and the books, the most helpful thing for me in finding the character of Fili was meeting Aidan Turner and the dynamic that we developed, working together over the course of shooting the films. We became very close and that relationship infused our characters' brotherly bond.

I don't really like trying to craft a performance too much before I go on set, because invariably things change, especially with Peter. I created it on set, reacting to the scene and the other characters. It kept things alive for me.

Hanging out with the other Dwarf actors, like Aidan, Graham McTavish, and Jimmy Nesbitt, we all got along really well. We socialized when we weren't working and a natural camaraderie sprung up that for me was really helpful because I had something real and tangible to draw upon on set.

I remember my audition focussed a lot on how Aidan and I connected as people. Fortunately, we connected well. While the audition was quite jokey, once we started filming it became clear that there was an element of seriousness that had to be maintained as well, just because of Fili's position as an heir, so the larking-around part of the character that we had imagined

glory and naivety, and then as things became more real and life-threatening, the innocence was lost and the reality of conflict asserted itself. I think, especially in the first film, there was a light-heartedness in Fili because he was excited to go on the journey, a big boy's own adventure. Things became more real as they went along – Thorin was almost killed, Kili was wounded, the Dragon attacked. It became apparent to him that this was not a fun little adventure, but a very serious cause and no-one was safe.

The younger Dwarves weren't encumbered by all the Dwarf history the same way the older members of the group were. Young people often want to rebel or shrug off their cultural prerogative. While Fili couldn't completely rebel, because he had responsibilities as an heir of Durin, he didn't hold some of those same ideas about what it meant to be a Dwarf as rigidly as the elder Dwarves might have. In time I think he might have adopted more traditional Dwarvish ideas, if he had lived beyond the battle. Until he had experienced the same things that fed their distrust or hardened their positions, those probably just seemed like things that old people thought or did.

The same would be true for Kili, possibly even more so, given he was the younger brother and didn't have the prospect

So Kili liked Elves. The rest of us Dwarves gave him a hard time about that. There were rumours within our ranks that maybe Elrond was actually his real father. Maybe there had been some fence jumping? Kili didn't look quite as Dwarven as the rest of us, did he? Maybe it was just jealousy on the part of the rest of us, but, you know, the Dwarf nose – it's quite a heavy thing to carry around every day and he didn't really have one. What was going on there?

All joking aside, Fili and Kili were a tight unit. They were close and as a pair they had a sense of fun about them. I think Nori looked at them and was perhaps a little bit envious of their relationship in the beginning, because our family of three brothers didn't start out as close. We were a disparate crew. Nori barely knew Ori and he was irritated by Dori who was such a mother hen, always trying to tell us what sort of Dwarf to be. That had a lot to do with why Nori left his family and had chosen to live on his own in the first place, before he joined the Quest. I think the relationship that Fili and Kili had was a model of what he wished he had with his brothers, which by the end of the journey they had begun to build.

Jed Brophy, Actor, Nori

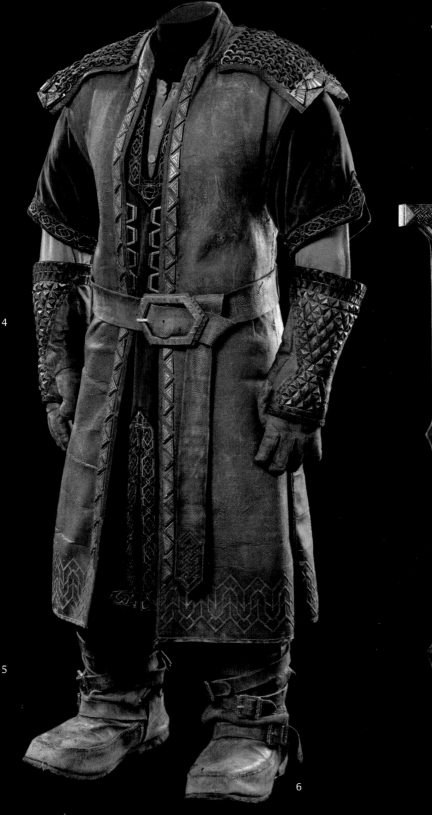

I had really enjoyed fighting with the paired swords that Fili started the adventure with. It was weird at first, like playing cricket with your left hand, but it ended up feeling very natural and I loved it once I got used to it.

For *The Battle of the Five Armies* Fili got a new weapon. This new sword was more like a Scottish claymore, a massive two-handed blade not quite as tall as me, but not far off. Fighting with that thing was quite different, and holding it one-handed when we were all on the chariot was a work-out for the forearm! It was a new fighting style that was required, but I enjoyed it a great deal because fighting two-handed I got to put some real power into my swings.

Even in the early conceptual art the gear Fili was wearing into the fight was quite light because he was always seen as a character who was quick and light on his feet compared to some of the other Dwarves. The battle costumes had to be moveable for us to be able to fight in them, and in terms of Middle-earth I think it made sense that we had costumes that suited our way of fighting. Bombur was like a tank, a big cannonball, whereas Fili and Kili were lighter and their swordplay required movement, so we ended up in more maille and lighter armour. Our gear was less about protection and more about movement.

Dean O'Gorman, Actor, Fili

We gave Fili a long sleeveless tunic of leather, like a coat with patches of chainmaille around the shoulders, but sleeveless to avoid hindering his movement in battle. Having made samurai armour for other projects, I understood the sensibility of how this sort of costume should go together. If someone raises their arm in a heroic pose and there is a sleeve it can often pull the whole costume up, so instead we kept the sleeves separate from the coat, making them part of a soft velvet under tunic with embroidered edging. We used a leather laminating process to create a pattern in embossed relief on his coat, similar to what he had on his earliest costume.

Fili's belt was quite long, with a royal metal decoration at the chape.

Bob Buck, Costume Designer

4-5. *Details of Fili's battle costume: belt (4), gloves (5).*
6. *Fili's battle costume.*
7. *Fili's Erebor sword.*

OIN & GLOIN'S BATTLE COSTUMES

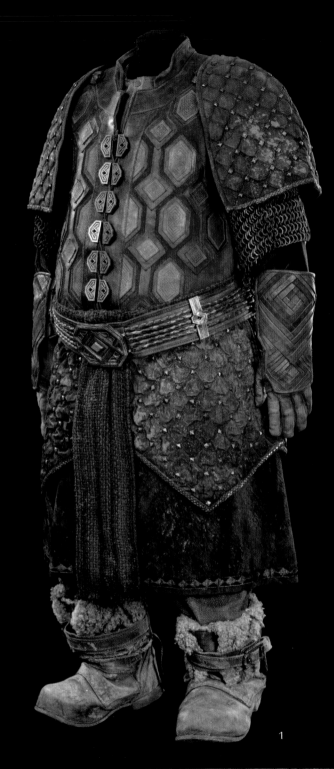

Having removed his outer armour pieces, Oin's battle costume consisted of a leather tunic with quilted panels. We stamped the leather with angular Dwarven geometry which I thought worked very well. He wore a soft, woven belt around his waist that recalled his old wool and cotton over-tunic, linking the costumes he wore at both the beginning and end of the trilogy. I am a fan of bleaching fabric and then putting colour back into it again. It can give a garment that is intended to look older a little bit of subtle distressing, giving the fabric a history. We did this with Oin's rich burgundy material. The sleeves were embroidered and we put little pieces of metal into them, introducing some intricate detailing that suggested a high level of craftsmanship on the part of the Dwarves who once lived beneath the Mountain. They also caught the light nicely, so as the costume moved in and out of shadow the highlights would catch torchlight and glint beautifully.

Bob Buck, Costume Designer

The heavy armoured costumes that we put on to go to war were absolutely amazing. The differences from one to another were very clearly identifiable and each reflected the character of its wearer. They were so striking to behold. From a practical point of view, they weren't necessarily going to be so good to fight in, which saw us change clothes into something less encumbering before we actually went out to fight.

I was reminded of some of my Scottish ancestors way back around the thirteenth century. In that period in history, you would get an awful lot of posturing going on before armies fought. They would line up and show off their wicked blades, or horrible war machines, or siege engines – lots of intimidation. Then they would go in to fight and they wouldn't even have their kilts on. That's where long-tailed shirts came from. They would just grab their shirts, tie them under their crotch and go into battle wearing nothing but that.

John Callen, Actor, Oin

There was a great sense of brotherhood in our Company. I worked most closely with John Callen, Oin being Gloin's onscreen brother, but what was so lovely right from the word go was that we had past association from many years back, so there was already a real warmth between us. John had taught my daughter Sophie at the New Zealand Drama School. In terms of playing brothers that was magic right out of the gate and hasn't let up since. John is a soulful person with great wit and a beautiful voice. He is a wonderful storyteller and so obviously delights in language and repartee. He was a very cheerful spirit and wonderful to be on the journey with. We remain close and so are our families.

In terms of the entire Dwarf Company, we all formed strong bonds and look forward to any occasion to reconnect. I went and visited Stephen Hunter and his family recently in Sydney, am catching up with Graham McTavish shortly and expect a visit from Adam Brown next week. We all keep in touch. Jed Brophy and I have a strong association from being in plays together. I have directed Jed. The relationships formed have become lasting. We shared a remarkable experience together and it brought us all very close. We will always watch each other's backs and follow each other's trajectories with great interest.

Peter Hambleton, Actor, Gloin

Very early on in our training we were working with Terry Notary. He was very keen for us to be tactile with one another, so there was no sense of our middle-class Anglo Saxon hesitance of being in each other's space and touching one another. We learned to be very comfortable with each other physically and how we each moved.

We did do an awful lot of weapons and fight training in those early days of the project, which was a couple of years behind us by the time we got to film our action for *The Battle of the Five Armies*. It all came back and into play, even then, as we came charging out of the Mountain and into battle with the Orcs.

John Callen, Actor, Oin

1. Oin's battle costume.

2-3. Details of Oin's battle costume: buckle (2), brigandine skirt (3).

nk one of the things you must develop as an actor on such
ugely collaborative project like *The Hobbit* is a heightened
se of trust. We were responsible for only so much and around
was a crew of hundreds or thousands who supported us and
t upon what we did, making it into something so much
iter than we could visualize. When asked to do something,
have to trust that it will end up looking amazing and not
ry about or doubt it in the moment as you offer up your

here were times when we were doing things for the battles
hases and it was impossible to really have a true sense of
v it might fit in the final jigsaw puzzle construction of the
. Our actions might be grabbed and digitally enhanced in
ie way, mixed with CGI action and enemies, or the specific
ons of our characters might be motion-captured by our
it counterparts later. There was a huge sequence of the
le stuff that those talented performers pulled together after
iad left, portraying our Dwarf heroes fighting in battle and
cing us look incredibly kick-ass!

i addition to specific action, we did a number of shots in
ch we were in battle mode and basically just going for it,
ning through our repertoire of blows and moves in our
ticular character's style, improvising, in a sense. Gloin had
imber of moves with his axe that he favoured, for example.
would run sequences of action and they would be shot
n different angles and in different ways, grabbed and
own into the mix for the director to have if and when he
ited it later when he was putting together his battle action.
as our role as actors not just to offer very specific moments
eaction and acting, but also to supply that range of material
t could go onto the kitchen table for the chef to chop up and
b from as he artfully composed his salad.

rust, faith and belief – it was very important that we had
ense of ownership of our characters and their journeys
ough the piece, but we also respected and understood that
much of it was designed, driven and directed by factors
ond us. Healthy egos are good for actors to have because
y help us survive and push our cases, but I think the best
es also have a sense of humility, generosity, and faith in both
process and the amazing people we work with.

Peter Hambleton, Actor, Gloin

A couple of months out from the commencement of shooting
we assigned specific stunt doubles to each of the thirteen
Dwarves, Bilbo, and other lead characters. Our choices were
influenced by the face shapes and heights of the actors as
they had to match as closely as possible, but the physical
demands of each role had the greatest effect on determining
who would be matched up with whom.

The trio of stunt performers, scale doubles and actors
behind each Dwarf all became very close. They worked
together on the same chaaracter for so long that they all
developed a very good understanding of their characters.
That made things easier for me because the doubles could
bring their idea of who a character was to a fight and inject
that essential character driven detail.

We put the actors through a physical training regime to
get them ready for the demands of the shoot. There was a lot
of one-on-one work with each cast member, helping them
develop and master the particular skills they might need
for their characters, including specific weapons training.
Something that was important to appreciate was that while
it was possible to run around and fight and perform actions
in tank tops and track pants, once in the bulky costumes
with prosthetics and oversized Dwarf boots, things became
significantly more complicated and challenging. The
prosthetic hands, for example, made it difficult to hold onto
and swing weapons. Weta Workshop's prosthetics team
developed mitts that were open on the inside surfaces of
the hands which helped mitigate that, but even closing your
hands without something in them required effort, because
of the thickness of the silicone, meaning the muscles of the
forearm were always in tension.

Training for so long was very beneficial because the guys
built up a tolerance for the suits and prosthetics and became
used to working in them and performing through them.
We tried to give each character something different in the
way they moved and fought so that they each had their own
unique signatures.

Glenn Boswell, Stunt Co-ordinator

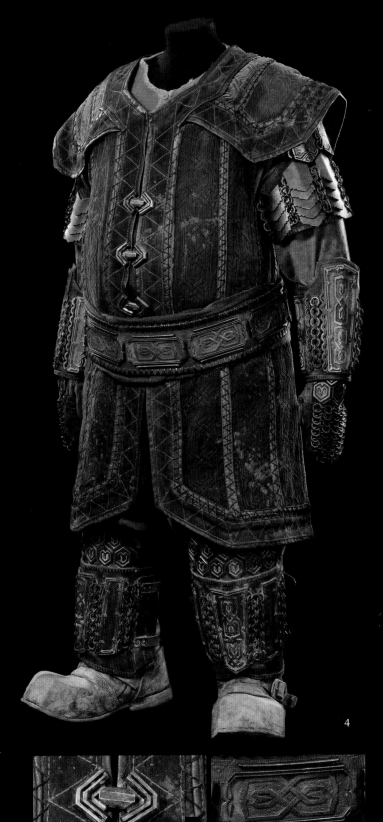

Gloin's battle costume.

5-6. Details of Gloin's battle costume: tunic fastenings (5), belt (6).

5

6

BIFUR & BOFUR IN BATTLE

Sticking with his established rough aesthetic, Bifur's main leather garment was pre-worn and knocked about. We included some quilted leather and velvet, but aged and with a rough fur edge.

Bofur, meanwhile, kept his hat and scarf throughout the films. The characteristic gold-mustard colour of the hessian in his first costume was brought back, this time in velvet. On Bofur's cuffs we brought back a weave technique that we used on his very first costume, but foiled so that it came across more richly in camera. For some complementary colour I threw some purple at Bofur, used here and there to define the edges of his tunic.

Bob Buck, Costume Designer

1. *Detail of Bifur's battle costume.*
2. *Bifur's battle costume.*
3. *Bifur's war axe.*
4. *Bofur's war hammer.*

It was lovely that we were encouraged to develop backstory and depth for our characters, grasping opportunities to build on tiny clues from the books and also come up with things, ourselves. We had the notion of our family being a different tribe that came from the books, plus in Bifur's case there was also the question of where the axe in his head came from, something I get asked about all the time.

In my imagined backstory, Bifur was a really nice guy who had a family and a lovely life, once upon a time. He was a toymaker, but his family was slaughtered by Orcs and all he was left with was their memory and this weapon embedded in his skull. The injury left him unable to speak except in Khuzdul, the Dwarves' native tongue, and he didn't know where he was half the time. He was a crazed, maniac fighter when he got going and would need to be pulled off a dead adversary by Bofur.

I liked the idea that all through the journey to Erebor Bifur was looking for the Orc to give the axe back to. There were lots of different ideas bandied around. Peter and I had spoken about the possibility of him yanking the axe out of his head and using it to kill an Orc. I was unaware of this, but Peter's team explored a lot of ideas and eventually came up with the elaborate set up that we shot in which Bifur head-butted an Orc and the axe head got stuck. They both ended up going over a cliff, but Bombur clambered over his back and jumped on the Orc, at which point both Orc and axe popped free and Bifur was saved. Bombur then came and handed it back to him. Both characters got their only English lines in the entire trilogy, delivered in Bofur's same northern Irish accent; 'Here you go,' to which Bifur replied, 'Well, you know where you can stick that.'

While that scene was only in the extended edition of the film, if viewers were to look closely at the end of the theatrical cut, they would notice there was no axe in Bifur's head when he was saying goodbye to Bilbo.

William Kircher, Actor, Bifur

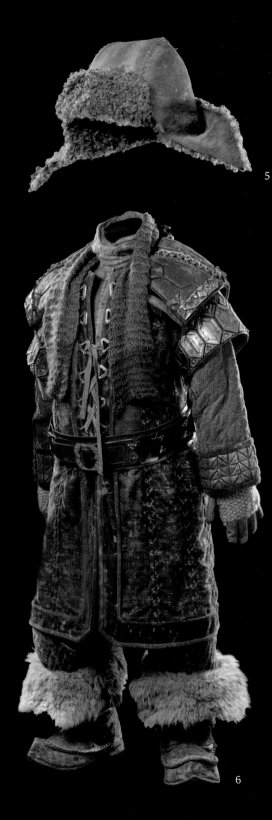

5. Bofur's hat.
6. Bofur's battle costume.
7. Detail of Bofur's battle costume.

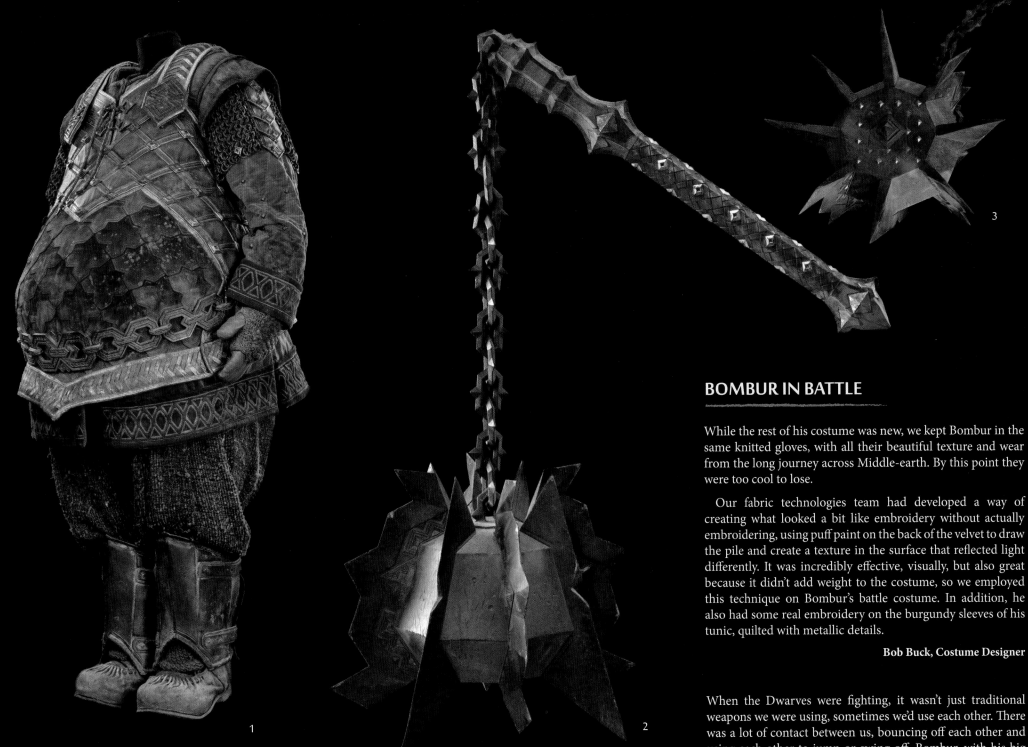

BOMBUR IN BATTLE

While the rest of his costume was new, we kept Bombur in the same knitted gloves, with all their beautiful texture and wear from the long journey across Middle-earth. By this point they were too cool to lose.

Our fabric technologies team had developed a way of creating what looked a bit like embroidery without actually embroidering, using puff paint on the back of the velvet to draw the pile and create a texture in the surface that reflected light differently. It was incredibly effective, visually, but also great because it didn't add weight to the costume, so we employed this technique on Bombur's battle costume. In addition, he also had some real embroidery on the burgundy sleeves of his tunic, quilted with metallic details.

Bob Buck, Costume Designer

When the Dwarves were fighting, it wasn't just traditional weapons we were using, sometimes we'd use each other. There was a lot of contact between us, bouncing off each other and using each other to jump or swing off. Bombur, with his big guts, was a bit of a weapon, himself. It was like someone using the ropes of a boxing or a wrestling ring, and we'd throw guys into axes and all sorts of really physical stuff. Orcs think that's just how we roll.

Stephen Hunter, Actor, Bombur

1. Bombur's battle costume.
2-3. Bombur's battle flail.
4. Weta Workshop Supervisor Rob Gillies fits Bombur's horn, a work in progress, on actor Stephen Hunter.
5-6. Details of Bombur's battle costume.

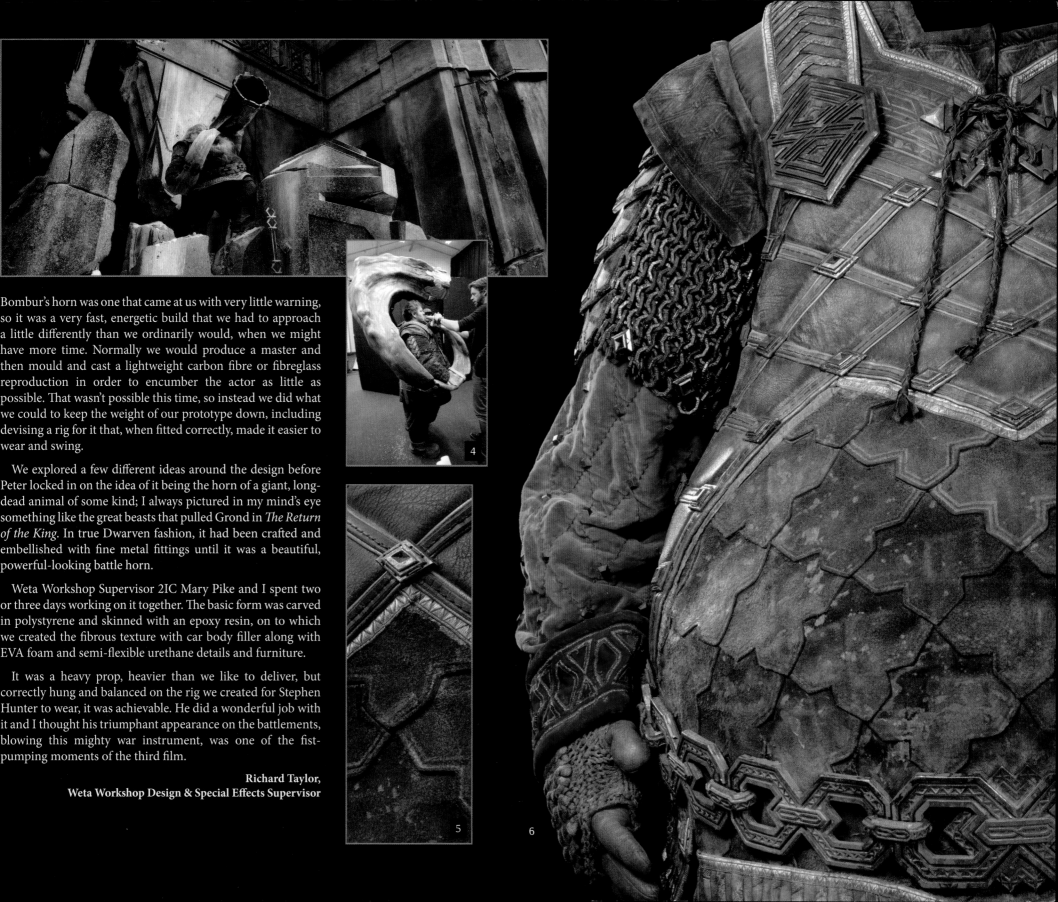

Bombur's horn was one that came at us with very little warning, so it was a very fast, energetic build that we had to approach a little differently than we ordinarily would, when we might have more time. Normally we would produce a master and then mould and cast a lightweight carbon fibre or fibreglass reproduction in order to encumber the actor as little as possible. That wasn't possible this time, so instead we did what we could to keep the weight of our prototype down, including devising a rig for it that, when fitted correctly, made it easier to wear and swing.

We explored a few different ideas around the design before Peter locked in on the idea of it being the horn of a giant, long-dead animal of some kind; I always pictured in my mind's eye something like the great beasts that pulled Grond in *The Return of the King*. In true Dwarven fashion, it had been crafted and embellished with fine metal fittings until it was a beautiful, powerful-looking battle horn.

Weta Workshop Supervisor 2IC Mary Pike and I spent two or three days working on it together. The basic form was carved in polystyrene and skinned with an epoxy resin, on to which we created the fibrous texture with car body filler along with EVA foam and semi-flexible urethane details and furniture.

It was a heavy prop, heavier than we like to deliver, but correctly hung and balanced on the rig we created for Stephen Hunter to wear, it was achievable. He did a wonderful job with it and I thought his triumphant appearance on the battlements, blowing this mighty war instrument, was one of the fist-pumping moments of the third film.

**Richard Taylor,
Weta Workshop Design & Special Effects Supervisor**

Ori's battle costume mixed his signature mauve palette with the coppery tones of his regal armour. He retained the chain of his gorget and shoulder pads and sported an armoured vest with purple velvet. This film marked the first time in the trilogy that Ori actually looks like a Dwarf who could take care of himself and not appear vulnerable. We aspired to create a costume that combined enough armour elements with the fabric to sell that idea as, by this point, his arc from naive tag-along to seasoned, capable warrior was complete. He certainly appeared more substantial.

Bob Buck, Costume Designer

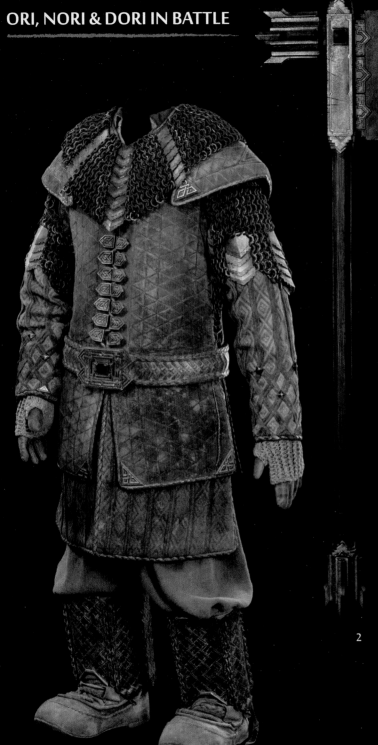

At the beginning Ori's clothes were all very knitted and woolly; soft and lilac. There was also the ridiculous stage when he was dressed up in Lake-town armour and robes that were far too big. Finally, when we got to Erebor and our characters donned their armour, Ori got some chainmaille and a big axe.

I got to ditch Ori's scarf, too. Everyone used to ask, 'How did you keep that thing on all the way through the journey?' He'd escaped from Goblins, fallen out of a tree, flown on an Eagle, been in a barrel, been covered in fish and still kept hold of the scarf. To be truthful, I wish I could have lost it sooner because it was heavy!

We had done our Dwarven boot-camp training right at the beginning of the project and part of that involved fight training with different weapons, including an axe. There were stages to the training that represented different stages in Ori's development, starting out with some timid slingshot action, then a little bit more beef, and finally letting loose with the big axe at the end when he'd really discovered his mojo.

I just remember thinking, when I first got the axe, it's too big! I tried playing with it and the axe was controlling me. I really wanted Ori to be in control by the end so I talked to the guys about having it made at a bit more of a manageable size, which they did and it made the difference. With the armour and the new axe, at least now Ori looked like he could take care of himself.

Even then, Fran was quite keen on the idea that, even wearing his armour, Ori's helmet would be a bit ill-fitting and sit slightly askew, so while he was almost cool, he still fell at the first hurdle.

Adam Brown, Actor, Ori

Ori was a young Dwarf and the idea was that he hadn't seen much battle, if any, before the beginning of our story. He got better as he went along, but we initially gave him a fighting style and weapon to suit his naivety: a slingshot. Dori was protective of his youngest brother so he was mostly keeping an eye on Ori. We came up with little vignettes involving groups of characters beforehand, which we adapted during the frantic shooting, in order to keep things as expedited as possible. The premise was that the family groups would stick together and the various brothers would look after each other. The way they all coordinated was also very interactive, so you could tell these guys all knew each other very well and could anticipate each other's moves and be where they needed to be.

Glenn Boswell, Stunt Co-ordinator

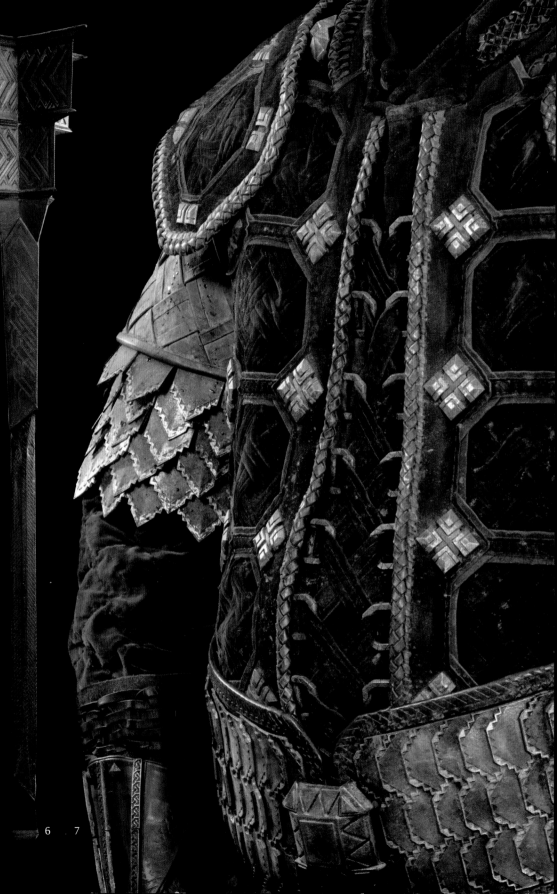

Dori's regal armour included a great fin-maille skirt which he retained for his battle costume. Beneath was a velvet skirt with the puff-print patterning technique applied to suck the pile in and generate an interesting texture. The leather pieces Dori wore over the top more or less organically evolved out of the processes involved with its materials. In the end I was actually surprised how Russian it felt.

Looking at the Dwarves as a whole, they each lean in a slightly different direction in terms of nods to cultures from our own world. There was almost a hint of matador in Dori's shoulder panels, which we kept free of the sleeves to allow for as much movement as possible. The final colours of the complete costume mixed Dori's signature purple with a rusty orange-brown leather. It was great to be able to bring back the purple.

Given the fastidious nature of his character, we also gave Dori a suitably fancy belt. I was very happy with how rich his costume ended up, as was Mark Hadlow. Mark is an actor who loves costumes and this one was quite embellished and rich, very appropriate for a Dwarf with Dori's sensibilities and pride who has found himself in the midst of the greatest treasure hoard ever known. It was different and satisfyingly original.

Bob Buck, Costume Designer

5

4

1. *Ori's battle costume.*
2. *Ori's battle axe.*
3. *Detail of Ori's battle costume.*

4. *Detail of Dori's battle costume.*
5-6. *Dori's mace.*
7. *Detail of Dori's battle costume.*

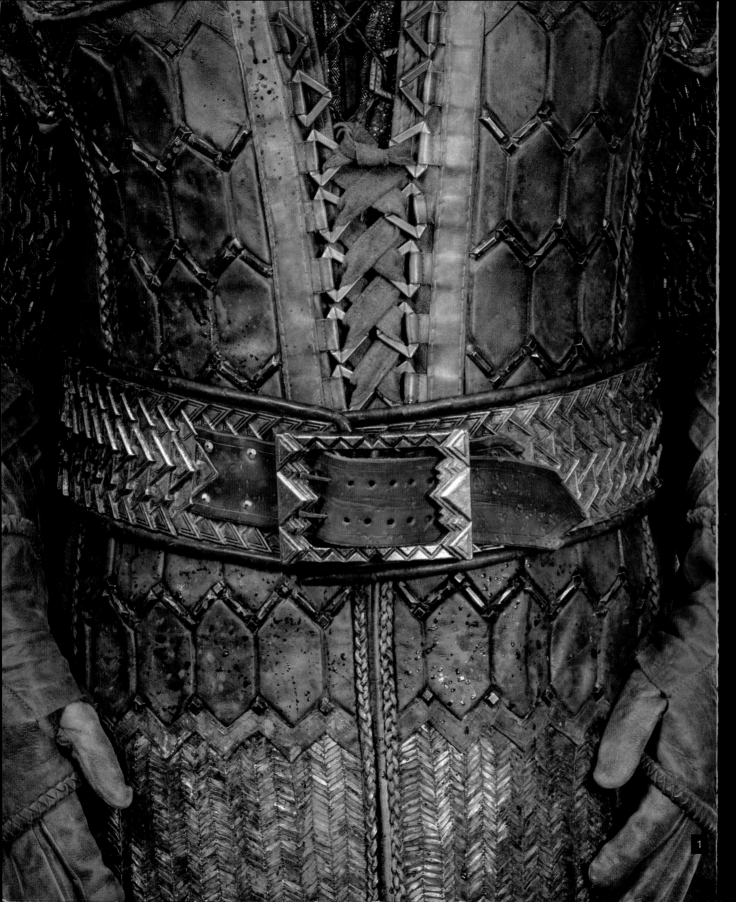

Nori's heavily armoured look came with more colour again, introducing a rich copper, so when he stripped back the hard armour components and went into battle we kept some of that in his printed burgundy skirts and leather gloves. Those gloves were cool. We have made a great many gloves throughout the films and they were often an important component, in the Dwarven outfits in particular. Whether hammering, carving, mining or fighting, they would always need gloves so they became part of the Dwarf costume vocabulary. Nori's battle gloves had metal embellishments. Once aged and dirtied, the contrast between the glinting highpoints and darker parts was very pleasing. They looked both practical and ceremonial.

Nori's main battle tunic was padded leather and contrasted against the warm brown of his skirts and gloves with a slate grey. His arms were clad in chain sleeves tucked into his gloves.

Bob Buck, Costume Designer

There is that thing that berserkers do where they shuck off their armour. As far as they are concerned it doesn't really matter. It isn't going to help them in the end and would probably just slow them down. While the Dwarves had put on all their fancy armour in the Mountain, when it came time to fight it wasn't that sort of battle. Our job was to try and break through that Orc line and get out there to help Dain, so it made more sense to drop all that stuff and go out as light and mobile as possible.

Jed Brophy, Actor, Nori

Something we played with was how the various family group members among the Dwarves tend to pull together when there's something going on. In battle, the brothers might tend to coordinate and work like little teams, just because they are so familiar with each other and also because family is important to them. In Mirkwood, when the Dwarves were all tripping out and there was some arguing going on, lines were drawn along family lines. Similarly, in Erebor, when Thorin was being affected by the gold, there were moments when you would see the Dwarves reacting, and they're in their family groups, arguing the points of contention between groups. If anything, I wish there had been more time to spend with them and see that sort of thing.

Mark Hadlow, Actor, Dori

1. *Detail of Nori's battle costume.*
2. *Nori's mace.*
3. *Nori's shield.*
4. *Nori's battle costume.*

Mark Hadlow, Adam Brown and I were very keen to have a moment in the final film in which the three brothers Dori, Ori and Nori fought side by side, as a unit. It was especially important for Adam's character. Ori had been on a journey from total naivety about what it even meant to be a Dwarf, full of enthusiasm but not knowing anything about fighting or the wide world when we began, having grown through the trials and tribulations of the journey to become a real Dwarven warrior by the end.

For Nori too, who had always been on the periphery of Dwarf culture, the Quest had given him a sense of belonging. Nori had always been an outsider. He didn't say a lot in the films, but that was because he was a watcher, and I think he intentionally kept himself apart because he wasn't totally convinced by this Quest. He was ready to split in the beginning, if necessary, at least until he began to understand what was at stake. For Thorin it was about reclaiming what the Dwarves had lost. For Nori it began as an opportunity to pick up some good loot, because he was too young to have witnessed what went on with the Dragon and Moria. He didn't have that sense of loss because all he'd known was what he had, which was what he'd been able to swipe. Nori wasn't a petty Dwarf, but neither was he invested in Dwarf society like the others.

By the end, I think this Dwarf loner had found his family and a place where he could belong. He was part of this Company that had come together around Thorin. Nori had definitely changed from being all about himself and almost reactively not wanting to do what his older brother did but still feeling a bit protective of his younger brother, to a point where he was part of a real Dwarf clan, a brotherhood of warriors. We were our own dirty dozen.

Peter talked about the Dwarven race having something in their genes – when backed into a corner they have an instinctual predisposition to fight together as a unit, to anticipate each other and work as a finely tuned team. We wanted that to show when we fought in the final battle. We felt it offered the opportunity to show how these brothers came together and operated in a three-person fight, back-to-back. The stunt team choreographed something for us that we learned individually and then put together in the back lot, was recorded and shown to Peter. We got an opportunity over two or three days during the last weeks of the shoot to put it into practice, which was pretty cool. While all the Dwarves fought together in the Battle of the Five Armies, we also had our own, separate one going on. These three dysfunctional brothers, who had bickered and bothered each other all the way along, finally got it together and were a real family. We were saving each other and working together in innovative ways. One of us might be in trouble and his brother would throw an axe which would embed itself in

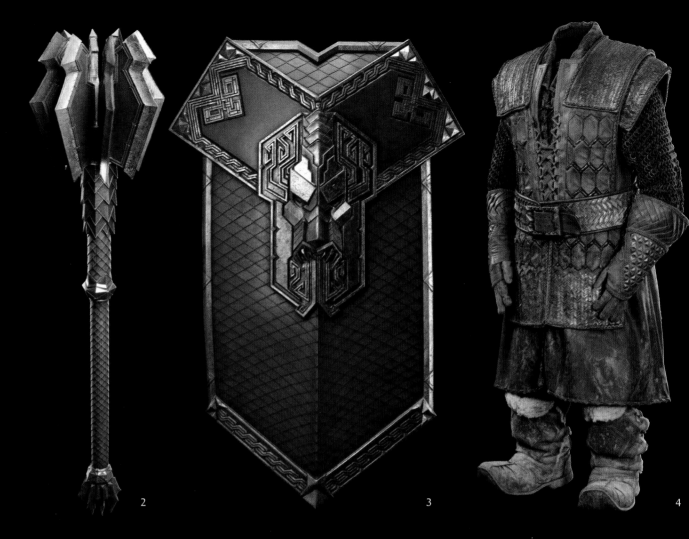

2 3 4

an Orc and then be pulled out by someone else to then defend themselves, then chucked back to the other brother. In a number of ways it was similar to what we did in the barrels.

These movies being so full and with so many characters to follow, we had to be realistic about how much we would expect to see in a final cut, but it was great fun to play.

Jed Brophy, Actor, Nori

We shot some fun stuff for the battle that involved Ori taking the lead and his brothers backing him up, which was a nice progression for the character. It showed how far Ori had come. I had moments where I was either saving Dori or catching him as he was falling, a nice role reversal from the dynamic that the three of us had going for most of the films.

Around the table at Bag End, I'm sure Dwalin and Thorin were wondering who Ori was and what possible use he could

be on their trip. I am sure they thought he would drag them behind, but by the end he had earned their respect by sticking it out and still being there.

Ori had his mojo by the end. He was still an unlikely hero, but he could be proud of himself, knowing he was there at the end, holding his own, staying alive and not getting anyone else killed protecting him.

Adam Brown, Actor, Ori

At Erebor Nori ended up with a big star-sectioned mace, which I thought was going to be a one-handed weapon but it turned into something probably better used two-handed. It was huge! I rehearsed at home with something that I made myself, just so I could get used to the idea of using it. A lot of the blows were the same as they would have been with the long staff Nori began the journey with, although it didn't have a pointed end. The mace had beautiful blades sticking out which were quite deadly.

Jed Brophy, Actor, Nori

A significant new sequence in the extended edition of *The Battle of the Five Armies* was the confrontation between the Elves and Dwarves, in which the two armies actually came to blows before the Orcs turned up. Dain's goat cavalry would play their part, charging down the hillside at the Elves and Lake-towners. That charge also introduced Dwarf war chariots, setting up a new scene in which Thorin rode a goat up to Ravenhill, leading Balin, Dwalin, Fili and Kili aboard one of the ram-drawn battle chariots. In a spectacular action sequence they battled Trolls, Wargs and other creatures as they hurtled down the frozen river, eventually cutting the rams free to climb the steep mountainside, with Balin staying behind with the chariot to cover their ascent.

Matt Aitken, Weta Digital Visual Effects Supervisor

The chariot chase sequence was one of my favourite experiences on the entire project. Richard Taylor showed us the massive, working Dwarf chariot prop they had built at Weta Workshop. It was the coolest object I had ever seen. He explained how it would have what was essentially an arrow-firing machine gun (thank you, Peter) that Dwalin would be blasting away on.

As with all things to do with the making of these films, a lot of it was done on the hoof when it came to actually filming the sequence. We learned that you couldn't go in with rigid ideas. It was a case of adapting as things happened. We were shooting and Peter was quite literally feeding us hand-written script pages. Ken Stott and I were resting between takes on the chariot. Peter came over and handed us each a page of script that he had just come up with, 'Right, this is what we're doing next.' I looked at him I said, 'So this is now the script of *The Hobbit*?' and he replied, 'Yep, it's the most expensive home movie ever made.'

And the beauty of that statement is that it isn't hyperbole. It truly describes the attitude with which Peter has approached this entire six-film saga. It has been made with the passion of a home movie.

Graham McTavish, Actor, Dwalin

1. *Previs blocking of the chariot chase sequence.*

> *"There's too many of these buggers, Thorin. I hope you've got a plan."*
>
> *- DAIN IRONFOOT*

That was such an amazing sequence to shoot. I don't think I have ever seen Graham McTavish having more fun. It felt heroic too, hanging onto that chariot and swinging our swords. Even though we were shooting against green screens I could see the scene so clearly in my mind. It was also our last big fun moment before things got really dark in the story.

Dean O'Gorman, Actor, Fili

The chariot charge up to Ravenhill was a desperate manoeuvre. We were finished, outnumbered and being beaten, when Thorin said, 'We have to cut the head off the snake.' Get to Ravenhill and kill Azog and the Orcs would be leaderless. It was our only chance, but we also knew it was a suicide mission. There was a beautiful moment on the chariot between Balin and Dwalin. We were on our mad journey toward Ravenhill, but the rams pulling the chariot were being picked off by Wargs and we were slowing down. It was obvious we weren't going to make it. Balin made the call to cut the lines, telling them all to go ahead on the backs of the goats while he stayed behind on the immobile chariot, firing the gun, surrounded by enemies in a last stand. Dwalin and Balin shared a beat there as the understanding passed between them that this was goodbye, that they would probably never see each other again. 'My goat riding days are over,' Ken stated with a wry smile. It was beautiful, and a lovely moment between the two brothers that called back to their introduction in Bag End, two films ago.

Graham McTavish, Actor, Dwalin

The chariot chase presented us with opportunities to motion capture Orcs getting taken out by the Dwarves' chariot in some incredibly cool ways. We had a full-sized skeletal frame of the chariot on the motion capture stage which could be puppeteered by hand or set on a gimbal, allowing us to create whatever kinetic action we needed. We captured attacks from all sides.

Something that I love to do is have the same performer provide capture for both sides of an attack. I've killed myself numerous times on these films. For example, we might shoot an element of a scene where an Orc would charge into battle only to find himself on the receiving end of a Dwarf's hammer. The performer would be on a rig which would suddenly stop him mid-charge, throwing his body in a way that imitated him being violently hit. Then I would have the same performer reloaded into scene as the Dwarf. He would hit a pad where the Orc's head would have been. Layering the two shots and syncing the timing resulted in a beautifully vicious piece of action. What's more, I have found that when the same performer captures both sides of the action, he's all the more intense about it. I don't know what animalistic behaviour drives this, but they really want to hurt themselves! They always seem to want to give themselves the best death from the best attack! I believe it stems from being so personally invested in the scene and the pride that comes from owning that complete action.

**Isaac Hamon,
Stunt Performer / Motion Capture Performance Coordinator**

The chariot sequence had a lot of interesting beats and characters – War Trolls, Wargs, Stumpy, Ogres and Orcs. It was a really fun sequence to work out. Peter wanted to film it with his virtual camera system, which was great for us because it meant we could map out long sequences of animation with complex choreography and creatures. That's always fun because it's basically handing our animators a blank canvas. Creature work is the best when you're an animator, because no one knows how a creature moves until you define it, so you get to explore how the subjects move and find character in it. I think the things Peter was having the most fun with when we were working on the chariot race were all the diverse bad guys they encountered.

Michael Cozens, Weta Digital Animation Supervisor

With all the physical activity, the fights, and everything we had been through over two and a half years shooting these films I had managed to avoid any injury. I had trained hard and strengthened myself to make sure that was the case, but the chariot scene was the one that broke my streak. It was the big Dwarf crossbow that did the deed. It was very heavy and I was holding it with one arm while firing the crank with the other, swivelling it like a massive machine gun at the front of the chariot. Originally it was actually firing and loading practical arrows but the speed wasn't quite where Peter needed it to be so after a few takes Peter said, 'Forget it, we'll do them digitally, later.' That meant I could really let loose and wind that crank like my life depended on it. It was massively fatiguing on my arms and a couple of days later I started developing tendonitis, but I still look back on that day and smile because it was such great fun. We were surrounded by the usual green gimp-suited men acting out what would later become digital Orcs, Wargs and Trolls, but for the most part we were reacting to Peter's shouted direction, 'Look out, there's Orcs on the right! Quick, there's a Warg coming in from the left! Oh no, here comes a Troll, attacking from behind!' Here we were, Dwalin on the gun up front, Balin driving the reins, and Fili and Kili on either side, giving it everything.

We were being fed new lines of script as we were shooting and there was an exchange between Aidan and me during an attack by a Troll. I was yelling at him to kill it and he was shouting back that he was trying. Peter was calling out lines from the new script and told me, 'Okay, so you say to Kili, 'Aim at his jam bags!' and Kili says, "He doesn't have any jam bags!" and you yell back, "Just shoot him!"'

I remember thinking, 'jam bags'? Really? But we laughed and screamed the lines and Peter was pleased.

Lunch came along and we all broke for food. I ended up sitting opposite Philippa Boyens, who had co-written the script, and remarked that we were shooting the chariot. She asked how I liked the new lines, to which I replied, 'It's fantastic. The whole jam bags thing is hilarious.' Philippa looked perplexed, 'Jam bags?' and then I could see it dawning on her: 'No, yam bags! It's supposed to be yam bags!' It was a typo!

Of course, we'd shot that bit by then, but I told Pete and I don't think I have ever seen him laugh so much. He almost pissed himself. He thought it was wonderful. Jam bags it was and shall always be.

Graham McTavish, Actor, Dwalin

*"We're going to take
out their leader!"* - THORIN

IRON HILL DWARF WAR CHARIOTS

Peter imagined a kind of ginormous chariot of destruction that he wanted the Dwarves to ride on in the battle, so Richard Taylor and Weta Workshop obliged and delivered exactly that. As the on-set armour and weapons team looking after all Weta Workshop's deliverables, we inherited responsibility for it once it got to set.

It was wider than a normal trailer but we managed to get a vehicle transporter with blocks of wood on it to support the chariot and escorted it gingerly through the suburbs down to the shooting stages. For its action on set it was towed behind a six-wheel Polaris multi-terrain vehicle. It had been designed with action in mind that would see it rolling along at around a sedate ten kilometres per hour, but Peter kept telling them to go faster and faster until I think it was clocking something more like 40 kilometres per hour with the Dwarves all hanging off it, fighting and firing the giant crossbow-catapult mounted on it. It was a beast of a thing that I think borrowed a little bit of its aesthetic from *Mad Max*!

Jamie Wilson, Armour & Weapons Production Manager

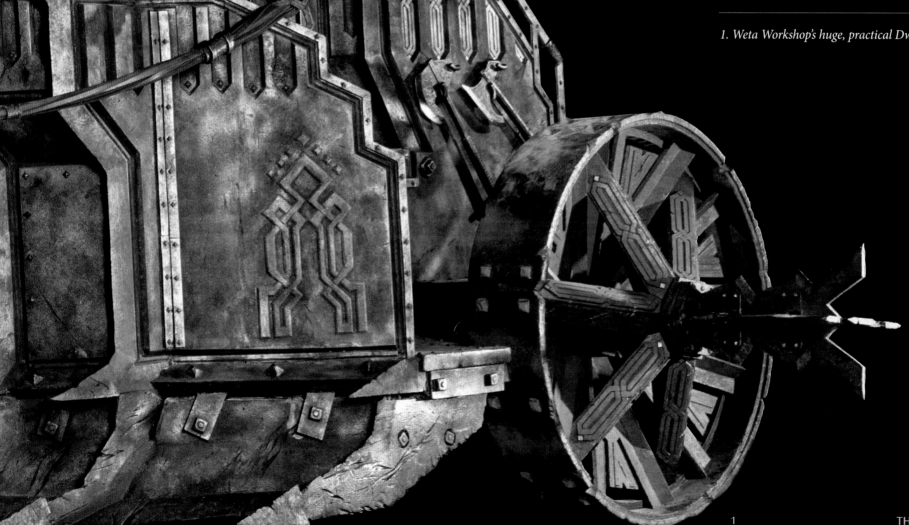

1. Weta Workshop's huge, practical Dwarf war chariot.

The chariot was a massive build for us at the workshop, but also something of a treat at the very end of what was many years working on the project. Our team thoroughly enjoyed bringing this to life. What we built was a fully working war chariot at around 130% actual scale because we made it for Dwarves to ride. It was designed so that it could be hooked up and pulled behind a vehicle at decent speeds. It had fully operational wheels and axle with a structure sound enough for ten guys to stand on and hang off. On the front we had a massive crossbow that actually worked. We painted it in a palette to match the Iron Hill Dwarf armour. The whole thing reminded me of a monster car from a cartoon, or some tricked-out 1920s car converted into a hot rod.

It was shot down on the set with Dwarves clambering all over it, firing crossbows and swinging swords, knives between their teeth and waving hammers or axes, like some kind of goon squad, and, rolling by, it was a sight to behold.

Rob Gillies, Weta Workshop Supervisor

Appreciating that in the modern cinematic world we don't get to build many things physically any more, and especially not since the 3D nature of *The Hobbit* precluded us making miniature environments the way we did for *The Lord of the Rings*, it was an absolute delight and surprise when producer Zane Weiner approached me one day on set to ask whether we wanted to build a Dwarf chariot! We were coming to the final days of the project and the chariot turned out to be the very last thing we were asked to build.

Normally a build like this would fall to Dan Hennah's 3Foot7 Art Department to construct, but they were up to their armpits already, so it was offered to us, an opportunity we were most thankful for as it was a super-cool prop. Designs were offered up by our conceptual design team, including Designers Frank Victoria, Greg Tozer, Paul Tobin and Nick Keller. Nick went on to finalize the design once Peter gave his feedback through successive rounds and the look was honed to something which we mocked up in cardboard for Peter to approve for building.

The build was led by Alex Falkner, the head of our Props Model Making team. We had barely two weeks, so it was an incredibly ambitious project. Peter asked for it to be light enough to be pulled behind a four-wheel drive vehicle or manoeuvred by a team of people, that its wheels be removable, and that it could be positioned on a six-way motion mover if necessary; basically providing for any and all shooting options down on set. We built it on a steel chassis with all the engineering pick-up points necessary to give Pete maximum flexibility.

We began cladding the body with Dwarven panels and detail, which we didn't have the luxury of creating after we had built the basic chassis. Because of the time constraints we were under, everything had to happen at the same time, so we had the designer refining details while the 3D department was modelling parts, pieces were being milled or printed and elements were being moulded and cast. Alongside that, there were leather elements that had to be crafted, so we had multiple teams all working on it at the same time.

We had to also consider the functionality of the machine, because it was essentially a prototype, but the only one we would have time to make. There were going to be Dwarves riding and operating the chariot, so we had to make sure that they could do so safely with their costumed big hands, cumbersome bodies and short legs, clambering on and off as well as fighting.

We were also cognizant of things like lines of sight, designing positions for people to stand on the chariot that allowed Peter to shoot past certain characters to others in a tiered fashion, being careful not to create obscuring elements in the design that would make it problematic to frame around.

To ultimately pull it off successfully was, I think, as much a triumph for our facilitation team as for the incredible artistic and manufacturing teams that built the prop. Our production crew is often unsung, but they do an amazing job coordinating and resourcing all the diverse disciplines cooperating on a project like this one, often within incredibly tight time frames.

Richard Taylor,
Weta Workshop Design & Special Effects Supervisor

I got to make the giant, Gatling gun-like crossbow that was going to be mounted on it. The guys called it the Boar-lista. There was no time to make and mould it in sections, so it was all steel and weighed a tonne. As heavy as it was, what made it cool was that it was functional. I made a ratcheting mechanism that pulled back the tusks in a very similar way to the standard Iron Hills Dwarf infantry crossbow. It fired massive bolts, and I made four magazines for it. The actual feeding mechanism didn't work because that was always going to be digital, but the firing mechanism worked very well, especially since the entire thing was turned around in less than a month and went through numerous design changes along the way.

Alex Falkner,
Weta Workshop Props Model Making Supervisor

1. Detail of weapons fastened to the side of the war chariot.
2. Weta Workshop Supervisor Rob Gillies tries the reins of the chariot, mid-build, while Woodworking HOD Paul Wickham and Technician Hynie Rasch work on the chariot.
3. Detail of chariot wheel.
4. Weta Workshop Technician Jamie Renson and Props Model Making Supervisor Alex Falkner string the chariot's crossbow.
5. Detail of war chariot surface patternwork.
6-7. Weta Workshop Technician Jamie Rencen with Paint Technician Kiri Packer (6), and Props Model Making Texture Artist Paul Van Ommen (7) work on the chariot's wheels.
8. Detail of the crossbow's leather upholstered stock. ·

5

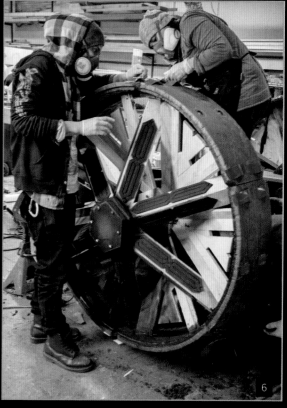

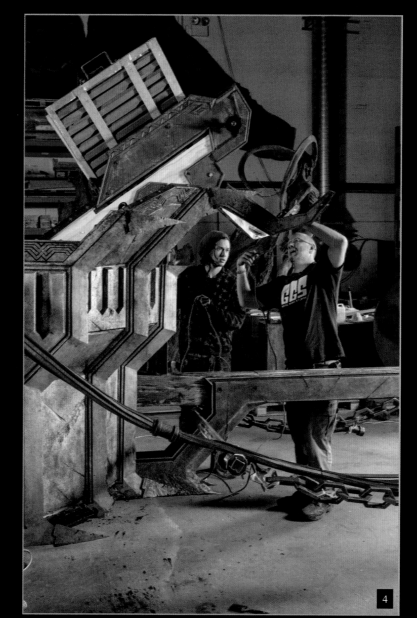

4

6

7

8

RAMS AND GOATS

The designs of the rams and goats were based on approved concept artwork, so there was a fantasy element to them, but we also referenced real-world animals to keep them grounded and plausible in feel. There might not be any one variety of goat or ram on earth that looked exactly like these Dwarf animals, but they needed to feel like they could live alongside our own kinds. We showed Peter a lot of pictures of different types of very wild looking mountain goats and he picked favourites for fur or wool texture and colour. There was one goat in particular that Peter really liked for its face. It had an incredibly staunch look, like the kind of goat you wouldn't want to mess with – perfect for our Dwarves to take into battle.

Matt Aitken, Weta Digital Visual Effects Supervisor

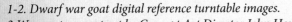

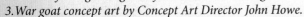

1-2. Dwarf war goat digital reference turntable images.
3. War goat concept art by Concept Art Director John Howe.

We put a lot of fur on the goats and rams. It was very dense and we were quite worried about it for a while. There was something like four million strands on a single animal. It was a relief in the end that it worked so well. In fact, it got to the point where we began to jokingly refer to the rams and goats as units of measurement for how dense things were. 'How much hair is there on this creature?' 'Oh, it's about two-thirds of a goat.'

We were creating the grass for the battlefield and measuring the growth. There was a question about how much we could do, but we figured that if we could render twenty goats then we'd be fine as the grass was only going to be about four goats' worth of rendering!

Marco Revelant, Weta Digital Models Supervisor

When we're talking about an expensive render, it's not money we're talking about so much as time and processing power. An expensive render is one that takes a long time for the computer to do because of all the detail. It could sometimes take seventy hours to render a single frame, which is crazy! Any time we could find a way to get around that without losing quality on screen, we would.

**Gino Acevedo,
Weta Digital Textures Supervisor/Creative Art Director**

4-7. Dwarf war ram Digital reference turntable images, including detail of wool (7).

8. Dwarf war ram digital reference turntable images showing individual variation.

1

ALFRID LICKSPITTLE

n a way I think Alfrid embodies the physical decay and sad state of Lake-town. He's just surviving. It's interesting to me that once he gets out of that house with the Master, he actually gets a little bit more life in him. In a horrible way, the destruction of the town and loss of the Master had the potential to have been the best thing that ever happened to him. But, it wasn't in Alfrid's nature to leave servitude, because he lacks the strength of character to survive on his own. Self-preservation has put him in that position and he doesn't know what else to do, so he repeats the same mistakes, only now Bard is in charge and he s a different animal to the Master. He owes his life to Bard and t was good for him to get out of that house and get some fresh air, but what happens when they get to Dale shows he doesn't know how to live any other way.

It's interesting that for many years Bard was clearly the enemy. Alfrid and the Master saw him as a threat, a trouble-maker just by virtue of his moral strength and what a contrast that is to the Master's qualities. Bard is athletic, intelligent and moral, which we can never be. Alfrid and the Master are manipulative and wicked, so perhaps it should be no surprise to Alfrid when eventually he discovers that his services are no longer required, and the Master jettisons him off the side of his overladen barge.

In the wake of that betrayal, and the Master's subsequent death, Alfrid became attached to a reluctant Bard. I don't think Bard had any use or want for a manservant, but he took him on anyway. The truth is that Alfrid is a civil servant to his bones and the kind of creature that gets kicked around if he sn't attached to a bigger friend. He doesn't know how to do anything else so he attaches himself to whomever can protect him, and Bard was too nice to say no. Maybe he felt he could handle or even redeem Alfrid? Instead of casting him out to the angry townsfolk who are all too ready to hang him, Bard chose to tolerate Alfrid's service for as long as that lasted.

Alfrid is a warped individual, so even once he is under Bard's wing, he fails to understand what Bard is all about. The decay of Lake-town was mental as well as physical and that shows in Alfrid. He can't comprehend what drives Bard. He's consumed by the notion that gold is what keeps you afloat (paradoxically, considering what happened on the barge), and he is so afraid of being trampled under someone's boot that he keeps operating the same way he had beneath the Master and completely misses his chance at a new life.

Ryan Gage, Actor, Alfrid Lickspittle

Bard would give anyone a chance, a second chance, and maybe even a third, so he wasn't ready to simply throw Alfrid to the mob, but unfortunately Alfrid completely failed every time he was presented with an opportunity to become a better person. The scene we shot in which Alfrid was stuffing his bra with gold coins, a pathetic image in front of Bard, standing with his children, content even amid the horror of this war-torn ruin, I thought demonstrated perfectly the tragic difference between the two men. Bard had everything he wanted, while Alfrid could never be happy and would always be hungry, desperately trying to hold onto these meaningless material possessions. His final end was good riddance.

Luke Evans, Actor, Bard

ALFRID'S DEMISE

I think everyone felt that Alfrid had earned himself a very special death, though it turned out we would have to wait til the extended edition to see it. Gandalf was contending with a huge, deformed Troll and his new staff (courtesy of Radagast was giving him some trouble. The Troll was essentially deformed because we needed it to have a mouth large enough to accommodate Alfrid, who had run the other way and ended up hiding in a catapult basket. One of Alfrid's coins slipped from his stuffed blouse and bounced, chink, chink, chink setting off the trigger mechanism that released the catapul arm and sending him flying into the air, straight into the Troll's open mouth. All that could be seen of him was his feet sticking out of its throat, a stroke of luck for Gandalf who was about to be killed by the now-choking creature.

Matt Aitken, Weta Digital Visual Effects Superviso

The one we called the Alfrid Troll was very different in proportion to the others. While he had to have a much bigge mouth to fit the action Peter had in mind, he also couldn't be too big because he had to fit in the frame with Gandalf and be in the right spot that lined up with where Gandalf was looking which had already been shot. That meant he had to be quite compact.

We basically put Alfrid where he needed to be and modelle the Troll to fit around him.

Marco Revelant, Weta Digital Models Superviso

1. An early, work-in-progress incarnation of the Alfrid Troll digit

MASTER OF WAR

Though it was something that was canned fairly early on, we had actually designed and built a suit of armour for the Master of Lake-town that he was going to wear during the battle. In the final script he never lived that long, so the costume never got as far as being filmed, but it was built and I recall we had one fitting with Stephen Fry before things changed.

Basically, it was a big version of the Lake-town guards' armour, with an enlarged belly plate and an absurd helmet that came complete with garishly coloured ostrich feathers sticking out of the top.

Rob Gillies, Weta Workshop Supervisor

1-2. The Master of Lake-town's armour, including detail of the over-sized belly plate.

1

2

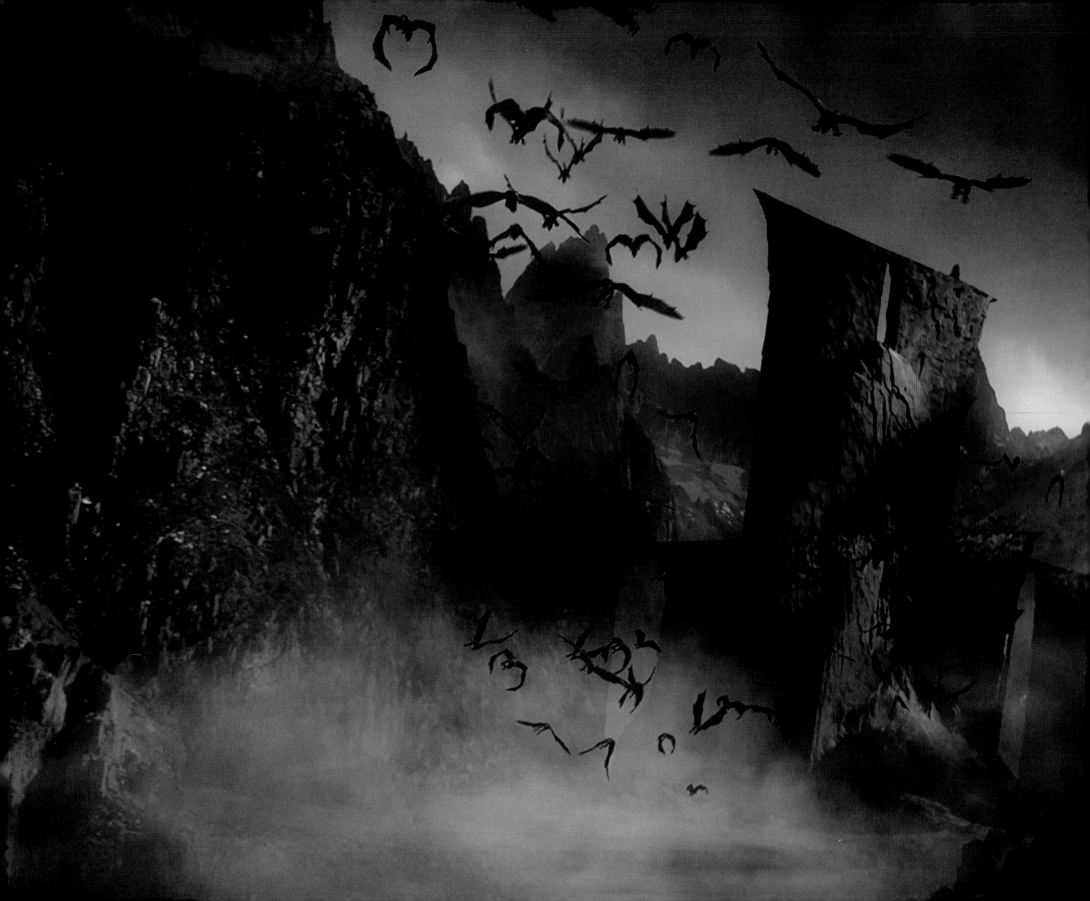

GUNDABAD UNLEASHED

Azog will not leave victory to chance. Though his forces already outnumber the allied armies of the Woodland Realm, Iron Hills and militia of Lake-town, the Pale Orc has sent his progeny, Bolg, to Mount Gundabad in the northwest, there to raise a second army of towering Orcs. Reinforced by the Gundabad horde, Azog is sure to secure the Lonely Mountain now by overwhelming force.

Drawn from the dark lands beyond the Gundabad fortress, once the realm of Angmar and still a place a dread, Bolg's warriors include regimented ranks of rust-clad troops as well as a surging advance guard of sprinting Berserker Orcs, the biggest and most savage of their kind. Goblin mercenaries, rat-like and eager for a share of the spoils, swell Bolg's ranks. As his army marches out of Gundabad's pits the bestial Berserkers sprint ahead of the column in a pack, hungry for battle, while overhead flies a vast cloud of fighting bats, darkening the sky and screeching in delight at the smell of war.

Having crossed the wastes to the north of Mirkwood, Bolg's army descends upon Erebor from the north, ascending the Mountain's flank behind Ravenhill in the hopes of sweeping down upon the allies with surprise from over the saddle between Ravenhill and the summit. If Bolg's manoeuvre is successful, Elves, Men and Dwarves will be outflanked in a devastating pincer and Azog's victory assured.

BOLG

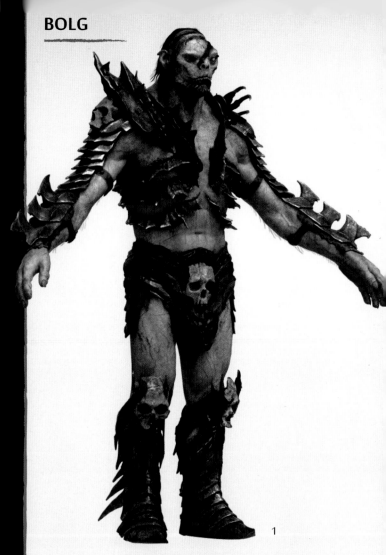

he third film were a new design. These were bigger
entirely new shape than the ones from the first
sed Radagast. We played with their proportions,
und the fact that we knew they had to be big
able to transport Legolas but not be too big and
g. They couldn't be so big that they would put up
t the Eagles when they came in to save the day.

quite a bit of time detailing the face. The nose
uple of times until we found something that Peter
working. They had creepy eyes that were stuck
we didn't get the chance to look at them very
e film. We wanted the eyes to look diseased and
Their sequences got cut back in the editing or we
seen more of them. I think that's why the Eagles
easily. The bats were pissed off for being mostly

Marco Revelant, Weta Digital Models Supervisor

e all based on a design of Alan Lee's, which had
re grown over. I tried some paint-overs of the
l to explore how diseased and disgusting we could
es as well as exploring colour and different nose
g to steer it away from being too pig-like.

Gino Acevedo,
ta Digital Textures Supervisor/Creative Art Director

How many bats make up a swarm: 200, 300? We went back
and forth on numbers as we tried to get the balance in density
of bats right. At one point there were Goblin riders on them.
It was pretty cool, but in the end it was decided that the bats
should really just be bats. Having riders implied they needed
to be steered, whereas if they flew themselves then perhaps it
lent more meaning to the notion of them being specifically
bred for war and suggested an intelligence that the Orcs had
figured out a way to use.

These Gundabad bats were a new variety, distinct from those
in the first film. While they were smaller and furred, these new
bats were mostly hairless and had their eyes fused shut. Peter
wanted their size to be evident, so he asked for us to have them
swoop down closer to camera in order to get a better sense of
their scale, because later in the film we would see Legolas hitch
a ride on one and it was important that it be evident that they
were large enough to support his weight in the air.

David Clayton, Weta Digital Animation Supervisor

Bolg got some new armour stuck on for the battle. Because
his armour went straight into his skin we had to make sure
that he could move without anything deforming or looking
weird. He also had a new weapon to fight with when he met
Legolas again.

Marco Revelant, Weta Digital Models Supervisor

The facial animation on Bolg was a mix of facial motion
capture work and a good dose of entirely key-framed
animation. It was very old school, in a way, like the old days
working on *The Lord of the Rings*, prior to the rise of facial
capture, and great fun.

Matt Aitken, Weta Digital Visual Effects Supervisor

*rt by Weta Digital Textures Supervisor/Creative
Gino Acevedo, painting over war bat digital
ntable.
warm concept art by Concept Art Director John*

*3. Concept art by Weta Digital Textures Supervisor/Creative
Art Director Gino Acevedo, painting war bat digital reference
turntable, exploring possible wing patterning.
4. Digital reference turntable image of war bat.*

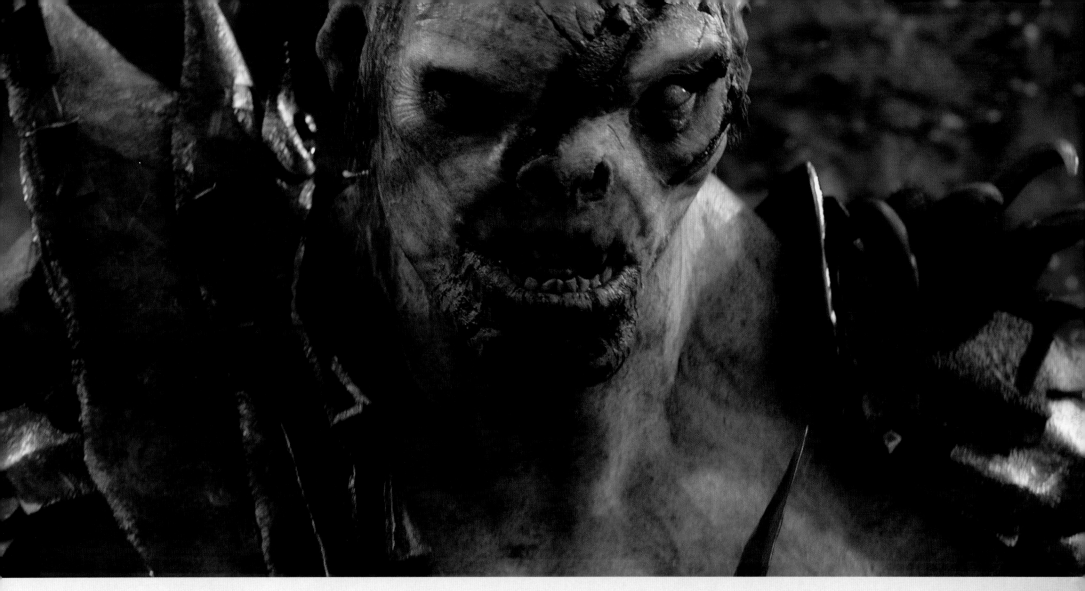

Bolg was a unique character to animate because he was so animalistic, predatory and monsterish. He didn't possess the kind of intelligence that Azog displayed. The way things evolved, Azog's motion was predominantly driven by motion-capture, slowed down to help give him appropriate mass but nonetheless the backbone of his performance, whereas Bolg tended to have a lot of shots that were essentially fast, punchy, visceral violence. We also had a lot of shots with Bolg which were filmed with a green-screen suit-wearing performer who was providing reactions for a live-action lead, so it made sense to key-frame him. Consequently, there was more key-framing for Bolg than perhaps there was for Azog, and it resulted in a different style of movement. He occupied the same world as Azog, but was more of a savage monster.

A lot of the animation notes we got from Peter concerning Bolg centred on him feeling adrenalized the whole time. He should never relax for even an instant. In the fight with Tauriel there was never a moment's rest. He was relentless, and then went straight into fighting Legolas. He was tireless, a Terminator of an Orc. He was savage, but he was also intelligent and calculating, and obviously enjoyed fighting, savouring his victories in a creepy, psychotic way, so we had him lick his lips when he had the upper hand and not really react to pain. It was almost as if he enjoyed it or got a buzz off it: 'Another injury? No problem. It's another just scar and another piece of metal I'll screw on when I get back to base.'

Characters like Azog and Bolg were obviously a combination of motion capture, facial capture and key-framing, to various degrees depending on the shots and characters. Peter supplied what he liked from his shoots and invited us to contribute our own ideas as well. That is always the most enjoyable thing from an animation perspective – being able to come up with an idea, execute it, have it be accepted by the director and then see it on the screen. It's what you always want and it feels great when it happens that way.

David Clayton, Weta Digital Animation Supervisor

1. *Armoured Bolg reference turntable image.*

GUNDABAD ORC SOLDIERS

The Orc soldiers that Azog led to war from Dol Guldur were originally designed to be Gundabad Orcs. They were big, upright, mean, Uruk-hai-like characters that would be more imposing and dangerous to the heroes than little Goblins. As the script developed, these guys ended up departing from Dol Guldur instead of Mt Gundabad, and then, quite late in the process, the idea of a new army coming from Gundabad came back.

As a result, the new Gundabad Orc soldier designs were extrapolated from what had already been done, so they ended up looking very similar in armour design and stature to Azog's army, but with some key differences to help make them distinct and link them to the fabulously iconic shapes John Howe had introduced on the Gundabad fortress. In the film we saw Bolg sent by Azog to Gundabad to bring this army into the fight. We can presume that Azog's army, meantime, was drawn from other parts of Middle-earth, including the force occupying Moria at that time.

Daniel Falconer, Weta Workshop Designer

The Gundabad Orcs were an army of soldiers, like Azog's troops, but there were some differences. John Howe came up with such a strong shape motif for Gundabad that was carried through everything, so it popped up again in their helmet crests, their flags and banners – everywhere. It was like the Red Eye of Sauron or the White Hand of Saruman from *The Lord of the Rings*. It was their badge.

Their armour was darker, more saturated and rusty, which matched the look of the tower they came from. We wanted to be sure the colour would read through the grading we knew the film would undergo so we pumped up the intensity of the rust on the armour and even things like the displacement of the veining on their skin. Without the grade it could look quite overpowering, but it worked in the final shots.

**Gino Acevedo,
Weta Digital Textures Supervisor/Creative Art Director**

We started work on the Gundabad Orcs by matching the conceptual artwork by John Howe and Weta Workshop that Peter had approved as closely as possible. We actually went over the artwork and matched it as closely as we could with our models, posing and even texturing and lighting them, so that Peter could see one-to-one comparisons to the artwork that he liked. Then we could generate whatever we needed, creating variation in the costuming and mixing and matching elements to create diversity in the army. There were new helmet designs that were either based on designs by John Howe or a refurbishment of some of the older helmets and they had flags and banners that gave us more options and helped make them different enough from Azog's army.

Marco Revelant, Weta Digital Models Supervisor

The Gundabad army arrived at the battle just in time to get smoked by the Eagles. We had some bigger chunks of action fleshed out for them, but at that point in the film the rhythm wasn't theirs. It was important only that we, as an audience, understood that they were being dealt with and could focus on the important character action that was playing out between Thorin and Azog and Bilbo. It was basically when the battle and its creatures became a moving backdrop that the audience didn't need to worry about. It is very smart to recognize those moments in a film, when the focus has to shift. Luckily that is something Peter does very well.

Michael Cozens, Weta Digital Animation Supervisor

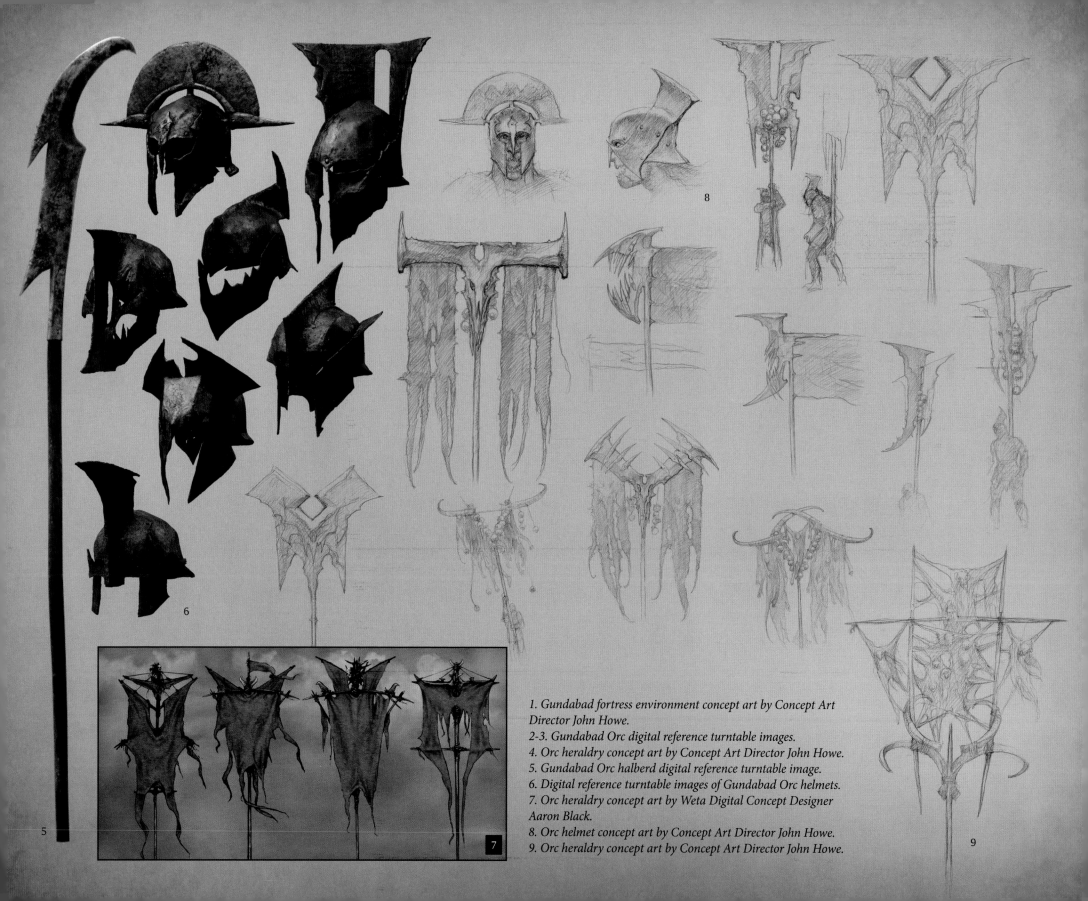

1. Gundabad fortress environment concept art by Concept Art Director John Howe.
2-3. Gundabad Orc digital reference turntable images.
4. Orc heraldry concept art by Concept Art Director John Howe.
5. Gundabad Orc halberd digital reference turntable image.
6. Digital reference turntable images of Gundabad Orc helmets.
7. Orc heraldry concept art by Weta Digital Concept Designer Aaron Black.
8. Orc helmet concept art by Concept Art Director John Howe.
9. Orc heraldry concept art by Concept Art Director John Howe.

BERSERKER ORCS

The Berserker Orcs were inspired by designs done at Weta Workshop. They were more animalistic and some were very pale. The Berserkers had longer arms with big forearms, more gorilla-like than the other Orcs. They felt wilder. They were muscular and their proportions were less human than most of the rest of the Orcs we had built over the years.

Marco Revelant, Weta Digital Models Supervisor

We wanted the Berserkers to seem chaotic next to the lines of Orc soldiers, whom they beat to Ravenhill, sprinting ahead of the main column of Bolg's army. They were like wild mountain men. It came through in both their design and their animation. We kept them very agile and quick, so they were always moving fast, attacking en masse, quickly scaling walls ahead of the main army's arrival.

R Christopher White, Weta Digital Visual Effects Supervisor

The Berserkers had a distinct running style which we got to see when they burst through the soldiers' ranks and sprinted out of Gundabad. There was asymmetry in their step lengths, favouring one side when running.

Our primary reference for what we called the Berserker Orcs' behaviour was apes. In terms of posture, they were always hunched in the upper body, their heads barely projecting above the shoulder line.

Aaron Gilman, Weta Digital Animation Supervisor

Their armour was different than the other Orcs, looking hand-made, using a lot of leather. They had very pale skin and glowing, reflective eyes, which worked well in the frosty environment of Ravenhill.

R Christopher White, Weta Digital Visual Effects Supervisor

Peter really wanted the Berserkers' eyes to pop strongly on screen. The guys actually added a lot more lights to get those specific reflective glints that made them look like they were glowing. It was very cool affect, and accentuated by giving them dark eye sockets. Some even had black sclera.

**Gino Acevedo,
Weta Digital Textures Supervisor/Creative Art Director**

1

2 3

We studied the conceptual art done by Weta Workshop's artists very carefully. Creatures would get modelled based on artwork Peter liked, rigged, animated and placed into shots, but we also went back to those original design drawings again and redid the facial animation, sometimes so that we could be sure we were really capturing what Peter had responded to in that artwork. For a lot of those characters, like the Berserker Orcs, the audience would only have the briefest of moments to focus on them on screen, and in those moments we went back to the Weta Workshop artwork. If we had the Workshop face on our Orc and it was reading well in the shot, then that was a win. It could be as subtle as the flick in a pencil line that suggested a particular eyebrow line or snarl, the intangible qualities that Peter might respond to in a concept image and which might be the difference between it being approved or not. It could be easy to lose that subtlety in the long translation process that every character went through to finally make it into a shot, but we were very cognizant of their importance. In the end it actually simplified the performances, which I think worked well on screen.

Michael Cozens, Weta Digital Animation Supervisor

1. Berserker Orc weapon digital reference turntable image.
2-3. Berserker Orc model #1 digital reference turntable images.
4-6. Berserker Orc model #4 digital reference turntable images.
7-8. Berserker Orc concept art by Weta Workshop Designer Nick Keller, upon which Berserker #4 was based.

1

2

3

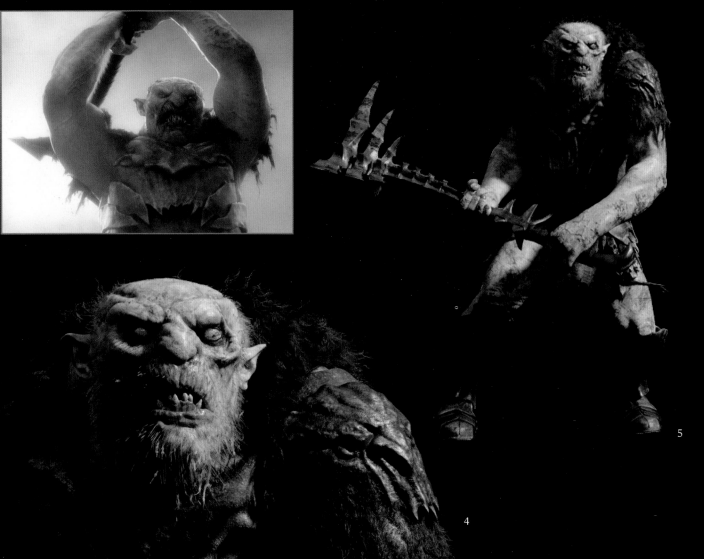

4

5

6

In the fights we went for a lot of stabbing and slashing, barging and cutting. The Orcs were always on the offensive and even somewhat suicidal to a point. Even though some of them had shields they were really just another weapon to the Orcs that carried them.

Glenn Boswell, Stunt Co-ordinator

1-2. *Berserker Orc model #3 digital reference turntable images.*
3. *Digital Berserker Orc armour geometry line-up.*
4-6. *Berserker Orc model #2 digital reference turntable images.*
7-8. *Berserker Orc model #7 digital reference turntable images.*
9. *Berserker Orc concept art by Weta Workshop Designer Nick Keller, upon which Berserker #7 was based.*

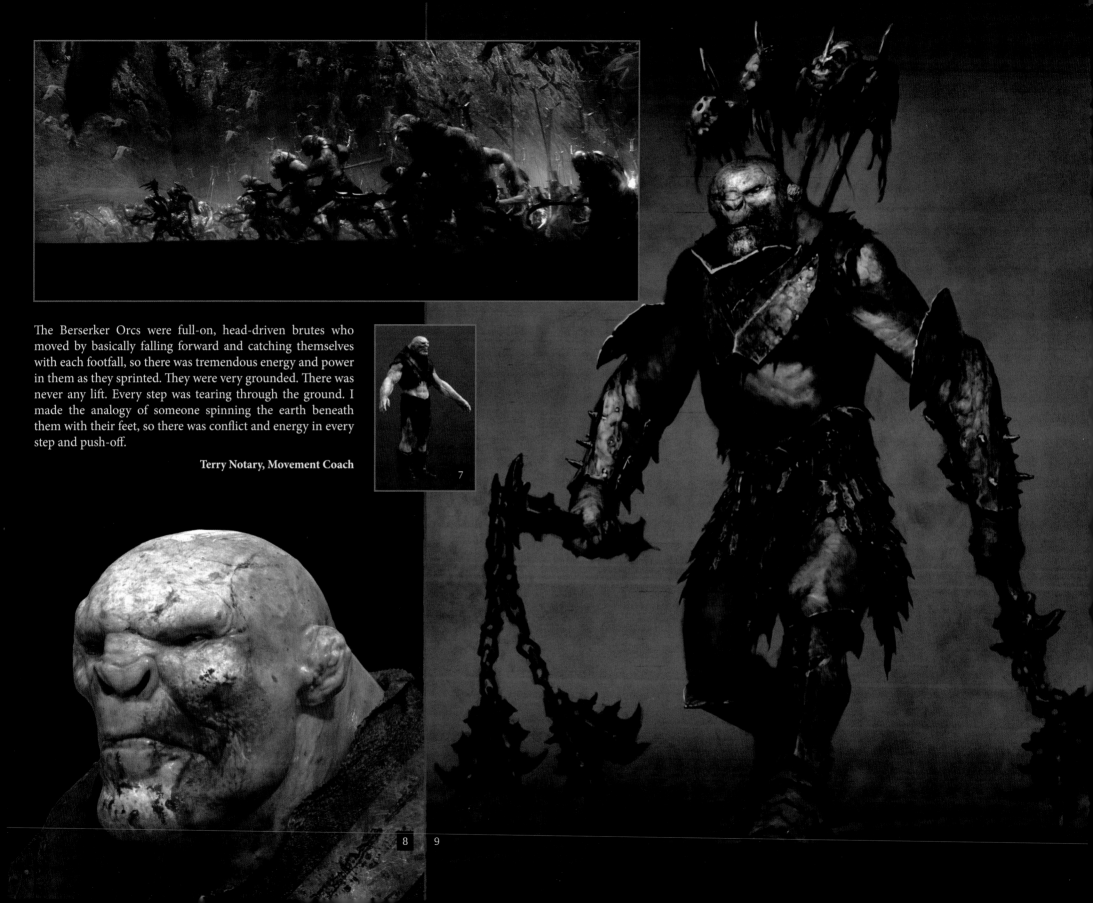

The Berserker Orcs were full-on, head-driven brutes who moved by basically falling forward and catching themselves with each footfall, so there was tremendous energy and power in them as they sprinted. They were very grounded. There was never any lift. Every step was tearing through the ground. I made the analogy of someone spinning the earth beneath them with their feet, so there was conflict and energy in every step and push-off.

Terry Notary, Movement Coach

7

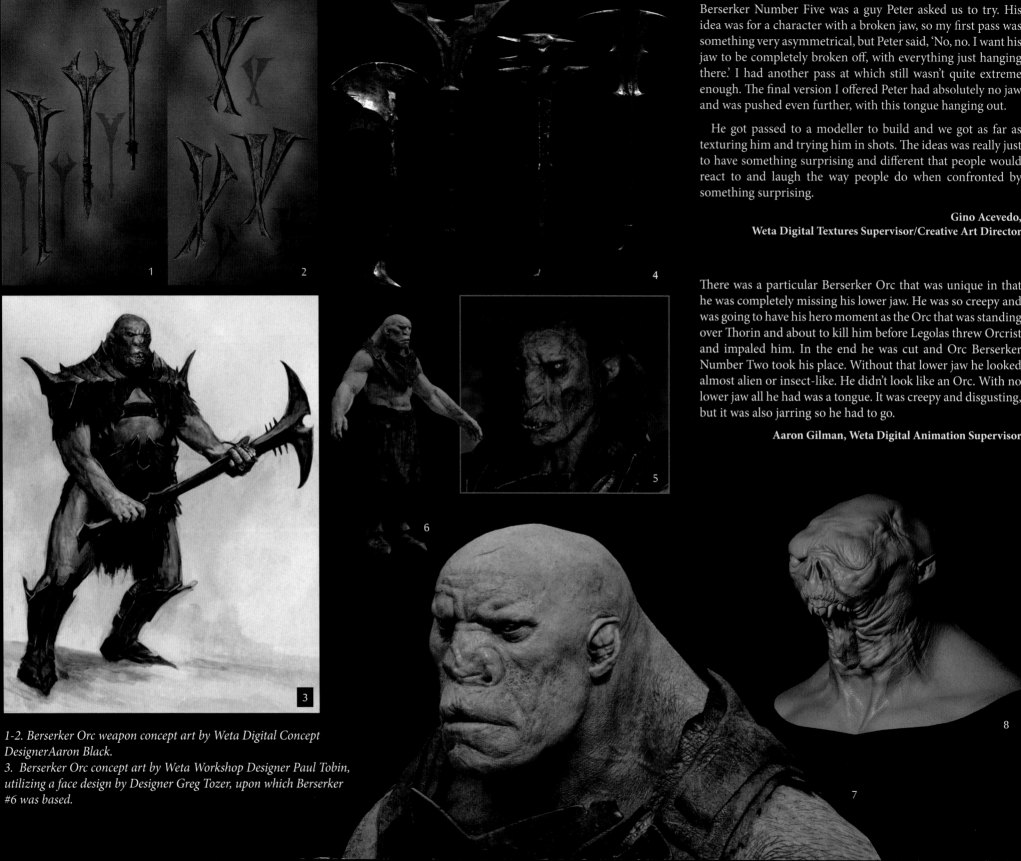

Berserker Number Five was a guy Peter asked us to try. His idea was for a character with a broken jaw, so my first pass was something very asymmetrical, but Peter said, 'No, no. I want his jaw to be completely broken off, with everything just hanging there.' I had another pass at which still wasn't quite extreme enough. The final version I offered Peter had absolutely no jaw and was pushed even further, with this tongue hanging out.

He got passed to a modeller to build and we got as far as texturing him and trying him in shots. The ideas was really just to have something surprising and different that people would react to and laugh the way people do when confronted by something surprising.

Gino Acevedo,
Weta Digital Textures Supervisor/Creative Art Director

There was a particular Berserker Orc that was unique in that he was completely missing his lower jaw. He was so creepy and was going to have his hero moment as the Orc that was standing over Thorin and about to kill him before Legolas threw Orcrist and impaled him. In the end he was cut and Orc Berserker Number Two took his place. Without that lower jaw he looked almost alien or insect-like. He didn't look like an Orc. With no lower jaw all he had was a tongue. It was creepy and disgusting, but it was also jarring so he had to go.

Aaron Gilman, Weta Digital Animation Supervisor

1-2. Berserker Orc weapon concept art by Weta Digital Concept DesignerAaron Black.
3. Berserker Orc concept art by Weta Workshop Designer Paul Tobin, utilizing a face design by Designer Greg Tozer, upon which Berserker #6 was based.

When it came to fighting Orcs who would later be digital, we would be in full costume and usually on a proper set, but our enemies were guys in green suits who provided us with things to react to and wallop. It's hard to mime that kind of thing believably when you're striking empty air, so having them there was a great help and made the fights interactive, even though the final bad guys would be inserted digitally, later. There was a lot of that up in Ravenhill, and also in some of the material that we shot for the flashbacks to the battle outside Moria, with Balin and Dwalin fighting side by side against multitudes of Orcs who were green guys being fed at us on the set. There was much more of that material filmed that didn't make it into the films. Often we swapped out our real weapons for rods that were later turned back into weapons digitally so that we could actually impale Orcs without killing stuntmen, but it was no less full on to shoot, in full costume, performing lots of relentless action.

Graham McTavish, Actor, Dwalin

4. Berserker Orc weapon digital reference turntable image.
5. In-progress Berserker Orc look exploration.
6-7. Berserker Orc model #6 digital reference turntable images.
8. Unfinished greyscale geometry of unused Orc Berserker #5, with his missing lower jaw amd lolling tongue.
9-10. Berserker Orc concept art by Weta Workshop Designer Gus Hunter, upon which Berserker #8 was based.
11-13. Berserker Orc model #8 digital reference turntable images.

VIOLENCE & RATINGS

In a film about war, with lots of gruesome deaths, we had to be very mindful about staying within our intended rating. We wanted to paint our villains in a bad light in Act One so that when we killed them in Act Three those deaths were earned, otherwise Legolas and the rest of the heroes might not feel justified in their actions and just seem like a bunch of serial killers.

Orcs having black blood was one way to diffuse the violence of the various beheadings and other violent deaths throughout both trilogies. Red is visceral, black isn't. We also found that there was a cumulative effect in terms of beheadings. It was possible to have too many.

We could also employ some tricks to make violent shots seem less nasty by drawing attention away from the impacts.

David Clayton, Weta Digital Animation Supervisor

GOBLIN MERCENARIES

The Goblins came back to have another go at the Dwarves in *The Battle of the Five Armies*. I only wish we had seen more of them because I loved playing Goblins. They are terrible little backstabbing, conniving creatures and it's impossible to play that without having a sense of humour. They were a lot of fun to play in a mocap suit.

Terry Notary, Movement Coach

We chose some of our existing Goblins with proportions that fit best with the action we needed them to accomplish in their scenes. We also created a new armour design for them that we could separate into bits and pieces that each Goblin could wear in different configurations, such as with a helmet or not, arm guard or none, etc, giving us the most variation without a lot of extra work, considering they were only in a handful of shots.

Marco Revelant, Weta Digital Models Supervisor

We dug out some reference of the armour worn by the Orcs in Moria from *The Fellowship of the Ring*, the idea being that these Goblins were maybe related or that there was some link there. The helmet we gave some of the Goblins was based on that old Moria Orc helmet with the teeth and jagged fins.

**Gino Acevedo,
Weta Digital Textures Supervisor/Creative Art Director**

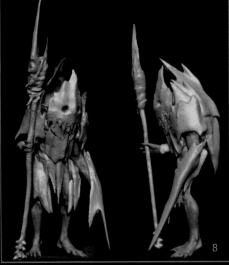

1-4. Goblin armour ZBrush concept sculpture by Weta Workshop Sculptor Daniel Cockersell.
5-8. Goblin armour concept art and ZBrush sculpture by Weta Workshop Designer Andrew Baker.

9-11. Goblin armour concept art by Concept Designer Aaron Black, painting over Goblin digital reference turntable images.
12-14. Goblin armour concept art by Weta Workshop Designer Nick Keller.
15. Goblin mercenary digital reference turntable images.

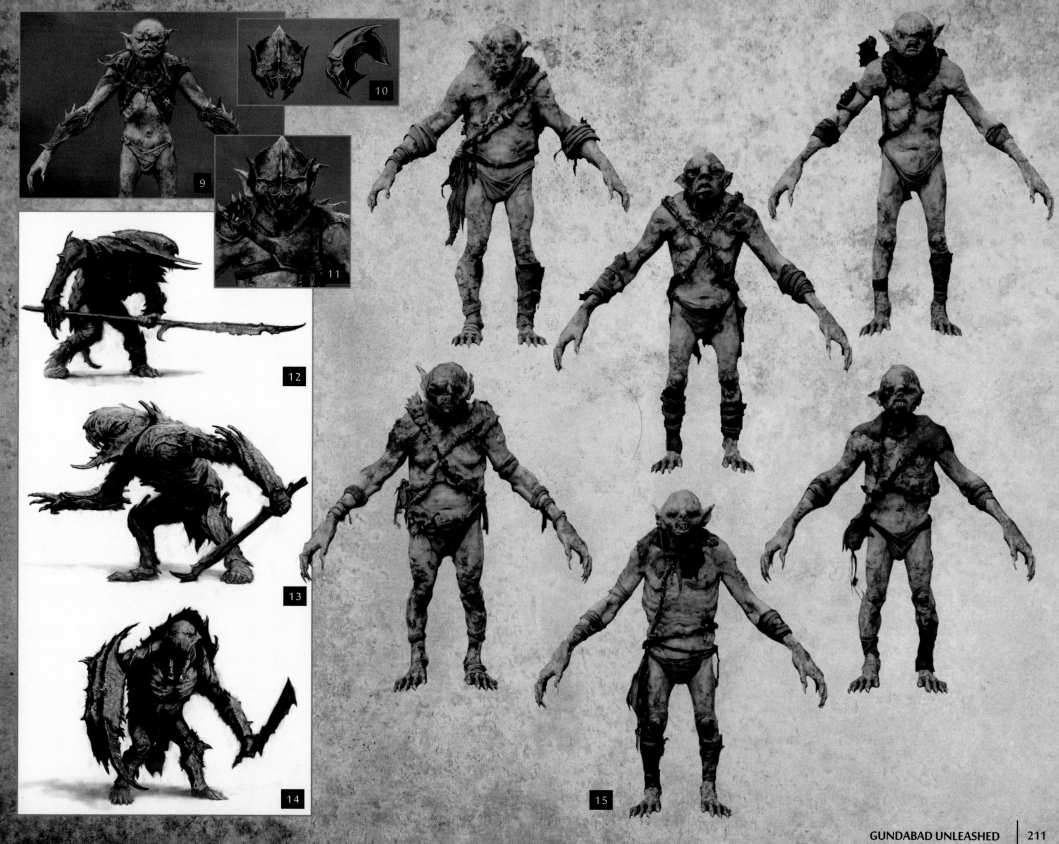

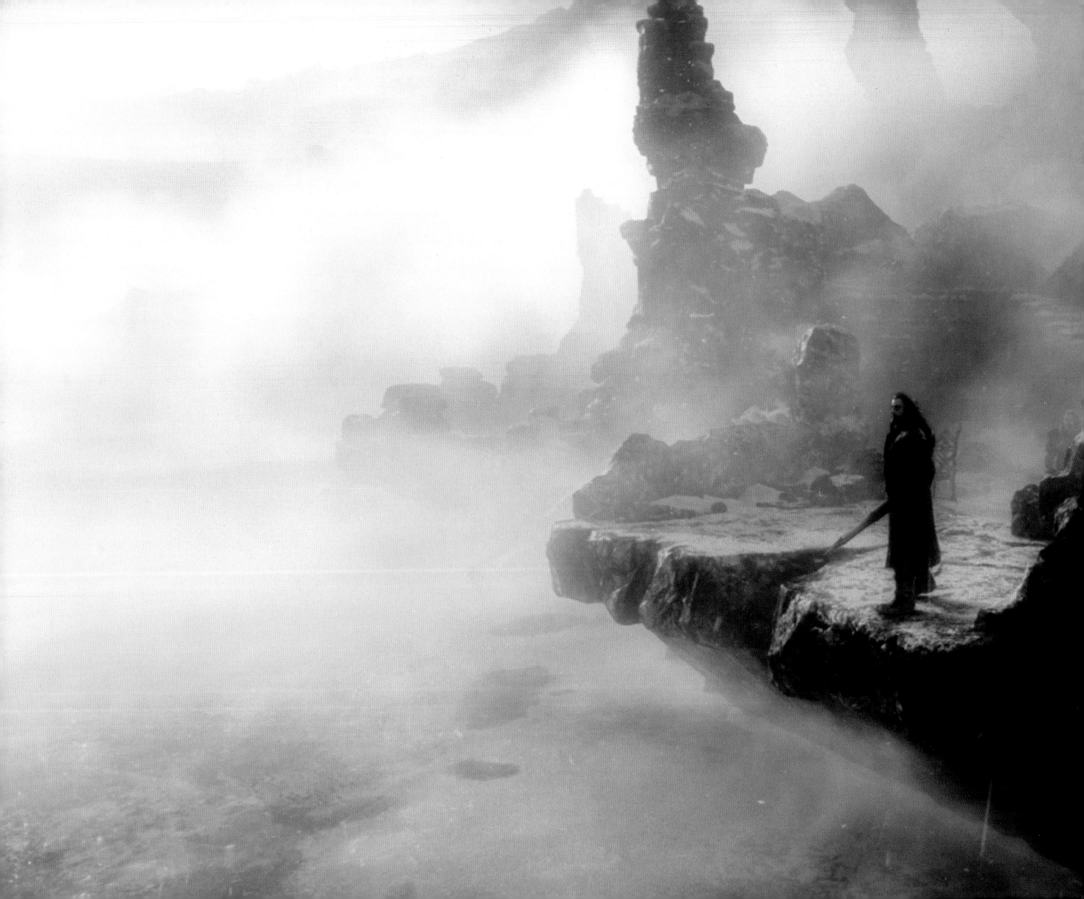

CUTTING THE HEAD OFF THE SNAKE

K nowing defeat is assured if they cannot turn the tide, Thorin leads his best warriors in a desperate bid to reach the ruined watchtower of Ravenhill where Azog commands the battle. Thorin intends to 'Cut the head off the snake.' Leaderless and disorganized, Thorin reasons that the Orcs might be contained or driven from the field with a renewed push, even with their advantage of numbers; killing Azog is the key.

Too wise to succumb to blind vengeance, Thorin is cautious in his approach, sending his keen-eyed, quiet-footed nephews to scout the seemingly deserted maze of passages and balconies they find upon gaining the heights. Kili and Fili pick their way through the ruins, alert for signs of danger, but even their sharp wits are not keen enough to avoid the trap that has been laid for them, for Azog observed Thorin's ascent and has lain in wait.

Recognizing the danger as word comes of Bolg's imminent arrival, Bilbo rushes to Ravenhill to warn his friends even as Legolas and Tauriel battle their own way there in defiance of Thranduil. Fili is seized by the enemy and slain before his uncle's horrified gaze, Azog savouring the first taste of his victory over the line of Durin he has sworn to destroy. While Thorin and Dwalin fight the first waves of Bolg's army swarming over the Mountain's arm to flank them, Kili is next to fall. Even Tauriel's arrival, engaging the riven Orc together, cannot save him, and the youngest Son of Durin is killed before his love's eyes.

Bereft, Tauriel takes Bolg over the precipice, but the brute is not so easily dispatched, rising again to bear down with murderous vengeance upon her helpless body. Only Legolas's intervention saves the Elf-maid, and, having toppled a tower to bridge the ice gulf between them, the Prince of Mirkwood takes the fight to Bolg upon the crumbling masonry. As Beorn, Radagast and the Great Eagles sweep down from a bright sky to shatter the spearhead of Bolg's army and save the day for the allies, Thorin and Azog find themselves alone upon a field of ice, there to settle once and for all the blood feud that has fuelled so much destruction; the stage is set for their final confrontation.

THE RUINS OF RAVENHILL

Ravenhill was a design that came to fruition late in the piece and there were many iterations. As the final design began to take shape through concept art and the script, Dan Hennah guided the conceptual model-makers in the creation of a scale model in which the spatial relationships between elements could be defined. Peter was able to determine how and where the action sequences would take place, and with the model approved, Dan was able to determine which parts of the set actors would practically interact with and would therefore need to be built. These areas were marked on the model, and the set designers took to work creating plans for the built set.

Two sections were built as practical sets; one area was used predominantly for Bolg, Tauriel and Kili's confrontation, and the other was a huge set built in K Stage. Both were very intricate, full of tunnels you could get lost in, and if you are one who gets spooked easily, it was not a place to be when the crew had left for the day and all the lights were all turned out.

Given the repetitive nature of the pattern work, shapes, and clever design of the set build, it was possible to use many sections of the giant K Stage set to depict different parts of Ravenhill. A good portion of the K Stage set was the edge of the frozen lake, with towering elements of Ravenhill's fortress that almost reached the roof of the studio. Layered with various platforms, stairs, tunnels and precipices covered in snow, this was the set that was the backdrop for Thorin's final battle and the end of line of Durin

Karen Flett, Art Department Co-ordinator

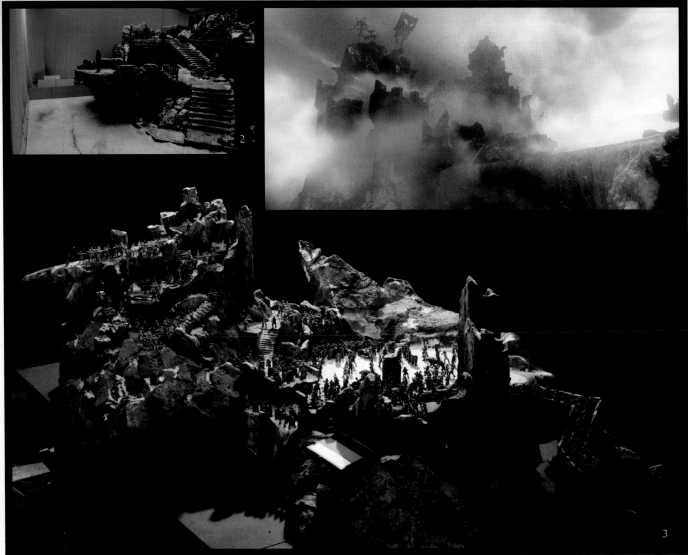

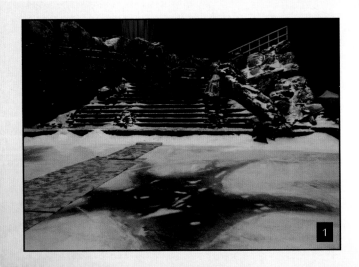

Much of Ravenhill was shot on a live set in a way that the same piece of set could stand in for different parts of a larger structure. We replaced a lot of it to help achieve that illusion, swapping out walls and other elements to differentiate the spaces and integrate them, however a huge proportion of Ravenhill only ever existed as a digital environment. It was a labyrinthine ruin of tunnels, precipices and walls where Azog could lay his trap for Thorin. The entire environment had to be cohesive, but also diverse enough in its layout and geography to offer unique, recognizably different areas in which to stage the climactic fights to be staged there. Part of that involved given Ravenhill its own signature features, including fog and ice, which presented interesting cinematic opportunities.

Joe Letteri, Weta Digital Senior Digital Effects Supervisor

Peter wanted the fog upon Ravenhill to be almost like another character, flowing in and out of the architecture in interesting ways. We started by trying to simulate the currents in the entire area, but quickly found that customizing our simulations to each unique area of battle gave us the most interesting results. As the battles reached the higher altitudes of Ravenhill, the winds became more intense. The fog started to burn off as the day came to its end and the final fight between Azog and Thorin took place out on the ice.

R Christopher White, Weta Digital Visual Effects Supervisor

1-2. Physical Ravenhill sets.
3. Ravenhill concept miniature.

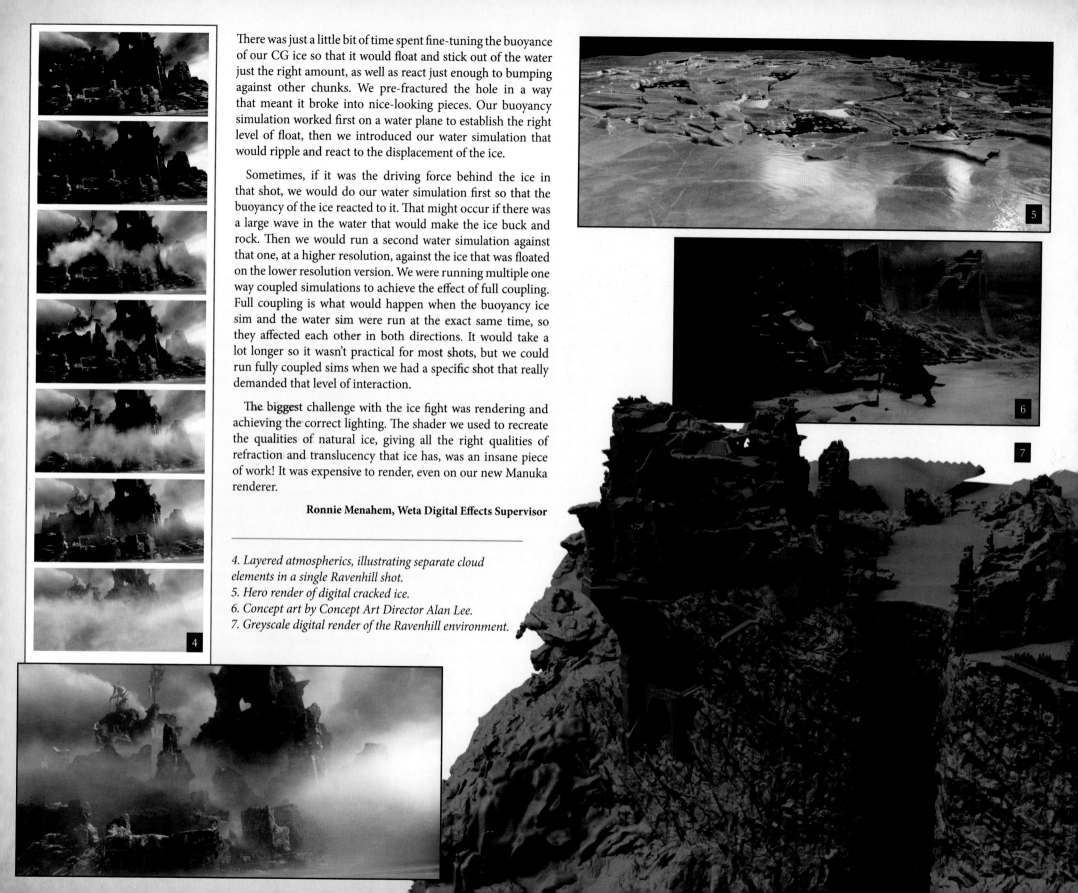

There was just a little bit of time spent fine-tuning the buoyance of our CG ice so that it would float and stick out of the water just the right amount, as well as react just enough to bumping against other chunks. We pre-fractured the hole in a way that meant it broke into nice-looking pieces. Our buoyancy simulation worked first on a water plane to establish the right level of float, then we introduced our water simulation that would ripple and react to the displacement of the ice.

Sometimes, if it was the driving force behind the ice in that shot, we would do our water simulation first so that the buoyancy of the ice reacted to it. That might occur if there was a large wave in the water that would make the ice buck and rock. Then we would run a second water simulation against that one, at a higher resolution, against the ice that was floated on the lower resolution version. We were running multiple one way coupled simulations to achieve the effect of full coupling. Full coupling is what would happen when the buoyancy ice sim and the water sim were run at the exact same time, so they affected each other in both directions. It would take a lot longer so it wasn't practical for most shots, but we could run fully coupled sims when we had a specific shot that really demanded that level of interaction.

The biggest challenge with the ice fight was rendering and achieving the correct lighting. The shader we used to recreate the qualities of natural ice, giving all the right qualities of refraction and translucency that ice has, was an insane piece of work! It was expensive to render, even on our new Manuka renderer.

Ronnie Menahem, Weta Digital Effects Supervisor

4. Layered atmospherics, illustrating separate cloud elements in a single Ravenhill shot.
5. Hero render of digital cracked ice.
6. Concept art by Concept Art Director Alan Lee.
7. Greyscale digital render of the Ravenhill environment.

PREVIS

At one level it is gratifying to know you have scored a hit with an idea in a meeting when the director responds and says, 'Yes, I love it!' but Peter never operates that way. In that sense he keeps the process very honest, because we go back and keep pitching ideas without going too far down any particular avenue just because it got lots of vocal praise, bottle-necking the flow of ideas. That might seem slightly frustrating, because you may not know exactly where you stand, but it is also genius because it keeps the broadest range of ideas flowing.

Randy Link, Weta Digital Previs Supervisor

Ultimately, what I love about previs is the opportunity to sit in a room full of creative people and engage together to come up with ideas. That is such fun.

Jamie Beard, Weta Digital Previs & Animation Supervisor

Previzualization as we use it today is essentially a more advanced version of storyboarding, where we produce a mock-up of a sequence for a film that the director can review before having to commit to it. Where storyboards were done with a pen and paper, we now use 3D models created and animated in the computer. It looks more advanced, but essentially the process is designed to attain the same goal, which is to encapsulate the director's vision in a working form as quickly as possible.

Jamie Beard, Weta Digital Previs & Animation Supervisor

On some films the previs is done before a single frame has been shot. In those instances it is a tool that the director might use to show his or her actors and other crew so that everyone understands the world or intent behind what will be filmed. In other cases previs can occur when the director is already deep into a film and a lot has already been established and its purpose is to help push the whole thing along. Different directors use it differently on different projects.

Randy Link, Weta Digital Previs Supervisor

1-2. Still frames from previs animation for The Battle of the Five Armies: Beorn laying waste to Gundabad Orcs (1), the Dwarves on their ram-drawn war chariot.

PAs previs artists, it's our role to assist in creating a low resolution mock-up that represents the director's vision. It can offer a relatively cheap way of exploring ideas and trying things so that an informed choice can be made to either embrace or discard them. And it can come in at any stage in the process. On *The Battle of the Five Armies* everything had been filmed before we did our work, so instead of being an isolated unit we were working with the legacy of what everyone else had been doing so far and there was a lot to bear in mind. Offsetting that caution, experience had also granted us a very good understanding of how Peter operated and the kind of things he responded to, which greatly assists creative efficiency. The director is a film's metronome, the key ingredient in the soup. They define how everything will flow. If they turn left, the project moves left, and every director is unique, so understanding how they work and what they want is essential to a smooth previsualizing process.

Peter loves to shoot a lot of previs, sometimes before he ever lifts a camera. He challenges us but also gives us the benefit of his trust. He actively encourages people to share their ideas in our sessions with him. Often he would sit quietly and take it all in, but not necessarily give any clue at the time as to whether a particular idea stuck or not. He would have us fill his pot with ideas and then go back and dip into it when he needed to later, so we might not know whether he'd used an idea we had suggested until we saw the finished.

Jamie Beard, Weta Digital Previs & Animation Supervisor

It's our job to come up with ideas. We sometimes use the word gag when we are talking about what we offer up, but it is for the convenience of a term. Gag is a nice, short word, but it undersells what we try to achieve, really. The word gag suggests a funny anecdote, but we're interested in telling a story. We're in the tricky business of trying to provide a director with inspiration and putting a visual to something which doesn't exist yet. We vomit up ideas that begin conversations and, if we're lucky, that regurgitation doesn't get cleaned up too much before it gets on the screen.

Randy Link, Weta Digital Previs Supervisor

The intention with any idea is always to support the characters. Ideally, what we come up with tells you something about the characters and isn't just action filler. In the 1920s there was a gag man on staff whose job it was to come up with gags for the Fleischer Studios cartoons: 'Hey, it's funny if our character plays the xylophone on a skeleton!' Then Disney came along and changed things completely with *Snow White and the Seven Dwarves*, because Disney said that a joke had to back up the character performing it. A Dopey gag would be different to a Grumpy gag, and either one would tell you something about that character. They weren't gags for their own sake, but for the sake of story and character. That is just as true today and informs what we aspire to do in our work when we brainstorm ideas for Peter.

Jamie Beard, Weta Digital Previs & Animation Supervisor

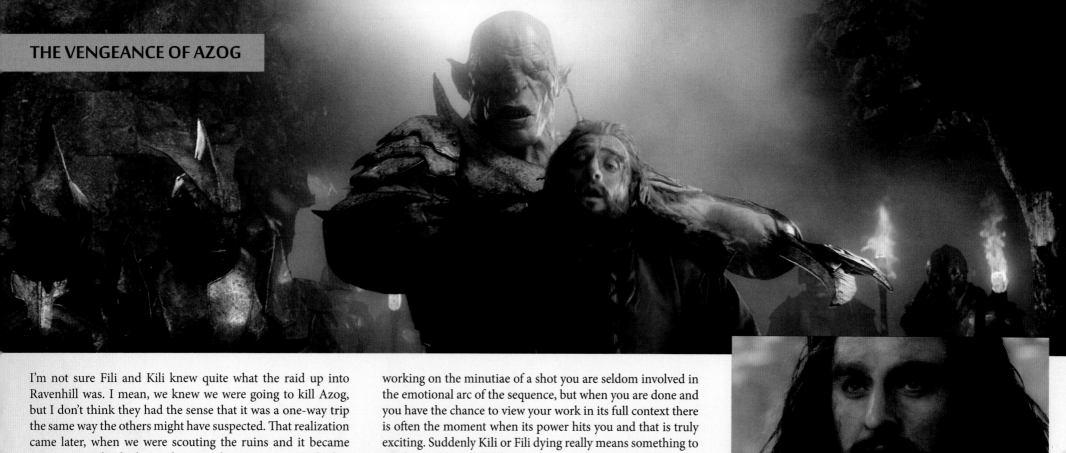

I'm not sure Fili and Kili knew quite what the raid up into Ravenhill was. I mean, we knew we were going to kill Azog, but I don't think they had the sense that it was a one-way trip the same way the others might have suspected. That realization came later, when we were scouting the ruins and it became apparent to Fili which was the more dangerous way. He had to be the big brother and go that way, knowing it could be a trap. For a while there was some dialogue in the script between Fili and Kili, a moment when we kid each other, 'You can't fight with that.' He said he could and I called him an idiot, 'Takes one to know one,' or something like that. It was some light banter, but the heavier subtext was basically, 'Take care and I hope I see you again,' knowing that might not be the case. Fili was stepping forward and being the protective older brother.

Dean O'Gorman, Actor, Fili

There were a lot of fights up on Ravenhill. Fili could have had one to, but the feeling was that wasn't the moment Peter wanted in the film at that point. This was a trap and Fili never stood a chance. What I could glean from Peter was that Fili's capture should be a surprise, certainly for Thorin and hopefully the audience too. It was an 'Oh no,' moment. And his death was an execution, cold and cruel.

Glenn Boswell, Stunt Co-ordinator

The third film's conflicts were among the most compelling of the trilogy to work on because there were real dramatic consequences to their outcomes. At the point at which you are working on the minutiae of a shot you are seldom involved in the emotional arc of the sequence, but when you are done and you have the chance to view your work in its full context there is often the moment when its power hits you and that is truly exciting. Suddenly Kili or Fili dying really means something to you beyond being the shot you're working on that week.

Fili's death went through some discussion and different versions were explored. For the film's theatrical release we debated whether we should see Azog's spike emerge through Fili, which was decided against. We discussed having him dangle on the spike as Azog lifted it, but again, no. Finally, Azog used to just slide Fili off the spike in order to drop him off the edge of the tower, but that was deemed too violent as well, so in the end the action came down to Azog unspiking the Dwarf and holding him up with his good hand before releasing him. Then the discussion became whether that would remain the same in the extended edition release or whether some of the more gruesome bits should be reinstated.

In the end, the important thing in all of these major character deaths wasn't so much the violence of them, but the drama and what passed between the characters. I animated Azog's close-up immediately following his killing of Fili. It was a very simple performance, Azog glaring down at Thorin in delight, just inhaling and exhaling as he gave Thorin the stink-eye, but that was all that it needed to be. It had weight and was very satisfying to animate.

David Clayton, Weta Digital Animation Supervisor

It's so strange, but there was such an emphasis on the technicalities of getting the scene right when we were shooting it that I never really got the full weight of Fili's death until after we were done. Shooting the scene was quite a technical exercise because of the rig I was on and other things. It was good to do a bit of a yell and after a few takes I really started to feel the weight of the scene, but to be honest it wasn't until the premiere and getting to see it in the cinema that I fully grasped how brutal and affecting the scene really was. I knew it was coming, but it still came out of the blue, relatively speaking, and it was very violent. It was really only seeing it then that I understood why people said it was a hard scene, and very emotional. It wasn't for me, until that moment, but in the cinema I think I had some objectivity, and then I was right there with everyone else.

Dean O'Gorman, Actor, Fili

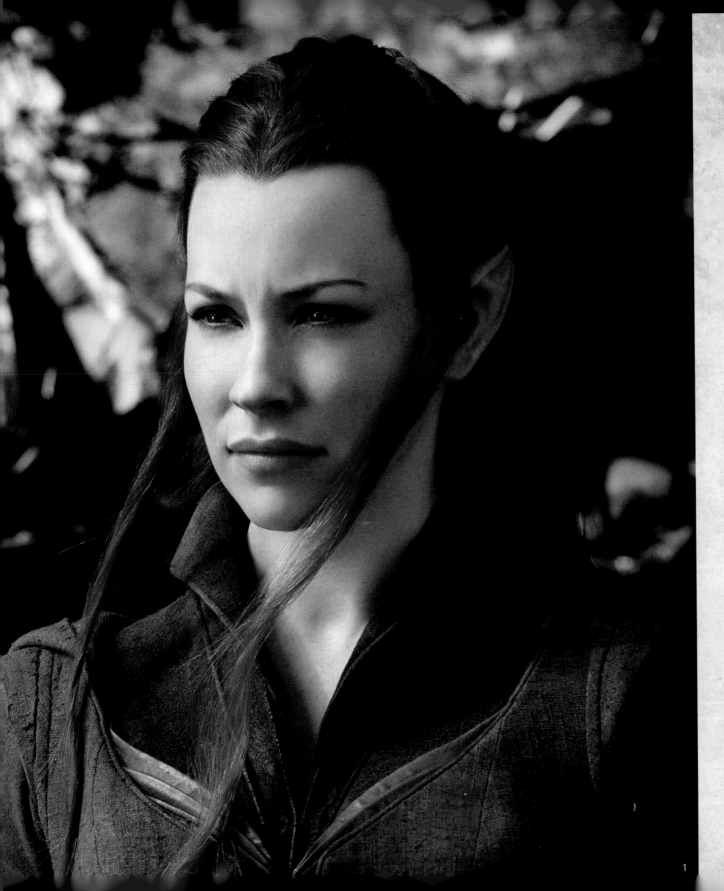

TAURIEL

Tauriel is a little different than Cate Blanchett's aloof and ethereal Galadriel in that she has a romantic story arc. Where Galadriel is removed and remote, Tauriel is an Elf who lives in the same world that we do and in our films she comes to love a Dwarf. That in itself presented some challenges for us in devising the looks of both characters. The necessity for audiences to be able to identify and share the feelings of both Tauriel and Kili has a lot to do with why he didn't look like a younger version of Gimli, and is also why Tauriel wasn't six feet tall. It was very important that their physicality not be a barrier for audiences to accept their relationship, or cause them to find it unintentionally funny. As Fran challenged us to achieve, if you looked into their faces, you had to believe that there could be some kind of attraction between them. Fortunately Evangeline Lilly has the most beguiling smile, which I think is a big part of the appeal of any character she plays.

I received Tauriel's design drawings when I was still in England, before coming to New Zealand for the shoot. I recall seeing that she had hair down to her knees and Peter asked me, 'Can you do that?', to which I replied, 'Of course, no problem,' and then went away biting my nails, thinking, 'Oh my, how do I do this?'

As with everything, we found a way. The wig was already being made, but I realized it wasn't going to be long enough. We couldn't have them start again because that would be too expensive, so I had an extra piece made that would be attached at the bottom of her wig in a kind of sleeve, hidden amid her locks, turning a three or four foot wig into a five-oot one.

With the exception of Legolas and Thranduil, who were of a different lineage, the Mirkwood Elves were to be earthier in their hair tones, and as a hero character in their ranks, Tauriel was to have long, reddish hair that would help her stand out and give her a unique look. Up till this point we had three women with significant parts in the films: Cate Blanchett's Galadriel, with her pale silver-blonde locks, Liv Tyler as Arwen, who was dark, and Miranda Otto's Éowyn, not an Elf but nonetheless with long hair, who was a blonde. We hadn't had a fiery auburn-haired Elf yet.

When it first arrived the wig was too dark. It took three lots of highlights to achieve the colour that we needed, a lighter, brighter hue, which then had to be replicated on her various doubles' wigs, because, like all our hero characters, we had multiples. Peter kept telling us to go redder, and I think we could probably have pushed it even further than we did.

1

Tauriel's pointy Elven ears were quite large. We offered Evangeline three sizes of ear tips and after some discussion and trying them on she chose the largest, which I think did look the best. We had all expected to be using the smaller, or medium-sized tips, but with her wig the longer ears simply worked the best and gave her an almost pixie-like quality that was appropriate for the character. Tauriel is a little bit boyish, adventurous and rebellious, and Evangeline has that twinkle, an impishness that was very attractive and a wonderful counterpoint to Legolas's stateliness and Thranduil's frozen demeanour.

Finally, Evangeline having such beautiful green eyes meant we didn't need to give her any contact lenses.

Peter King, Make-up & Hair Designer

The Elf ears we created for this trilogy were gelatine and produced essentially using the same techniques we employed for *The Lord of the Rings*, but with the exception of Legolas's, they were new sculpts. Legolas got fresh moulds at least, but we kept his ears the same as the design seen in the other films. Thranduil's ears were a very different shape to Legolas's, but looked really nice, while Tauriel's were quite elongated and unique in shape, a choice made to help distinguish her people from the other Elves, being of a different Elven line. They were a little chunkier and projected out of her hair more. The same was true of all the new Mirkwood Elves.

We started calling the ear-tips chicklets and had four different sculpts. In total we had eleven variations, including hero Elves, which, when glued to another person, can look completely different; so even if an extra is wearing Tauriel's ears, they likely won't look like her. Weta Workshop would receive such large orders for new ear-tips, sometimes 300 ears, that they had to run every mould they had access to. Some of the girl extras would get very excited when I told them they were being fitted with Galadriel's ears.

Tami Lane, Prosthetics Supervisor

One of the highlights of working with Peter, Fran and Philippa is how collaborative they are. All processes on *The Hobbit* have been collaborative. I was able to be involved in the evolution of all aspects of Tauriel's look. When it came to her ears, I was given a choice of sizes, but the largest were my immediate favourites. The unique design of the Silvan Elves' ears that Tauriel had help set her kind apart from the Sindar, including Legolas.

Evangeline Lilly, Actress, Tauriel

Tauriel was in love with a Dwarf, but it wasn't even the Dwarf aspect of that expression of feeling that sat so uncomfortably with Thranduil and stir him to rage when she disobeyed him. I find love most interesting when it sits next to a profound heartbreak. What Thranduil understood of love was not the rush of excitement or the great feelings and romance that you experience when you first fall for someone. What he knew was the loss of it, and the heartbreak that inevitably accompanied it.

When Tauriel claimed to be in love, he didn't understand what it even looked like anymore, couldn't understand what this feeling she claimed could be, and he denied it. Love as he once knew it had been soured in him by the pain of loss.

Lee Pace, Actor, Thranduil

I have always thought that Elves, being immortal, would have a deep and profound kinship, far more complex than human love and attraction. Tauriel's affection for the Dwarf Kili is perplexing for Legolas. As written into the films, it became a story point that partly explained why he left the closed world of the Woodland Realm to embark on a journey that eventually saw him join the Fellowship of the Ring.

Orlando Bloom, Actor, Legolas

1. *Evangeline Lilly as Tauriel.*
2. *Evangeline Lilly in the make-up chair with Additional Make-up Artist Hil Cook.*

In finding Tauriel's performance I cannot deny that I looked to Cate Blanchett and Liv Tyler's portrayals of Galadriel and Arwen to establish my sense of general 'Elvishness'. That said, I also intentionally steered away from the performances of those women in developing Tauriel, specifically. Tauriel was a young Elf, immature and inexperienced in contrast to those of her kind whom we met in *The Lord of the Rings*. She was only half Legolas's age.

I was left to conjure up something entirely different for Tauriel, and that was really fun. I spoke at length with Peter, Fran and Philippa about her character and she slowly evolved from those conversations. We imagined an Elf woman who was delighted by life, passionate about justice, wilful and spontaneous. She lacked the stillness, wisdom and staid energy of her elder counterparts. She also lacked their cynicism. Tauriel was open to life and Middle-earth, wanting to embrace it and know it more intimately, rather than running or hiding from its decay.

As funny as it may sound, a character that would sometimes come to mind when I was making choices for my Tauriel performance was Tinkerbell. Tink reacted in a spirited way to threats to anything that she loved. There was an undeniable power that emanated from even such a tiny, half-dressed vixen, and the way that Tink always seems somewhat alone seemed relevant as well. The little fairy felt an impossible love for Peter (a very awkward size match) which in some ways paralleled the attraction Tauriel began to develop for Kili, and Tink had her magical qualities. These were the funny little things that would spring to mind when on set, or in preparing my scenes.

Reading the first chapters of Tolkien's *The Silmarillion* was also invaluable to learning about Tauriel and the Elves. I learned more about my character there than from any other source. Understanding the origin and nature of Elves was not only educational, but totally enchanting. It gave me a new fervour for playing this role. My favourite of the original Valar, who presided over the Elves and from whom they learned, was Yavanna. And, how wonderful, since Tauriel is a daughter of Yavanna, being an Elf of the woods and trees! Though Yavanna was much, much more ancient and wise than young Tauriel, I looked to her to reach Tauriel's softness and light.

It was also impossible not to think about Tauriel in the wider context of how women tend to be portrayed in genre films and other media. I struggle with the image of women in the fantasy and sci-fi genres. Even in their new, more empowered roles, women have yet to be embraced for what is truly captivating in them. In thinking of empowered women in recent fantasy, my mind immediately goes to Galadriel's 'All shall love me and despair' scene and Arwen's 'Flight to the Ford'. Both scenes gave me a sense of the power of women in an authentic and stirring way.

That said, while we have Fran and Philippa, where are the other female writers, producers and directors in this genre? Where are the women telling their own stories? Where are the stories with subject matter that address what is in women's hearts? Do women even know what those stories are, or have we been telling men's stories for so long that we've lost touch with our own?

I love playing 'action women', as is evident in most of the roles I have chosen. I enjoyed Tauriel's action scenes immensely, and was more excited to learn to fight on a wire than I was about learning my lines, but do I think that portraying a woman who slays and kills evil 'like a man' is the way to empower young women who watch these films?

The answer is no.

Do I think that playing a flawless woman is the way to empower young women?

Again, no.

I think that young women, more than anything today, need to see the humanity of the characters they idealize, both on and off screen. They don't need to see my air-brushed face on the cover of a magazine. Young girls need to know that I struggle with my self-image, too. We need to encourage each other. We need to stop competing for the attention of men and start honouring each other.

My message to young women who love fantasy is, consider your own story in the light of the genre you love, and create! Don't just follow, don't just participate! Start anew and be your own hero!

Evangeline Lilly, Actress, Tauriel

Aidan: The Tauriel/Kili thing was unrequited in the sense that it's all wistful looks and wishes. We never really got to spend any time together. It was a 'what could have been' kind of love. It never had the chance to become passionate, although at the end of the movie she was crying over my death, which was pretty cool. Not everyone got that.

Dean: Yeah, that's true

Aidan: It was pretty awesome, actually. I mean, Tauriel wasn't going to cry over Oin's grave, was she?

John: Well, she wasn't in love with me.

Aidan: Not for a second, even. You know, she just wouldn't go there.

John: No, well, pensioners don't get that.

Aidan: Oin, no. Balin, no. Fili, no...

Dean: Oh, potentially a little bit for Fili. I feel there was a little bit of something going on there.

Aidan: I don't think she ever looked at you, bro.

Dean: She held my hand under the table.

Aidan: No she didn't.

Dean: She did, just a little bit. I didn't want to say anything at the time because I thought, 'hmm this is probably not appropriate' but...

Aidan: We'll talk about this later.

Aidan Turner, Actor, Kili
John Callen, Actor, Oin
Dean O'Gorman, Actor, Fili

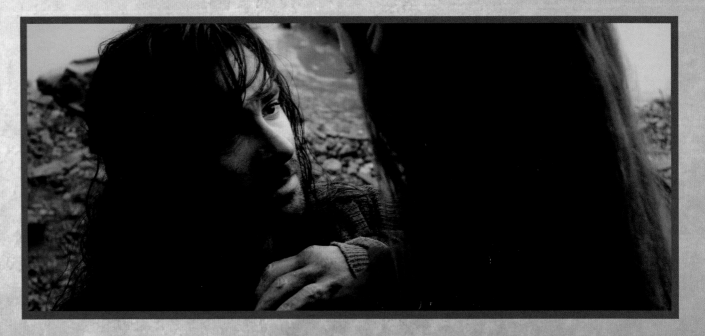

Tauriel fights with paired daggers, an ancient art form in martial arts that I am in awe of. Tauriel does not fight using martial arts, but I was trained using some basic martial arts concepts to help me solidify my swings, jabs, posturing and footwork (which was atrocious!).

Tauriel's fighting style was designed to look effortless, devoid of any show or pretence. Elves move seamlessly and naturally. They kill without effort. Elves are also notorious marksmen with their bows and arrows. Tauriel, as head of the Guard of the Woodland Elves, would be no exception. One of the things I was always striving for in my archery was a sense of calm, deliberate movement. Any hunter, especially a sniper, can tell you that panic and frantic movements are your death. You won't make your mark.

Evangeline Lilly, Actress, Tauriel

Tauriel and Legolas were even more efficient in their movements than the best of the Elven soldiers in the army because we imagined them as elite fighters, while Thranduil was the best of the best.

Tauriel was fast, efficient and clean. Evangeline Lilly was surprisingly good but still feminine at the same time as being lethal. The thought behind giving her small knives was that she was so quick that she could react to an attack and take advantage of an opening to deliver her strike before the attacker had even completed their intended move. She would move in close and under their guard, making it difficult for them to use big weapons against her. Her specialty was moving in close to slice and stab, and getting back out again very quick and efficiently. She used a reverse grip on one of her blades so she could comfortably deliver cuts forward and behind, covering a wide area. It became her signature way of fighting.

We were always looking to create character moments for each of our heroes in their fights and ways in which their fights could be different. Even though we had seen her be incredibly deadly against other Orcs, Tauriel's final battle with Bolg didn't go her way at all. She had met her match and got slammed around pretty badly, which made the fight more interesting because she wasn't winning and it wasn't obvious to the audience what the outcome would be. She was trying to save Kili, but she could fail, she could lose, she could die, which meant that there was a real emotional stake in the fight.

Glenn Boswell, Stunt Co-ordinator

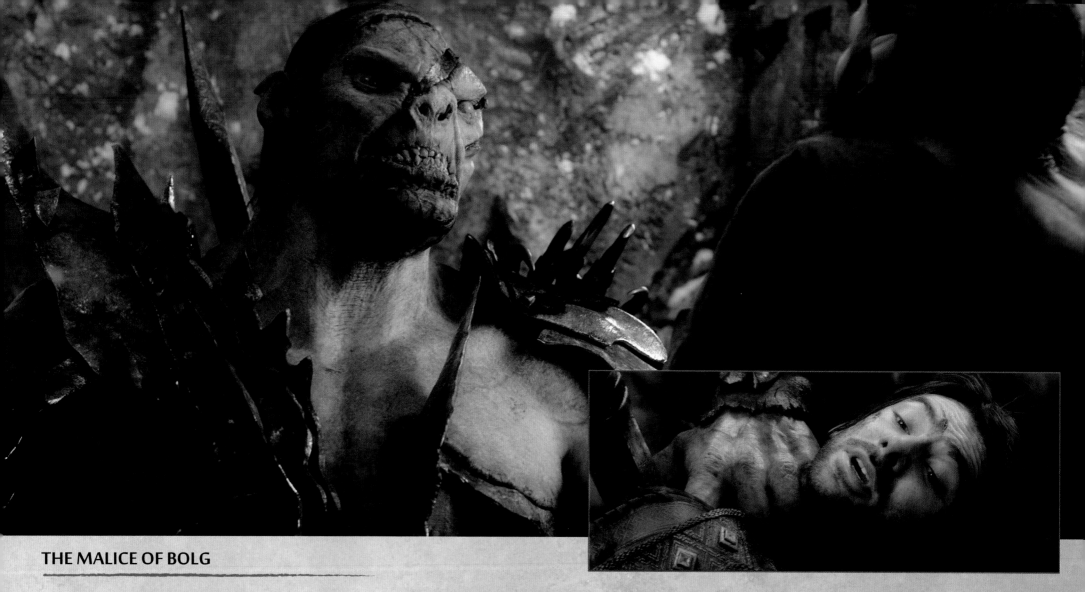

THE MALICE OF BOLG

Tauriel fought her way to Ravenhill in search of Kili, putting herself between the Dwarf and his would-be Orc killers. The fight did not go well for her, with Bolg killing Kili before her eyes and almost destroying her as well.

Compared to Azog and Thorin's climactic battle on the ice, the scrap between Bolg, Tauriel and Kili was more intimate and confined. The combat was limited to a smaller area with a lot of close hand-to-hand fighting. This was one of the ways we tried to keep it feeling very different to the other battles. Each one had to have its own flavour. This also played into Kili's slow death scene, which Tauriel, injured, was forced to watch.

R Christopher White, Weta Digital Visual Effects Supervisor

That fight was very brutal and taxing. Evangeline Lilly was incredible to work with: she had such a natural way of moving and was really into the fighting. The worst of the crashing and bashing was done by our Tauriel stunt double, Ingrid Kleinig, but Evangeline worked very hard. She was tough.

We worked hard to give Tauriel her match in this fight, and from the first hit we wanted it to be clear she was off her guard and hurting, so the stakes were high. She had been holding her own against the Orcs until she was surprised by Bolg while looking for Kili. From that point onward it had to look like she was in serious trouble, which would motivate Kili to come charging to help her and ending up getting himself killed.

We captured pretty much all of that live on the set, with lots of defenders, rams, pulleys and the Art Department's typical soft set, built to make the impacts easier on our performers. Nothing we asked of the Art Department was ever too hard for them and I can say the crew from that department on *The Hobbit* were amongst the finest I have ever had the pleasure of working with.

The fight ended with Tauriel, distraught at Kili's brutal death, taking Bolg with her over the edge of the cliff. That then led into Legolas fighting Bolg, who came off better in the fall.

Glenn Boswell, Stunt Co-ordinator

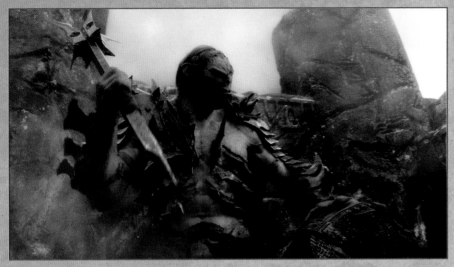

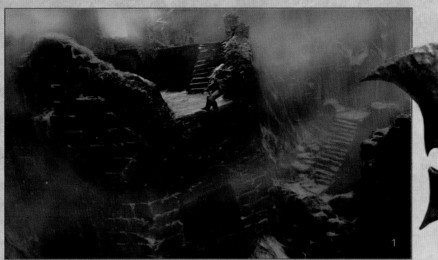

1. *Legolas versus Bolg fight visual effects concept art by Concept Art Director Alan Lee.* 2. *Digital reference turntable image of Bolg's mace.*

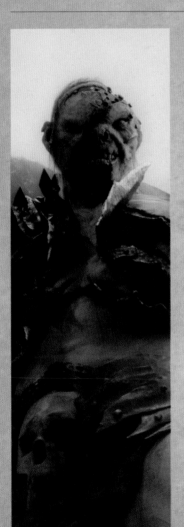

After a bad start in the match with Bolg Tauriel managed to claw her way back slightly by midway through, but was overwhelmed again by the end. The fight went through some changes as we worked on it. One of the biggest changes was when he first rushed her from behind, knocking her down. We had versions where he just pushed her against the stairs, but in the end Peter thought it would be most violent if he just did a jumping kick into her back. It's such a nasty thing to do, and so violent and powerful that it seemed exactly like the kind of attack Bolg would carry out.

Then, without any hesitation, he had grabbed her and was shoving and throwing her. In certain quick moments when we really wanted Tauriel to be impacted violently by Bolg's blows we either partially or wholly substituted a digital double.

The live-action material we started with was very well orchestrated. It was full of fast cuts and had plenty of energy. It was shot with Michael 'Big Mike' Homick playing Bolg. We animated over the top of Mike, juicing up his actions a little here and there to add more adrenalin or speed. We were careful not to inject too much speed into his animation for fear it would make him lose his weight and power, but it was important that he feel unpredictable and fast. Bolg was twice as large as Kili and half again Tauriel's size. They had to exist together believably in the same shots so there was only so fast he could be before it wouldn't look right, but fortunately it was turned over to us early and we had time to experiment and refine the sequence.

David Clayton, Weta Digital Animation Supervisor

Bolg's weapon in the third film was a new one and derived from the action he had to use it in. We had shots based on the live-action material that had been filmed, which established a certain type of thing. We knew how he had to kill Kili and we knew how he had to fight Legolas, so based on those requirements we came up with a fairly simple bladed mace on a long handle with a spike on the other end. It meant that when it came time to kill Kili, he could simply flip the mace around and use the spike end to impale him. It had all the weight of this massive mace and Bolg's own strength concentrated down into this brutal, simple tip. He was able to almost throw it, guide it through and let the weight do the work, which added to the cruelty of the act and the violence of the moment.

For a while we actually had the impaling last longer, with cuts back and forth between Kili and Tauriel, witnessing this, as Bolg continued to push it through. It was very uncomfortable to watch and, not surprisingly, too much for the film's rating! The longer death scene spoke more to Bolg's sadistic nature, but even the shorter version was still pretty horrible.

David Clayton, Weta Digital Animation Supervisor

My mum always joked that if I ever died on screen she wouldn't look. I used to brushed it off, 'Mum, it's just acting!' but after seeing Aidan die on screen, I was really affected. He was basically my best mate on the film. I know it was Kili and not Aidan Turner dying, but it was so hard to watch because of our friendship, and then seeing Thorin go as well, and even my own character's death, I was surprised how affected I was.

Dean O'Gorman, Actor, Fili

2

LEGOLAS

At the time I was first cast as Legolas I had just finished three years of drama school training. Movement was a very big part of my training. I had actually spent time during drama school studying the movement of lizards at the London Zoo and I saw the movement and physicality of Legolas as very important to creating the character. There was a description in the books of Legolas running across snow while the rest of the Fellowship had to dig their way through. That lightness of foot, agility, his awareness and ability to hear and see things before anybody else, led me to consider what animal he might be. I felt that there was a feline quality to my understanding of his movement; the ability to pounce or stop on a dime; the idea of him having eyes in the back of his head, always bristling, ready for anything. I had also been watching the Kurosawa classic *The Seven Samurai* and studied Noh Theater at drama school, both of which had an influence. The attitude and economy of movement that great samurai exhibit was something that became a very useful way into the character for me.

Orlando Bloom, Actor, Legolas

What I loved so much about the Battle of the Five Armies was that when these forces came together in the battle, they never imagined it would end the way that it did. They couldn't have imagined how large it was going to become, that so many would lose their lives, how out of control it would become, so quickly. The battle reformed them into something new, changed and impacted the lives of everyone who was involved so that they would never be the same again. Alliances were forged and grudges were forgotten. Elves, Men, Dwarves – some lost their lives, including meaningful characters whose deaths had profound, lasting consequences, but even those who survived were forever changed.

That is what happened to Legolas and Thranduil. The king saw his son for the first time as a warrior, an Elf who had his own path to follow, who would leave the kingdom to travel into the world and make the difference he has it within him to make.

Thranduil fought in great battles in the past. He stood against the enemy with the rest of his people ages ago. Now Legolas would take that mantle forward. I think the Elven-king looked upon his son with incredible pride as well as sadness, because in him there would always be the reminder of the love he lost, Legolas's mother. Their parting was a very full scene, full of very complicated emotions, the father acknowledging his son and also letting him go, knowing it was time for him to go off into the world, to make his own choices and to fulfil his destiny.

When Thranduil was talking to Legolas about Aragorn, he believed there was greatness in that direction and he was encouraging Legolas to follow it, to match it, to go and live in service to Middle-earth, embracing its dangers and to actively fight the growing evil in a way that Thranduil hadn't in recent times. I think he understands that Aragorn's emergence might hold the possibility of good things to come.

Thranduil's isolationist policy might be motivated by loss, but I think it also had to do with obligation. Thranduil was responsible for keeping his people safe in the Third Age. The time of Men was coming. A shift was happening in the world and Thranduil wanted to keep his Elves safe. He was able to do that by closing his doors to the dangerous forest on his doorstep, by literally going underground, locking his gates and sitting safety, drinking wine with his Elves, everyone safe and enjoying their immortality in peace. I think he looked back at the great Elven kingdoms of the First Age when the Elves locked themselves away to avoid engaging with a world that had become hostile or strange to them. He was part of that time and lived among the great Elves of the past, so he recreated their way of life and their secret, underground, guarded realms. That way of dealing with the world lived on in the Woodland Realm. Thranduil was preserving it for as long as he could, holding on as the memory of that time faded.

The Battle of the Five Armies, what Legolas did and all those who died fundamentally changed Thranduil and opened his eyes to reengaging with the world again.

Lee Pace, Actor, Thranduil

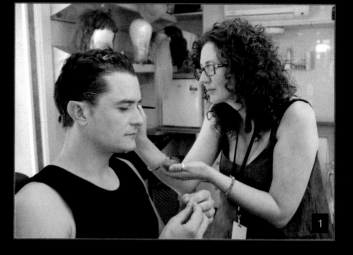

We had new contact lenses for Legolas in these films. Orlando Bloom has brown eyes but Legolas had to have pale blue irises, so he wore lenses in the first trilogy and again in these films. This time around they were a little brighter in hue in order to compensate for the colour sucking tendencies of the new cameras. In every other measurable way, his make-up and hair was the same as it was a decade earlier, and for us it was so lovely to see him back!

Peter King, Make-up & Hair Designer

1. Additional Make-up Artist Nancy Hennah assists Orlando Bloom in the make-up chair.
2. Studio photography of Orlando Bloom in make-up and costume as Legolas.
3. Weta Workshop Master Swordsmith Peter Lyon shapes the blade of Orcrist on the linishing machine.
4. The pommel of Orcrist featured four small crystals.
5. Detail of Legolas's saddle harness metalwork.
6-7. Legolas's saddle (6) and detail (7).
8-9. Legolas's sword, unused in the final film, including detail of hilt (8).
10. Orcrist.

I designed a new sword for Legolas, based on the design of the paired white knives he had carried in all of the films. It was a beautiful prop, but the decision was made to give him Orcrist instead, which made total sense for the story, so the new weapon was never used.

Daniel Falconer, Weta Workshop Designer

Orcrist was a fantastic new addition to Legolas's weaponry. It played an important role and was a story point between him and Thorin in *The Hobbit*. Legolas reclaimed the Elven blade from the Dwarf on their first encounter, only to return it to him in his moment of need in the third movie. It is always fun to play with a new tool, and Orcrist was a beautiful weapon.

Orlando Bloom, Actor, Legolas

I was thrilled to see Legolas return Orcrist to Thorin. That was an extraordinary weapon in action and some of my favourite of Thorin's fight moments were from the final film. Richard Taylor had a vision for that scene from the first moment he and his team conceived the blade and it was a privilege to be part of his work in action.

Richard Armitage, Actor, Thorin

In their fights, Legolas and Thorin both used Orcrist, the ancient Elvish sword that Thorin found in the Trolls' cave back in the first film of the trilogy. The difference in size between the two characters meant they wielded the same sword in different ways. Thorin was very good with it, but because it was built for someone Legolas's height we felt Legolas would be faster with it. For Thorin it was slower to lift and just slightly more cumbersome, while Legolas was very much at home with what was always an Elvish blade. Of course, when Legolas probably wants it the most, in his fight with Bolg, he doesn't have it, which was a great character moment. He had chosen to throw it to Thorin, so instead he had to use his knives and his wits to defeat the big Orc.

Glenn Boswell, Stunt Co-ordinator

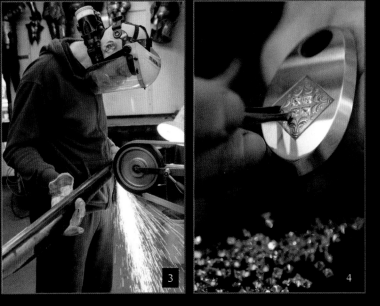

3

4

Like everything else, the Elves had their own particular style of saddles. Everything on an Elven saddle was decorated with curving, intricate lines. Even the stirrups had characteristic Elven tracery. Legolas and Thranduil both had their own, unique saddle designs.

Tim Abbot, Saddle Maker

5

6

7

8

9

10

STUMPY THE TROLL

The Legolas and Bolg fight was set up by Legolas first needing to bridge the rocky gap in front of the frozen waterfall. He was out of arrows and had to save Tauriel from Bolg, so he needed a new plan. Enter Stumpy, the blind, quadruple-amputee, albino Troll…

Stumpy's demise at the base of the tower was entirely key-framed animation. That Troll was a lot of fun because it was clear from his design that he had a history to him, which added to the texture and depth of Middle-earth.

It was fun animating Stumpy. Apart from his initial whaling on the tower before Legolas leapt down on him, he was basically dead throughout all of his Ravenhill action. Peter wanted Legolas's sword to go through his brain and kill him instantly, but that before he expired we had a few moments when his body was operating on the last impulses sent from his presumably tiny brain, which enabled Legolas to steer him with his sword, plodding peg-legged, combined with falling forward to smash into and knock down the tower. He had to hit it hard enough to knock it over, but not so hard that it was inconceivable that Legolas could have survived, and we had to get the sword out in a nice, clean action at the same time. That was a bit of a juggle, but fun, trying to make sure Legolas came out looking cool.

David Clayton, Weta Digital Animation Supervisor

Stumpy was designed to have a little Orc rider perched in a saddle on his shoulders steering him with chains. James Nesbitt's Dwarf, Bofur, had his moment to shine in the battle when he climbed up and seized control of Stumpy's reins. The blind Troll had no idea who he was fighting and obligingly flailed his spiked mace ends, causing havoc.

Balin's chariot was in danger from an armoured Battle Troll with huge blades on his arms and was forced onto the surface of the frozen river. The Troll gave chase in a great sequence with some exciting and dynamic camera angles. Witnessing all this, Bofur steered Stumpy to take out the pursuing Battle Troll and save his friends on the war chariot.

Matt Aitken, Weta Digital Visual Effects Supervisor

I think, watching him, you really feel kind of sorry for Stumpy, because he had no arms and legs except these horrible weapons and his eyes were sewn shut, so he couldn't see. The whole time we saw him he was being jerked around by someone. Stumpy probably didn't even know where he was. Peter wanted him to be a character that we had mixed feelings about. He was a bit revolting but Peter thought we should also feel a bit sad for him, like that very first Cave Troll in *The Lord of the Rings*.

Marco Revelant, Weta Digital Models Supervisor

Going back to do more capture work on Stumpy for the extended edition, not having performed him for some time, I used various tricks to help trigger my muscle memory, like walking with sandbags, weighing down my feet or locking my knees. These physical triggers remind me of what it felt like to be that character. Of course, actually performing the capture with fifteen-kilogram sandbags in each hand wouldn't be practical; but it was a helpful prompt to get me back into Stumpy mode.

Stumpy was one of the characters to require a very delicate approach because he had such specific and challenging characteristics. We had to be very aware of the limits of his physicality; he was completely blind, led around by an Orc strapped to the back of his head, forearms replaced with chains with morning stars for hands, and prosthetic steel legs with spiked wrecking balls for feet, plus he weighed tonnes! Stumpy was a huge creature. Even though he was a completely fictional character, we strived to ground his actions with a believable performance that would stay true to the physical limitations imposed upon him.

When I could, and especially with the lead characters, I would re-watch live-action clips to familiarize myself with a character's particular movement style as it was essential that the motion capture reflected the creative choices and efforts the actors put into establishing their characters. I sought to honour the work they had done so there was no jarring transitions to any digital versions of their character. I would find footage and watch it over and over, paying attention to things like gait, how a character held himself or how they conveyed their intentions.

Some characters were easier to find than others. Because during live-action shooting I stunt-doubled Oin, played by John Callen, it was always easier for me to find that character again. I'm also told I made a good Tauriel, while Bilbo however required more focus; Martin Freeman had a very unique way of presenting and holding himself and had such a distinctive walk.

Isaac Hamon,
Stunt Performer / Motion Capture Performance Coordinator

1. Concept art for Stumpy's flail ends by Concept Art Director John Howe.
2. Stumpy digital reference turntable image.

THE FALL OF BOLG

The second and final square-off between Legolas and Bolg was staged upon the crumbling remains of a tower straddling Ravenhill's frozen waterfall. The action had been blocked out early on and Peter shot Orlando Bloom according to that plan on a green-screen stage without any set elements. The collapsing tower on which they would fight, like Bolg himself, would be entirely digital. On the green screen stage Orlando had a stunt performer in a green-screen suit playing the part of Bolg, whom he could react to and fight organically. Orlando's performance then determined our timings for Bolg, who we key-frame animated to meet his blows and provide motivation for Legolas's dodges and jumps. It sounds simple, right? How it actually all happened was significantly more complex and took months!

Matt Aitken, Weta Digital Visual Effects Supervisor

1-2. *Master scene animation of the Ravenhill tower collapse with a diagnostic camera angle. The framing is for reference rather than intended for any specific shot, which Peter would choose later.*

The concept behind the fight between Legolas and Bolg was that the Elf would use his speed and agility to get around on the collapsing structure and make it as difficult as possible for Bolg, who was bigger and heavier. Peter wanted it to be collapsing out from underneath them while they were fighting.

Beginning with a conversation I had with Peter about what he had in mind, we went away and built a basic bridge-like structure in our stunt workshop area. We explored the broad strokes of how Legolas and Bolg's final battle would play out on our rough mock-up. My main concern was understanding what the story of the fight was, what it needed to say at different times in the fight, who was winning, who was losing, when, why and how. We plotted it out on the flat to start with and then walked through the motions on our makeshift bridge, figuring out action that would happen at different levels, what the falls were, and trying to create a blueprint for each character's movements.

We shot what we had come up with on video and I talked Peter through it, then went away to incorporate his notes, reshoot the new choreography and return the next day to show it to him again. Once we had done this a few times we locked down the action in more detail, including figuring out exactly what we would need to build on our stage to properly film the fight with all its movement between levels, things collapsing and the falls.

During the fight, parts of the structure they were on would be reacting, breaking away and crumbling beneath them, so it wasn't as simple as fighting on a flat surface, but far more interesting. It meant we had to be clever in figuring out what we had to build and how we could shoot it. How much would be shot on the set with Orlando Bloom and the main shooting crew? How much would we do back on the mocap stage and what set or prop pieces would we need the Art Department

to build? It was important that we got that bit right so that the Visual Effects team had everything they needed as far as interactions between our performers, the set and all the many digital elements they would later add.

Legolas had his own style, with typically Elven flips where he would go under or over, while Bolg was tough, heavy and brutal. We knew all about Legolas from the previous trilogy, so we worked with what had been established as his fighting style and looked at making him even more efficient in his movements. We walked Orlando through the choreography, breaking the fight into three or four stages so it was manageable and easy for everyone to follow, then we got into the training with him.

Michael 'Big Mike' Homick was our lead Orc. An ex-basketball player, Mike is something in the range of 6'8" or 6'9" in height and very agile, so he approximated Bolg's physical presence very well and was a great performer. Mike performed many of our big Orcs.

The Art Department built the final chunks of green-screen tower that we would shoot on in pieces. It was like a giant, bright green building set. I had broken the fight into four or five sections and we rebuilt our green obstacle courses to represent the structure as it was during those stages of the fight and in those places. We kept the whole thing quite close to the floor for safety purposes. Orlando Bloom spent many days running around on those green courses!

Due to the sheer complexity of all the elements, with the crumbling platform and changing levels, this proved to be an exceptional fight for us to produce. The fights weren't always as involved or time-consuming as this one, thank goodness!

Glenn Boswell, Stunt Co-ordinator

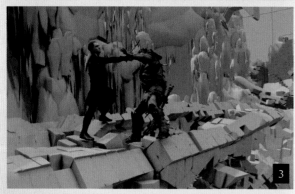

The concept had been established, some previs had been generated and Peter had shot live-action material with Orlando Bloom as Legolas fighting Big Mike on the tower, but there were some big gaps between what existed and what Peter wanted that action to be. We received a preliminary version of the live-action sequence and our animators roughly rotomated what Legolas and Bolg's stunt stand-ins were doing so that we had an approximation of their action in animated form. We then generated a CG version of the sequence that mapped out the entire fight and ran for about a minute, filling in all the gaps in the coverage.

Peter reviewed this master scene file and specified important things like how the tower should fall, how long it should take and how it should wedge itself into the frozen waterfall environment, at which point Bolg should jump onto it, what the rate of structural decay was as they were fighting or how often big blocks were falling loose. Tweaking the master scene file, we could answer all of these questions and adjust the environment design as necessary to accommodate what Peter needed. We made sure that the tower was feeling precarious enough and that there was stuff falling off frequently enough throughout the fight, but without eroding it to a skeleton of a building too soon for it to sustain its position. Questions about the choreography of the fight itself were also answered by working through the master file. It took months because there was so much to work through, but once it was done it was our blueprint for the scene.

David Clayton, Weta Digital Animation Supervisor

To get around having to work with a digital environment that was built with every single block as a separate element, we divided the tower's state of collapse into six stages so that it could collapse as Legolas and Bolg fought. Each stage began with a solid tower model, plus whichever blocks were going to fall away in that portion of the sequence. We might, for example, begin a stage of the sequence with a chunk of tower and end it with ten per cent having fallen away. Only those blocks that had to fall away in that stage were split out as individual objects, the rest of the tower being a single, solid model. For the next stage, we would start with a smaller tower and replace the subtracted portion with a new bunch of loose blocks split out to fall away. This approach meant the number of assets we were dealing with at any one time was much more manageable.

Matt Aitken, Weta Digital Visual Effects Supervisor

It's amazing what reference exists when you go looking for it. For example, we found video of a big skinny building being felled with a detonation at its base that fell almost exactly how we needed our tower to collapse; though it didn't hold together quite as well as ours did, a conceit made to service the needs of the script in our case. When making our films we looked at the reference in order to ground ourselves in reality, but we weren't recreating reality in some kind of documentary, so there was license to depart from what we saw for the sake of a cinematic event. We are in the business of creating wow factor, so while we embrace realism, we also push the boundaries for spectacle and fun.

Breaking the collapse into six stages allowed multiple animators to be working on it at once. Once the design of the tower was fairly locked down we were able to get quite refined in our animation. Then we sent each stage to Peter, as it was done, to shoot on the stage with his virtual cameras, giving him the freedom to shot the action however he wanted. Everything he shot went straight to Editorial for him to edit into his sequence along with the live-action material he had already filmed. The result was a complex sequence of shots, both live-action and CG, but all shot through Peter's cameras in his style.

Once he was happy he would turn the shots back over to us and we could grab his tracked camera data from the mocap stage and use that to finesse each shot, refining our animation, shot by shot, with full awareness of the camera and cut.

This system of creating a master scene file has been a really good process for developing the animation. It frontloads our work and allows us to get a sense of the entire scene. We can block out the action thoroughly, so when the shots come back to us we just need to refine what appears in camera, and it keeps Peter in complete creative control of how he wants to shoot.

David Clayton, Weta Digital Animation Supervisor

1-4, 7-11. Views of master animation for the Ravenhill duel between Legolas and Bolg, Stage 4 (1-4), and Stage 6 (7-11) in the multi-stage breakdown of the fight.

The entire sequence was technically intricate. There was a lot of Models Department work, and the animators were blocking in dynamic motion on the blocks that were falling so that Pete could review and approve it. Those pieces were being published to our FX Department. Secondary chunks of rock were coming off in little explosions as Bolg's mace impacted with the stonework and being worked in by our FX Department as a simulation. Then there was also snow falling and the frozen waterfall as a backdrop, which was quite expensive to render because of its translucency.

Matt Aitken, Weta Digital Visual Effects Supervisor

When Legolas fought Bolg for the first time in the previous film the big brute of an Orc had actually landed some blows on Legolas and drawn blood. We wanted to drive home the idea that this was a new experience for Legolas. It was actually difficult for him, which helped show how dangerous Bolg was and set up their final fight on the collapsing tower in the third film. There were intentional links that we designed into the choreography of those fights. Legolas pulled a stunt on Bolg that eventually led to the Orc's demise, flipping around to land on Bolg's shoulder, delivering a blow and somersaulting off. It was a trick move that Bolg used against him in their alleyway fight of the previous film that resulted in Legolas being thrown against the wall. This time Legolas switched the tables and it proved to be the decisive move of their scrap.

Glenn Boswell, Stunt Co-ordinator

The remains of the tower finally gave way and fell with Bolg to smash on the ice and rocks below. We originally had it disintegrating into lots of individual bricks, but Peter had us reinstate larger chunks because he wanted to concentrate attention on Bolg being taken out by the chunk that satisfyingly squashed his body.

Matt Aitken, Weta Digital Visual Effects Supervisor

5-6. Concept art by Concept Art Director Alan Lee.

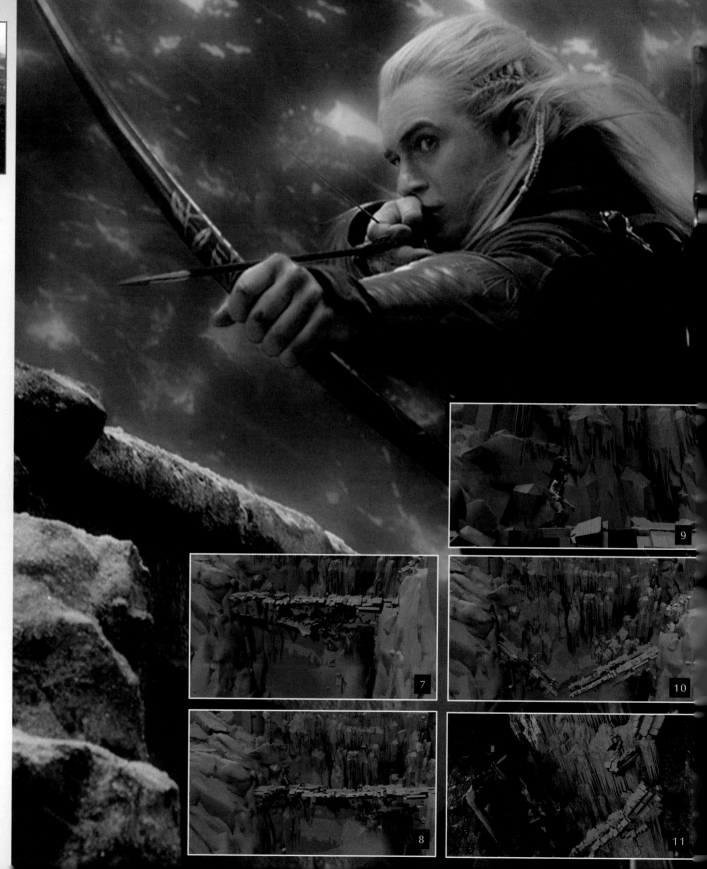

ICE & STEEL

The Previs team was asked to come up with ideas for Azog and Thorin's climactic fight. This was the big battle that would close both their story arcs. We were asked to offer up different ways in which they could fight, including different staging options and ways for them to injure each other. There were all kinds of ideas thrown in. The ice lake presented some opportunities, including one idea which had Thorin going underwater and coming up under an old ship that was stuck in the ice.

However, we knew that it really couldn't be a big fight. It was a one-on-one slug fest. We could come up with wild ideas, like them climbing onto a Troll and all kinds of other silliness, but that would ultimately just have been distracting from what the heart of what this fight was about.

Jamie Beard, Weta Digital Previs & Animation Supervisor

That fight had to come down to looking into your enemy's eyes as his life left them. You couldn't have Azog and Thorin fighting on Eagles. It had to be intimate and brutal, two guys smashing each other until one or both were dead.

Randy Link, Weta Digital Previs Supervisor

The script was very vague in terms of the details of Azog and Thorin's fight, which gave us great latitude. I started out by investigating what terrain had been designed to understand which parts were frozen ice and which were ruins. We had the big size difference between the characters to think about, too. There were lots of other fights happening in the same general location at around the same time, so I wanted to try and keep them each as different as possible. I figured we could have the fight spill down levels, and another idea that was tabled was to change Azog's weapon. I thought he could grab some nasty piece of the ruin to use against Thorin, which led to the chain and stone.

We had to create a disadvantage for Azog, because he was such a big fella. The best way to achieve that was to unbalance him, which led to having him on the ice and it breaking. I presented ideas to Peter and he put them together with his own, which gave us some solid direction for the fight choreography.

We had a pretty solid fight amid the ruins. We had Thorin on the back foot all the time because we didn't want to make it easy for him. By the time he was down on the ice things were going badly and we had all the other Orc Berserkers rushing in to have their go at him. Orlando Bloom's Legolas narrowly saved him by throwing Orcrist. The sword went flying to impale the Orc that was about to kill Thorin, which was great because it got the famous sword back into his hands, where it belonged, for the end of the duel.

Glenn Boswell, Stunt Co-ordinator

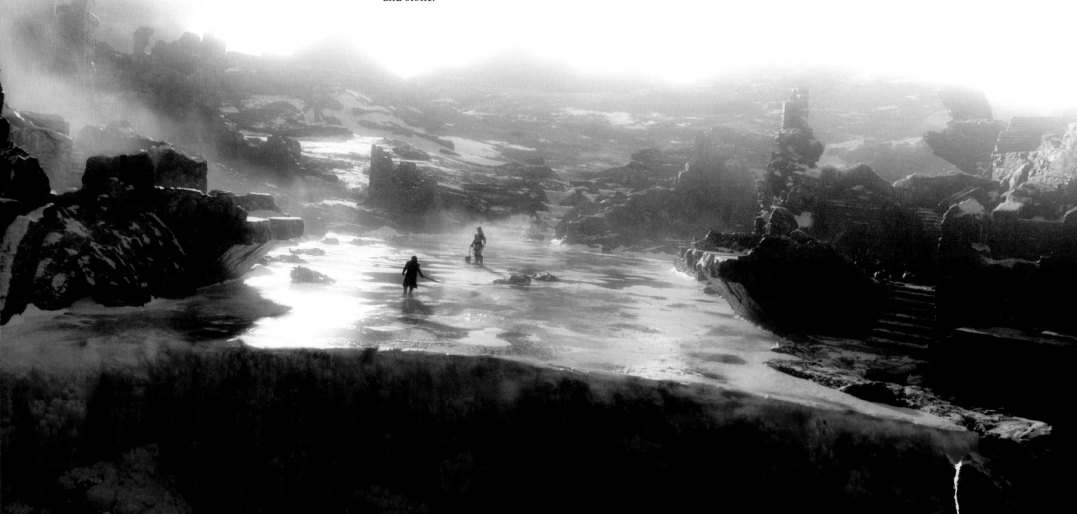

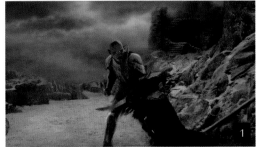

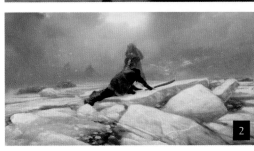

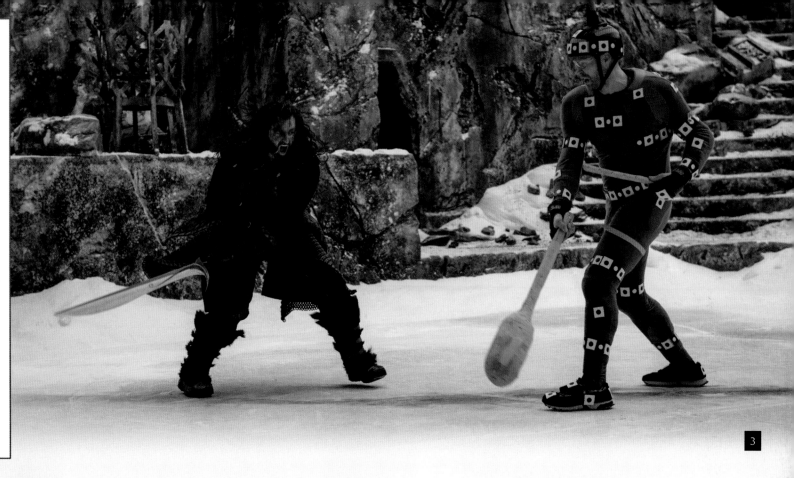

The ice beginning to shatter around them with all of Azog's wild blows was the opportunity for us to show that Thorin was using his brain to help turn the odds to his advantage. On the set we worked with the Art Department to build an ice gimbal that we could film the characters on and get some good reactions to the unstable surface.

At the end of that sequence Thorin threw the rock to Azog and jumped back, letting the ice sheet tip the shocked Orc beneath the surface of the lake. I remember when that idea was brought up, Peter really liked it, and then he said, 'Well, what happens if we have Thorin follow Azog, who is drifting under the ice, and then all of a sudden Azog stabs him in the foot, through the ice, and then smashes through?'

Then the thought was, we still need to come up with a way to kill Azog and yet leave Thorin with a fatal injury, because it was important that he live long enough to have his final moment of reconciliation with Bilbo. I had the thought, 'What if Thorin is using his weapon to block Azog, but Azog's strength and weight was so great that Thorin realized his impalement was imminent?' At that point he'd have to make a choice, which is great because it made it a character moment again. Thorin chose to withdraw his weapon and let Azog stab him, knowing

that then his sword would be free to deliver the killing blow to the Orc. It would surprise Azog, who was busy delighting in his victory and never saw it coming, but it also mean that Thorin was sacrificing himself. Peter signed off on it and we were on our way.

I handed the fight to one of our stunt guys, Steven Davis, who was very good at coming up with details. I described the structure of it and how I wanted it to go. Steven embellished it with his details and we went through it again, adjusting the crucial beats as necessary so that it told an interesting enough story with the advantage and danger shifting throughout.

In some of our wide shots Thorin was played by a 5'2" scale double, while Michael Homick, who was our 6'9" stunt double, made a pretty impressive Azog. We even accentuated Michael with a noodle on his head to provide Thorin with a higher eye line. Michael, of course, would be entirely replaced by the digital Azog, but it was crucial on set that the characters' respective heights were born in mind because it affected the angles of their strikes. If Thorin was trying to behead Azog, for example, he had to aim high, hence the noodle to give Thorin a point to aim for and get that blow going in the right direction.

The wide shots actually worked out very well. Even though Thorin was supposed to be a Dwarf and Richard Armitage was actually over six feet in height, shooting past 'Big Mike' and cheating the angles, we were even able to use Richard in the same shot. The way Peter and his Director of Photography, Andrew Lesnie, shot it, the size gag worked. This sequence was among the last filmed and by this time everyone on the production was very familiar with the scale issue and how to best achieve it. There were multiple versions of weapons at different scales, for example, which could be confusing earlier on the project, but by this time everyone had it down.

Manu Bennett wasn't there on the set when this stuff was shot, but he came in for his motion capture and dialogue work towards the end. There was a six-week, intense motion-capture block and this was some of the last material to be covered on the mocap stage.

Glenn Boswell, Stunt Co-ordinator

1-2. Concept art by Concept Art Director Alan Lee.
3. Richard Armitage and Stunt Performer Michael Homick fight on the Ravenhill set.

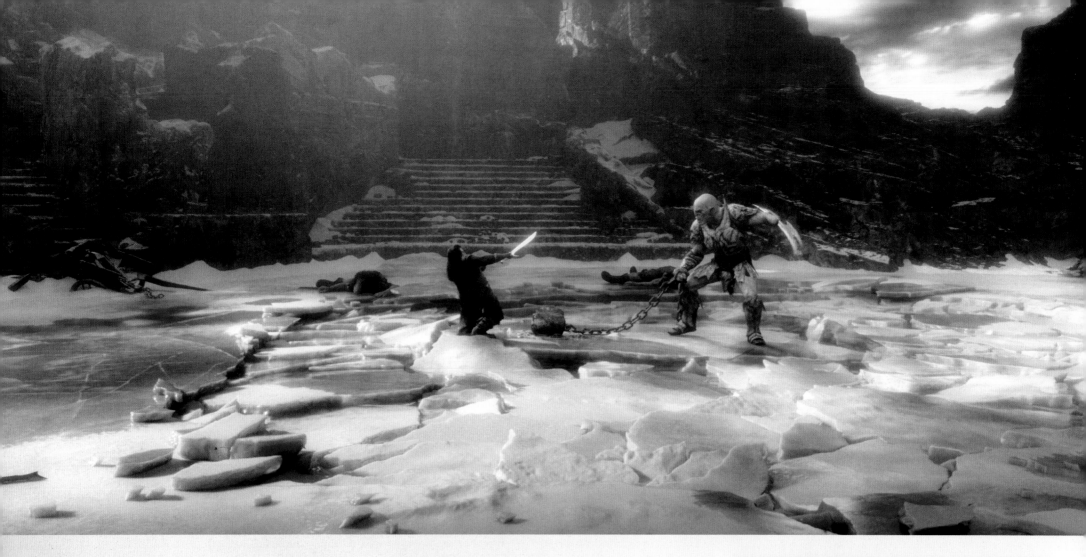

Much of the Azog and Thorin duel became entirely digital as a result of the complexities of that fight – the scale difference, the ice, the weapons – it was a very difficult thing to shoot live. On the set there was a hydraulic structure intended to simulate the tilt and sway of the ice slab Thorin and Azog found themselves on. Peter had a very specific timeline in mind that played out across each shot in the sequence, telling the story of how the ice cracked and would eventually form the ring around them, creating an island of ice that Thorin exploited. The live-action shots were sometimes at odds with this, so we rebuilt and reordered a lot of the shots in the sequence. That process included shooting a fresh round of motion-capture with Peter to get some of the new material that we needed.

It was important that we all understood how and when the ice broke, how far it travelled, how large it was compared to the little lake it was sitting in and how it all related to the action, so we generated some previs for internal reference purposes.

One of the tricky bits we encountered was the block-and-chain weapon that Azog swung. We had several of different weight and design. The heaviest was 4.5 kilograms. Manu Bennett swung that two or three times and was done. I tried it myself and it was insanely heavy; it just wasn't practical. There was a 2.5 kilogram version that could be swung perhaps a dozen times before you felt as if your arm would fall off, and there was a half-kilogram version that was a segmented plastic rod with a little weight at the end.

The design that proved the most useful was a one-kilogram sandbag on a rope; heavy enough to provide a sense of resistance but, with the sandbag end, it didn't bounce all over the place when it landed. The blocks tended to land on a corner and bounce off, which fed back and stimulated motion in the wielder's body that we didn't want.

Aaron Gilman, Weta Digital Animation Supervisor

1. *Shooting a portion of the battle using the green screen gimbal ice sheet set up.*

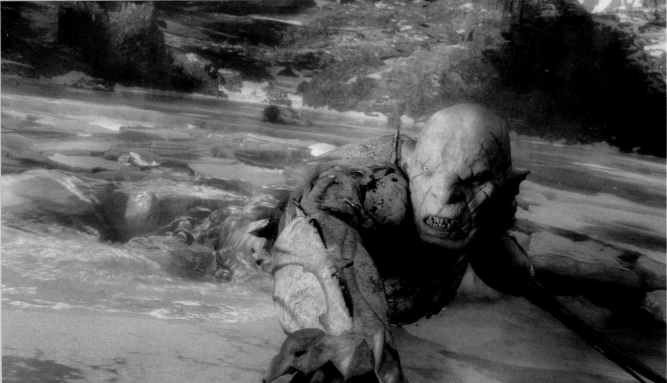

Another complication was presented by the ice Thorin and Azog were on, meaning they needed to slip. We came up with a way to simulate slips on the motion capture stage by strapping a kind of mock roller skate, made of ball-bearings and a wooden pad, to one of the performer's feet. It was resistant enough that they could walk on it by applying careful pressure, but could also generate a good slide. We used this for a few shots including some beyond the Azog and Thorin sequence, when Legolas was shooting Orc Berserkers charging across the frozen lake.

I wanted to try to avoid key-frame animating Azog and Thorin's slips, because that isn't simply a case of shifting a foot. A true slide affects the hips, torso and everything, so to keep that looking convincing we tried to get as much information as possible from the motion capture stage. It is certainly possible to key frame it, but a lot more work, and we already had plenty of that!

We went to the live-action shoot for Thorin's hero shots, but much of the wider action was accomplished with a motion-captured performer, as was Azog. Motion-capture is a wonderful tool for specific things, like naturalistic humanoid motion. We would be crazy not to use it when available, but it also has limitations. It gives an animator a lot, but there is a limit to how much you can manipulate it in response to a client's creative notes. Captured motion that has been altered has a breaking point where it starts to look keyed and the integrity of the performance has been lost. It is easy to lose things like weight or power once you begin messing with the motion too much. You reach a certain point at which it would be better to go back and reshoot it again on the stage with new direction.

Fortunately, striking that balance is something the artists at Weta Digital have become very good at. The key framing/motion-capture relationship at Weta is constant, in the sense that we almost never plug motion-capture into a shot and call it done; motion always goes through our key-frame artists. Whether it's adding more power or energy, or subtracting it, some modification is inevitable and there are always creative decisions to be made. Sometimes the modifications remain with our dedicated motion-capture artists while other times our key-frame animators will work on it. Conversely, we also frequently create animation that is entirely key-framed with no motion-capture input at all. Though we had reference of Manu Bennett jumping, which was incredibly helpful and we tried to preserve the character in his posing, Azog jumping out of the ice was an example of a purely key-framed action in that fight.

Aaron Gilman, Weta Digital Animation Supervisor

2. Concept art by Concept Art Director Alan Lee.
3-4. Face cam footage of Manu Bennett being performance captured (3) is used to derive a foundation for the facial performance, seen here applied to the animation model of Azog (4).
5. The motion capture stage set up for capturing Azog's slide into the ice in the same shot.

We really wanted the environment to have an effect on the battle between Azog and Thorin. The forces of the wind and snow were felt strongest in their battle as it began higher up on Ravenhill. They added to the energy of the fight. As the fight continued and spilled out onto the frozen lake we used the break-up and movement of the ice to help define the progression and increasingly precarious nature of their battle. For the audience to understand how Thorin finally outsmarted Azog and tipped him under the water we needed to make sure that the story of the ice's breaking was shown clearly throughout the battle.

R Christopher White, Weta Digital Visual Effects Supervisor

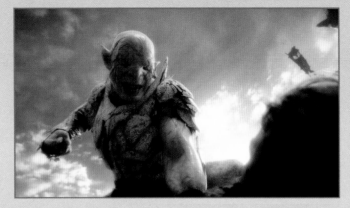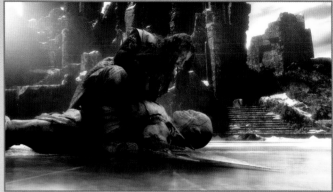

The ice was a beautiful, stark environment to stage the fight in; offering opportunities to contrast blood and ice, the way it could break and move, the water current beneath it, the clarity of it in places, and the kind of camera moves that the environment permitted.

Jamie Beard, Weta Digital Previs & Animation Supervisor

"He stood alone against this terrible foe, his armour rent ..."

- *BALIN: AN UNEXPECTED JOURNEY*

The battle concluded with Azog's blood staining the waterfall black. I worked on the previs animation to illustrate that idea, which was something Peter really wanted to see. I put something like seventeen times the volume of blood in it that could possibly fit in Azog's body. It was being reviewed in the dailies and Joe Letteri, Weta Digital's Senior Visual Effects Supervisor, remarked, 'Uh, that's a lot of blood.' If I had my way it would have been shooting out like a volcano! I know I went too big, but sometimes you have to do that with an idea to help it gain traction; it can always be dialled back later. Sometimes in a room full of people and ideas you have to shout an idea at the top of your lungs to be heard (figuratively, of course). If we'd begun that shot with the right amount of blood it might never have been noticed and made it through.

Randy Link, Weta Digital Previs Supervisor

A lot of effort and thought goes into designing eyes for characters and creatures. We were thinking about how Azog's eyes would read against his skin, and it wasn't just the colour of his irises. His sclera ended up very blood-shot, which made the pale blue stand out even more and helped him feel unique amongst all the other Orcs.

The sequence in which Azog went under the ice was something we looked at closely. Daniel Bennett would always help me out with this sort of thing; doing physical tests to create reference material for the Effects guys. Dan printed out a picture of Azog and photographed it under a slab of ice to see how the light transmitted through the cracks and fractures. It was very interesting to see how that would look and how much of him was visible, including how clearly you could read his eyes.

**Gino Acevedo,
Weta Digital Textures Supervisor/Creative Art Director**

There was some concern that the black blood staining the ice waterfall might be ambiguous or that audiences might not know what it was. Fortunately that appears to have been unfounded. From the screenings I have attended, and in talking with people who saw the film, the audience picked up on it immediately and reacted really well to it.

R Christopher White, Weta Digital visual Effects Supervisor

1-2. Frames of previs animation depicting Azog's black blood, seen from under the ice (1) and staining the ice falls (2).

3. Hero render of digital cracked ice.

3

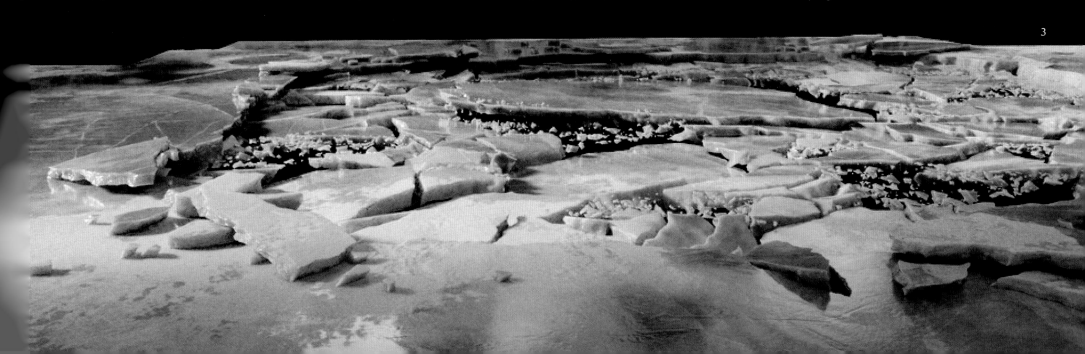

BEORN

Peter's brief regarding Beorn's make-up and hair was to create something that wasn't simply human, but integrated some animalistic qualities, because the character was a shape-shifter. We imagined that Beorn's hair could have a nonhuman texture and Peter suggested we try using horse hair, which is thicker and coarser. We sourced some and I dyed it different shades, including even some surprising colours, like pale blue or yellow, to achieve the coolness that I wanted in his mane. I then mixed the different coloured hairs together into a wig that was a combination of many hues, just as people's heads of hair are in real life. Variation and layering of colours is what gives hair life and interest.

The wig itself was made in-house. Horse hair can't be knotted, which is a traditional way of creating wigs, so instead it had to be woven. Each of his wigs took thirty metres of weft.

We had all sorts of drawings that suggested different ways of going, but in the end the hair design was defined on the actor, in the make-up chair. We decided to give Beorn something like a coxcomb that was like a ridge of hair extending all the way down his back when he was shirtless, evoking an animalistic quality. We intentionally avoided the kind of flowing-haired mountain man look, not wanting to make him look like a trapper or hillbilly; Beorn had to seem like he was part of the animal kingdom rather than someone who was living off it. The final character of his mane was almost wiry or bristly, like a hog's back.

The concept behind Beorn's eyes went back and forth – would he have blue eyes as a man which then translated across to his bear form, or would he have brown, bear eyes as a beast that were imported into his humanoid form? This latter was the way it ended up in the final film, thanks to digital manipulation, though when we shot him it was the former. Either way, the eyes were a chance to link his two forms and it was always the plan that they would be the one consistent element when he changed.

We tried some large fake teeth to begin with, but they really were too large and bestial, and would have been a problem for him to talk with. A little exaggeration can go a very long way when it comes to teeth, so it didn't need to be extreme.

Peter King, Make-up & Hair Designer

Beorn had a quality to him that was all about depth and gravitas. He could never be forward or project himself. He had depth and drew back into himself so that his voice felt like it was coming from somewhere deep inside his body.

Terry Notary, Movement Coach

Mikael Persbrandt brought his native Swedish vocal qualities to Beorn. His was the only accent in all the films not rooted in the British Isles. I thought it was both exciting to have a novel acoustic blend in the mix and also very fitting for the character. Beorn stood apart from the other races of Middle-earth, the last of his kind, hailing from a region that we hadn't visited before in the films.

Leith McPherson, Dialect Coach

Though he used an appropriately simple (if huge) axe made by the Art Department for his wood-chopping scene in the second film, we made a huge battle axe for Beorn at Weta Workshop. There was a chance that it might be used in the chopping scene, so we built a very heavy version which had an armature inside it and 30mm of steel along the edge for practical in-camera chopping. It was a monster of a weapon, but we never ended up seeing it in the films as whenever he was fighting he was in bear mode.

Alex Falkner,
Weta Workshop Props Model making Supervisor

1. Unused Beorn's battle axe prop.
2-3. Beorn's wood splitting axe, including axe head detail (3).
4. Set dressing from Beorn's home, including axes and other tools.
5. Mikael Persbrandt as Beorn.
6. Concept art of Beorn's eyes by Weta Digital Textures Supervisor/Creative Art Director Gino Acevedo.

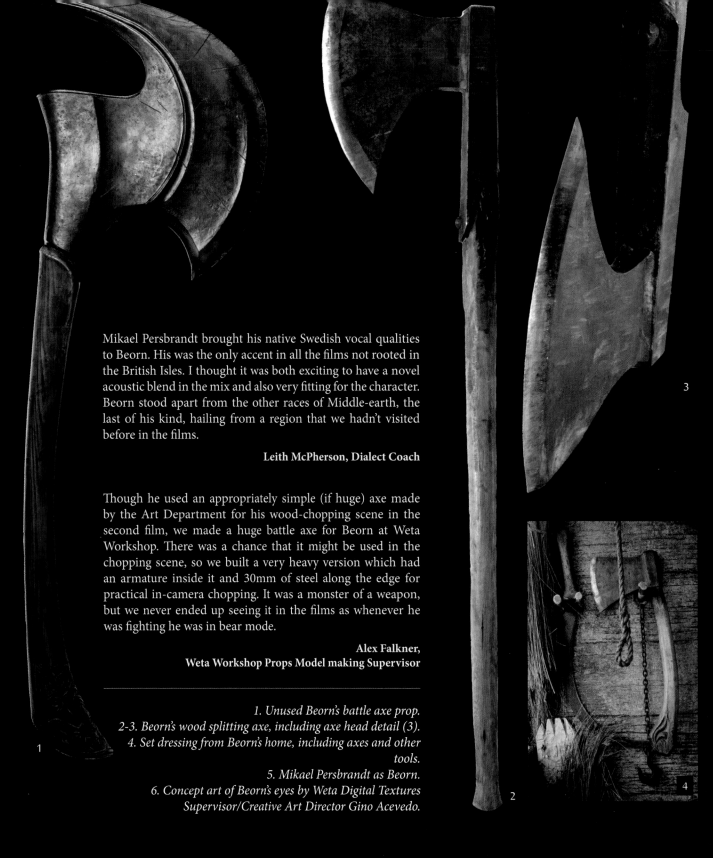

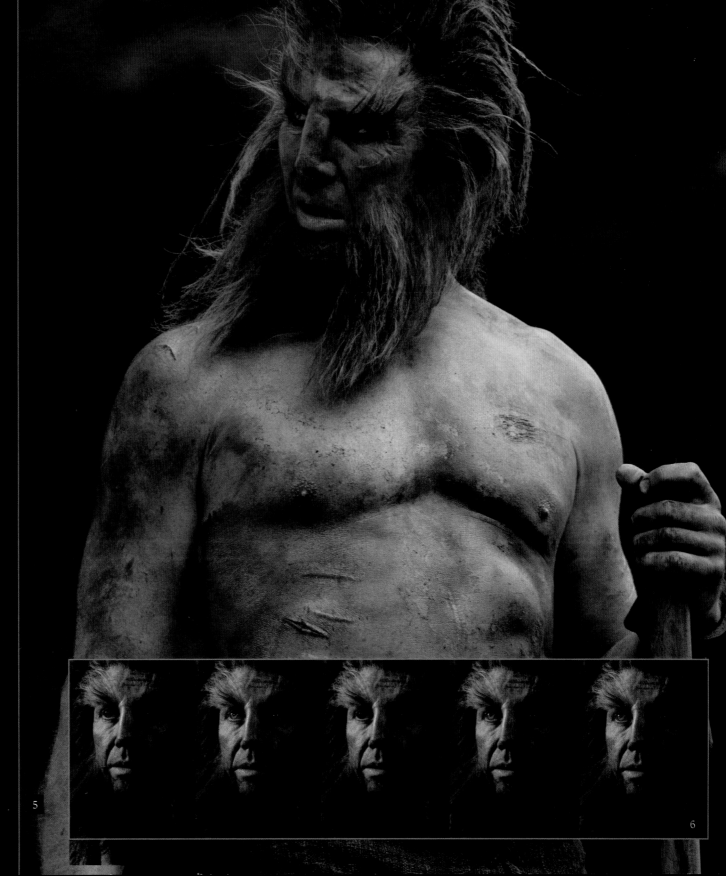

> *"The bear is unpredictable, but the man can be reasoned with."* - *GANDALF: THE DESOLATION OF SMAUG*

We were shooting on location in a remote part of the South Island of New Zealand and Peter asked to run through a scene in which Beorn was to chop some wood. This was the first time we had the axe, chopping block and actor all in the same place, and once they were all together it became apparent that the axe felt a little diminutive. Peter thought maybe it would be nicer if it was another third bigger... by this afternoon. Was this possible?

Being brave or foolish, or both, I said we will give it a go, and as they set up another shot I leapt in the car. We were in Paradise, which is exactly as its name suggests, but also happens to be in the middle of nowhere, two hours from Queenstown, the nearest large town. I had a possible lead based on the name of a guy given to me by a local crewmember, who was said to do a little metalwork from time to time. We had his address so I took off down the road, a little worried about what I was going to encounter.

I found his home and knocked. Fortunately he was at home, and I hastily explained our situation, asking if there was any chance he might have an arc welder we could borrow and some steel? He was very forthcoming with help, thank goodness, and before long we had dug some steel out of his back garden. Normally the exercise of remaking a prop at a new scale involves callipers, mathematics and precision, but in this situation we didn't really have time or resources – we just tore into it. It took about three hours to put the new prop together, including fashioning a new handle. We fumbled through and managed to sharpen and create a practical enough axe in record time, which I thanked him for, threw it in the car and drove hastily back to set with the head of the axe still warm on the seat. I leapt out of the car, thinking, 'Oh what a great job I've done: I'm early, I can get up there and give this a nice paint job and it will be perfect,' just in time to hear Peter on the PA system asking for the axe to be brought on set. With my heart in my throat I ran up through the scenic tent, grabbed some antiquing paste and smeared it onto the prop as we were running up to hand it over to the actor.

One of the great things about Peter as a filmmaker is that he understands what he asks of his crew because he used to do it all himself, so he appreciates when we're able to pull off magic tricks like producing an axe on a few hours' notice in the middle of the countryside.

Ra Vincent, Set Decorator

5

6

Beorn was a fantastic character to be involved in helping realize. Being a skin-changer, he has both humanoid and animal forms, his human form being played by the brilliant Swedish actor Mikael Persbrandt whereas the bear version would be an entirely digital creation. His description in the books was essentially a large black bear, so early on in the process we were involved in exploring to what extent he was simply a large powerful bear with great presence and to what extent there might be a fantasy aspect to his appearance.

It was always Peter's intention that there be some aspects of Beorn's human appearance in his bear form, and vice versa, so the hope is that he is recognizable in both forms. We explored different ways in which this might be achieved and found ourselves concentrating on areas such as around the eyes and potentially also some of his facial hair and mane characteristics.

When the audience first met Beorn, he was in his bear form, stalking the Orcs and then later chasing the Company. With a shape-shifting character, you might expect to meet them in human form first and then witness them transform, but in this case Peter has done it in reverse, introducing us to the bear first and then having the Dwarves and Bilbo meet the man, a bit gingerly considering their experience the previous evening! Later we would see him in his bear form again, and of course when he appears on the battle field.

Beorn was as challenging as any creature we have done, not least because of his fur. He's also a very active character with a huge frame, so a massive presence when compared to Bilbo or the Dwarves.

There is a misconception about digital creatures and the assumption that you can simply digitally scale things up and down as needed. While technically that is true, artistically there are fairly rigid limits to how far things can be pushed before they just don't work. There is a zone, plus or minus ten percent, perhaps, within which it is safe, but beyond that things like fur don't work. Our beasts' fur is groomed to a particular scale – push it too far outside of that scale and it looks unconvincing.

If we scaled him down he'd look like a pompom, or begin looking too bald if we made him too large, so we try to lock down things like size as early as possible. Fur is something that helps establish scale. It comes down to things like the thickness of the strands as much as length and grooming. An animal can be made to look larger by having very fine hairs. The human eye is astoundingly astute at recognizing when things aren't right, right down to hair width, so if we got it wrong people would pick up on something not being correct, even if they weren't consciously able to identify the source of the issue.

Also, the way fur moves, falls and behaves dynamically is not uniform, but different for different species, so figuring out exactly what properties our bear fur would have also involved research and decision-making as we sought to replicate how real bears' fur looks and acts.

So why not hire a bear and shoot it against a green screen? Firstly, Beorn isn't just a bear; from a design perspective, that wouldn't work. The most important reason we wouldn't do that, however, is performance. We need Beorn to do some very specific things, particularly in battle, and some of the moments in which he would appear had to be very carefully choreographed. For that there was no substitute for an animated creature. Using the example of Beorn's appearance at his own front door in the second film, as the Dwarves are attempting to barricade themselves inside, Beorn's head had to fill the frame, be wedged in the doorway, his jaws slavering and snapping. It was just more humane and so much easier to do it digitally.

In terms of design, Beorn doesn't necessary hew to any single species that we know from our earth. He is an amalgam of several species, with aspects derived from and inspired by a number of large, fierce bear species, including grizzlies. The Kodiak bear was one we looked at a lot, because they are so large, but as his design demonstrates, there are significant differences as well.

Matt Aitken, Weta Digital Visual Effects Supervisor

Though we had seen Beorn in the second film of *The Hobbit*, we took the opportunity to make some tweaks and improvements for his brief appearance in the third film. We were in a meeting with Peter when he pulled out a sketch that Weta Workshop Designer Gus Hunter had done and said, 'This looks great.' He liked the fur and the general feel of the face. Fortunately it wasn't completely different from what we had, so with a few tweaks that most people wouldn't even notice without a side by side comparison, we were able to make those little improvements.

**Gino Acevedo,
Weta Digital Textures Supervisor/Creative Art Director**

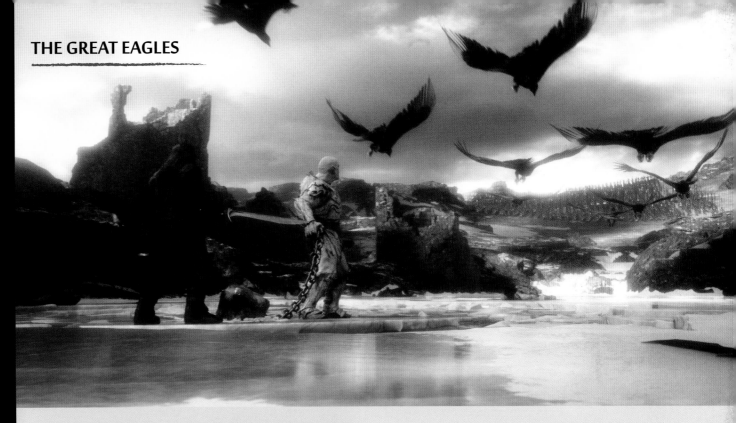

THE GREAT EAGLES

armelo Leggiero, one of our animators, had specifically equested the chance to work on the Beorn transformation iece at the end of the battle. Carmelo had animated Beorn's ansformation in the second film and was eager to do it gain. Beorn was in the film and then wasn't, then was again, hen wasn't. It went back and forth a number of times so poor Carmelo rode an emotional rollercoaster. Eventually Beorn round up in the final cut which put the smile back on our nimator. Once we had confirmation that the shot was in the lm it was animated in just three days.

The transformation was accomplished across three separate CG puppets. First we designed the performance with the umanoid Beorn puppet with a lot of pose reference and nput from Peter as to what the silhouette should be. It was bit like the classic werewolf transformation gag, looking up gainst the moon.

Next the performance was applied to what we called the ransformation version of Beorn. Essentially this was the ame puppet, except that it was globally scalable to the ize of the bear, which was significantly bigger. Each limb ad a channel we could toggle on and off that provided a ransparent view of what the bear limb would look like in the ame pose. It plugged into the publish so our Creatures team vould know that those frames represented where Beorn's imb was growing.

The transformation mesh was then topologically matched o both the human and bear hero models, including the face. he hero model of the Beorn bear was blended part by part ccording to the published animation transformation values. Once all of the blended transformations were approved, the nesh was then baked and ready for final sculpting. The head ransformation was done by the Facial Models team.

Aaron Gilman, Weta Digital Animation Supervisor

-2. Beorn concept art by Concept Art Director John Howe.
3-5. Beorn's bear form digital reference turntable images.
5. Beorn concept art by Weta Workshop Designer Gus Hunter.
7. Previs animation of Beorn in bear form, savaging Orcs.

1. Test render of Eagle wing feathers.

"The Eagles are coming!"
- BILBO BAGGINS

The most challenging aspect of the Eagles was their feathers. In order to achieve the level of realism that was demanded and which would hold up to the scrutiny of the big screen we built our birds with actual digital feathers, right down to the tiny hairs and filaments that real feathers are made with. They're amazingly complex things that interact and move in surprising ways, ruffling as air flows across them in flight, shifting and sliding over each other when the bird moves, so it wasn't really possible to cheat them with simpler solutions. It basically took some very clever simulation work, based on real-world physical properties and equations. What was developed made much of the problem-solving automatic, but still able to be directed, so our animators could control the simulation to achieve what they wanted from each shot but not be bogged down by having to animate each feather individually.

Kevin Andrew Smith,
Weta Digital 2nd Unit Visual Effects Supervisor

2. Eagle digital reference turntable image.

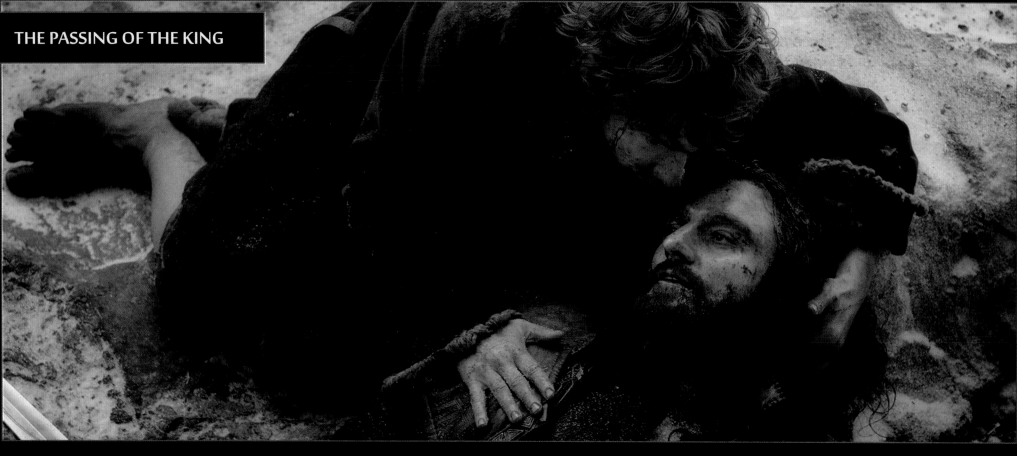

Thorin's relationship with Bilbo was key to the character's evolution in the story. From the beginning the relationship had been unfolding and gaining a kind of warm clarity. Bilbo proved himself to be a useful asset. Once inside the Mountain, Thorin remembered it was Bilbo's initiative that led to the riddle of the back door being solved, and it was Bilbo who faced the Dragon. Thorin's disintegrating relationship with his Company infused the intensity of his singular obsession with Bilbo.

Bearing in mind Thorin's irrational mind, he began to see Bilbo as his sole confidante. Narratively we were driving towards betrayal, and Tolkien's scene on the battlements in which Thorin attempted to throw Bilbo from the ramparts was a shocking moment in the novel. We had to ensure the relationship was galvanized. I suspect it was quite one-sided in its intensity – Thorin was deluded at this point and no one really trusted him – yet when Bilbo justified his actions to the Elf King and Gandalf he revealed his true sentiments about Thorin; he defended his king. It was not until the battle when Thorin had emerged from his sickness and seen what he had become that Bilbo witnessed the true warrior-king, his friend, who fought to the last.

It was ultimately Bilbo's journey. The mithril vest which Thorin gave to the hobbit ultimately saved his life, while the Dwarf lost his own. The final scene between them, as Thorin asked for his forgiveness, was always a moment from the book that moved me. I believe Bilbo forgave him long before: 'He was my friend.'

Originally this reconciliation was to occur in a room away from the battle, but taking it on to the battle field made it feel so much more desperate and immediate. I imagine at the moment of one's death there are words that must be said. There were mistakes that Thorin made. He had failed but ultimately he had also won. He saw the Orc armies defeated and Azog slain. His kin had fallen, but there was a legacy and a final exchange.

To die at peace required Thorin to right a wrong. I found his speech about hearth and home very moving. It is the one thing that he and Bilbo recognized in each other, for all their differences – the need to go home.

Richard Armitage, Actor, Thorin

Thorin was written in the book as an old Dwarf. Had we been completely faithful to that we might have cast someone to play a character more like Balin's appearance in age. One of the problems we would have encountered, if we had cast Thorin at his described age and appearance in the book, would have been investing in someone whose life was nearly done. That was why we wanted a younger Thorin, because it was important that the audience invest in someone who might have gone on to become a great king, humble and wise, the father of a great empire and people. The tragedy was of him being cut down, by sword or sickness of the mind, in his prime, when he could yet have fulfilled so much hope.

In truth, however, I still thought of Thorin as older than Balin, even though he might look younger in our films. It is a bit like Aragorn and his line, descended from Elendil, blessed with long life. Thorin was a direct descendant of Durin, whom they called Deathless. Like Aragorn, I think it could be reasoned that Durin's line aged differently than other Dwarves.

Philippa Boyens, Screenwriter & Co-producer

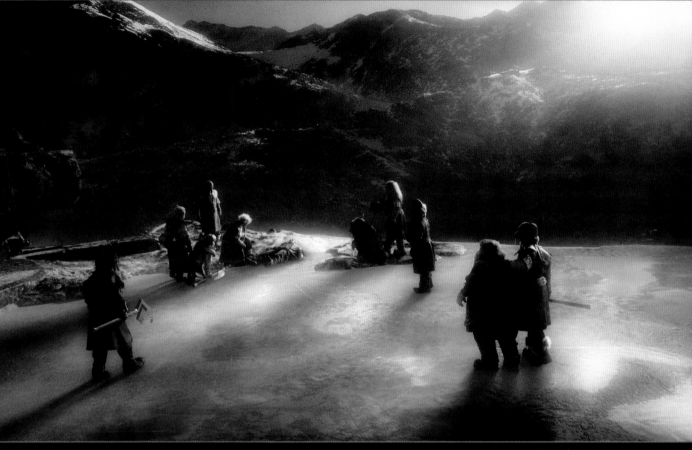

Ken Stott was beside himself over Thorin's death, over Fili and Kili. Balin was very, very upset as a character. He had invested everything in Thorin. Thorin, Fili and Kili – they were our hope. Balin was going to look after them, to be there for Thorin as he carved a new future for the Dwarves. I think Ken's performance was one of the best in the films in terms of Balin being the eyes of the people. Nori certainly looked to Balin for answers, and to Dwalin, his brother, as well.

Most of us weren't on set to actually see Fili, Kili or Thorin's deaths shot. I think we would have liked to have been, to be there to witness what happened and to be able to take it on board, but sometimes in battle you don't, so perhaps it happened the way it was supposed to. Sometimes you come upon something as an aftermath and it can be equally as soul-destroying. It really was a destroying moment for our characters, and affecting for us as actors, too. One of the great things about Peter is he is great at letting us, as actors, take the time to actually feel stuff. He loves reaction shots and has always given us plenty of direction and rehearsal leading up to those important moments. He let us know what he was looking for so that we have the time to process how that affected our characters as individuals and as a group. Our reactions to the deaths of Fili, Kili and Thorin played as a group dynamic. We picked up on the pathos coming from every other member of the group, the heavy feeling that hung over the scene.

What I really love about our group was that we jumped into that combined way of operating so easily. There was no disparity in terms of the way we approached things. We fed off each other's performances and energy. It came from the top. We played it within our family groups. I remember Graham McTavish wanting to find Ken Stott. Nori was looking for Ori and Dori in that moment. We each sought out our family members to be reassured that they were there, to know they had made it through and to console each other. We had survived and we had won, but we had lost as well. It was a bittersweet moment; a great movie moment, but also a sad one to shoot.

We shot that stuff at the very end, among the very last things that were filmed, which was, I think, probably by design. I think it was a smart decision to schedule it that way. I took photographs of all of the cast out of costume on that last day and we were really happy, proud to have come so far together on this amazing journey, but there is this kind of underlying sadness behind the eyes in the pictures because we also knew that this was it, that it was over.

Jed Brophy, Actor, Nori

I don't know if it was planned (I suspect it was), but my last shot of the entire trilogy was the moment in which Dwalin witnessed Thorin die. We shot an entire sequence where Dwalin was fighting his way through Orcs to try to get to him, because I could see what's happening and I could see he needed help, but there were too many Orcs in between us. I was desperately trying to claw my way to Thorin. I lost my axe and was reduced to fighting with the jade knife, carving my way through, disembowelling and beheading, breaking their necks and even crawling over bodies at one point, but it's too far and too late. Then I saw him fall. It was the last thing that we shot and we did it a few times. When Peter finally called a wrap on it, I burst into tears, quite literally. I lost it, I couldn't even speak. There haven't been many things that have happened to me in my life that provoked such an instant emotion. It was very raw, but I think it was the culmination of everything up to that point, the transition from warrior to bereaved brother in arms that I was performing for Dwalin, seeing a friend die, the end of his journey and also mine.

Graham McTavish, Actor, Dwalin

1. Concept art of Thorin and Beorn by Concept Art Director John Howe.

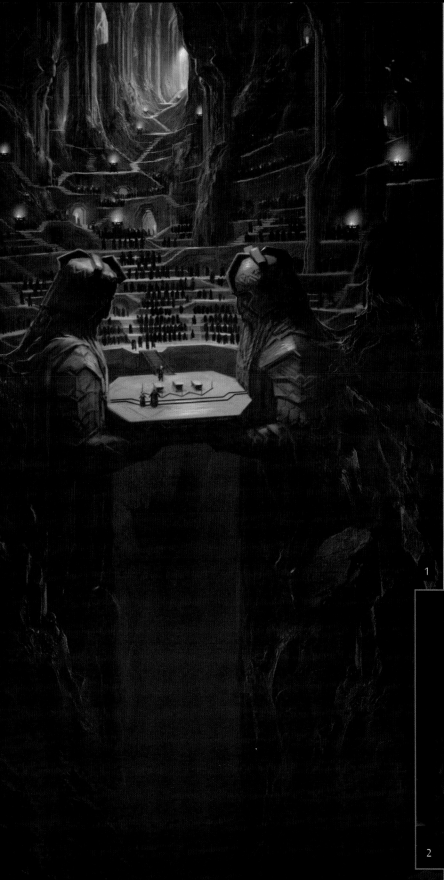

BURIED IN THE ROOTS OF THE MOUNTAIN

There was so much loss in this story. The funeral scene we shot had a profound sense of reverence. It was a huge day for us when we shot it, and quite emotionally overwhelming. Our characters were, and so were we by the end of it, realising that we were all going home.

The Dwarves had won the battle, but we had lost the future that we had been fighting for.

Jed Brophy, Actor, Nori

After the battle at Ravenhill, and upon learning what had happened there, we remaining Dwarves who had survived said goodbye to our revered leader and the brothers, Fili and Kili. There was chanting in which the Wizard led us. There were lines in there about mountains and stone, about the deep things for which Dwarves care and which Gandalf clearly understood. It was rich, marvellous stuff, and there before us, arranged on three stones, were our fallen heroes.

They weren't just dummies lying there, but the actual actors, our friends, which I think made it all the more powerful for us. We filed slowly past them, each taking a moment to pay our respects. There was hugging and tears. It was very moving to shoot.

John Callen, Actor, Oin

3

1

2

When we filmed the funeral scene, with everyone saying their goodbyes to us, Peter piped in the most beautiful, sad music. I was dead so I couldn't express, but I was lying there listening to all my friends come up and stand next to me, crying or reacting as their characters would to our deaths. It was actually a really sad day, but an important scene that provided closure to the story.

Dean O'Gorman, Actor, Fili

I've talked before about the culture of familiarity and trust that developed among our Dwarf ensemble, the result of us going through so much together. An example of the closeness we developed was the filming of our farewell to Thorin and his nephews. Peter conducted the shoot with very moving music playing on the set to establish a tone and pace. We ran different takes and angles as each Dwarf had his moment with the dead. We played it like jazz, each waiting and giving the others their space and respect before taking his own turn to step forward. Each of us had our moment and took our time to feel it as we stood before our friends, then moved on when it was right. Shooting that scene all together as an ensemble had a tremendously profound and beautiful quality to it.

Peter Hambleton, Actor, Gloin

Thorin's funeral took place in a new setting, a full 3D environment. It was built as a physical set but we extensively remodelled it to make it even grander. The three sarcophagi upon which Thorin, Fili and Kili lay in state remained, but the platform on which they sat was suspended between two giant Dwarf statues with a void beneath. A vast amphitheatre was filled with Dwarven mourners, Iron Hill Dwarves bearing torches.

Matt Aitken, Weta Digital Visual Effects Supervisor

1. *Concept art of the tombs by Concept Art Director Alan Lee.*
2. *Funeral concept art by Concept Art Director John Howe.*
3. *Concept art of tomb statuary by Concept Art Director John Howe.*
4-5. *Early funeral concept art by Concept Art Director Alan Lee.*
6. *Early funeral concept art by Concept Art Director John Howe.*

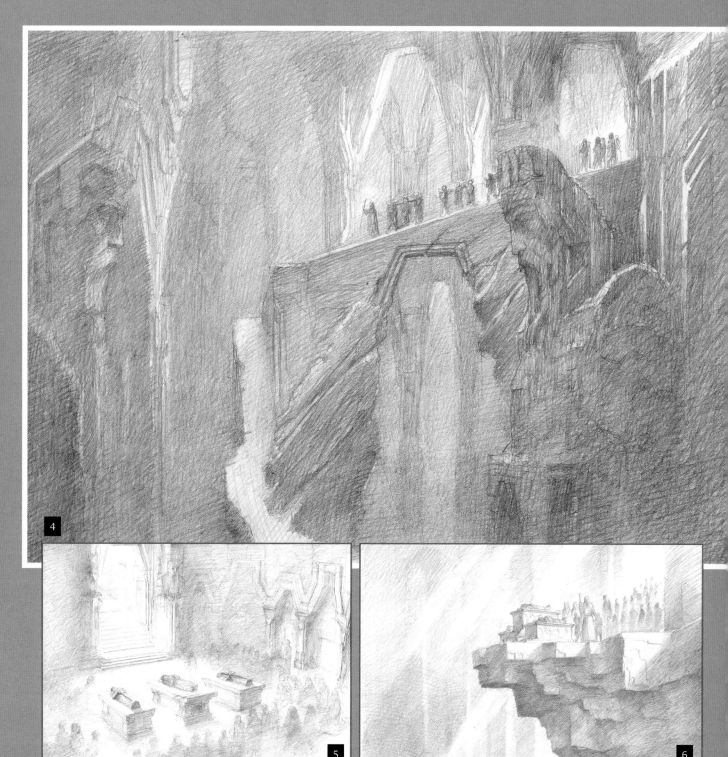

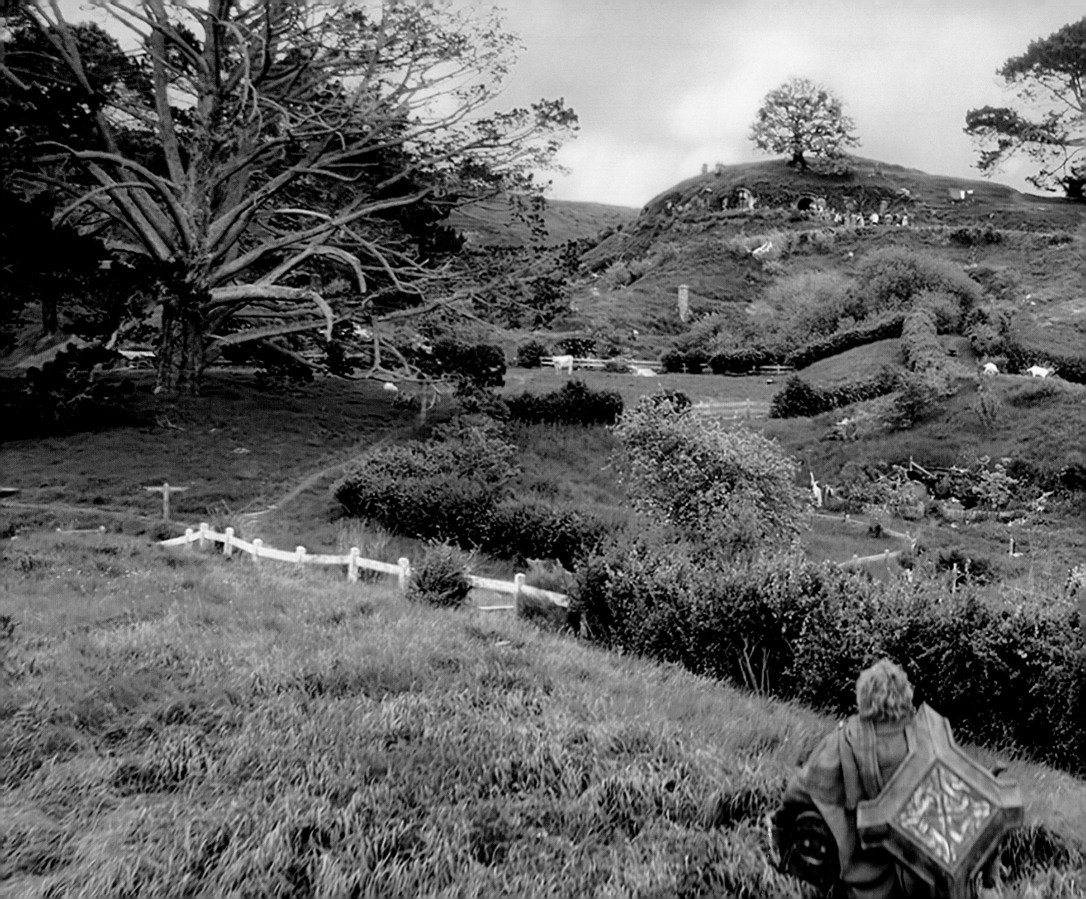

THERE & BACK AGAIN

T he battle is won, yet so much blood has been spilled and so many are the dead that there is no sweetness to the taste of this triumph. Among the fallen are the last of the Sons of Durin: Thorin Oakenshield, the Dwarf who would be King, and his nephews and heirs, Fili and Kili. Elves, Men and Dwarves have given their lives in battle, and though peace will reign for generations in the north thanks to this victory, a cold, quiet grief blankets the Lonely Mountain like new snow.

Deep inside the Mountain they fought to win, Thorin and his sister-sons are laid to rest in stone, the Arkenstone and great sword Orcrist upon Thorin's breast. Sad farewells are sung and said, and Bilbo quietly takes his leave of the Company to begin the long journey west, retracing his steps toward home.

Parting with his friend and guardian Gandalf upon the borders of the Shire, Bilbo takes the final steps of his journey alone, finally coming upon a scene of organized chaos on his doorstep, where an auction is taking place. The belongings of the now presumed-dead Mister Bilbo Baggins are being hawked to the highest bidders, among them his sour-faced cousin Lobelia Sackville-Baggins. Flustered by auctioneer Grubb's demand for proof of identity, Bilbo produces the contract he signed a year before with Thorin, at the commencement of his quest. Asked who this Thorin person is, the hobbit answers, with a note of sadness in his voice, 'He was my friend.'

PARTINGS

Bilbo took his leave of the remainder of our Company and set out for Bag End. There was no long and drawn out goodbye; it was a quiet affair.

I think Dwalin was the last Dwarf in the Company to trust the hobbit. Dwalin was a suspicious Dwarf, by nature. Unless you are related to him his default position is one of distrust, and there were many things about Bilbo that gave Dwalin reason to be suspicious of him.

'The wild is no place for gentle folk,' he pronounced at the outset. He took convincing that Bilbo wasn't going to be a complete liability, and while the hobbit saved them more than once along the way, it really wasn't until the moment on the battlements of Erebor, when Thorin was going to throw Bilbo over the side, that Dwalin truly saw it differently.

That was the first time his convictions had been so shaken that he could suddenly step outside himself and see things for how they were. He realized in that moment that the one they should be trusting was the hobbit, not the King under the Mountain. Dwalin was the fundamentalist of the group; Thorin was the king, a great man and his was the only true cause. There was no room for grey area in his perspective; Elves, Lake-men, Wizards, they couldn't be trusted. He didn't have much time for people that didn't look like him, so it probably never occurred to Dwalin to give Bilbo a chance.

The saying, 'Never trust a Wizard,' had been passed down to them by their fathers, and Bilbo, as far as Dwalin was concerned, was Gandalf's man, thrust upon them against their inclinations; so it meant a great deal for him to accept Bilbo, to trust him, and to love him.

When we filmed our final goodbyes and Bilbo turned to see all the Dwarves standing in silence, I felt that scene was very genuine. Some of the Dwarves were tearful. Dwalin was not the sentimental, weeping sort, but he would still feel the significance of that parting and he paid his quiet respect to Bilbo with sincerity, bowing before him. While the others had politely offered Bilbo their service at Bag End, Dwalin never bowed until that final moment, when they parted; a real and meaningful gesture.

Graham McTavish, Actor, Dwalin

BEYOND RAVENHILL

I was asked at a convention recently what Dwalin's future might be, beyond the Battle of the Five Armies. What was Dwalin doing by the time of *The Lord of the Rings*? We know from the books that when Balin later led a force of Dwarves in what would become an ill-fated quest to reclaim Moria from the Orcs, Dwalin wasn't with him. Having got to know Dwalin in *The Hobbit* trilogy, it is curious that he didn't go with his brother. This is speculation, because it isn't written anywhere in a book or script, but I really believe that the deaths of Thorin, Fili and Kili affected Dwalin so profoundly that I think he just wanted to shut the door on the world. In non-Middle-earth terms it would probably be characterized as post-traumatic stress, but in less grandiose language I think he was broken by it. I don't think he ever recovered, and could imagine him living quite a lonely life after his friends were laid to rest in the Mountain. I can't imagine there was a lot of laughter in his life after that loss. I think his adventuring days were done, which is probably why he didn't go with Balin to Moria.

Graham McTavish, Actor, Dwalin

In the end, after we had won the battle, after the Dragon was dead and we had counted our gold and we had buried our dead friends, I think the real question remaining was, what exactly did we gain? In our estimation it had been a just war. We began our journey with a gung-ho, 'Hey, isn't this fun, chaps?' attitude, but the reality of seeing our brothers, cousins and sons killed raised the question of whether that Mountain and its treasure were as important as we all thought. I think those are the questions on Oin's mind in the aftermath, certainly after the loss of Thorin, Kili and Fili. In reading *The Lord of the Rings* I learned that Oin survived long enough after the events of *The Battle of the Five Armies* to go with Balin to Moria and try to take that place back from the Orcs. Oin was taken by the Watcher in the Deep, the same creature that had a go at Frodo. It appears that, once again, when someone said they were going to go on a quest to reclaim lost Dwarven heritage, he put his hand up and said, 'Alright, we'll go and get this sorted.'

John Callen, Actor, Oin

Gloin was one of the lucky ones who survived the quest for Erebor and the battle that followed. In the book of *The Lord of the Rings* he was in Rivendell and met Bilbo again. He was already a venerable old Dwarf by then, white-bearded and representing his people at the Council of Elrond. Tolkien wrote that he went on to live till he was 253 and of course his son Gimli was a tough little character who was both a big part of Frodo's adventure and also established a new Dwarf realm of his own. Gloin had a happy retirement, though there is the sense that his story wasn't over. After reclaiming the Mountain at such a terrible cost, I think Gloin would have felt it was his duty to ensure the place was returned to its former glory. So many people of all races lost their lives in that astonishing battle, and it couldn't be for nothing. For those who were left behind there was the ongoing task of cleaning up and rebuilding, which would probably have gone on for decades. I like to think of Gloin using his managerial skills to organize that recovery phase, rebuilding, looking after people and stimulating the Dwarf economy. Given the kind of character that he was I would expect that he would have become a fairly serious player in the recovery of the Dwarven nation. It would have been a lot of work, but he would have been up for it.

Peter Hambleton, Actor, Gloin

Ori was the group's chronicler. It became very important to him that story was recorded and passed on. I made a conscious effort to keep my notebook with me through the journey, so you might see Ori in pictures, clutching his book the way other characters might hold on to their sword. It was his default position of comfort, to be holding his journal because its contents were so important to him. In the course of the journey he realized that his scribbles and notes about their trip were actually valuable and that the whole endeavour was something that should be documented so that it could be retold and kept sacred by future Dwarves.

It was also Ori's connection to the bigger Middle-earth story, because we would later see that he was still chronicling the progress of the Dwarves in *The Lord of the Rings* when they found what remained of him in Moria, clutching the book he had been writing about that adventure.

The portrait of Bilbo that Frodo held at the very beginning of *The Hobbit* was another link, something Ori had drawn and given to Bilbo. I remember there was some talk about shooting a scene in which I gave it to Bilbo before the end to bring that little link full circle.

Adam Brown, Actor, Ori

Nori was still alive when Frodo went to Mordor. He was mentioned by Gloin as being with Dain in Erebor, along with Dori, Bifur, Bofur and Bombur. Ori went with Balin and Oin to Moria. If there were ever more stories to be told, I'd like to know why Nori didn't go with Ori, instead choosing to stay in Erebor.

Peter Hambleton and I talked about trying to find some moments in the journey in which you could see Gloin teaching Nori some Dwarven lore. Gloin was so deeply rooted in all things Dwarven, while we imagined Nori had lived on the fringe; journeying together, we imagined Nori might learn a bit about his heritage and come to connect with it a bit more. We did see them paired up from time to time. They buried the Troll chests together, but there was never really a chance to play out that story we had come up with and get those specifics into the story.

Reclaiming Erebor was a big deal for Nori. He found his place. Before Erebor, because he had no standing in society, I think Nori's attitude was 'I'll just look after myself.' There are all sorts of individuals in society who end up in a place where they just decide that they can't really trust anyone, and so they figure there's no benefit to them in being worthy of trust. Nori was one of those guys. I maintained that he knew about Wargs because he'd seen them from afar, that he'd seen Trolls from

afar, and he had probably traded with Elves, so he was a littl bit worldlier than some of the others. He didn't love Elves bu he was quite happy to take their money.

I think after the whole Erebor experience and seeing how the Elves and Thranduil in particular treated Dwarves, looking upon them as lesser beings, it helped solidify to Nori who i was that he belonged with. 'Alright, I'm a Dwarf; this is how it going to be and I'll stay with my own kind.'

Jed Brophy, Actor, Nor

After it was all said and done, I think Bifur would have gone home. I think he went back to the Blue Mountains and rebuil his life. He would have given up fighting and tried to rebuild the family he had lost. Without the axe in his head, I always saw Bifur as a bit more like Bofur, quite a charming, positive person. The Dwarf we were introduced to in Bag End was completely zoned out. He was sitting there wondering who al these people were. I don't think Bofur really wanted to take him with them on the quest, but he didn't know what else to do with him, so they brought him along. As the journey went on, Bifur became more lucid, gaining direction and a sense of purpose, until finally, by the end, he had become a whole person again.

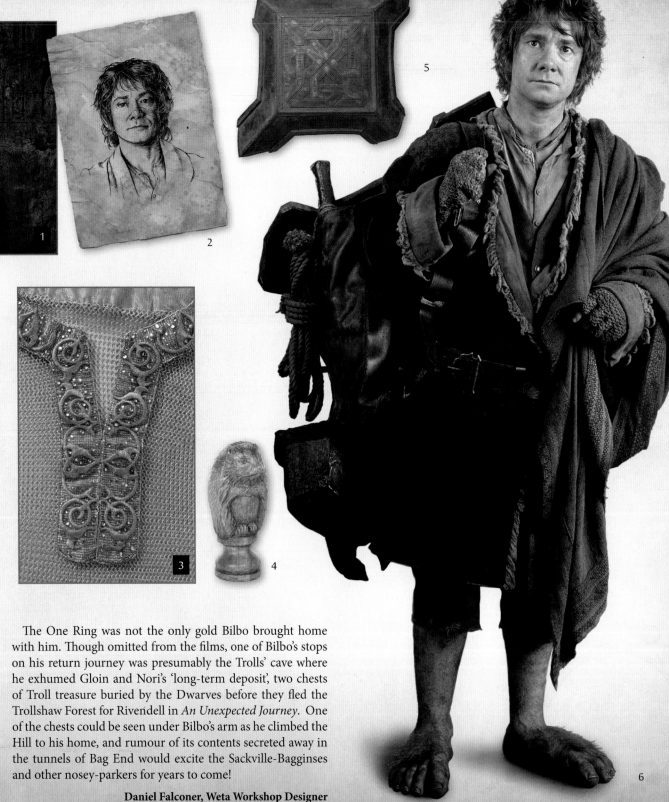

Eschewing his claim to a fourteenth of the treasure of Erebor (one wonders how he would ever have gotten that home in any case!) Bilbo took his leave of the Dwarves and went home with just a handful of mementos to remind him of his experiences and friends.

Frodo's investigation of the chest in Bag End revealed a number of keepsakes that would resound with greater significance by the third film, among them a carved piece from Beorn's chess set and Ori's portrait of Bilbo, but among the items of particular significance was his shirt of Mithril maille. The shirt had been a gift from Thorin when Bilbo had been the most conflicted about his relationship with the Dwarf King, but which saved his life and would one day save Frodo's as well. Because the prop had already been established in the first trilogy this delicate garment was a straight reuse of that which was designed for *The Lord of the Rings*, and, like his sword Sting, was another element tying the six-film saga together.

The other important linking device, and arguably the most important prop in all six films, was the One Ring, though even Gandalf didn't suspect at this time that was its true identity. In a gorgeous scene between the two characters, as they parted upon the borders of the Shire, Gandalf made it plain that despite Bilbo's attempts to hide it from him, the Wizard was well aware that he had found a magic Ring in the Goblin tunnels, and cautioned the hobbit to treat it with respect. Only later would the true nature of this, most momentous of artefacts become clear to Gandalf, spurring Frodo's quest as told in *The Lord of the Rings*.

As it was in the first trilogy, the One Ring was produced in multiples of varying sizes by the artisans of Jens Hansen Gold & Silversmith Ltd, based in Nelson, New Zealand.

The One Ring was not the only gold Bilbo brought home with him. Though omitted from the films, one of Bilbo's stops on his return journey was presumably the Trolls' cave where he exhumed Gloin and Nori's 'long-term deposit', two chests of Troll treasure buried by the Dwarves before they fled the Trollshaw Forest for Rivendell in *An Unexpected Journey*. One of the chests could be seen under Bilbo's arm as he climbed the Hill to his home, and rumour of its contents secreted away in the tunnels of Bag End would excite the Sackville-Bagginses and other nosey-parkers for years to come!

Daniel Falconer, Weta Workshop Designer

Bilbo received a brooch that was worn like a clasp upon his wrap for the journey home. It had a Celtic flavour with lots of interesting shapes made of intertwining, pointed geometry and sharp, repeating triangles. It was different in shape to most of the other pieces we had created for other characters by that point, and in fact by so late in the project it was becoming quite difficult to come up with something new and interesting, but I thought it turned out well.

Bob Buck, Costume Designer

The souvenirs that Bilbo brought home with you were funny because they were actually made at the very beginning of the shoot, years before we ever shot a frame for the actual battle of the five armies. We had a rough design for the Gundabad Orc helmets so one of them was made along with an old Dwarf shield design that was actually a piece of set dressing for Moria during the first trilogy. The helmet, if you looked closely, wasn't the same as the ones that actually ended up being used in the battle.

**Alex Falkner,
Weta Workshop Props Model making Supervisor**

1. *Martin Freeman in costume as Bilbo Baggins on the ruined Dale set, holding the One Ring.*
2. *Bilbo's portrait by Ori, created by Graphic Artist Daniel Reeve.*
3. *Detail of Bilbo's Mithril shirt.*
4. *Bilbo's souvenir carved chess piece, from Beorn's home.*
5. *Dwarf shield prop.*
6. *Studio photography of Martin Freeman as Bilbo, preparing to return home.*
7. *Bilbo's souvenir Orc helmet.*
8. *Bilbo's Dwarven brooch.*
9. *Dwarf-made Troll hoard treasure chest.*

BAG END AUCTION

Bilbo's return to Bag End wasn't trouble free. When he came home it was to find himself presumed dead and the contents of his house being auctioned in the lane to all manner of eager opportunists. Only producing his contract to prove his identity saved the last of his belongings from being sold off to the highest bidders.

Ra Vincent, Set Decorator

Auctioneer Tosser Grubb and Master Worrywort were among our most character-filled hobbits. Both had huge prosthetic noses. I have to say that Worrywort was a particular favourite of mine. He really turned out so well.

Tami Lane, Prosthetics Supervisor

I had someone tell me they thought the big noses on some of our hobbits were ridiculous. I lived in Bath, which is famous for cider. There were lots of cider houses, especially in the 70s, and in one of them there were these four old blokes who sat there every night on the same four seats drinking cider together. They had noses even more extreme than ours – huge, purple and gnarly. That's what happens when you drink your whole life.

Peter King, Make-up and Hair Designer

1. *Timothy Bartlett in make-up and costume as hobbit Master Worrywort.*
2. *Merv Smith in make-up and costume as Tosser Grubb*
3. *Prosthetics Supervisor Tami Lane applies Timothy Bartlett's nose and ears, transforming him into Master Worrywort.*

The Sackville-Bagginses were fun. They're nasty people. We first saw them in *The Lord of the Rings*, but they were older. This time we got to design them a little more and have some fun with their looks. With all hobbits, there is a roundness and a jolliness, but we wanted Lobelia to be waspish. Elizabeth Moody played her in her brief appearance during *The Lord of the Rings*, and she had very raised eyebrows and curly hair. We matched the eyebrows but because she would be more dressed up in her appearances in *The Hobbit* we decided to style her hair into more of a do this time. We under-painted her mouth so that she looked like she had pursed lips and held back on her blusher to make her look cold.

Lobelia's husband, poor hen-pecked Otho, never took off his hat, which is a bit of a shame because his hair underneath was greased completely flat on top and he looked ridiculous.

Peter King, Make-up and Hair Designer

1. Brian Hotter in costume as Otho Sackville-Baggins.
2. Otho Sackville-Baggins's green double-breasted waistcoat.
3. Detail of Otho Sackville-Baggins's alternate, grey double-breasted waistcoat.
4. Detail of Otho Sackville-Baggins's cravat.
5. Lobelia Sackville-Baggins's floral straw hat.
6. Erin Banks in costume as Lobelia Sackville-Baggins.
7. Lobelia Sackville-Baggins's embroidered shawl.
8. Lobelia Sackville-Baggins's parasol.
9-11. Details of Lobelia Sackville-Baggins's costume: apron (9), full skirt (10), green petticoat (11).
12. Lobelia Sackville-Baggins's flower basket.
13. Lobelia Sackville-Baggins's striped green jacket.

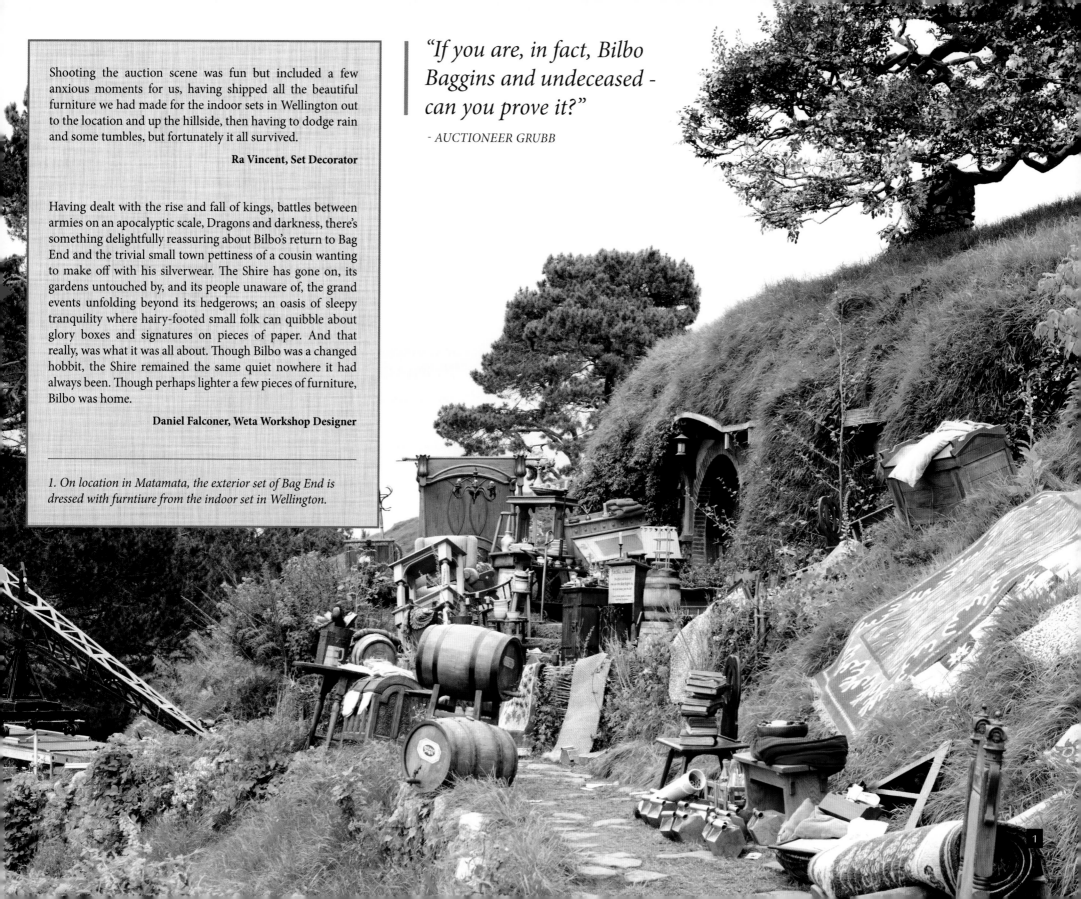

Shooting the auction scene was fun but included a few anxious moments for us, having shipped all the beautiful furniture we had made for the indoor sets in Wellington out to the location and up the hillside, then having to dodge rain and some tumbles, but fortunately it all survived.

Ra Vincent, Set Decorator

Having dealt with the rise and fall of kings, battles between armies on an apocalyptic scale, Dragons and darkness, there's something delightfully reassuring about Bilbo's return to Bag End and the trivial small town pettiness of a cousin wanting to make off with his silverwear. The Shire has gone on, its gardens untouched by, and its people unaware of, the grand events unfolding beyond its hedgerows; an oasis of sleepy tranquility where hairy-footed small folk can quibble about glory boxes and signatures on pieces of paper. And that really, was what it was all about. Though Bilbo was a changed hobbit, the Shire remained the same quiet nowhere it had always been. Though perhaps lighter a few pieces of furniture, Bilbo was home.

Daniel Falconer, Weta Workshop Designer

1. On location in Matamata, the exterior set of Bag End is dressed with furntiure from the indoor set in Wellington.

"If you are, in fact, Bilbo Baggins and undeceased - can you prove it?"

- AUCTIONEER GRUBB

1

About the Peninsula

WETA WORKSHOP

Weta Workshop is a multi-award winning conceptual design and manufacturing facility based in Wellington, New Zealand, servicing the world's creative industries. Weta Workshop draws on more than 25 years of filmmaking experience and is led by five-times Academy Award®-winner, Richard Taylor. Their crew members are expert in a diverse range of disciplines and enjoy engaging in projects, from preliminary technical analysis and conceptual design through to manufacture and final delivery of product, anywhere in the world. Weta Workshop provides design and manufacturing services on *The Hobbit*, designing creatures, armour and weapons, and building armour, weapons, prosthetics and physical creature effects.

WETA DIGITAL

Weta Digital is one of the world's premier visual effects companies. Led by Senior Visual Effects Supervisor Joe Letteri, Weta Digital is known for uncompromising creativity and a commitment to developing innovative technology. Groundbreaking performance-driven digital characters like Smaug, Gollum, Kong, Neytiri, and Caesar (from Dawn of the Planet of the Apes) are widely acknowledged as some of the best digital characters ever put on screen. Weta's development of revolutionary virtual production workflows for Avatar, The Adventures of Tintin, and The Hobbit trilogy has firmly integrated digital production techniques into the film production paradigm.

Co-founder Peter Jackson established Weta Digital in 1993 to create the visual effects for his film Heavenly Creatures. The company went on to cement its reputation for cutting edge visual effects with work on blockbusters like The Lord of the Rings trilogy and King Kong.

Weta Digital has five visual effects Oscars® and five visual effects BAFTAs to its credit, and has recently completed the visual effects for The Hobbit: The Battle of the Five Armies and Dawn of the Planet of the Apes.

ART DEPARTMENT

The 3Foot7 Art Department, led by Production Designer Dan Hennah, is responsible for creating the overall look of the film, bringing the Director's vision to the screen. The Art Department is responsible for creating all of the sets, props and dressings from concepts through to the finished articles. Their job is to create an environment that is so real, the actors feel completely in character wherever that may be: in a forest, on a lake, up a tree or in a cave. To achieve a look or atmosphere for a film involves many people. The Art Department on *The Hobbit* has more than 350 artists and craftspeople in workshops throughout the Miramar Peninsula. Starting with the Director's brief, ideas go through the concept stage before being turned into working drawings. Designs then go to the various departments to be made into a physical set, prop or dressing.

COSTUME DEPARTMENT

The Costume Department is ultimately responsible for the look worn by actors, stunt performers and body doubles in front of the camera. The department consists of 'off set' and 'on set' crew, each dealing specifically with either producing the costumes or dressing and maintaining the look and continuity during filming. 'Off set' crew are based in the workroom where designs are created, illustrations coloured, samples developed, materials sourced, patterns cut, fabric dyed, jewellery made, boots cobbled, costumes fitted and alterations completed. Finished costumes are aged to appear lived in. 'On set' crew work either in the studio or travel to location. As well as dressing the performers, they also attend to their comfort and safety by keeping them warm or cool between shots and attend to general maintenance and laundry. Continuity photos are taken and notes are written about how the costumes were worn for that particular scene. On *The Hobbit* the Costume Department consists of approximately 60 'off set' crew and 15 'on set' crew.

MAKE-UP & HAIR DEPARTMENT

The 3Foot7 Make-up Department creates characters by designing and applying make-up, prosthetics, wigs and beards to the cast. Every cast member, including extras, wears some form of wig and all the lead actors and their various doubles wear prosthetics. Four make-up department bases manage the large number of artists and extras. All activity is coordinated through the Make-up Room based at Stone Street Studios. This is also where wigs are made and mended, and hair is prepared for inclusion in the wigs, including the dying and curling. Seven five-seater Make-up Trucks positioned on the back-lot are used for applying prosthetics, make-up and hair on principal actors, some taking three hours to complete each day, under the eye of two supervisors. Offsite is another 18-station make-up facility for extras. There are 34 permanent staff though the department swells to as many as 60 during periods that call for large numbers of extras and stunt people.

STUNT DEPARTMENT

Where action was indicated in the script, the stunt department was tasked to translate those words into a tangible reality for filming. The stunt coordinator and his department were responsible for the action adhering to the director's vision and performed safely, with minimum fuss. Action in *The Hobbit* was always involved due to the numerous facets of the production: prosthetics, costumes, fat-suits, wigs, armour, weapons, and the cumulative effect of doubles and stunt performers in addition to the actors, the safety of all of whom was the responsibility of the stunt department. This responsibility also extended to include the crew working immediately in and around the action.

The Hobbit films required a team of up to a hundred stunt performers from various countries. Alternate teams were sometimes rostered on day and night shifts to meet the demands of filming. Choreography of all the action sequences and preparation of sets for specific action were also the responsibility of the department, including placement of wire work to accentuate any throws or impacts.

Prior to shooting beginning on the physically challenging production, the fitness of the actors was assessed and they underwent extensive physical and technical training with the stunt team for the work ahead. Working with other departments, costumes and make-up elements were refined and improved to allow the actors to more easily execute special movements and fight sequences.

DIALECT COACHES

The Dialect Coaches provided support and training for films' actors in preparatory sessions, on set and during additional dialogue recording. During preproduction their services included working with the filmmakers and cast members to help find key accents for specific characters. With the help of translations provided by Tolkien language expert David Salo, the Dialect Coaches also instructed cast members in the correct pronunciation of the invented languages of the Dwarves, Orcs and Elves, as well as helping them master and maintain their character's unique accent when speaking English. On set they also provided offline dialogue for characters whose actors were not present during that particular day of shooting.

PARK ROAD POST

Park Road Post Production is an internationally renowned purpose-built facility, providing award-winning sound and picture finishing alongside industry-leading development of digital workflows. On *The Hobbit*, Park Road's research and development team applied their techniques to build and define the new 48fps stereoscopic 3D pipeline. This unique, state of the art pipeline supported multi-camera, multi-unit film production alongside traditional post production pipelines. Finishing and delivering *The Hobbit* trilogy in HFR-3D was arguably one of the most significant developments in the last 80 years of cinema exhibition. Park Road is pleased to offer this new technical and aesthetic standard to filmmakers and audiences the world over.

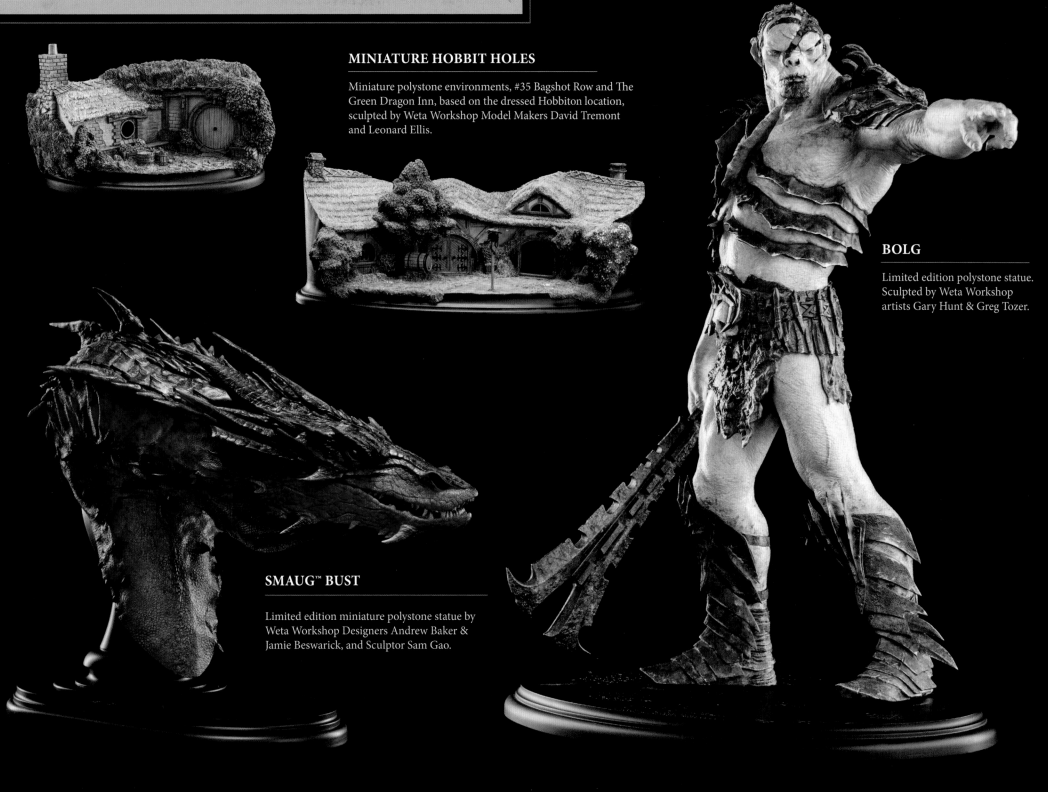

COLLECTIBLE ART

MINIATURE HOBBIT HOLES

Miniature polystone environments, #35 Bagshot Row and The Green Dragon Inn, based on the dressed Hobbiton location, sculpted by Weta Workshop Model Makers David Tremont and Leonard Ellis.

BOLG

Limited edition polystone statue. Sculpted by Weta Workshop artists Gary Hunt & Greg Tozer.

SMAUG™ BUST

Limited edition miniature polystone statue by Weta Workshop Designers Andrew Baker & Jamie Beswarick, and Sculptor Sam Gao.

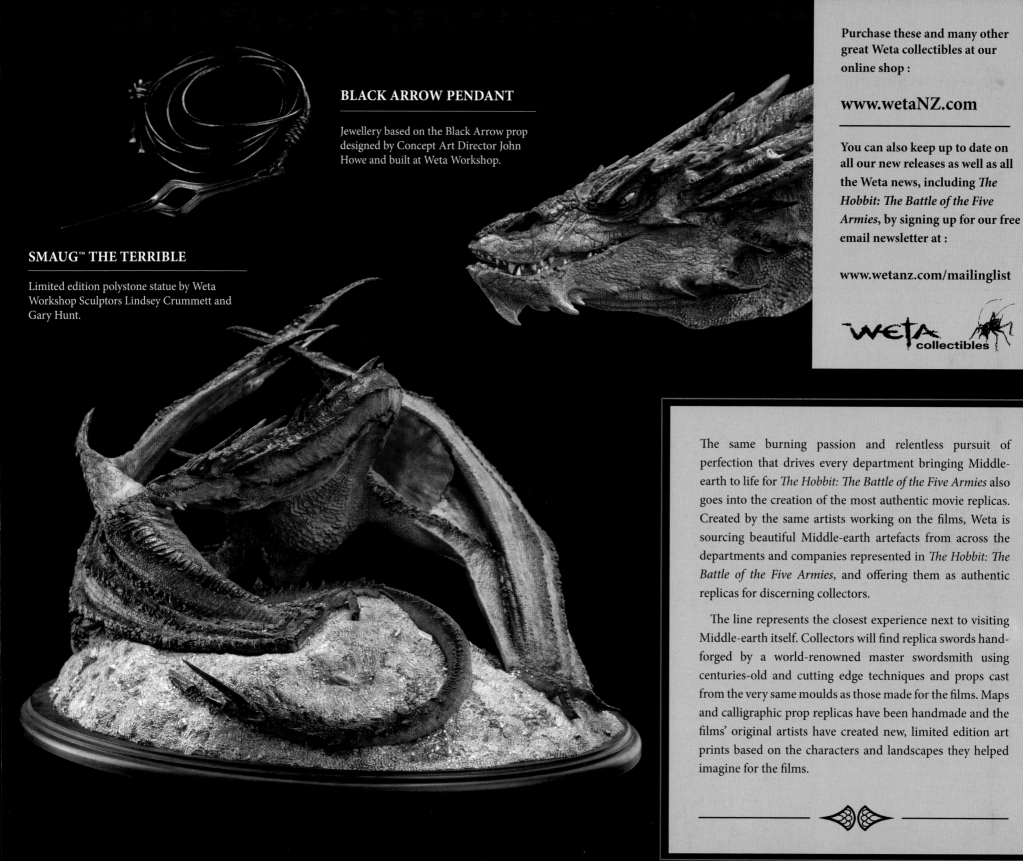

BLACK ARROW PENDANT

Jewellery based on the Black Arrow prop designed by Concept Art Director John Howe and built at Weta Workshop.

SMAUG™ THE TERRIBLE

Limited edition polystone statue by Weta Workshop Sculptors Lindsey Crummett and Gary Hunt.

The same burning passion and relentless pursuit of perfection that drives every department bringing Middle-earth to life for *The Hobbit: The Battle of the Five Armies* also goes into the creation of the most authentic movie replicas. Created by the same artists working on the films, Weta is sourcing beautiful Middle-earth artefacts from across the departments and companies represented in *The Hobbit: The Battle of the Five Armies*, and offering them as authentic replicas for discerning collectors.

The line represents the closest experience next to visiting Middle-earth itself. Collectors will find replica swords hand-forged by a world-renowned master swordsmith using centuries-old and cutting edge techniques and props cast from the very same moulds as those made for the films. Maps and calligraphic prop replicas have been handmade and the films' original artists have created new, limited edition art prints based on the characters and landscapes they helped imagine for the films.

AFTERWORD

One of the most exciting aspects of my time spent on *The Hobbit* was working alongside the many creative teams behind this great project. I enjoyed every opportunity to work with Sir Richard Taylor, Tania Rodger and their team at Weta Workshop; as well as the amazing crew of Weta Digital, under the discerning eye and leadership of Joe Letteri; Production Designer Dan Hennah and his Art Department; Costume Designers Ann Maskrey and Bob Buck; and Make-up and Hair legends Peter King, Tami Lane, Katherine Brown, Rick Findlater and Gino Acevedo, who was also a digital wiz. At Park Road Post I had the pleasure of working with the post production teams assembled around the discerning ears of the brilliant Chris Ward and Brent Burge. Working together, these artists brought the world of *The Hobbit* to life in vivid, vibrant detail.

From my very first day in New Zealand I was afforded dialogue with all of these departments and their leaders, working closely under the guidance of Peter Jackson, Fran Walsh and Philippa Boyens, I was invited to be invested in every aspect of the design of my character.

Weta Workshop created a face for Thorin Oakenshield (two, in fact) sculpted by Jamie Beswarick with painstaking detail, incorporating the viscosity and pliability of the silicone which I was to wear 240 times over my own face, as well as prosthetic hands to enlarge my own to Dwarf proportions. Haired and veined to an extraordinary level of detail and realism, they would hold up to the scrutiny of Peter Jacksons 3D microscope.

As actors, we didn't wear costumes, but were dressed in clothing our characters would have lived in; and we carried ancient, noble weaponry imbued with the character and history that Tolkien conjured in his writing, but crafted in varying weights for our mobility and comfort without any sacrifice in onscreen impact.

The way our weaponry was carried and retrieved spoke to the reverent respect in which they were held, not as disposable props, but as practical fighting blades. I still marvel at the four small diamonds in the hilt of the original hero Orcrist sword that I received as a parting gift and will forever treasure.

The creative team members who came together to make these films were true pioneers in their fields, designing and inventing new ways to make Tolkien's characters feel as real as possible, to enable an actor to exist inside a great deal of accoutrement, and still breathe … well, for the most part! From the racing driver cooling vests under our costumes to the hand-blown glass set dressing in Lake-town, from the handbound books lining crooked bookshelves in the Master of Lake-town's chambers to the million pieces of hand-stamped Dragon's gold, or the engraving on every single link of Dwarven chainmaille, the attention to detail and care with which everything was approached was awe-inspiring.

I think my favourite moment was walking on to set wearing Thorin's gleaming gold regal armour, the product of numerous designs and about ten fittings. I was secured into it with a drill and screws, draped in a heavy velvet cloak and had a crown upon my wigged and prosthetic-covered head. I could barely walk beneath it all, but I was absolutely determined that this whole beast of a costume would move around Erebor, up and down the ramparts and deep into the bowels of the Mountain with effortless ease, until the moment that it all became too heavy for Thorin to bear. It was that moment, when so much about the design informed the journey of the character, that defines to me why Weta Workshop and Weta Digital continue to be leaders in their fields. It is how the work of the Art, Costume, Make-up and Hair Departments and On Set crew of 3Foot7, as well as the masters at Park Road Post, continue to push technology and effects innovations to a place which surpasses audience expectations and enables completely new and immersive cinematic experiences.

Having spent a great deal of time with these great artists, I know this is merely the tip of the iceberg. What lies beneath is already beyond our imaginations; new technologies and techniques wielded by artists at the forefront of their crafts which will ultimately go beyond cinema.

One thing I observed and came to appreciate acutely whilst in New Zealand, working for Peter Jackson, was this very simple exchange that I think sums it all up; 'Can you make this happen?'

'YES.'

– RICHARD ARMITAGE,
ACTOR, THORIN

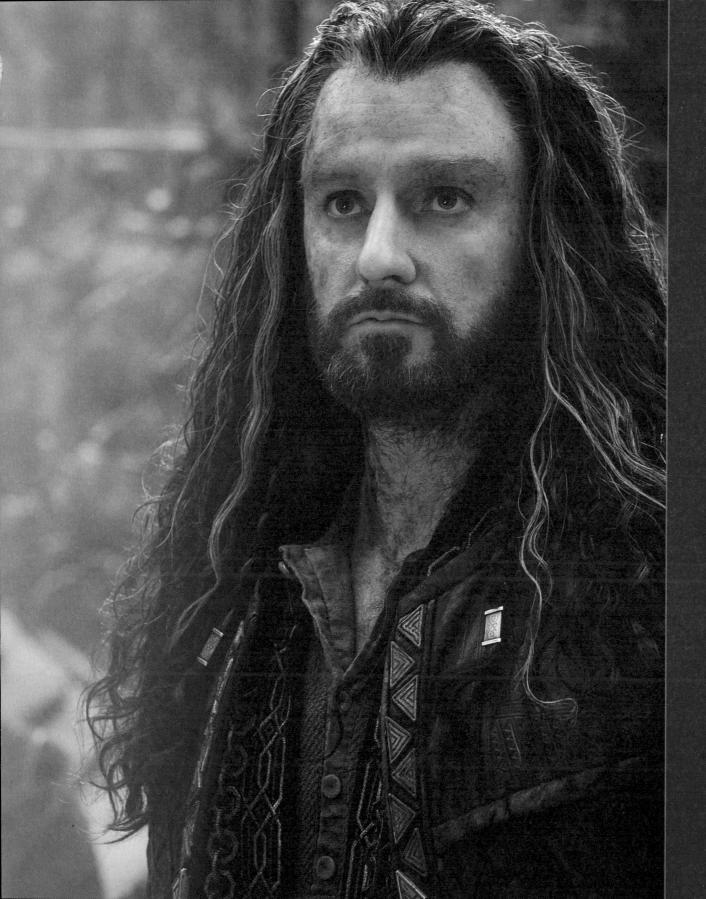

CREDITS

Writer and Art Director — Daniel Falconer

Layout Designer — Monique Hamon

Image Retouching — Chris Guise
Carlos Slater
Rebekah Tisch

Transcriber — Fiona Ogilvie

**Weta Workshop Design &
Special Effects Supervisor** — Richard Taylor

Weta Workshop Manager — Tania Rodger

**Weta Workshop Consumer
Products Manager** — Mike Gonzales

Weta Publishing Manager — Karen Flett

**Weta Workshop Design
Studio Manager** — Richard Athorne

Weta Workshop Photographer — Steve Unwin

**Weta Workshop Assistant
Photographers** — Wendy Bown
Michael Valli

Fold-out Battle Map Artist — Nick Keller

HarperCollins*Publishers* UK

Series Editor — Chris Smith

Senior Production Controller — Kathy Turtle

Design Manager — Terence Caven

Senior Designer — Cliff Webb

Art on chapter title pages 55, 91, 125 & 199 by Concept Art
Director John Howe